art matters

Julie Ault

David Deitcher

Andrea Fraser

Lewis Hyde

Lucy R. Lippard

Carole S. Vance

Michele Wallace

and others

edited by
Brian Wallis,
Marianne Weems,
and Philip Yenawine

art matters

how the culture wars changed america

New York University Press
New York and London

New York University Press
Washington Square
New York, NY 10003

Library of Congress Cataloging-in-Publication Data
Art Matters : how the culture wars changed America /
 Julie Ault . . . [et al.] : edited by Brian Wallis, Marianne Weems,
 and Philip Yenawine.
 p. cm.
 Includes bibliographical references.
 ISBN 0-8147-9351-7 (pbk. : alk. paper). — ISBN 0-8147-9350-9
 (cloth : alk. paper)
 1. Art and society—United States—History—20th century.
 2. Art—Political aspects—United States—History—20th century.
 3. United States—Cultural policy—History—20th century.
 I. Ault, Julie. II. Yenawine, Philip. III. Weems, Marianne.
 IV. Wallis, Brian.
 1953− .
 N72.S6A752 1999
 306.4'7'097309045—DC21 99-25880
 CIP

Photo credits:
Photographs and captions edited by Kristen Lubben
p. 8, Paula Court; p. 10, Basia; p. 12, Paula Court; p. 19, L. Charles Erikson; p. 22,
Blanche Wiesen Cook; p. 49, Lisa Kahane; p. 50, Colin; p. 54, Dennis Adams; p. 57
(right), Fred Krughoff; p. 73, Carolyn Wendt; p. 98, Zindman/ Fremont; p. 108,
Adam Reich; p. 111, Teri Slotkin; p. 180, Peter Bellamy; p. 223, Dona Ann McAdams;
p. 225, Richard Ross; p. 228, Dona Ann McAdams; p. 232, Dona Ann McAdams;
p. 234, Allan Clear; p. 246-7, Adam Reich; p. 252, Tom Klem; p. 261, Peter Norrman

About the cover:
Andres Serrano, *Piss Christ*, 1987, cibachrome, silicon, plexiglass,
wood frame, 60 x 40 in. Photo courtesy of Paula Cooper Gallery.
Art Matters grant recipient 1986, 1988.

Andres Serrano's *Piss Christ* became a flash point during the time of cultural crisis
which this book addresses. The image was, for a time, part of a visual shorthand used
by both sides of the public debate. But that *Piss Christ*—reproduced hundreds of
times in newspapers and magazines, carelessly cropped, in black and white, often
several grainy generations away from the original print—was not the work the artist
had made. It was merely a representation of some of the elements of its content.
Without the artist's composition, colors, and textures, the image was unavailable for
the kind of interaction with the viewer that creates connection and meaning. We
have used *Piss Christ* here because of its association with the "culture wars"; but it
is our hope that its reproduction respects its intrinsic value as a subtle and powerful
work of art.

On the back cover:
David Wojnarowicz, *Untitled*, 1988–89, gelatin silver print, 27 1/2 x 34 1/2 in.
Photo courtesy of the Estate of David Wojnarowicz and PPOW Gallery, New York.
Art Matters grant recipient, 1989, 1990, 1991.

Contents

4. Censorship and the Chilling Effect

5. Cultural Policy and Funding for the Arts

Acknowledgments

*This book is dedicated to the thousands of artists supported by Art Matters,
and to Laura Donnelley-Morton, who enabled that to happen.*

This book could not have been assembled without the help of a great
many individuals and organizations. The editors wish to thank, first
of all, the five authors who contributed original essays to this volume:
David Deitcher, Lewis Hyde, Lucy R. Lippard, Carole S. Vance,
and Michele Wallace. In addition, we want to thank several other
authors who generously granted permission to reprint their key
texts: Douglas Crimp, Richard Elovich, Coco Fusco, Holly Hughes,
Kobena Mercer, Martha Rosler, Kathleen Sullivan, the Estate of David
Wojnarowicz, and George Yudice. Artists Julie Ault and Andrea Fraser
have contributed two extraordinarily inventive artists' projects to the
book, and we thank them. And, of course, we owe a great debt to
Bethany Johns, our ever-resourceful designer, who miraculously created
a beautiful book out of an array of texts and fragments. Finally, we
wish to acknowledge the tireless efforts of our research assistants,
Karen Kurczynski, who created the chronology for the book, and
Kristen Lubben, who edited the photographs and captions.

The history of Art Matters, the nonprofit foundation, is really
a story of many dedicated and hard-working individuals. Although
some of these contributors are acknowledged elsewhere in this book,
we cannot overlook our outstanding former administrators Alexander
Gray, Bonnie Reese, and Margaret Sundell; and part-time staff Moira
Davey, Harper Montgomery, and Adam Simon. The success of the
Art Matters Catalog was due to Cee Scott Brown, Drew Souza,
Sean Strub, Esther McGowan, Cindy Cesnalis, Barbara Rausch, Mark
Uhl and many others. Art Matters also appreciates the generosity and
support of other foundations, especially the Andy Warhol Foundation
for the Visual Arts, the Joyce Mertz-Gilmore Foundation, and the
Rockefeller Foundation. Great thanks go to the Lannan Foundation
for their support of this publication.

BRIAN WALLIS

MARIANNE WEEMS

PHILIP YENAWINE

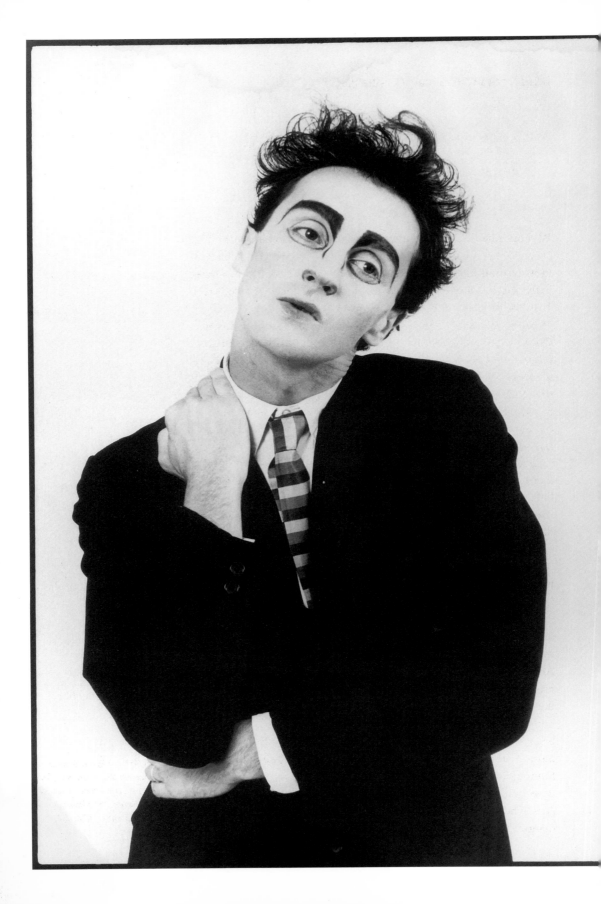

Introduction: But What Has Changed?

PHILIP YENAWINE

Without question, the culture wars of the late 1980s and '90s
changed the context in which the art world operates, particularly
in its relationship to government. A vocal, organized, and motivated
body politic, rooted in fundamentalist religious beliefs, hauled art
from the margins of society, where it thrived, to the center stage
of American culture, where it appeared bizarre and even ludicrous.
Conservative cultural critics, given an opening by the movement's
religious leaders, bashed everything from elitism to declining moral
standards. As both preachers and politicians decried some art as
sinful, blasphemous, or unpatriotic, they sought to reduce or elimi-
nate public funding for art in general. Courts of law, including
the Supreme Court, upheld laws enacted by these politicians that
allowed vague community standards and broad definitions of decency
to enter into the awarding of grants to institutions and individual
artists. And, in chronicling the debate, the national news media did
little to explain both sides of the story—that is, to educate the
American public about the arts—and more often simply fanned
the flames of controversy.

The culture wars happened in the midst of unprecedented artistic
activity, a part of which was an expanding spectrum of artists whose
works were exhibited. New sites, new media, new venues, and new
issues abounded, many of them reacting to what had come before.
Adherents of conservative but still dominant modernism found them-
selves being deconstructed, subverted, appropriated, and repositioned
by postmodernist perspectives so diverse as to defy categorization.
Alternative institutions, often explicitly critical of the status quo,
provided new venues for artists in addition to the white cubes of
the museums and commercial galleries. Art schools trained record
numbers of young artists, created many teaching positions, and
brought visiting artists (and thus much new information) to com-
munities throughout the country. New or enriched sources of
funding for art-making emerged, substantially encouraged by
government entities, especially the National Endowment for the
Arts, whose mandate included the fair representation of previously
marginalized voices and visions.

John Kelly as Egon Schiele
in *Pass the Blutwurst, Bitte,* 1986,
performance. Photo courtesy
of the artist. Art Matters grant
recipient, 1985, 1988, 1989,
1991, 1992.

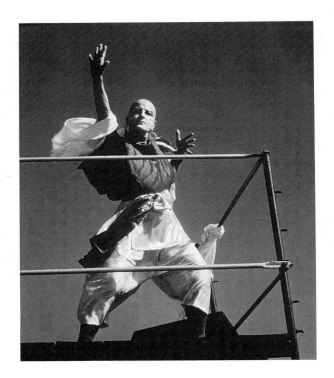

Rachel Rosenthal,
KabbaLAmobile, 1985,
performance, Los Angeles.
Photo courtesy of the artist.
Art Matters grant recipient,
1988, 1990.

Such national recognition and internal success allowed the con-
temporary art world a certain degree of complacency and a mistaken
belief that American society at large had embraced its avant-garde
viewpoints. There was in the early 1980s a heady belief in the social
significance of the new American art, and one could imagine, there-
fore, that the government and private patrons would continue to
support artistic experimentation and innovation, regardless of what
it said or looked like. As with modern technology, the positive value
of the "new" was regarded as a given.

This turned out to be myopic. The art world in general, especially
the cult of the new, was out of sync with the rest of American
culture. The accusations of elitism inveighed against the art world
during the early years of the Reagan presidency had some merit.
They were also a portent of things to come. Not even New York
was exempt from reaction. In 1981, for example, shortly after a
monumental steel sculpture by Richard Serra was installed in a
public plaza outside a federal office building, there was vehement
protest by government workers and officials who objected to the
imposition of this "inscrutable" wall of steel that others called art.
After nine litigious years, the federally commissioned, site-specific
art work was removed and destroyed.

Other trends in art, once discovered, turned out to be even more
disturbing. The advent of AIDS had prompted much new, angry,
and challenging art. And when the "real world" caught sight of art
that chronicled life at the receiving end of sexism, racism, and AIDS,

or that addressed sexual experience (especially homosexuality), or that questioned hallowed religious beliefs, the controversy referred to as the 'culture wars' began for real.

While conservatives attacked the visual art world with extraordinary zest in the late 1980s, it must be said that the status of art has always been suspect in America. As Lewis Hyde points out later in this book, most of the Founding Fathers held an extremely skeptical view of the arts, linking them with luxury, ostentation, and the antidemocratic prerogatives of kings. This view of art as elitist and nonessential continues to cloud political commentary on the subject to this day. Most politicians, when they deal with the arts at all, are either patronizing or dismissive, helping to account for the slow development of state and federal arts patronage. Arts agencies came about only in the 1960s and, even then, the levels of giving remained minimal by comparison to governments abroad.

Journalists also tend to be suspicious or openly derisive about the arts, as Julie Ault's artist's project in this book demonstrates. While such authors purport to speak for "the people," this assumption brings up a minor paradox. Many surveys tell us that a majority of Americans view the arts as important to their lives, even to the extent that they would willingly allocate tax dollars to support them, though preferably at the local level. If this is truly the case, then politicians and the media are out of touch with their constituencies— a tempting deduction in the late '90s. On the other hand, if we examine the marginal place of the arts within schools, we see that the advocacy registered in surveys rarely translates into budgeted mandates. This "soft" support for the arts and the lingering tradition of anti-intellectualism that undergirds it make the success of the anti-art rhetoric of the culture wars less surprising.

Elizabeth Streb/Ringside, *Backboard*, 1985, dance at the Central Park Bandshell, New York City. Performers: Elizabeth Streb, Henry Beer, Daniel McIntosh, Paula Gifford. Photo courtesy of the artist. Art Matters grant recipient, 1985, 1987, 1988, 1992.

The Wooster Group, *White Homeland Commando*, 1990, directed by Elizabeth Lecompte. Video still courtesy of the artists. Art Matters grant recipients, 1985, 1986, 1987, 1988, 1989, 1990.

The convergence of factors that fueled the culture wars also affected the private arena and helped to determine the course of a small foundation, Art Matters, which provides the lens through which this book examines the period. Art Matters' fellowships supported experimentation, including much of the art that others later found so troublesome (most of the art works illustrated in this book are by artists funded by Art Matters). Some of the foundation's initiatives addressed AIDS, while others were designed to counteract the damaging effects of the culture wars on arts funding and the rights of artists. The chapters of this book focus on the issues most central to the mission of Art Matters—art, diversity, AIDS, censorship, and funding—but it is our hope that they also help to explain the historical impact of this complicated moment of national debate over culture.

Private money has long been the mainstay of support for the arts in America, and Art Matters is a case in point. Art Matters was the brainchild of Laura Donnelley, a third-generation philanthropist and heir to a printing fortune. Laura and I met in 1978, when I was founding director of the Aspen Center for the Visual Arts (now the Aspen Art Museum) in Colorado and she was a member of our board of directors. In the early 1980s, Laura began to think about ways in which she could provide support for artists who were struggling to say something with bite and punch, who made "art that matters." Even though the gallery world was more diverse in those days, there was still little chance for adventurous artists to gain any appreciable income from their work. And the commercially successful artists were almost all white males. Laura felt that she could make a difference. As we talked about this together, the shape of Art Matters coalesced.

Within a couple of years, we had done the necessary legal work; had asked Mary Beebe, Cee Brown, and Laurence Miller to join us on the foundation's board; and set up shop in a loft in New York, where I had moved to become director of education at the Museum of Modern Art. Our first round of grants was made in 1985, totaling $160,900. Donnelley not only provided all of the operating and granting money for the first six years, but also created a small endowment to continue the foundation's operations after she refocused her giving in 1991.

The history of Art Matters mirrors in many ways the internal debates and the external dramas of the art world during the period of the culture wars. A good sense of the nature of the provocative

discourses that drove Art Matters can be gleaned from the comments of board members that artist Andrea Fraser has excerpted from long interviews she conducted and formed into the artist's project that appears throughout this book. There are also sidebars that detail various specific targets of Art Matters' funding.

Art Matters' giving focused primarily on fellowships for artists who were experimenting with mediums and ideas, and we attempted to allocate grants across the country. In general, the work we supported was noncommercial and interdisciplinary; we welcomed artists who challenged conventions. Our attempts to remain responsive to the issues of the times meant that a large part of our funding was directed toward political and activist innovations in art, but we also supported many artists and organizations whose aesthetic orientations were not explicitly political. The vision and effort of these artists contributed equally to the cultural landscape of the period, and, while not the primary focus of this book, were an important aspect of the foundation's activities.

For a number of years, before word of the foundation spread, we funded organizations that sponsored and presented new work, usually the alternative (and often artist-run) spaces that were cropping up in many cities across the country. We tried to make it easy for artists to get the money, eschewing lengthy applications or needs statements. We made the turnaround time as short as possible. And, although it was much debated, we developed a pattern of giving fairly small grants to many artists rather than larger ones to fewer. There was a sense at the time that most fellowship programs recognized a certain level of achievement and that grants most often went to established artists. By instinct, we made grants where need was simply assumed and promise, rather than accomplishment, was the issue.

When a grant application was denied, we provided feedback to the artist, if requested. Occasionally, we did so even without invitation because we felt it was important for artists to know how their work came across. When we found that slides or other documentation that had been submitted were inadequate to determine the quality of the work, one of us would visit the artist's studio, or we would supply money to improve the quality of the documentation. Sometimes, we invited artists to come and present their work to us directly so that we could understand work that does not communicate by any other means.

Todd Haynes, *Dottie Gets Spanked*, 1994. Film still courtesy of Zeitgeist Films. Art Matters grant recipient, 1987, 1988.

To a very real degree, Art Matters' funding was affected by a key aspect of government giving during the late 1970s and early '80s. In their programs for institutions and, later, for individuals, government agencies were far fairer and more democratic in supporting artists than the art world had been on its own. The NEA and similar state entities worked hard to allow marginalized voices an equal opportunity at money. Art Matters adopted this approach, as did other art funders at the time. To ensure that we had the diversity and breadth of experience and knowledge we needed, we expanded our board from five to thirteen people. Ironically, the drive for equitable representation of all people and visions, which Michele Wallace discusses in her essay and which seems to be democracy at work, was eventually cast in a negative light by the Right. The even hand of the NEA was seen as using tax money to support depravity and blasphemy.

When conservative groups started taking potshots at art in 1989, their wrath was often directed toward precisely the younger, more experimental, and more vulnerable artists that Art Matters had been funding. As Carole Vance and others in this book show, many of the highly publicized battles engineered by the Right sought to use standards of "decency" and "normality" to judge the social and political viewpoints of these artists. Much of the controversy played out in debates regarding the NEA, even though its grants were often tangential to the making or exhibiting of the works that were deemed offensive.

Art Matters responded to the funding crisis and the growing threat of censorship by making a particular effort to aid artists whose messages were endangered by the chilling effects of the culture wars. We also supported a number of organized efforts that

National Campaign for Freedom of Expression

In 1990, Art Matters gave fellowships to Joy Silverman and Alexander Gray to start an advocacy effort representing artists whose rights and needs were not necessarily addressed by other art world organizations mobilizing against attacks on government funding. The National Campaign for Freedom of Expression (NCFE) was in active operation later that year. NCFE remains the only nationwide organization exclusively dedicated to challenging the erosion of First Amendment rights as applied to the support, presentation, and creation of the arts in the United States. The heart of NCFE's mission is one-on-one work with artists under attack or simply seeking to promote freedom of artistic expression. It provides strategic advice concerning grassroots and national coalition-building, using the media effectively, legal referrals, support from community and beyond, mediation, and educational and reference materials. NCFE has created the Free Expression Network (FEN), a coalition of more than forty national organizations representing artists, record companies, the motion picture industry, booksellers, civil liberties groups, libraries, museums, theaters, publishers, and the Internet community, all concerned with defending the First Amendment. FEN also coordinates the Free Expression Clearinghouse Web site (www.freeexpression.org.) The National Campaign for Freedom of Expression Quarterly is a source of news and information for First Amendment and arts advocates, including regular information concerning the rights of minors. NCFE has recently published the Handbook to Understanding, Preparing for, and Responding to Challenges to Your Freedom of Expression. NCFE staff and board members also participate on panels, give workshops and lectures at conferences, conventions, colleges, and universities nationwide. For further information, call 1-800-477-NCFE.

directly challenged the government's position on cultural funding and AIDS research, including the National Campaign for Freedom of Expression (see p. 14) and Visual AIDS (see below). This was, in part, an effort to defend some of the art Art Matters had encouraged artists to create. In this way, Art Matters became a participant in the activism of the late 1980s, supporting strong statements and actions intended to protest social inequities and to produce change.

Although Laura Donnelley understood our ardor and stood by us as we reshaped our giving, the oppositional stance that Art Matters had forged was difficult for her. Sadly, but with great grace, she turned the foundation over to the board, leaving us with a modest endowment to support our ongoing work—funding aesthetically challenging art, much of it politically motivated. Although an act of exceptional generosity, the endowment was too small to sustain the level of funding that had been attained. Facing the virtual elimination of governmental funding for the creation and display of art that was socially charged, we felt that Art Matters was needed more than ever. It was not an issue of money alone, however, because both the NEA and Art Matters stood for something that was endangered by the culture wars. Our advocacy of inclusiveness was perhaps as important as the dollars awarded.

What occurred subsequently led to the decline of the foundation, but is worth telling as it relates to the perils of the nonprofit art world. After Donnelley withdrew, Art Matters surveyed its grantees to see what they wanted us to do, given our limited resources. The results were inconclusive, but it was clear that they wanted us bigger, not smaller. We tried to

Visual AIDS projects
Top: John Giorno, 1993
Bottom: Barbara Kruger, 1992. Art Matters grant recipient, 1988, 1989, 1992, 1993.

Visual AIDS

Visual AIDS began as a loose association of artists, writers, and curators who met beginning in 1988 to address the toll that AIDS was exacting on the art world. In 1989, Art Matters helped fund their first project, Day Without Art, a commemoration by over 800 arts institutions for those who lived with or had died from AIDS. This annual event is now marked in a huge variety of ways by 8,000 arts institutions worldwide. In 1990, Art Matters fellowships to two individuals, Patrick O'Connell and Alexander Gray, created a staff for Visual AIDS. The organization has many different kinds of programs dedicated to helping artists with HIV/AIDS, using artist projects to call attention to the epidemic, and developing an archive of art about AIDS to serve as a reference tool and the basis for organizing exhibitions. Among Visual AIDS' best-known projects are The Ribbon Project, which turned a simple Red Ribbon into an internationally recognized symbol of AIDS awareness; and Night Without Light, a commemoration that coincides with World AIDS Day/Day Without Art (December 1 each year)—for fifteen minutes, the lights on Manhattan's historic buildings and monuments are turned off in recognition of those who have died. Across the world, other cities, including Tokyo, Sydney, Paris, and Berlin, are now joining to dim their skylines at sunset. Currently Visual AIDS' most ambitious project is the Archive Project, which raises money to provide materials for low-income artists with HIV/AIDS; documents the work of artists with HIV/AIDS (presently 8,000 slides by over 200 artists) and provides them with career training and exhibition support; locates free legal advice to help them safeguard their estates; and provides referral services to social services agencies.

increase our capacity to give at first by a traditional approach: making fundraising appeals to foundation colleagues, particularly our partners in the Arts Forward Fund (see below). We presented them with the opportunity to use Art Matters as a conduit for making grants to individuals; most of them were neither mandated nor legally structured to do this themselves, despite their interest and concern. Taking another tack, we sought contributions from the broad public that claimed interest in contemporary art. We initiated a number of professional mass mailings, inviting contributions of any size to our fund for fellowships. Returns barely covered the cost of the campaign.

Meanwhile, as government funding dwindled, only one real solution was being proffered by the public sector to nonprofit arts organizations: adopt the practices of the entrepreneurial world, and pull your own freight. After much debate and consultation with industry experts, Art Matters decided to give it a try. With the aid of our direct-mail advisor, Sean Strub, we invested our endowment in the creation of a mail-order catalogue of artist-made objects. We projected that within two to three years, this business would generate enough income for us to afford to maintain and even expand our grants program and at the same time support artists whose works we sold. Many artists willingly designed a wide range of clever products, which Art Matters produced. Handled impeccably by Cee Brown, the initial mailing of over a million catalogues yielded an impressive return ($1.2 million), not to mention garnering awards from the industry. A second edition also sold well, but since the income was insufficient to capitalize the new business for ensuing editions, we sought outside investors.

The business plan that Art Matters compiled was circulated widely among individual investors, catalogue entrepreneurs, banks, and foundations that made "program-related investments." Despite expressions of interest, we were unable to raise the relatively modest amount of sustaining capital that we sought—$1.5 million over two

The Arts Forward Fund

In 1991, Art Matters was involved in the conceptualization of the Arts Forward Fund and subsequently provided programmatic administrative support for it. Thirty-six New York City funders cooperated in this effort to bolster self-sufficiency among struggling arts organizations, many of them focusing on new art and facing the decline of government assistance. A strong assumption behind the Fund was that old fundraising and administrative structures no longer worked well enough and that fresh thinking was needed if organizations were to thrive (or in some cases, even survive) in the new climate. Financial administration was provided by the New York Community Trust, though the pooled resources that represented the Fund were controlled collectively by all thirty-six participants. The program was open to any arts group in the five boroughs of New York City. The Fund intended to send a positive and encouraging message to the arts community in New York City in a time of financial crisis, to change the nature of the dialogue between grantmakers and arts organizations, and to foster innovative collaborations. During the course of the Fund, thirty-six planning grants totaling $681,500 and seventeen implementation grants totaling $1,026,425 were awarded.

years—in the limited amount of time that we had. Catalogue entrepreneurs seemed to be discouraged by the limitations on growth; they saw artists as necessarily limited suppliers. Other investors and banks seemed uncertain about this kind of business in general.

The lack of support for this nonprofit, entrepreneurial model—which others had proposed and which Art Matters sought to put into practice—is also worthy of some examination. The principal question is, why did other foundations who were also committed to helping artists make their work not support our efforts, particularly as alternate funding sources were being eliminated? There are likely many reasons, but one tempting answer lies in the dominant conservatism of the art world, of which foundations are a part. Art Matters was out on a limb in terms of its funding priorities, and was clearly identified with the makers of the most challenging art. Though we actually supported a wide range of things, we had taken an overtly oppositional stance that seemed to have limited our options.

As Lucy Lippard shows later in this book, the "official" art world has historically viewed activist or oppositional art with distaste and attempted to distance itself from it. Art that criticizes the system, begs some kind of change, exposes taboos, or espouses a cause has long been questioned as art, even by many who take a liberal stance when it comes to aesthetic issues. In defending the NEA in the culture wars, for example, many of the agency's apologists cited the small number of "objectionable" grants it had made. It was, they inferred, only a small proportion of art that was troublesome—that is, "unpatriotic," "blasphemous," "sexually charged," or "descriptive of reprehensible lifestyles." In trying to save the NEA, these arts advocates tacitly granted its strongest critics the right to object to it on these questionable grounds.

The Art Matters Catalog; Fall/Winter Issues 1995, Spring Issue 1996. Designer: Drew Souza.

The Art Matters Catalog

The Art Matters Catalog was initiated in 1994 to sustain and potentially expand the foundation's grantmaking activities. The catalogue was funded in its startup solely from Art Matters' endowment with the goal of supporting artists in two ways: by advertising and selling the products of artists working in the marketplace, and by using profits to provide fellowships. The first Art Matters Catalog was published in fall 1995, the second in the spring of 1996.

Both catalogs far surpassed the projections of experts in the industry, exceeding projected sales for Fall 1995 by 20 percent, grossing over $1.2 million, and achieving higher average orders than comparable catalogs for The Metropolitan Museum and the Museum of Modern Art. The 1995 Catalog also received first place in the Consumer Catalog division from John Caples International, one of the highest achievements possible in the direct-marketing industry.

The Catalog was also widely covered in the media, from feature articles in *Time*, *Newsweek*, and the *New York Times* to over fifty design and shelter magazines. The call for entrepreneurial activity from the nonprofit arts community had found a fitting example in this project. Before the Catalog became self-sustaining, however, it reached a point where additional investments funds were required. Despite an energetic search for investors, none were forthcoming.

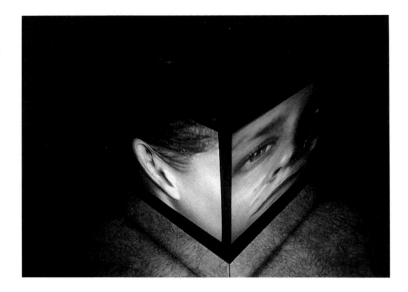

Judith Barry, *Imagination, Dead Imagine*, 1990, video installation. Photo courtesy of the artist. Art Matters grant recipient, 1987.

This admission was abetted by the fact that artists and arts institutions had become so accustomed to operating by their own values and conventions that they were surprised that others might not understand or approve. When the attacks on art began, for instance, there was no attempt to address through education or an open exchange of ideas any of the general misunderstandings or fears about contemporary art. Museums, the one arts institution that did acknowledge some kind of responsibility to the public, did make some efforts to educate the public in general, though most of their exhibitions and programs dealt with the art of the past rather than the art of our own times. But, given the challenge, even they failed to come forward with a concerted effort to explain art's social value, or to offer insights into why artists do what they do, and why it is accepted (if not always relished) in the art world itself. There was no serious attempt to build a language that might bridge the gap between the tiny world of high art and the rapidly expanding world of popular culture.

The 1980s might be noted for the quantity of art that was particularly difficult to understand, both for its subject matter and its political views. This work ranged from Robert Mapplethorpe's highly aestheticized depictions of sexuality and sexual practice to Andres Serrano's idiosyncratic musings on Catholicism, from Karen Finley's performances of poetic rampages against sexism and other phobias to David Wojnarowicz's evocations of the redemptive power of sex and his rage at the treatment of people with AIDS. Such work can be disturbing or confusing, even to the practiced viewer, and was always intended as such. If viewed superficially or

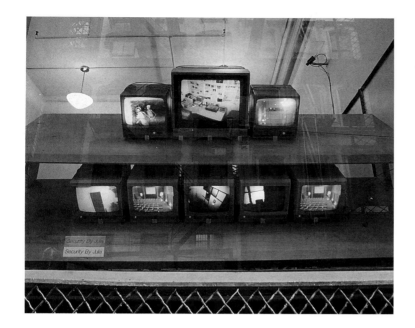

Julia Scher, *Security by Julia (viewing area for closed-circuit television)*, 1988, video installation. Photo courtesy of Andrea Rosen Gallery. Art Matters grant recipient, 1987, 1988.

without understanding of the artist's motives and the context in which he or she worked, it can be shocking. Thus, when works like Mapplethorpe's photographs of certain gay sexual practices and naked children came to the attention of art-world "outsiders," they were met with hostility. Vocal opponents, who already distrusted art and, ironically, rarely saw the works they came to vilify, often heard these works described incompletely in mailings and in the press, and responded indignantly.

The point I want to make, though, is that the art-world defenses against attacks by such uncomprehending viewers were from the start half-hearted and unconvincing. For example, when the Mapplethorpe photographs became the centerpiece of an obscenity trial in Cincinnati in 1990, the art world could muster only two relatively weak responses. The first was to call upon established art-world authorities to assert the artistic merits of the photographs based on their own expertise. In other words, it's art if we say so. The second defense emerged under cross-examination, when deeper explanations of the images were required. Here, the art-world experts explained Mapplethorpe's photos in terms of their formal qualities and technical perfection, as if the shocking subject matter should be overlooked in favor of Mapplethorpe's brilliant compositions and technique. Jurors later confessed that they were unconvinced by the testimony but felt unqualified to judge this specialized subject. It was simply the weight of the art-world witnesses that had prevented conviction. If the prosecution had produced even one similarly credible witness, the jurors implied, it would have won the case.

Perhaps the Mapplethorpe defense team considered it too risky in that context to try to justify art that upsets our preconceptions—and they might have been right. It is complicated to explain art that attacks conventions, especially art that asserts that a gay man has just as much right to a public presentation of autobiography as anyone else. It distresses me, however, that such arguments were not made, and part of this is because art-world practitioners were confused and divided themselves. Once, also in 1990, I asked an audience of program directors and administrators from performance spaces around the country who among them could explain the work of Annie Sprinkle to the skeptical public. Sprinkle had recently been attacked by NEA critics for enacting at an NEA-sponsored space her own brand of performance art, which involves ironic anatomy lessons, including the opportunity for members of the audience to inspect her vagina. None of the performance art experts took up my challenge to explain Sprinkle's work, which, admittedly, is not an easy one. One or two people tentatively offered the opinion that maybe Sprinkle's performances weren't art after all. Divided, unconvinced, and certainly unprepared to talk, we found ourselves in a trap that might have been set by others, but was baited by ourselves.

In the cases made infamous by the culture wars, the principal defenses of this problematic art came from the legal community: the artist's generalized right to freedom of speech was argued, not the inherent value or meaning of their art. In this way, the art world actually allowed some of the most passionate, personal, and transgressive artists of the 1980s to be demonized, protected solely by the thin veil of free expression. To the artists, it felt as if they were in a debilitating process over which they had no power. Their work multiplied in meaning beyond their intent and control, and they were seldom invited to represent or defend themselves.

As supporters rather than players, foundations can claim a lesser role in all of this than those who present or write about art. But they make choices about what they fund, and it is in thinking about

Estate Project for Artists with AIDS

In 1991, with the involvement of Art Matters, the Alliance for the Arts (New York City) initiated the Estate Project for Artists with AIDS intending to develop a way of advising artists on estate planning, as well as providing strategic direction for the arts community in the face of the enormous cultural losses created by AIDS. Since that time, 75,000 copies of the resulting publication, *Future Safe*, have been disseminated internationally in English and Spanish. By 1993, the Estate Project was actively pursuing a national program of archival projects, including the Virtual Collection, a digital archive of work by visual artists with AIDS that has been developed in conjunction with the Getty Information Institute, and which brings together an extensive collection of images created by artists with AIDS. This archive makes it possible for curators and historians to have access to this material over the Internet. An even larger effort is the Estate Project's initiative to catalogue and preserve the majority of AIDS activist video made in America. A core group of 250 hours of tape is now being preserved and housed at the New York Public Library. The Estate Project is also preserving independent film in partnership with the Academy of Motion Picture Arts and Sciences and the Solomon R. Guggenheim Museum to develop standards of

this that one of the more insidious effluents of the culture wars becomes a concern. From very early in the struggle, the art stalwarts worried about a chilling effect: an elimination of funding in categories where trouble might arise, an easing away from controversy by arts presenters and sponsors, and perhaps even a shifting away from "problematic" subject matter by artists themselves. Today, in 1999, the elimination of funding is obvious, easy to document through an examination of the budgets of government arts agencies. It is also possible to claim that Art Matters was itself a victim, chilled out of existence. And yet, its efforts might still resonate: a number

Lari Pittman, *Out of the Frost*, 1986, oil and acrylic on wood panel, 82 x 80 in. Photo courtesy of Regen Projects, Los Angeles. Art Matters grant recipient, 1986.

preservation. The Estate Project's Dance Initiative consists of a new publication, *A Life in Dance*, and a national survey of dance documentation. The Estate Project is also developing a project to digitally document dance using motion capture technology. The Estate Project views the art works created by artists with HIV/AIDS as vital historical records of a time of crisis, and its program as a possible model for other communities whose cultural legacies are endangered.

The Critical Needs Fund for Photographers with AIDS

In 1992, Art Matters and Photographers + Friends United Against AIDS initiated a collaborative effort, The Critical Needs Fund for Photographers with AIDS. Photographers + Friends and The Estate Project provided money from various fundraising activities and Art Matters publicized and administered the fellowships. By 1998, forty-five photographers had received assistance. The grants provided support for art supplies, archival purposes, and health care expenses, all intended to allow photographers with HIV/AIDS to continue their artistic practices. Applications were accepted on an ongoing basis, with notification made within a month.

Ada Gay Griffin and Michelle
Parkerson, *A Litany for Survival:
The Life and Work of Audre Lorde*,
1995. Film still courtesy of
the artists. Art Matters grant
recipient, 1992.

of forward-looking foundations have now
pooled their resources to create a new entity,
the Creative Capital Fund, for the purpose
of making fellowships to artists. We at Art
Matters see this as a legacy.

So, what has changed in America because
of all of this? The art world still operates in
its own self-involved way, fragmented though
it is. Artists still make a huge range of things,
and they seem to do it whether or not they
have grants or sales. If a chilling effect has
sent some artists back into the closet and
created more conservative programming,
it hasn't eliminated difficult art that boldly interrogates fixed ideas
about gender, sexuality, sexual behavior, race, or other identity
issues. Artists like Holly Hughes, Tim Miller, and Ron Athey still
talk loud and queer in public, though silencing them remains the
goal of a few.

Most arts organizations have tightened their belts and also found
new ways to support themselves. Encyclopedic museums run much
as they mostly have, touting historically validated art while wedging
contemporary art into odd corners. Modern museums still juggle
programs that provide historical perspective with those that attend
to new trends. Alternative spaces and institutes of contemporary art,
key targets of NEA defunding, still struggle with inadequate budgets
but most still operate. And despite all the efforts of '80s activism,
women and artists of color still have to fight for representation in
galleries and museums. Art schools and art-history programs continue
to attract large enrollments. People still tell pollsters that they feel
the arts should be supported, and yet the place of the arts in public
education is still minimal.

But something has changed: it is now very hard to recreate the
feeling of safety and fearless adventure that was palpable in the early
1980s. Although AIDS is as much a reason for this as the culture
wars—as David Deitcher discusses in his essay in this book—it is
also hard to recover from being vilified. Some of the artists who
told their own stories about living in America in ways that were
brilliantly insightful, no matter how "negative," no matter how stark
or intimate, were irreparably wounded. David Wojnarowicz, for
example, did not have time to heal. When Rev. Donald Wildmon
attempted to raise money by publicly labeling him a pornographer,
David, who was already very ill because of AIDS, sued him and
won. But from then until his death a year later, David's creative

Bruce and Norman Yonemoto,
Environmental, 1993, mixed
media, two channel video
projection. Photo courtesy
of Blum & Poe Gallery.
Art Matters grant recipients,
1987, 1992, 1997.

output was virtually nil. And I believe that one of the toughest
spirits of the times had been broken.

This book is an attempt to recapture the period before that
happened, when art was vital and engaged, and upstart organizations
like Art Matters could still make a difference. Our intent is to
encapsulate the public controversy over art in words and images,
to describe and examine what happened and why. We have tried
to present a wide range of perspectives, from active participants
and artists to theorists and scholars. Though we are not of one
voice, we hope that what resounds is our shared conviction
that art matters.

Talking to Art Matters | a project by ANDREA FRASER

Between March and October 1997, Andrea Fraser conducted extensive interviews with the individual board members of Art Matters Inc. She constructed the following "conversations" by editing and intercutting the transcripts of those individual interviews. The interviews have been laid out in two columns: the romanized text on the right includes material relating directly to Art Matters, while the italicized text on the left includes more general information pertaining to the topics of each chapter. Fraser has undertaken similar interview-based projects for the Kunstverein Munich and the EA-Generali Foundation in Vienna.

The Art Matters Board

The Art Matters board members interviewed by Andrea Fraser are: **Mary Beebe**, director of the Stuart Collection at the University of California San Diego; **Adam Bernstein**, currently senior program officer at the Charles E. Culpepper Foundation; **Cee Scott Brown**, formerly executive director of Creative Time (1985–93) and executive vice-president of Art Matters (1990–96), where he was the driving force behind the Art Matters Catalog, who now sells real estate in the Hamptons; **Laura Donnelley-Morton**, collector, philanthropist, and donor to Art Matters; **Linda Earle**, currently director of the Theater Program at the New York State Council on the Arts, where the Individual Artists Program was founded under her direction in 1984; **Gai Gherardi**, cofounder and owner of l.a.Eyeworks in Los Angeles; **David Mendoza**, formerly executive director of the National Campaign For Freedom of Expression (1991–97), and now on hiatus in Bali; **Laurence Miller**, formerly director of the Laguna Gloria Museum (1974–90), and currently director of ArtPace, a foundation for contemporary art in San Antonio; **Lowery Sims**, curator of twentieth-century art at the Metropolitan Museum of Art; **Kathy Vargas**, a visual artist and director of the Visual Arts Program of the Guadalupe Cultural Arts Center in San Antonio; **Marianne Weems**, president of Art Matters since 1991, who now directs the multimedia performance ensemble, The Builders Association, in New York; **Philip Yenawine**, chair of Art Matters, former director of the Education Department at the Museum of Modern Art, and now codirector of Visual Understanding in Education; and **Bruce Yonemoto**, video artist and filmmaker.

Introduction:

"Supporting artists for their reasons—whatever they were"

Laura: I used to have that in the dining room—you know how you have a portrait of your ancestors in the dining room? It's by Donald Roller Wilson. All of his paintings are of monkeys. There's a very sinister story behind it, about a boarding house where the animals live but the owner, Mrs. Jakenson, is a cruel creature. They're always trying to get away with something, but she always finds out. That's Leon Golub. My children were raised on AMI. They hated artists—hated anything to do with art. But you know what? Now they look back and they say, "What a great childhood." Sitting and playing a song by Laurie Anderson. Little bits and pieces of life. A very old Nicolas Africano. . . .

Bruce: *I usually wonder why people from the private sector would want to be on certain boards. Is it a social thing? On higher levels, you can schmooze with declared geniuses who've already been sanctioned. You can share the light. But at Art Matters?*

Philip: Art Matters Inc. began because Laura Donnelley had more money than she needed to spend. She wanted to do something for artists. She was involved with the Aspen Art Museum, where I was the director from 1978 to 1982. She began collecting and had a great eye—even before AMI existed, she paid for Jenny Holzer's *Sign on a Truck*. After I left Aspen to become the director of education at the Museum of Modern Art, we developed the idea of a fellowship program for individual artists, especially artists who did not have income from their work. We started making grants in 1985.

Laura: I very quickly made a transition from being interested in collecting and owning art to participating in a process. That's what started AMI. Philip and I talked about artists making art. It was difficult to engage in that process where people just wanted to have nice shows on the wall. Supporting artists was just want I wanted to do with my resources. I've always been interested in art. It was a natural place for me to be involved.

Philip: For women with real fortunes, money can be a curse. Where's your place in life? You look at the role models around you: there are club ladies, there are ladies who lunch. She wanted to have a connection with people that was deeper and more real than money and she wanted to be recognized and treated as a human being.

Laura: Recently, a guy came by who thought he was being turned on to some art patron. He heard, "Oh, you might get some money out of that woman." He didn't know what it was all about. I said, "Remember AMI?" Getting involved in philanthropy was almost like an onus to me. Am I ever going to be able to get beyond that and have a life that's just my creativity? My God, there's this background I

have! What I have to manage in life is money. But I also had a strong streak of genuinely loving to watch another person thrive out of what I could provide.

Philip: AMI was Laura's first foray into major giving, and it was an act of incredible generosity. For five years, she picked up 100 percent of the tab and, at the same, time put funds aside for an endowment—which we didn't even know she was doing. If we found that we were struggling to narrow down our grants, there would be a moment when she'd get tearful and make it possible for us to give more. Most people would have said it was nuts for an individual to give so much more than she could deduct. Most philanthropists create a structure through which they can support whatever interests them. Laura created a board that actually had a vision and a sense of mission: finding artists to support and ways of supporting them. It was like giving us the best present that anybody could have given. None of us had any money to support contemporary artists. All of us worked for organizations that circumscribed our activities. Having the capacity to grant someone money because you just believed in their work empowered us in ways that were really quite wonderful. Laura never insisted that her views were more important or pushed a personal agenda. That's one of the reasons why it was called Art Matters Inc., not the Laura Donnelley Foundation.

Laura: It wouldn't have occurred to me to name AMI after myself. I didn't want to use it to elevate myself into prominence.

Philip: Mary Beebe came up with the name. Art Matters Inc. Ami, friend of artists.

Gai: *Most of the boards that I know are made up of people who are not in the community of the artists and often have sensibilities that are in opposition to artists.*

Mary: My involvement began, like everybody's, because of Philip. I was director of the Portland Center for Visual Arts in Oregon. Laurence Miller was at the Laguna Gloria in Austin. And Cee Scott Brown was the director of the Holly Solomon Gallery and later of Creative Time.

Laurence: To a certain extent, the history of the concerns of AMI are Philip Yenawine's concerns. While there existed a commonality of concern, very rarely do I remember conversations about issues that had not been brought to the table by Philip.

Philip: In 1990, we decided to diversify the board. There was a discussion about what complexion it should take, should it include money people or not. We decided that the better stance was to continue to be a board of professionals. We didn't want to create a situation where half the board can't give but knows something while the other is just there for money.

Adam: *At most private foundations there's not one artist or arts administrator on the board of trustees.*

Linda: I've been involved with AMI since 1990. Other people were brought on quite soon after I was: Bruce Yonemoto, Kathy Vargas, Lowery Sims, Adam Bernstein, and Gai Gherardi, the most recent. David Mendoza was on before me.

Marianne: *And the gap between staff and trustees is usually enormous and unbridgeable.*

Marianne: When I finally had to leave my job as AMI's first administrator I was asked to join the board. It was a decision for a younger artist and smarty-pants over an older money-bags. Then I became president.

Laurence: The decision not to pass the foundation leadership down the hierarchy but to give the presidency to Marianne was a value statement in itself.

Lowery: *There are very few instances where trusteeship doesn't devolve into rife paternalism. Usually, there really isn't much contact with the constituency.*

Kathy: *That lack of familiarity tends to make trustees more conservative and less aware of the drastic needs of the arts community.*

David: The AMI board has a different culture than most in that we're all arts professionals. But we're in many different roles: Philip works in education; Linda and Adam with funders; Mary, Laurence, and Lowery as curators; Kathy, Bruce, and Marianne as artists.

Laurence: *Speaking as someone who has suffered from trustees for years and years and years as a museum director, I have very mixed feelings about trusteeship. Most of the trustees I've worked with weren't interested in conflict or learning.*

Kathy: *Because all of us are in the art world, we could use all of our multiple levels of expertise to bring different artists from different areas and ethnicities into the process.*

Gai: As a business person, I was concerned about how appropriate I would be as a board member.

Bruce: Gai is one of the only corporate people I've served with on a board who truly understood her role in an arts organization.

Linda: *We could cut out a whole layer of bureaucracy and deal directly with artists' requests. And in considering applications, we were free of the kinds of concerns that the public dollar is tied to. We could make decisions that would be called arbitrary and capricious in the view of the state, decisions based on feeling. But it was understood that feeling was more than a personal thought passing like a cloud through your mind. It was based on years of experience and knowledge of the field.*

Gai: I'm often asked, "How do you judge?" My God! For somebody like me, I feel incredibly unable to judge. But through discussions and arguments and through informing oneself, a decision can emerge that's very solid.

David: I brought everything to our panels, from my degree in art history to being a gallery dealer, directing nonprofits that support artists, and years of attending performances and looking at art.

Mary: *Art professionals are considered elitist when we say that we know and others don't. But we have studied and spent time. We have a legitimate interest. Not that all of us agree. . . .*

Adam: I kind of step back and let the curators. . . .
That's not my academic background.

Bruce: Some of the board members, mainly because it wasn't their job, had limited experience with experimental art, particularly art made by younger people.

Laurence: Lowery, for instance. Artists that AMI supports are not artists she is generally concerned with.

Lowery: I'm the really conservative one on the board. My strengths are in painting.

Mary: *We would have arguments about whether painting is dead. A lot of it was pretty boring. But installation art can be boring, too.*

Linda: It was great to go in and have your agenda totally upset. Sometimes I thought, "Am I losing my mind? I usually hate this kind of stuff."

Bruce: I, of course, have an agenda. I like the really, really idiosyncratic.

Mary: My personal criteria? I guess it's a gut-level thing: what makes me think, takes me someplace I haven't been. I'm looking for a spark, an individual voice, a striving toward confidence, something that provokes a real response in me.

Adam: *Every member of the board has an expansive and tolerant view of what the arts should be allowed to be: that there should be room for exploration, that we shouldn't be quick to draw lines around what is or isn't art. There is by no means a single vision on this board, but I think there is a single openness.*

Laurence: *Most organizations support artists for their own reasons, not the artists' reasons. We really tried to support artists for their reasons—whatever they were. I don't remember any discussions about values, or about what institutions call value clarification. There was just an assumption that, whatever your values were, they were valuable. We knew that the way for individuals to learn was to take the risk that their own ideas might be overturned.*

Marianne: *AMI posed a challenge to more conventional foundation practices. It was structured to embrace things that would otherwise be disruptive. Remember when you came in and did that little performance?*

Andrea: That was in 1986. I had just done my first gallery-talk performance at the New Museum in New York. You suggested that I apply to AMI but I had no documentation of the performance. Not a single photograph! So the board let me come into a granting session and perform a little piece of it. It was my first grant.

Marianne: *Most foundations would never take the risk of coming face-to-face with an applicant. What else did we do? I'm trying to think of the other. . . irregularities.*

Philip: Sometimes we gave small grants just so people could produce better slides.

Lowery: We were flexible. If we got a fax saying, "Karen Finley needs $1,500 to do something or it won't happen," we could act quickly.

Marianne: There were good-fairy grants to people who hadn't applied but we wished had.

Phillip: AMI was an artist's advocate. Our point was money to work. We discouraged proposals and didn't care about resumes. We just wanted to look at the art.

Marianne: In four years the applications grew from 35 to 600 per granting session.

Philip: Since our grants were not big, people applying usually needed the money to work. And the vast majority of the artists that we supported had never gotten funding from anybody. It was a message that this work matters. It has a compelling reason for being on the earth. It has values that forward an agenda.

Mary: I used to argue for giving fewer bigger grants. But, boy, when you get the feedback that we got. . . .

Gai: The story from somebody that $2,000 meant the difference between thinking they were the biggest piece of shit in the world and were going to have to go to work at Dairy Queen and forget about everything they ever thought was important. . . .

Laurence: Or a 4:00 a.m. conversation with Felix Gonzalez-Torres when he started talking about how important it was when this weird foundation gave him a $1,500 grant. He didn't remember that I was on the AMI board.

Cee: We helped validate work. We gave Jenny Holzer one of her first grants, when a lot of people thought her work wasn't art, just words. It meant a lot to her.

Mary: As the '80s wore on, we were proud to give grants to people no one else was going to give money to, people who defy the Jesse Helmses of this world.

Laurence: We supported art that articulated issues and concerns in confrontational ways, voices that would jeopardize the funding base of mainstream arts institutions. But in addition to encouraging artistic subversion, AMI was also subversive in its management.

Lowery: We're now a foundation without assets, but we are still a foundation with ideas. I hope we can raise money to bring people together and talk about some of the gut-wrenching issues in art in a nonbureaucratic way.

Cee: We either close this chapter and close the book, or open up the next chapter and see what happens. I'm of the mind that this is not about closing the book.

Bruce: I'm an activist in the promotion of any critical discourse in any of the arts. I'm not going to stop and David is not going to stop. Linda is not going to stop. I don't think any of us will stop. It's important that critical agendas become institutionalized in some way; I don't care if that means they're no longer as radical as they once were. They're still radical in today's context.

Cee: For a small foundation, we did have a lot of impact. A lot of issues were addressed and a lot of repercussions came from the seed money or input contributed by AMI and by individual board members. In the arts in this country, in the '80s and '90s, AMI was at the forefront of all the advocacy that was being led on behalf of individual artists, on behalf of artists with AIDS, and on behalf of freedom of expression. That's pretty remarkable. And then on top of all that, to set out to find a way to help artists become self-sustaining. . . . That was a brave little fellow.

New Approaches

chapter **1**

to Visual Culture

"Dear Friend of the Arts:" | **a project by** JULIE AULT

"The practice of art and the study of the humanities require constant dedication and devotion. While no government can call a great artist or scholar into existence, it is necessary and appropriate for the Federal Government to help create and sustain not only a climate encouraging freedom of thought, imagination, and inquiry but also the material conditions facilitating the release of creative talent."

–The 1965 Arts and Humanities Act, which created the National Endowment for the Arts

"In 1960, the Labor Department's Occupational Outlook Handbook cautioned against a career in the arts, 'The difficulty of earning a living … is one of the facts young people should bear in mind in considering an artistic career … It is important for them to consider the possible advantages of making their art a hobby rather than a field of work.'"
— *American Canvas*, NEA, 1997

"Between 1970 and 1980, the number of art workers increased by 48%, while their earnings during this period decreased by 37%."
— *American Canvas*, NEA, 1997

Culture and Government

"show me the money"

Dear Friend of the Arts:

President Johnson signs the National Foundation on the Arts and the Humanities Act, September 29, 1965

COMPARING COMMITMENTS
Public expenditure on the arts and museums, in dollars per person

Sweden	$45.6
Germany	$39.4
France	$35.1
Netherlands	$33.6
Canada	$28.5
Britain	$16.1
U.S.	$3.3

Source: NEA

Source: *Time*, August 7, 1995

A budget is priorities made concrete.

The Eighties:

$53.9 million
The Payson family put *Irises* up for auction at Sotheby's in 1987, where it was bought by Alan Bond for $53.9 million, a nearly 130-fold increase in value over 40 years.

Three for the Image Machine. In SoHo, a trio of rising reputations but uneven talents (Robert Hughes, Time, March 14, 1983)

Riding the Rebounding Art Market You still can get promising works by rising painters at moderate prices. (Steven H. Madoff, Money, September 1985)

Golden Paintbrushes. Artists are developing a fine eye for the bottom line. (Kim Foltz and Maggie Malone, Newsweek, business section October 15, 1984)

New Art, New Money. The Marketing of An American Artist (Cathleen McGuigan, The New York Times Magazine, February 10, 1985)

Careerism and Hype Amidst the Image Haze. American painters of the '80s are buffeted by cultural inflation (Robert Hughes, Time, June 17, 1985)

Giving Art a Bad Name (George F. Will, Newsweek, September 16, 1985)

The art market explodes. (Larry Black, Maclean's, December 15, 1986)

At What Price Art? The Answer Is: High, Very High. (Bradley Hitchins, Business Week, December 29, 1986)

To be rich, famous, and an artist. (Julia Reed, U.S. News & World Report, March 9, 1987)

There's one born every minute. Hyped by dealers, sustained by increasing numbers of wealthy collectors, the market for contemporary art is soaring. Will it plunge? (The Economist, May 27, 1989)

Art Goes to Wall Street A Professionals' Guide to Financial Matters (Donald R. Katz, Esquire, July 1989)

$80,000 1947
Irises remained in France for the next 48 years in the possession of a number of distinguished collectors, until the Seligmann Gallery in New York acquired it in 1937. It passed through the hands of two more New York galleries, then in 1947 was acquired by Mrs. Charles S. Payson for $80,000 ($420,000 in today's dollars).

$0 1889
Van Gogh sold only one painting in his lifetime. He received no money for *Irises*.

TIME, NOVEMBER 27, 1989

NEW ART
NEW MONEY
The Marketing of
An American Artist
by Cathleen McGuigan

"The decade is half over, but already one begins to feel the peculiar sensation of looking back on the art of the '80s."

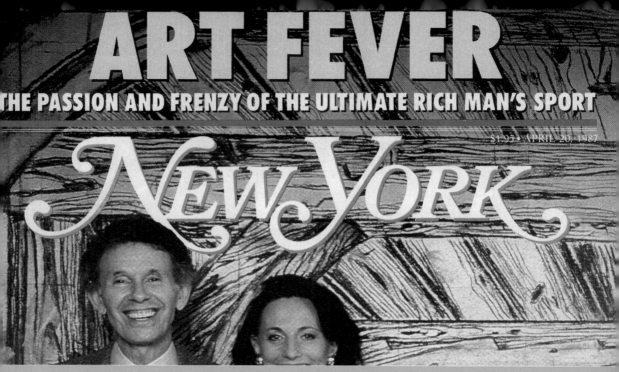

ART FEVER

THE PASSION AND FRENZY OF THE ULTIMATE RICH MAN'S SPORT

$1.95 • APRIL 20, 1987

New York

"Forget the old "art equals beauty" stuff. There are art holding companies and even investment indexes now. The Sotheby's Art Index, which tracks prices for paintings, ceramics, and old furniture, has shown a compounded annual return of 19 percent over the past five years. Modern paintings in general appreciated by 40 percent between the springs of 1986 and 1987— a period in which an unprecedented bull market on Wall Street took the securities indexes up only 27 percent."[2]

"Auction houses once again are resounding with the happy sound of the gavel's boom. Indeed, boom was the word used by David Nash, fine arts director at Sotheby Parke Bernet in New York City, after its record-breaking $37 million sale of Impressionist and Modern art on May 18. There is a palpable excitement in the art world. Its market is coming back stronger than ever after the deep recession."[3]

"American museums have been hit too by a 1986 change in tax law. In the past, a collector could donate a painting and write off its current market value against taxable income. Now the donor can write off only the price he originally paid (often, almost by definition, a fraction of what the work would cost today). The Art Dealers Association of America says the number of offers to museums has fallen by half. Gifts to the Metropolitan Museum of Art fell by 70 percent after the 1986 tax law went into effect."[4]

"But can it keep up? Keiffer says the boom is hooked to the rest of the economy. The art market could start to weaken, he warns, 'if the Reagan situation worsens or problems develop in the junk-bond market or more big merger schemes falter.'"[5]

"And New York has more than Zeitgeist. It is the home too of Madison Avenue. Behind the boom lies the way selected artists—the man as much as the art—are hyped by dealers and their pals, stooges or suckers in the media with the right rhetoric; daubs become masterpieces, hoovered up by the voracious and ignorant consumers..."[6]

"Today's art market is publicity-fueled and driven by collectors who often invest for the sake of profit rather than art. It is described by dealers and curators as 'irresponsible,' and comparisons with Hollywood and Wall Street are frequent."[7]

WallStr

SoHo

"Their openings are covered in ArtNews, but their lifestyles are covered in People."[8]

Hollywo

"Gallery owners are also changing their style. A sharp eye for good art isn't enough anymore; many gallery owners realize they must master marketing, promotion, pricing and other hard-core business practices. Public-relations consultants, investment advisers, legal and tax experts and other business consultants are now commonplace in the art industry. In fact, some young artists now complain that the talk in art circles no longer centers on critical topics about the craft itself, but on career structuring and market positioning."[9]

"...capitalism is the atmosphere in which culture must now survive."[10]

Crucifix in Urine Offends Art Lover, Richmond News Leader, March, 18, 1989

Museum Offended Christians, Richmond News Leader, March 29, 1989

Photos Challenge Viewers, Richmond News Leader, April 1, 1989

Pastor Attacks 'Art' as 'Anti-Christian,' Washington Times, April 26, 1989

A Life-and-Death Struggle For the Arts?, Los Angeles Herald Examiner, June

Art That Offends, Laws That Retaliate, New York Times, June 11, 1989

Corcoran, to Foil Dispute, Drops Mapplethorpe Show, New York Times, June 1

Artists Protest Corcoran Cancellation, New York Times, June 15, 1989

Art, Trash and Funding, International Herald Tribune, June 15, 1989

Why the Corcoran Made a Big Mistake, Consequences of the Mapplethorpe D

Drawing Line for Taste Must Be Done in the Dust, Richmond Times-Dispatch,

Let's Stop Funding Tasteless Art

Government Can't Dictate Taste

At the Corcoran, a Chilling Case of Censorship

How Can We Clean Up Our Art Act?, Washington Times, June 19, 1989

Legislation Offered to Limit Grants by Arts Endowment, NY, June 21, 1989

Funding Art That Offends, NEA Under Fire Over Controversial Photo, Washir

Art and Accountability, Washington Post June 22, 1989

Helms and Arts Endowment: An Escalation, June 23, 1989

Corcoran Cancels Photo Exhibit

Protest at the Corcoran

Artists, Activists Protest at Corcoran

900 Protest Corcoran Cancellation, Washington Post, July 1, 1989

Art on the Firing Line, New York Times, July 9, 1989

Of Guts and the Gallery, Washington Post, June 23, 1989

Arts Agency Saved by $45,000 Compromise

Public Funds Need Not Support Private Tastes

House Proposes Tighter Rules on Arts Funding, Los Angeles Times, June 30,

Juggling Money, Taste and Art on Capitol Hill, New York Times, June 30, 1989

A Mercy-Killing for the NEA?, New York Newsday, June 30, 1989

Is Art Above the Laws of Decency?, New York Times, July 2, 1989

Whose Art Is It Anyway?, Time, July 3, 1989

House Sends Art Endowment Message on Taxpayers' Taste, New York Times, J

Fine Move Keeps Arts Agency Alive, New York Newsday, July 13, 1989

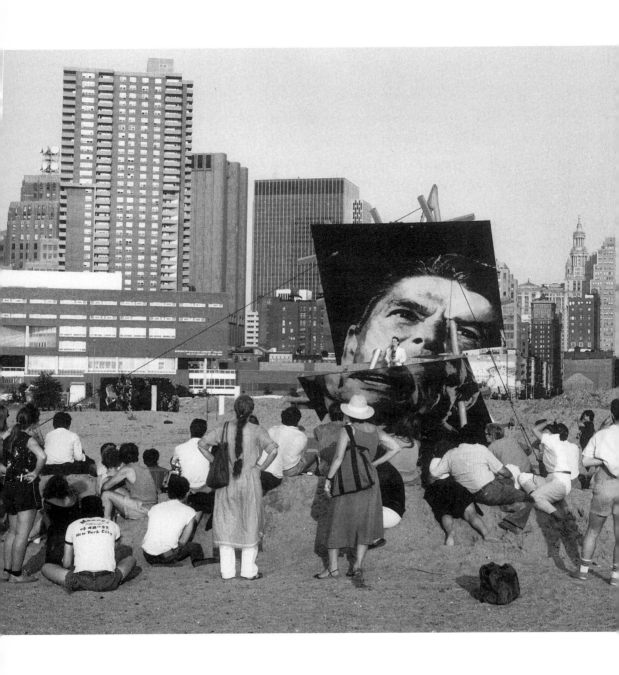

Too Political? Forget It

In memory of David Wojnarowicz, Rudolf Baranik, and Ed Eisenman, art activists

LUCY R. LIPPARD

"Whose history is remembered? Do other stories go untold?"
 — REPO History, 1992.

Art matters in a different way to me now than it did fifteen years ago. Having fought over three decades for the idea that art and politics do mix, that art can be made effective in social contexts, during the period covered by this book I also had to come to terms with the ways art and politics don't mix.

I remain primarily interested in the contradictory, mysterious ways in which artists and objects or actions enter society, in what images mean and do to people, and how contact and lack of contact with their audiences affect what artists do in the studio. I'm particularly fond of art's potential to open people's eyes, to make them see, think, feel, and act. I want to know all I can about the relationship of the parts to the whole, of the artist to her/his life, of the object to the context in which it is made and to the audience for whom it is intended. I still yearn for artists to find more elbow room in social life, to challenge the liberal assumption that significant artistic questions and analyses can only be made from a so-called neutral middleground, that anything to the left of that particular position is either unsophisticated (read "uneducated") or rhetorical (read "a little too clear for comfort"). But the mostly forgotten history of efforts on behalf of these ideas comes back, both to hearten and to haunt me.

Before the culture wars officially began and before Art Matters found itself labeled "too political," the image wars had been under way for some time. Those of us further out on the art-world margins were let in on the secret early, and in no uncertain terms. In 1983, an NEA grant to the group I worked with—PAD/D (Political Art Documentation/Distribution)—was vetoed/censored by NEA Chairman Frank Hodsoll, after being approved by the peer panel. This was especially annoying since we never would have bothered to go through the tedious application process had we not been directly solicited by the NEA. In 1984, Franklin Furnace, with the fearless Martha Wilson at its helm, was singled out by right-wing

Chapter opener:
Guerrilla Girls, *Guerrilla Girls Review The Whitney*, 1987, graffiti installation, The Clocktower, New York City. Photo courtesy of the artists. Art Matters grant recipient, 1986.

Left:
Creative Time, *A Podium of Dissent*, 1985, performance by Nicholas Goldsmith and Dennis Adams at Art on the Beach. Photo courtesy of Creative Time. Art Matters grant recipient, 1985, 1986, 1991, 1992.

1st ISSUE POLITICAL ART DOCUMENTATION /DISTRIBUTION
February 1981

PAD:
Waking Up In NYC

PAD (Political Art Documentation/Distribution) is an artists' resource and networking organization coming out of and into New York City. Our main goal is to provide artists with an organized relationship to society; one way we are doing this is by building a collection of documentation of international socially-concerned art. PAD defines "social concern" in the broadest sense, as any work that deals with issues—ranging from sexism and racism to ecological damage or other forms of human oppression. We document all kinds of work from movement posters to the most personal of individual statements. Art comes from art as well as from life. Knowing this makes us want to learn more about the production, distribution and impact of socially-concerned art works in the context of our culture and society. Historically, politicized or social-change artists have been denied mainstream coverage and our interaction has been limited. We have to know what we are doing. In New York. In the US. In Canada and Latin America. In Europe. In Asia and Africa. **The development of an effective oppositional culture depends on communication.**

PAD celebrated its first birthday with a Valentine's evening of entertainment and discussion around a slide show of political art (followed by dancing, but not in the streets—yet). We began in February 1980 as an amorphous group of artworkers dimly aware of a mutual need to organize around issues, but without much notion of how to do it. We met at Printed Matter once a month and agreed to start collecting documentation so we would have a physical core from which to reach out. For a while we looked at each other's work, discussed it, and thought about a social club and various possibilities for cultural activism. Then in late Spring we were offered a room in a former high school on the Lower East Side under the aegis of Seven Loaves—an umbrella group for community arts organizations. Suddenly we existed physically. We had to be in the world, and that led to the present structuring, still in process.

We have three kinds of meetings now: 1) The relatively flexible core or work group of 15-20 people gets together on three Sunday afternoons a month at the Seven Loaves space (when not too cold). Here we deal with: soliciting and handling of the archive materials; how to connect with other cultural organizations in NYC with similar purposes so there's no overlapping and duplication of work. (For instance, we are working with Cityarts Workshop, which has an impressive resource center on the community mural movement, and with Karin di Gia of Gallery 345, who has a collection of original political art.) We are also beginning to connect with and inform each other about the political events and struggles taking place in the city, understanding the ways these relate to national and international situations. Finally, we are thinking about collectively created issue-oriented exhibitions in public spaces, such as windows, subways, libraries, etc.

2) The open meetings with which we began. They take place on the second Sunday of every month at 8 PM at Printed Matter (7 Lispenard St., NYC 10013; 925-0325). Here reports are made from the work group and a brief visual or verbal presentation is given by a PAD member or guest as a sort of laboratory to stimulate discussion, education, consciousness raising and activism.

3) We are just beginning a series of public events centered around specific social issues seen in their historical perspectives, focusing on how they were opposed or supported by the socially concerned art of the time; for instance in May, a day on militarism in the "cold war" era, the Vietnam era and today, discussed by people from WRL (the War Resisters League), CARD (Committee Against Registration for the Draft) and artists who have done work with anti-militaristic content. We want to understand how the dialectic between oppositional art and society changes and takes different forms at different moments. These public afternoons will be publicized, and will lead up to an Autumn conference, at which we hope to bring together a wide coalition of cultural groups and artists. (For more information on events, see the "Calendar" section of PAD.)

PAD's theory is going to develop out of real experience instead of from the idealized and romanticized notion of a

UN CERTAIN ART ANGLAIS!

A Certain English Art. (Postcard) Rasheed Araeen, 1979

PAD/D, *1st Issue* (later *Upfront*), February 1981, Political Art Documentation/Distribution Newsletter. Visual from a postcard by Rasheed Araeen, used to announce the exhibition "Some British Art from the Left," Artists Space, 1979, and to call for the formation of an archive of socially-concerned art which became PAD/D in 1980. Courtesy of the artists.

groups and threatened with NEA defunding and censorship for presenting Carnival Knowledge's feminist/porn star performances, among others. In 1983, Jerry Kearns and I published an article in *Artforum* titled "Cashing in a Wolf Ticket," in which we listed a group of people we perceived as "activist artists." The magazine's editors saw this as such a dangerous label that they called each person on our list to see if it was okay to call them activists in print. On top of that, in a disclaimer printed with our article, they divorced the magazine from what they euphemistically called our "deeply held beliefs."

This experience showed that the '50s-style redbaiting, revived by the newly elected Reagan/Bush administration, extended to the cultural domain. We knew we were in trouble when even the ACLU was demonized, when even liberalism became "the L-word," and when Jeremiah Denton resurrected a version of McCarthy's House UnAmerican Activities Committee. By 1984, an art critic could accuse cultural workers in the Central America movement of being "dupes," exacerbating the remains of cold-war animosities that already nurtured the seeds of domestic terrorism and the militia movement. It was a time, yet another of those times, when art was called to be on the front lines and artists had a hard time figuring out whether they belonged there, and if so, what to do there.

Activist artists saw what was coming. Group Material responded with a button and street performance calling for "No More Witch Hunts." In 1981, artist Jerry Kearns organized (and I then cocurated with him) a traveling exhibition called "Image Wars," a visual critique of the ways advertising and imagery manipulate us. The subject was racism and sexism—what later came to be known as "representation" (although we didn't even know the term at the time). It was the first in a series of "exhibitions as artworks" we conceived along the lines then being pioneered by Group Material, Fashion Moda, Colab, and the San Francisco Poster Brigade, mixing original work by avant-garde artists with images from the popular and political cultures, using bright colors, raw lettering, and anti-institutional installation techniques. We tried to make each wall or room a dynamic collage in itself, reflecting the revival of interest in installation art within the mainstream. We enlarged and collaged some of

the material to make anonymous pieces of our own. The always useful surrealist idea of ripping images out of their own realities and forcing them into cohabitation to create a new reality provided the kind of jolt we hoped would recast the dominant culture's images in our own contexts.

With hindsight, this show and its title predicted the preoccupations of the 1980s, but its language and form were more blunt, accessible, naïf, and rhetorical than much of the art that followed. In the course of the decade, sexism became "gender" and racism became "multiculturalism." As postmodern theory became further divorced from activist practice within the complexities of deconstruction, the normally fragmented art world split into even smaller pieces. In this process only certain histories are recalled.

One form of censorship is cultural amnesia. What is dismissed often reveals as much about the zeitgeist as what is canonized. Events and artists forgotten by art-world power structures (and even the alternative art scene has its power structures) can, when recalled, evoke something alien, perhaps even threatening to a high-cultural identity. Working in New York since the late 1950s, I have seen several waves of forgetfulness sweep over the art world. Reinventing the wheel is one of our favorite pastimes. It fuels the planned obsolescence that in turn fuels the art market. I remember, for instance, the Artworkers Coalition, in the late 1960s, "discovering" with a shock of recognition the writings and activities of the Art Front from the late 1930s and early 1940s. We would have been a lot further along in our own ideological debates and strategic aesthetics had we known which of their actions worked and which didn't, despite the obvious differences between the historical moments. But, as is often the case, lessons weren't learned and the same mistakes continued to be made over and over again.[1]

Why didn't we know about Art Front? Why didn't I learn in college art history courses about the radical politics of Pissarro or Picasso? Or the sociopolitical contexts in which Russian constructivism, dada, and surrealism took place? Why, indeed. Such information simply wasn't taught in the schools in the 1950s or early '60s, any more than art history classes today are taught about the Art Workers' Coalition's proposals to put artists on the boards of all the New York City museums and to tithe all artists to support poorer artists and an alternative artists' gallery system. Who remembers today that it was the Ad Hoc Women Artists Committee picketing the 1970 Whitney Annual that prompted the museum to increase

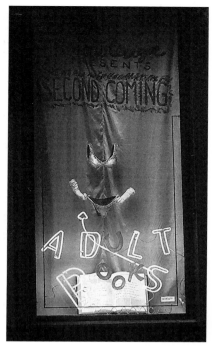

Franklin Furnace, *Carnival Knowledge: The Second Coming*, 1984, installation and performance series. Photo courtesy of Franklin Furnace Archive, Inc. Art Matters grant recipient, 1986, 1987.

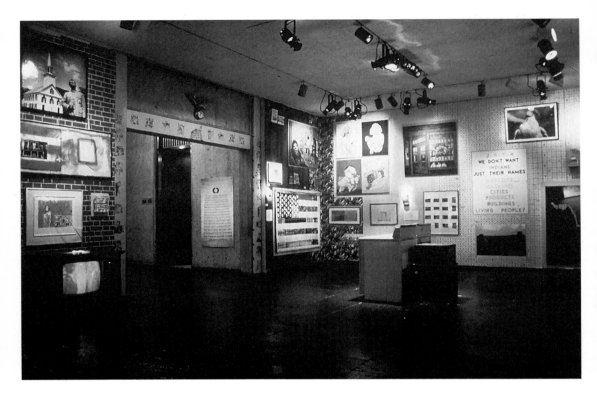

Group Material, *Americana*, 1985. Installation at the 1985 Whitney Biennial. Photo courtesy of Julie Ault. Art Matters grant recipients, 1987, 1988.

the number of women included by some 400 percent? And what studio classes today are given the option of working for varied audiences within and without the art world? Fortunately, there are some exceptions. But they are few and far between. No wonder activist and community art, always a stepchild, is so slow to evolve.

Despite a certain level of politicization that filtered into the art world during the 1980s, the process came to a grinding halt with the reception of the 1993 Whitney Biennial, which daringly featured some work with some politics and was then savaged by the press for its trouble. Fifteen years ago, when Art Matters was founded, feminist and activist art initiatives from the 1960s and '70s were already struggling with cultural amnesia.[2] We worried then (and we worry even more so now) that our histories would be forgotten and ignored or—worse still—distorted.[3] When younger artists express interest in our neglected pasts, we are initially so pleased that it seems ungrateful to challenge their interpretations or even dispute factual inaccuracies. Revisionist histories can be more accurate than the original versions. Yet, when primary sources and first-hand accounts are not respected, when people crucial to the movements are neither consulted nor interviewed for books on the subject, or when the information they offer is passed over in favor of data more sympathetic to other agendas, the conclusions drawn are questionable. It was recent experiences like these that prompted my examination here of memory loss.

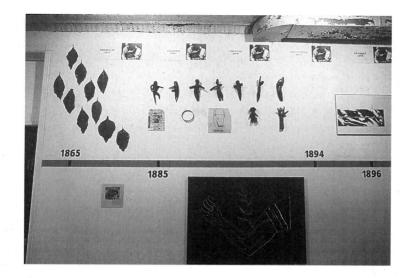

Group Material. *Timeline: A Chronicle of U.S. Intervention in Central and South America*, 1984. Installation at P.S.1. Photo courtesy of Julie Ault. Art Matters grant recipients, 1987, 1988.

Among the most commonly forgotten aspects of the art of the late '70s and early '80s are the works of artists of color (especially those who fit none of the pigeon-holes cherished by the minstrel show of modernism) and of lesbian and gay artists. The first specifically lesbian art show in New York was organized by Harmony Hammond in 1977 at 112 Greene Street, and a related issue of *Heresies* was published on the subject. A year later, the "Nigger Drawings" show at Artists' Space prompted many in the art world to wonder where a young white male artist got off using such an inflammatory title for his otherwise innocuous exhibition of black-and-white abstract drawings. (At one point he claimed that all artists were "niggerized" in this society; at another point he said he got charcoal dust all over his face while making the work.) The African-American arts community, alerted by Howardena Pindell, organized protests and the liberal white art world found itself in the villain's role of backing the artist and insisting that in art, anything goes. An abyss emerged between those avant-garde artworkers (myself included) who perceived themselves as the left and those who perceived themselves as automatic liberals by virtue of being artists at all. The spectacle of the art world's encouragement of racism in the name of artistic freedom led to the formation of Artists Against Racism in the Arts (AARA), directly raising consciousness within a racially mixed group for the first time since the late 1960s.

Ironically, such tolerance for racism and sexism in the art world is often based in the concept of free speech, as is tolerance for sexual discrimination and harassment in the legal world. Dangerous as it is to suggest that any external ethical and moral forces should "control" artistic expressions, what about the internal forces? Should there be controls or should artists be allowed any excess, including images that inspire hate, fear, homophobia, misogyny, and xenophobia? The

"Nigger Drawings" show and AARA raised the issue, still unresolved, of where artists' responsibility to the public begins and ends. Some would question whether artists have any social responsibility at all. Is art outside the fray until it is dragged in by external forces? The NEA controversies of the early 1990s, which threatened the arts' economic survival, triggered participation by many artists who would have preferred to remain apolitical.

My own perspective on such questions results from a trajectory that is peculiar in comparison to that of most of my colleagues. Looking back on the past several decades of my involvement with the art world, I sometimes feel like I was living in a parallel, if porous, universe. I've wended my way from a position that was briefly central in the art world to one that is largely outside or adversarial to it. I spent the late 1960s protesting the Vietnam war and looking for ways that artists could participate in those angry, turbulent times. Then I spent most of the '70s writing and organizing in a feminist context, thrust back into the art world on behalf of women's work. By the late 1970s, I was ready to apply what I'd learned to a broader field. I became increasingly involved with left politics, writing journalism as well as "criticism," and trying to forge some kind of new context for the arts in this society. My extended decade was defined by local organizing with artists (which is like herding cats) in PAD/D, publishing with left-wing feminists in *Heresies* (a collectively edited publication devoted to "feminism, art, and politics"), national cultural organizing in the Alliance for Cultural Democracy (ACD), and two other activist projects: Artists Call Against U.S. Intervention in Central America (a nationwide campaign of artists' actions in more than thirty cities in the U.S. and Canada, organized in conjunction with the Institute of Arts and Letters of El Salvador); and *How to '92* (an activist's handbook accompanying ACD's Campaign for a Post-Columbian World). Each of these had a profound influence on the work I was doing for a living and the books I was writing, as did trips to China, Cuba, and Central America, and working with Printed Matter, an artists' bookstore I cofounded with Sol LeWitt. I made demonstration art with various groups and, in collaboration with artist Jerry Kearns, wrote articles, did performances, and organized exhibitions (including several for District 1199's Bread and Roses). The idea was not only to include culture in the political arena but also to create a culture that was inherently responsive to political events and community needs.

While I don't enjoy reliving my past, I don't enjoy seeing it vanish either. Reading up for this essay, I was struck by the continued neglect of one sector, one time period: the immensely vital hard-core

art/political activism of the first half of the 1980s, which set the stage
for the activism of the late 1980s and early '90s, a time when a
lot of things that were made and said in the 1960s and '70s were
reframed in more elegant and complex forms and updated language.
An otherwise intelligent and inclusive article on activist art in the
'80s expertly demonstrated the provincialism of the New York art
"scene" by dismissing most of the first half of the decade—the con-
tributions of Fashion Moda and PAD/D, the glorious outpouring of
demonstration art in June 1982 at the largest disarmament manifesta-
tion ever, billboards "corrected" by artists, guerrilla performance art,
gritty anarchist comics like World War 3 Illustrated, the hilarious,
hard-hitting, and good-natured sex education side shows of Carnival
Knowledge, Suzanne Lacy's innovative fusions of performance and
community organizing, the groundbreaking cross-cultural exhibitions
at JAM (Just Above Midtown), most of the women's art movement,
'zines and artists' books—to name just a few of the omissions.[4] I
list all of this for the record, simply because most of it is not in the
record, or else it has been filtered in from irrelevant and ignorant
angles. Such absences go to show, yet again, that if artists don't
concentrate on the art world, if they are primarily concerned with
audiences who will never write, curate, collect or fund art, they run
the risk of being forgotten before they are even acknowledged.

It is ironic that PAD/D (1980-87) itself was initiated as an anti-
dote to cultural amnesia. After living for a year in England, I was
impressed by the socialist and community-oriented arts there and
disturbed by how little I'd heard of them. The lack of communica-
tions between progressive artists around the world was depressing.
Each group was reinventing ideas and actions that had already been
tested and worked out by groups elsewhere, sometimes decades
before. When I returned to New York, I curated a small exhibition
of British artists from the left, and on the announcement card called
for materials to begin an archive of socially concerned art. Despite
the awkward name we laid on it before we had any idea what we
were up to, PAD/D became an activist art organization at its first
meeting.[5] The time was ripe, again. It was the third progressive
artists group to be founded in New York in a decade, following the
Art Workers' Coalition in 1969, Artists Meeting for Cultural Change
in response to the Bicentennial in 1976, not to mention AARA and
all the feminist groups. Over the next eight years, PAD/D tried to
reconcile the continuing conflict between art and politics in a society
where art has lost its social context. By producing art in direct col-
laboration with progressive issue-oriented groups, we expanded the
models for activist art and made it better known through network-
ing outside the uninterested art mainstream. We were convinced

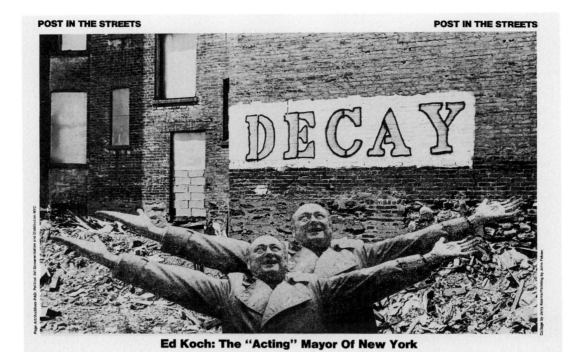

Ed Koch: The "Acting" Mayor Of New York

PAD/D *Upfront*, Number 3,
December/January 1981,
newsletter. Visual by Jerry
Kearns with John Fekner's
stencil in background.
Courtesy of the artists.

that both image-making and the art process provided an important
symbolic focus for exchange and a rallying point for social action.

The immense PAD/D Archive, which began its life at Charas on
the Lower East Side, now rests in state at the Museum of Modern
Art Library, perhaps the group's most lasting contribution.[6] But our
goal of finding ways for an artist to have "an organized relationship
to society" was best served by the distribution wing: PAD/D's public
projects (among them, "Death and Taxes," "the February 26th
Movement," and "Not For Sale"), our Second Sunday panels/
performances at Franklin Furnace, coalition-building with ethnic
cultural groups around the city, and the magazine *Upfront*.

It is not surprising that this blast of activity and increased support
for politicized culture took place as the Reagan/Bush administration
took power...and took power farther than we thought it could be
taken only a decade after the revolutions of the 1960s. As social
gaps widened in the early 1980s between rich and poor, CEOs and
workers, the housed and the homeless, religious family values and
feminist and GLBT sexualities, similar cracks appeared in the art
sphere. Tensions were exacerbated between rich and poor artists,
mainstream and alternative, theory and activist practice, modernist
and postmodernist allegiances, feminist "essentialists" and "decon-
structivists." As a boastful, inconsiderate, and greedy Republican
ethos pervaded the yuppified nation, a militant activism was sparked
on the politicized fringes of the art world. The trend toward public

display, toward art styles used for other than purely aesthetic ends in other than neutral locations (though most postering took place in SoHo, Tribeca, and Loisaida), reflected a larger need for artists to "work in the gap between art and life" that has resurfaced periodically over the last century.

Since the mid-'60s at least, there has been an underground or peripheral movement against the commodification of art. The market-and-magazine system—the only social platform provided for art in this society—is inadequate to art ideas involving communication, responsibility, and social contexts. Conceptual, performance, and installation art as well as artists' books and alternative spaces were all intended to bypass the market. In the late 1960s, Seth Siegelaub and his posse of conceptual artists (Doug Huebler, Lawrence Weiner, Robert Barry, and Joseph Kosuth) devised ways of distributing art that subverted the power structure with international catalogues and artists' books that were art and exhibitions in themselves. They were so successful that they too were absorbed into the commercial framework. With less commercial success, the women's art movement in the early '70s developed its own versions of these forms within women-only events and spaces, especially in California and then in New York.

During this period there was a growing understanding that socially conscious artists would have to create the contexts and distribution systems as well for these new art forms—an awesome responsibility for those who had expected to spend their lives cloistered in studios and praised in museums. I recall yelling at lecture audiences comprised mostly of art students and working artists, "Do you think anyone else cares enough to change the art world? If artists don't do it, who do you think will?" Knowing that the art context would change only superficially if the world itself wasn't changed, by 1980 I was even angrier, or more frustrated. I questioned the effectiveness of our efforts to date in a performance piece called "Propaganda Fictions," berating my disconcerted audiences (who tended to be friends or sympathizers): "YOU LOUSY ARTISTS..."[7]

High Performance, Summer 1993, published by The 18th Street Arts Complex, Santa Monica, Cal. Art Matters grant recipient, 1987.

Yet many younger artists emerging from art school in the late 1970s were refusing to melt passively into the current system. Their diversely expressed malaise resulted in the formation of collectives like Group Material, Fashion Moda, Colab, ABC NO Rio Dinero, High Performance, Franklin Furnace, World War 3, CUD (Contemporary Urbacultural Documentation), and (later) Bullet Space, among others.[8] Sometimes—as in PAD/D—they joined forces with those of us who had been tackling social issues for years. The Lower East Side (allied with the South Bronx) split off briefly from SoHo before it was colonized by SoHo (again briefly,

before SoHo itself got bypassed for Chelsea). Young artists were working in ad hoc spaces, on the piers, under the bridges, in rough, poor neighborhoods, forming tentative coalitions with young artists there who were usually untrained but who offered a vitality not to be found within the white cube. White artists aspired to the high energy of hiphop music, breakdancing, and graffiti. Performance, music, and punk style were integral parts of what came to be known as the East Village scene. Punk music clubs merged with the art scene. There was a lot of dancing. I was always quoting Emma Goldman: "If there's no dancing at your revolution, I'm not coming."

The early 1980s were angry, hyper, and hyped. The art was given to apocalyptic visions, fueled by Reagan's plan to rapture out and leave the hoi polloi below in case of a nuclear holocaust—the greatest global fear, along with the Central American conflagrations, while gentrification as a prelude to homelessness was one of the hot local issues. Urban grittiness and hyperbole was the style of the day. There was a passionately journalistic tone to much of the art that harked back to the 1930s. Even to some veterans of the 1960s image wars, like myself, this looked like a relatively hopeful moment, if marred by alarming symptoms of alienation: drugs, violence, homelessness.

Then came AIDS. If silence had equaled repression and oppression before, now it equaled death. Irony and ambiguity in art seemed increasingly apolitical and disturbing. A "retrochic" syndrome turned leftish political and feminist images back on themselves to evoke very different messages; neo-Nazi signifiers were casually tossed around. Lack of specificity in the art was paralleled by lack of focus in the politics, which emphasized aggression and rebellious behavior rather than issues. Thus, marvelously dynamic events like Colab's Times Square Show or the wildcat Real Estate Show (mounted without permission in a city-abandoned building), could be all over the place in terms of political content.[9] Most artists avoided saying exactly what and whom they were talking about. Galleries liked the energy, but specificity made them nervous. It wasn't fashionable within the art milieu to name names—that was a strategy that came from outside, from the political left. With a few exceptions, such as Hans Haacke and the Guerrilla Girls, then Gran Fury with ACT UP (AIDS Coalition to Unleash Power), such specificity signified the boundary between hardcore activism and the high-art markets and institutions. It was a time characterized by fusion and fragmentation, "shifting" and "contested" grounds, blurred boundaries, hybridized cultures, coalitions won and lost, interwoven academic disciplines—a time almost impossible to summarize except from specific viewpoints. It was also a time when the activist art commu-

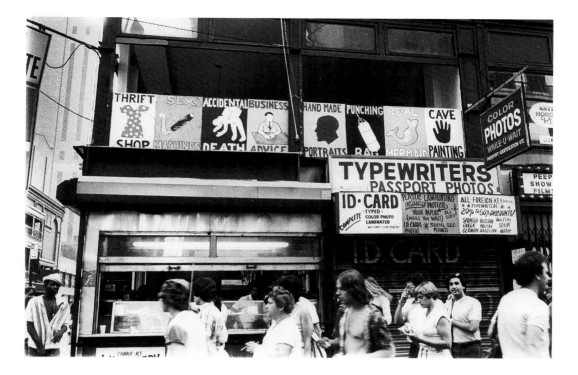

Colab, *Times Square Show*, June 1980. Second floor paintings on masonite by Tom Otterness. Photo courtesy Lisa Kahane.

nity was highly aware of the need to integrate experimental forms and social action—the avant-garde and community arts, which had rarely met until the early '80s.

There has long been a confusion between the notions of "political" and "activist" art, which is really a confusion between political and activist artists, exacerbated by the fact that they frequently cross over the unmarked boundaries. Loosely, very loosely, I'd say that the "political artist" makes gallery/museum art with political subject matter and/or content, but may also be seen calling meetings, marching, signing petitions, or speaking eloquently and analytically on behalf of various causes. Some of them are artists whose work is not perceived as political at all, such as Ad Reinhardt, Claes Oldenburg, or Elizabeth Murray. Others are overtly engaged within their art as well, such as Leon Golub, Nancy Spero, Martha Rosler, Michael Glier, or Peter Gourfain...I could go on and on. Political art makes people think politically through images, but it may or may not inform the audience about specific events or solutions or rouse people to take action.

"Activist artists," on the other hand, face out of the art world, working primarily in a social and/or political context. They spend more of their time thinking publicly, are more likely to work in groups, and less likely to show in galleries, though many have ended up there. Activists may snipe at the power structures from the art world's margins, or simply bypass conventional venues to make art elsewhere. Then you run into someone like the redoubtable David

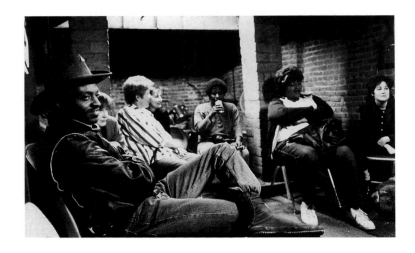

John Malpede/Los Angeles Poverty Department, *LAPD Inspects San Francisco*, 1987, a workshop in basement of "501 Cultural Club" in San Francisco's Tenderloin District. Left to right: Julious Jenkins, Jenny Bass, Linda Burnham, unknown, Vicky Jordan, Candy, Kristan Kann. Photo courtesy of the artists. Art Matters grant recipient, 1987, 1988.

Wojnarowicz, or Sue Coe, who have brilliantly confounded these artificial categories and were never afraid to say exactly what and whom they were talking about. Among the youthful energies snapping at the flanks of what used to be called the establishment, Group Material, in particular, bridged the gap between the avant-garde and the left activist art scene. The collective began on the margins with a temporary space on East 13th Street. Wisely, it stayed small, and soon began to work "parasitically" in other venues, with an atypically focused social agenda. Influenced by the raw quality of vernacular and semi-trained art coming from their Lower East Side home base, Group Material proposed a materialist art process and became a model for artists young and restless in the early '80s. In 1984 they began a series of "timelines" to remind viewers of otherwise neglected social contexts and histories. These one-room exhibitions juxtaposed a conglomeration of art, nonart, and unexpected materials with a superscript of dates painted around the room, a historical chronology of the events under scrutiny that corralled the wild art into some interpretive order and conveyed a political message.

One of the group's cofounders, Tim Rollins, developed a model for community education through art by applying this process to the lives of supposedly "uneducable" students in the South Bronx, when he started K.O.S. (Kids of Survival). Thanks to art-world attention earned by the unique formal and intellectual vigor of their work, Tim Rollins and K.O.S. had their moment in the media spotlight, unlike similarly innovative but less art-world-compatible groups. Far more attention should be paid, for instance, to such exemplary projects as Judy Baca's community murals and their rehabilitative educational branches; to the Woman's Building; to John Malpede's LAPD (Los Angeles Poverty Department); to the Border Arts Workshop and its spin-offs around San Diego; to Suzanne Lacy's brilliant "new genre" community events in Oakland; and to the numerous nonurban community organizations that are virtually

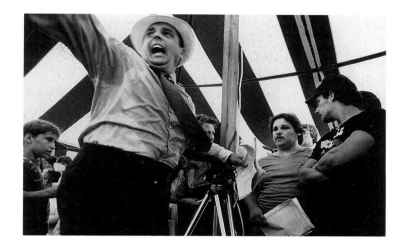

Appalshop, *Rough Side of the Mountain*, 1997, a video documentary by Anne Lewis, 58 minutes/color, produced and distributed by Appalshop. Still courtesy of Appalshop. Art Matters grant recipient, 1986, 1987.

unknown in the art world, such as Kentucky's Appalshop and Atlanta's Alternate Roots.[10] Heirs to these groups have fared somewhat better, but have hardly become household art words.

The second half of the 1980s (in New York, at least) was more focused on "local" issues and direct interaction, on AIDS, media, and homeless/housing issues. Those artists most closely involved with the left were suffering from the post–Cold War abandonment of revolutionary culture. The art cooled down stylistically and became more theoretically (and academically) oriented. By the end of the decade, deconstructivist feminist artists, postmodernist artists of color, and self-identified queer artists were the liveliest sources of postmodern criticism, though they lost some of their potential audiences through their reliance on jargon. More "traditional" feminist art had suffered setbacks with the overwhelming market embrace of a new and often reactionary expressionism that was almost ex-clusively male, and the advent of so-called postfeminism. (I've learned to be wary of anything rigidly defined as a "post.") The Guerrilla Girls had started wheatpasting their exaggeratedly plain, nonpictorial, public-service texts while wearing gorilla masks in 1985. These were more successful than even their funniest image works from later years, mainly because they impiously named the art world's stars and charged them with collusion. While GG's initial focus on career issues limited their reach, they also brought a hard-hitting humor to bear on the art world bottom line: gallery/museum representation and economics. Around 1992, the Guerrilla Girls were joined in the fray by the huge, vital, and short-lived Women's Action Coalition (WAC), courtesy of the Anita Hill hearings and a growing feminist backlash against postfeminist backlash. With its ecstatically militant drum corps and high-tech graphic-design tactics, WAC demonstrated the power of art at both major parties' political conventions that year.[11] Its demise due to infighting was a major blow for the women's art movement.

Artists of color both contributed to and profited from a new kind of hybrid multiculturalism that was simmering by the late '80s, less amenable to accommodating the dominant culture's stereotypes and also resistant to much left and alternative categorization. After an exhilarating (for white activists) period of more and less successful coalition-building, artist-theorists, cultural critics, and art historians like bell hooks, Michele Wallace, Judith Wilson, Coco Fusco, Amalia Mesa Bains, Margo Machida, Theresa Harlan, Marlon Riggs, and others have—often brilliantly—taken things into their own hands. Many well-meaning coalitions between white art communities, postmodern theory groups, and communities of color broke down by the mid-1990s, although they left behind them important friendships and alliances. "Multiculturalism" (for those who will still use the word at all) is now increasingly understood as excluding the participation of white people—sometimes a necessity because less energy is spent on combating ignorance and bias.

AIDS activism in the later 1980s and '90s represented not a new genre but a new level of intensity. As the art world lost (and is still losing) many of its major figures to the epidemic, what had passed for political art in the past seemed inadequate. Fueled by rage and fear of real and present danger, rather than hypothetical and distant disaster, AIDS activists used graphic arts, media savvy, and mass mobilization to great effect. The distinctions between homo- and gynoeroticism and homophobic depictions, like the distinction between retrochic, right-wing, lesbian, and feminist uses of images of nude women, became an ongoing focus of the anticensorship, obscenity and pornography debates.[12] In all too many social sectors, the mere depictions of man and man or woman and woman together ignited homophobia. So the anonymous San Francisco collective Boys With Arms Akimbo's "Just Sex" posters, and images by Gran Fury, ACT UP's art branch (including their inspired bus posters of beautiful young people in every permutation kissing, and Kruger-like posters for a 1988 "Kiss-In") took off from a ready-charged base of political immediacy and personal intimacy that few other issue-oriented artists could claim. Video, too, plays a major role in the GBLT community's activism, with 1980s groups like Testing the Limits and Visual Aids leading the way. Lesbian activist artists weighed in with collectives Fierce Pussy, Lesbian Avengers, and Dyke Action Machine. The logo of the Silence=Death project, with these words in white below a pink triangle on a black ground, went from a 1987 street poster to an art icon to a global symbol of resistance. Gran Fury summed up the art activist's dilemmas in a bold text poster that read in part, "With 42,000 Dead, Art Is Not Enough."

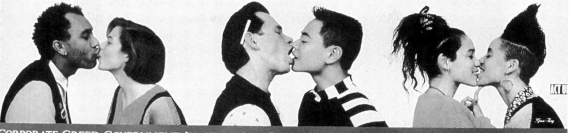

KISSING DOESN'T KILL: GREED AND INDIFFERENCE DO

CORPORATE GREED, GOVERNMENT INACTION, AND PUBLIC INDIFFERENCE MAKE AIDS A POLITICAL CRISIS

Gran Fury, *Kissing Doesn't Kill*, 1990, bus panel, 136 x 28 in. Photo courtesy of Tom Kalin. Art Matters grant recipients, 1988, 1989, 1990, 1991.

Despite all this activity, much of it highly visible, during the 1980s the atmosphere within the art world itself became so rarefied that much activist energy was drained away. Theory, generally characterized by obscure language, apolitical pretentiousness, and academic elitism divorced politics from actual practice, although there was never a clear line between left activists and radical theorists. Many of the deconstructivist ideas and analyses were powerful and important, but the mainstream art world's flirtation with Baudrillardian cynicism tended to reduce everything to construction and simulation. While some artists fed off the tensions produced, a kind of "be there or be square" attitude tended to discourage activist engagement. While claiming to be more politically sophisticated than their predecessors, some theorists tended to undermine all that feminist and political activists had fought so hard for since the 1960s. The ground indeed shifted beneath us. The rules were different. It is virtually impossible to continue organizing politically in an art world that dissects every act and idea into smaller and smaller fragments, until there is little left that can be believed (in). At best, the debates fueled a theorized praxis. At worst, the theorists were ignorant of the practice, or ignored it, and the gaps widened between the two. Although the '90s were predicted as the decade of renewed energies on the left and renewed activism in the art world, neither panned out. In 1991, the Gulf War briefly reignited a rash of reactive activism, but it had little influence or staying power.

One of the high points of the last fifteen years has been the rejuvenation of the notion of a public art. As public funding to individual artists is abolished and public confidence in art reaches an all-time low, there is a paradoxically vigorous outgrowth of outdoor art work intended for public enjoyment and edification (thanks in part to Creative Time, the Public Art Fund, and the Public Art Review, as well as to more spontaneous unfunded actions). Public

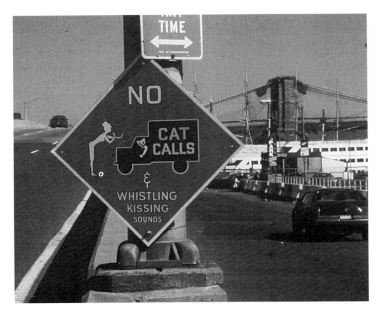

art has become a necessary urban amenity, not particularly radical but a great improvement on the ubiquitous bank plaza plunk art. Still more miraculous in this day and age is the burgeoning "new genre" public art (which includes performance, signage, impermanent monuments, community organizing projects, and social interactions with various groups), that has pushed the boundaries further, exemplified by the current work of Suzanne Lacy, John Malpede, and the San Diego sometime-collaborators David Avalos, Louis Hock and Liz Sisco, on the West Coast; New York's radical collective REPOhistory and their public sign projects, David Hammons, Mel Chin, and Marty Pottenger, on the East Coast; haha in Chicago; Rick Lowe's Project Row Houses in Houston; and the international feminist activists Women in Black, among many others.

Socially oriented artists of the early 1980s made public art or objects with all the apparent crudity and emotional power of outsider artists and pop culture. Within the mainstream, appropriated images and ideas led to some interesting new variations on the dada/photomontage/found object/ Warholian vortex, most of which were dependent on photography and text. The prevalent "scriptovisual" forms of the decade's second half were heavily dependent on conceptual art of the 1960s and '70s, now enlarged, slicked up, and cyber-technoed out of history. Video and performance were already in full swing, but branches of both became more accessible, with Paper Tiger television leading the way. By the early 1980s, video was taught in all the art schools. Since the equipment had gotten so much cheaper and lighter, it was far more compatible with real-world forays and activist interventions. Performance forked into spontaneous, often rude and crude improvisation and guerrilla/community events on one hand, and more theatrical high-tech spectacles on the other. Photography came into its own as a high (and high-priced) art in the '80s, but also lent itself to the growing interest in analytical documentation, gritty urban dramas, and social deconstruction. The installation format, often spiked with audio, video, or film, had reappeared after a

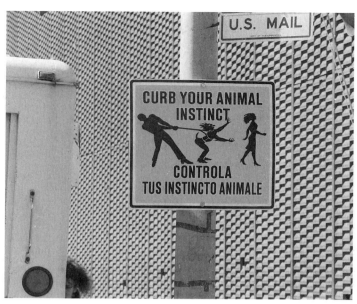

boomlet in the mid-'70s. And all these "new" techniques and mediums were accompanied by an increased savvy about how to get ideas across to a broader public.

Commercial artists had long borrowed ideas from high art, but now their practices became attractive in turn to fine artists who understood that the competition was communicating more successfully. (The motives were very different from earlier pop art.) Graphic design and signage

severed from the commercial sector became art forms in themselves in the 1980s and '90s, crossing aesthetic and political boundaries at will. Artists with a message began to compete with mainstream advertising and mainstream artists, without access to the deep pockets available to both. Signage ranged from John Fekner's stencils on industrial remains to talented graffiti writers like Lee Quinones, Crash, and the soon-to-be-high-artist Jean-Michel Basquiat. Other notable sign projects were Jenny Holzer's ambiguous polemics; the Guerrilla Girls' unambiguous polemics; Barbara Kruger's powerful admonitions; Edgar Heap of Birds's reminders of Native land origins; PAD/D's "Groundworks" and other stencil and sign projects; Robbie Conal's media-reactive posters; Ilona Granet's hilarious antisexist warnings; and Gran Fury's outraged wit. These artists were resorting to less equivocal means to get their messages across, even as theoreticians were preoccupied with other kinds of signs and signifiers. The widespread use of signage in public art may also suggest something of a loss of confidence in the power of the aesthetic image itself, or a need to separate from dependence on the image as manipulated by art critics, dealers, and curators. Like the activists' street stencils and "corrected" billboards, stealthily appropriated from the commercial sector by artists since the 1970s, sign language comes as a surprise from the alternate viewpoint, intervening and reinterpreting power plays from above.

When art happens on the margins of the art world, however intentionally placed, it is often shot down by the center's preferred weapons: quality, taste, publicity, and economic support. Denizens of the art world's upper echelons dislike the notion of either political or activist art, priding themselves on their ignorance of what goes

on outside the institutional and commercial milieu. But they reserve a special venom for those making art with social content. Activist art is often simplistically perceived as anti-intellectual, anti-aesthetic, dumbed down, or reduced to the lowest common denominator. Artists involved in activist campaigns in the 1980s were well aware that they (we) were considered aesthetically uninteresting by the arbiters of "high art" taste. While it's dangerous and inaccurate to say, as neoconservatives do, that any recognizable political content makes art superficial by its mere presence, it's true that irony, subtlety, wit, and calculated ambiguity can be powerful when consciously coded for specialized viewers rather than merely providing symbols of anarchy or rebellion or intellectual superiority. However, no matter how closely their inventive street posters and demo art may resemble "scriptovisual" gallery art, activist artists still tend to be considered too "earnest" or "naive," or "simplistic" by those who remain on the sidelines of the image wars. This is unjust, since many of them could be (and sometimes are) also turning out groundbreaking studio art for the market system. Those who avoid the commercial art system altogether have simply chosen to break different ground, making courageous choices not recommended by the art educators, the art critics, or the art funders.

In addition, nobody funds activist art (which explains to some extent why activist artists are often somewhat unsympathetic to the plight of those artists who have been more fortunate and are suddenly defunded). As we learned in PAD/D, it's a waste of time to ask government sources to subsidize potentially "subversive" activities. The aesthetic arbiters are usually unhelpful, since when you are making art to make a political point it is rarely ambiguous enough to be acceptable. Private funders are also out of the question since the values under attack tend to be their own. And left-wing political funders, strapped as they are, would rather fund grass-roots groups than the "art elite," which is always expected to pay its own way, even when it provides eye-catching and thought-provoking attention for the cause.

Art activists are always being asked if they think they can change the world, make a difference, have any effect at all. It seems harder for people to understand that in the early 1980s we were not under the illusion that artists could change the world alone or that we could take credit for a list of specific victories. Many of us were in it for the long haul, trying to develop art forms that would reach and mobilize people. We were trying to get under the cosmeticized skin of representation not only in the mass media but also in art itself, to develop a more complex understanding of the connections between studio and street work, academic and populist writing, and

all the stuff in between. We wanted to know how all the different kinds of art worked in the world, and how they complemented each other. We wanted to open up new contexts without entirely abandoning the conventional contexts. We wanted to protest specifically, but do so imaginatively. On the one hand, we wanted to communicate with and persuade a nonspecialized audience; on the other hand, we wanted to participate in the highest levels of discussion, to avoid being simplistic and rhetorical. We wanted to be innovative, but maintain a critical stance. In other words, we wanted to have our cake and eat it, too.

At the same time, like most progressive artists, we often labored under the illusion that we could make "the people's" art for them. (We dreamed of artists' books in airports and at supermarket checkout counters. For a while I had the idiotic idea of writing some kind of populist art "criticism" in the form of comics, handing them out on the street corners. I finally published a couple... in an art magazine.) Actually, we were often hanging out in the avant-garde hoping to make art more people could relate to. The reach for huge new audiences can exceed an artist's grasp to the point of absurdity, often resulting in a very small audience when the producer hasn't taken social and political reality into consideration. We were always trying to reach the "grass roots," but to our amazement, the religious right got there first.

These realities have resigned politicized artworkers to a certain level of blackout. We broke some new ground in the 1980s, but often felt mired in the contradictions that make activist practice so challenging and so vital. One form of internal censorship comes from the left, which doesn't always respect the role of culture, especially unfamiliar culture. At the same time, we were pressured from the right and the cultural mainstream. The art world demanded more complexity of activist artists and the political groups demanded more accessibility. Looking back, I realize that these factors probably contributed to the fact that PAD/D and three other rejected groups took the 1983 NEA vetos with a curious passivity and stoicism. (As did I when I was fired by the *Village Voice* in 1985 after four-and-a-half years of doing exactly what I'd been hired to do—write a monthly "column" on political, feminist, community, and activist art.[13]) We never expected much from the "establishment," and we were wary of being defined by the opposition. In the feminist movement, in particular, we were always debating the problem of being controlled by the process of reaction, which swallows up offensive energy in sometimes unnecessary defense. As literary theorist Homi K. Bhabha, paraphrasing Frantz Fanon, warns, "Paranoia never preserves its position of power, for the compulsive identifica-

tion with a persecutory 'They' is always an evacuation and emptying of the 'I.' "[14]

In some ways, the arts community has been asking for the problems brought down on its head since the late '80s. As a feminist, I'm certainly aware of the dangers of the blame-the-victim syndrome. Yet, the average avant-garde artist is extraordinarily isolated from her or his audiences. There needs to be some entrance, some clues, for those viewers who don't get it—not because they're dumb, but because they don't read the art magazines. Modernists and post-modernists alike are internally encouraged to "épater le bourgeois," and it should not have been such a surprise when the middle class was indeed flabbergasted. Artists themselves must take some responsibility for alienating their audiences simply for alienation's sake—or even for art's sake. On the other hand, responsibility is not the same as self-censorship, which is the insidious result of the lack of responsibility.

For better or worse, the prime constituency of a socially engaged art (for me as a writer, at least) is, first and foremost, artists themselves. If artists could be mobilized to think socially, to think out, the art market's hold on art-making might be loosened. The more artists are brainstorming and creating new contexts for art, the more exciting and effective an option activist art will be. One of the key issues raised by the fifteen years in question here is whether there still is a community of artists, a group of people who share beliefs and goals and will stand up for them and for each other when threatened. When a crisis arose—the threat to freedom of expression posed by the enfeebling of the NEA—was there a community to meet it? The fragmented, career-driven, rugged-individualist center supported by powerful galleries and institutions did not come through for artists in general when push came to shove. Art activists were unused to protecting artists; we were more often concerned with "others," ironically agreeing with the political groups dismissing art as less deserving of attention than broader social issues. Since many activist artists had been confronting the patriarchal right wing since the Vietnam War era, the mainstream's belated recognition of a "crisis" when censorship struck higher on the aesthetic ladder was taken with a certain skepticism. Some artists on the left wondered where everyone had been for the last decade, while others were uninterested in supporting colleagues whose work they perceived as apolitical and economically too far ahead of their own careers. As conservative watchdogs moved into mass culture and the corporations took over the cultural institutions, bringing self-censorship in their wake, art-workers began to understand better where we fit into the whole picture. And it was not a pretty picture.

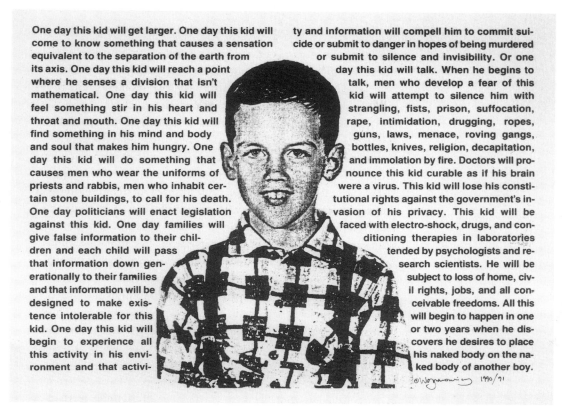

One day this kid will get larger. One day this kid will come to know something that causes a sensation equivalent to the separation of the earth from its axis. One day this kid will reach a point where he senses a division that isn't mathematical. One day this kid will feel something stir in his heart and throat and mouth. One day this kid will find something in his mind and body and soul that makes him hungry. One day this kid will do something that causes men who wear the uniforms of priests and rabbis, men who inhabit certain stone buildings, to call for his death. One day politicians will enact legislation against this kid. One day families will give false information to their children and each child will pass that information down generationally to their families and that information will be designed to make existence intolerable for this kid. One day this kid will begin to experience all this activity in his environment and that activity and information will compel him to commit suicide or submit to danger in hopes of being murdered or submit to silence and invisibility. Or one day this kid will talk. When he begins to talk, men who develop a fear of this kid will attempt to silence him with strangling, fists, prison, suffocation, rape, intimidation, drugging, ropes, guns, laws, menace, roving gangs, bottles, knives, religion, decapitation, and immolation by fire. Doctors will pronounce this kid curable as if his brain were a virus. This kid will lose his constitutional rights against the government's invasion of his privacy. This kid will be faced with electro-shock, drugs, and conditioning therapies in laboratories tended by psychologists and research scientists. He will be subject to loss of home, civil rights, jobs, and all conceivable freedoms. All this will begin to happen in one or two years when he discovers he desires to place his naked body on the naked body of another boy.

When the realities of the censorship crisis became evident, a loose-knit group of artists who had organized together off and on since the '60s immediately called meetings for "Censorship Emergency," a short-lived initiative that attracted large crowds but was soon replaced by more sophisticated national lobbying techniques. Suddenly, there was a mobilized resistance that brought previously apolitical groups together with working activists into a real force. The nonprofit group Art Matters led the way by funding (and founding) the National Campaign for Freedom of Expression (NCFE). This could be seen as a moment of truth for left-affiliated art groups as we knew them, a moment when higher-tech and more sophisticated strategies took over, better suited to the challenge of a well-organized right with its direct mail and talk shows than were the older means of visual confrontation. New techniques and approaches are crucial in the image/culture wars.

But there is no point in being nostalgic for other times and places in which a more "natural" context for art existed. The question today is how to find a space for culture in this society. The prolonged whine I've written here is a kind of mourning—not for a kind of activist art that no longer works as well as it once did, but for the loss of memory, for the loss of respect for what did work, and for what was boldly attempted. I'm not claiming points for activist art

David Wojnarowicz, *Untitled*, 1990, photostat, 30 x 40 in. Photo courtesy of the Estate of David Wojnarowicz and PPOW, New York. Art Matters grant recipient, 1989, 1990, 1991.

groups on the basis of conventional notions of "quality" or "origi-
nality," but in terms of its influential spirit and expanded context.
Nor will I drop the names of artists who have profited from the
accomplishments of lesser-known and more specifically political
artists. Competition has already done its damage in the art commu-
nity. Over the last ten or fifteen years I've watched artist friends
floundering—creatively, intelligently—in a sea not of their own
making. The moment that was 1980, with all its passions and pur-
posefulness, now seems very far away, less part of a continuum than
broken off from history and rarely remembered even by those few
socially oriented mainstream artists who make work influenced by
activism, but make it closer to the center.

Yet today there is more art being made around social issues within
the art world than there was in 1985. The tentacles of the art context
now reach beyond the mainstream galleries and museums, thanks to
innovative public art initiatives. Boundaries between mediums and
disciplines continue to be challenged. Cultural inclusion is a matter
of course... up to a point. Some major institutions are not afraid to
support social (not usually political) projects outside of their own
upscale neighborhoods. On the other hand, the "moderate" value
system of the art world's center has swallowed many once recalcitrant
figures, and it has become unpopular to advocate any disapproval
of bigoted, biased, or reactionary art lest it be interpreted as an
attack on the freedom of expression. The crucial question across
the economic spectrum today may be how to get people to think
for themselves and at the same time be to able listen to the
thoughts of others with different backgrounds, needs, and tastes.

My real point is a general one: that younger artists seldom under-
stand where they are coming from and thus lose track of where
they are going. They are flushed out of art schools on a rush of
idealism and inflated self-esteem into an indifferent world where
poverty awaits them, where they are seen as weirdos and elitists. Once
out in the cold, cruel world, even the greatest art is a commodity,
and the standards are determined outside the artists' communities.
This is confusing to young image-makers. The loss of continuity
engenders both an arrogance and a political pessimism that is
unhealthy aesthetically and socially. It's also a terrific waste of time,
and activist art is all about time—the intensity of the moment that
needs elucidating; the time away from studio, friends, family, and
wage earning; the time it takes to launch a major activist project;
and the time past, the time ahead, into which the action must fit.

One day, maybe we'll understand better how bad the present
context is for art-making. All across the political spectrum we have
been dulled and diminished by our own fears. But you can't be an

activist without being an optimist, and you can't be an activist without being a pessimist.[15] It is too simple to say that the art world never recovered from the Reagan/Bush era of greed and grandiosity, that it now lacks passion and purpose, that it has sold out. What has changed since 1980? Everything and nothing.

"I just want to change the world, that's all."
— MARTHA WILSON

1. Cee Brown, Art Matters board member, has made a similar point about the way WPA demise paralleled decline of NEA.

2. See my essay "Trojan Horses: Activist Art and Power," in Brian Wallis, ed., *Art After Modernism: Rethinking Representation* (New York and Boston: New Museum of Contemporary Art and David R. Godine, 1984), pp. 340-58.

3. Students at Cal Arts in 1998 were not even aware that the pioneering Feminist Art Program, instigated and taught there by Judy Chicago and Miriam Schapiro, had existed.

4. David Deitcher, "Taking Control: Art and Activism," in Nilda Peraza, Marcia Tucker, Kinshasha Holman Conwill, eds., *The Decade Show* (New York: The Museum of Contemporary Hispanic Art, New Museum of Contemporary Art, and Studio Museum in Harlem, 1990), pp. 180-97. Deitcher did, however, mention a lot of important activist work, most of which was not included in the catalogue for *The Decade Show*. For the most part, this book-length catalogue provides a good alternative view of the 1980s, despite lousy copyediting. (Judith Wilson, for instance, asked for but did not receive an errata to her article which had been changed to make it sound as though she disapproved of my book *Overlay* and approved of Bill Rubin's *Primitivism in 20th-Century Art* show at MoMA, when she had written the exact opposite.)

5. We soon added the second D, for Distribution, to the D for Documentation.

6. Its acceptance by MoMA was entirely due to the fact that the then librarian, Clive Phillpot, was a founding member of PAD/D who had helped set up the archive in its first incarnation. It has since been used to recall that period in the current less-politicized moment. For instance, Deborah Wye used the archive when curating *Committed to Print*, a 1988 MoMA show on political art, and in 1998 the education curator at the New Museum, Greg Sholette (himself a member of PAD/D), used the archive as source for *Urban Encounters*, an exhibition on artists' groups in the 1980s and '90s.

7. The text is published in my out-of-print book *Get the Message? A Decade of Art for Social Change* (New York: E.P. Dutton, 1984). See also "Hot Potatoes: Art and Politics in 1980" in the same collection.

8. For a lively overview of this period and many of these groups, see Alan Moore and Marc Miller, eds., *ABC NO Rio Dinero: The Story of a Lower East Side Art Gallery* (New York: ABC NO Rio with Collaborative Projects, 1985).

9. I considered the contradictions at length in "Sex and Death and Shock and Schlock: A Long Review of the Times Square Show" by Anne Ominous, *Artforum*, (Oct. 1980), reprinted in *Get the Message?*

10. For an excellent overview of this kind of work, see Suzanne Lacy, ed., *Mapping the Terrain: New Genre Public Art* (Seattle: Bay Press, 1995).

11. See *Confessions of the Guerrilla Girls* (New York: Harper Collins, 1995), *WAC Stats: The Facts About Women* (New York: New Press, 1993), *Cultures in Contention*, ed. by Douglas Kahn and Diane Neumaier (Seattle: Real Comet Press, 1985), *Reimaging America: The Arts and Social Change,* ed. Mark O'Brien and Craig Little (Philadelphia: New Society Publishers, 1990), and my own *The Pink Glass Swan: Selected Essays on Feminist Art* (New York: New Press, 1995).

12. For strategies to combat censorship, see *NCFE Handbook to Understanding, Preparing for, and Responding to Challenges to your Freedom of Expression* (Washington, D.C.: National Campaign for Freedom of Expression). For AIDS activism, see Douglas Crimp and Adam Rolston, *AIDS Demo Graphics* (Seattle: Bay Press, 1990), a book "intended as a demonstration."

13. I wrote about this in my last column, "Clash of '85," *Village Voice* (June 11, 1985); reprinted in *Get the Message?*

14. Homi K. Bhabha, "Remembering Fanon: Self, Psyche, and the Colonial Condition," in Barbara Kruger and Phil Mariani, eds., *Remaking History* (Seattle: Bay Press, 1989), p. 142.

15. Along with many of my colleagues, I am always quoting, and identifying with, Antonio Gramsci's famous line, "Pessimism of the intellect, optimism of the will."

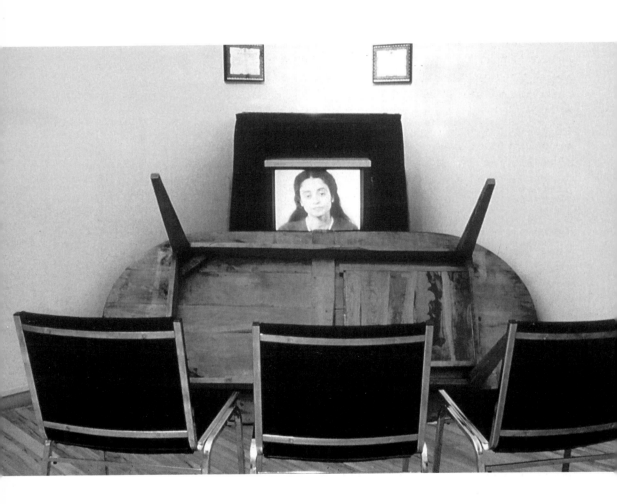

Passionate Irreverence: The Cultural Politics of Identity (1993)

COCO FUSCO

Hardly a week has passed in the last two years without public attention being drawn to yet another battle over identity and culture. Behind each debate linger fears and hopes about the image this country projects to its people(s) and to the rest of the world. *Who are we?* asked *Time* magazine, as statistics point to the changing (i.e., increasingly nonwhite) ethnic makeup of American society. *Whose values?* asked *Newsweek*, as many reel and others applaud at the radical Right's neofascist, universalist rhetoric. These questions have spilled over into the world of art in several interrelated and volatile debates over censorship, cultural property, and cultural equity. *Whose museums and whose aesthetics?* asks a new generation of critics, curators, and artists. *Whose icons?* wonder multicultural theorists and activists, as familiar elements of foreign worlds are absorbed with increasing speed by American consumer culture. *Whose image?* argue the lawyers involved in the lawsuit against Jeff Koons who, in the eyes of the law, "appropriated" and, in doing so, capitalized on another artist's photograph by reinterpreting it as sculpture without acknowledging a "source."

Where are we? We are in America, five hundred years after the beginning of the conquest and colonization of the New World, five years after the beginning of the sweeping transformations in the socialist world, and eight years from the end of the millennium. The last great empires of this century—the United States and the Soviet Union—are on the decline as superpowers, their respective economies tip into tailspins, and their international work forces become migratory "social problems." With the unraveling of these systems, the concept and reality of the unified, homogeneous nation-state and national culture become highly contested terrains. To these political and ideological changes we must add the fact that advances in technology have disrupted geographical, political, and cultural boundaries forever.

The collectively experienced anxiety provoked by these transformations has generated a plethora of identity-related conflicts, from geopolitical boundary disputes and the resurgence of ethnic tensions

Adrian Piper, *Cornered*, 1988, mixed-medium installation, dimensions variable. Photo courtesy of the artist. Art Matters grant recipient, 1987

This essay first appeared in Elisabeth Sussman et al., eds., *1993 Whitney Biennial Exhibition* (New York: Whitney Museum of American Art; 1993), pp. 74–85.

in Europe, to the concomitant racial unrest of North America. In Europe, these issues are being fought over principally in the geo-political sphere; in the United States, we find ourselves in more of an ideological battle over symbolic representation. This does not mean, however, that the battles in America are any less political; on the contrary, culture in this country is a critical, if not the most cru-cial, area of political struggle over identity. While the tensions in the East and the West do differ, they are nonetheless driven by the same underlying contradictory forces: on the one hand, economic inter-nationalization and the formation of "global culture" (symbolized by the European Economic Community and the North American Free Trade Agreement); and, on the other, political fragmentation based on regionalism, ethnic separatism, and extreme economic polarization. We struggle to preserve distinctions that, for some, can no longer be taken for granted, and, for others, appear for the first time to be within reach.

These conditions shape much of the art and the cultural debates of our historical moment. Physical and cultural dislocation charac-terizes the daily lives of many, if not most, of the people of the world. Those in a position of privilege live this condition by choice, conducting international business, using advanced technology, or playing virtual-reality games; others who are less privileged are com-pelled to live this sense of dislocation without respite as migrant workers, immigrants, exiles, refugees, and homeless people. Diasporic cultures rival those of the homelands in size and complexity. Exile communities often provide crucial economic support to imperiled "centers." Exile, and the split sense of self it entails, are paradigmatic experiences of identity for millions. Some nations exist without a place, while others exist only through authoritarian enforcement. The hegemony of national cultures is perpetually disrupted by "foreign" information, media, consumer items, and people. The once colonial condition of having to adjudicate between local and outside cultures and power structures has not been swept away by the postcolonial age; in fact, it bears resemblance to daily life in postindustrial societies, where advanced technologies facilitate con-tinuous transmission of information and commodities to different ends of the globe. Nonetheless, for some, these transformations do not necessarily signal greater availability of resources—only more intrusions into their lands and their lives.

In such a state of things, the very notion of cultural purity can seem like something of a nostalgic fantasy, one that not even "non-Western" societies can provide proof of any longer. Yet these issues continue to trouble many and are central to cultural debates about the condition of subaltern peoples in the United States. Our con-

tinued engagement with questions of identity would indicate that not even a shifting of borders will bring us to relinquish them altogether. Unlike many other interpretations of postmodernity that have suggested that the accelerated flow of cultural property has nullified fixed identities and power relations between them, subaltern theory and cultural practice have maintained the need to account for distinctions between political power (i.e., the ability to make things happen and how those with political power see themselves) and symbolic exchange of cultural symbols. While other schools of thought associated with postmodernism have interpreted identity as pure process, and as infinitely transformable and essentially performative, subaltern discourses have looked upon these positions as volunteerist characterizations that do not account for controlling forces that affect identity, such as racism and the determining force of collective historical experience. Such elisions still appear too similar to the racial violence that has robbed many in this country of the right, first to be considered human beings, and then to have access to political power. At this historical moment, then, the post-modern fascination with the exchange of cultural property and with completely deracinated identity can seem for many people of color less like emancipation and more like intensified alienation. Instead, for many, the times demand what Gayatri Spivak has called "strategic essentialism," that is, a critical position that validates identity as politically necessary but not as ahistorical or unchangeable.

Cultural identity and values are politically and historically charged issues for peoples in this country whose access to exercising political power and controlling their symbolic representations has been limited within mainstream culture. While some might look upon the current wave of multiculturalism as inherently empowering and/or new, others look upon the present in relation to a long tradition of "celebrating" (or rather, objectifying) difference as light but exotic entertainment for the dominant culture. From the perspective of those who have been geographically, politically, culturally, and econ-omically marginalized in and by the United States, these celebrations and the curiosity that drives them are not necessarily disinterested or inherently progressive phenomena. They are, instead, potentially double-edged swords, signaling both the exercising of control over cultural difference through the presentation of static models of diversity and the potential opportunity to transform the stereotypes that emerge with the imposition of control.

Those stereotypes that have grown ingrained over time cannot be easily dismissed and then simply cast off; they are both reminders of a painful legacy of bigotry and disempowerment that has fueled their systematic misrepresentation, *and* the starting point for under-

standing the racially inflected, voyeuristic impulses in Euro-American and other colonizing cultures. "Appropriation," a favorite buzzword of the 1980s art elite, isn't just about disinterested pastiche or tracing one's creative bloodlines to Marcel Duchamp and Andy Warhol; it is also about reckoning with a history of colonialist power relations vis-à-vis non-Western cultures and peoples to contextualize certain forms of appropriation as symbolic violence. In other words, although appropriation may not connote power inequities when conceived within other strains of postmodern culture, its historical and political implications in relation to European colonialism and American expansionism cannot be ignored, because the erasure of authorship and the exchange of symbols and artifacts across cultural boundaries have never been apolitical or purely formalist gestures. That mainstream culture has periodically expressed desire for subaltern art has never obligated anyone to deal with subaltern peoples as human beings, compatriots, or artists. That is, perhaps, until now.

While the claims to absolute authority in issues of cultural identity and property are at times problematic (since no one, in the end, speaks for every member of a group), the ways that these dealings are represented in the mainstream media and even most of the art press are invariably tendentious. Little effort has been made to distinguish between dominant cultural attempts to curtail an artist's right to express his or her aesthetic sensibility and a subaltern critique of institutionalized racism and privilege; in fact, the blurring of these distinctions has fueled the debates over political correctness during recent years. Nonetheless, many if not most of the criticisms leveled at those who raise questions about cultural appropriation are hardly substantive; rather, masked by platitudes about quality and freedom, they are often expressions of displeasure that heretofore underheard sectors of society choose to have opinions about culture at all. As the left and right invoke "imagined communities" of "the audience" to justify their assuming the authority to speak, this "audience" is deemed either too sensitive and innocent or much too smart to mistake evil for good. Anyone who challenges an entrenched power structure's absolute "freedom" to make money or meaning in whatever way it finds desirable can be labeled anti-American, socially backward, and artistically ignorant. Any subaltern question or protest, even if its aim is not to curtail but to contextualize, can be perceived as threatening to the current cultural order of things.

For the privileged purveyors of culture in this country—be they artists, teachers, critics, collectors, benefactors or exhibitors— confronting the limitations of one's knowledge and relinquishing authority can be seen as a challenge or a crushing blow. This

prospect has generated another spate of defensive retaliation in the past two years, using very old tactics. In the summer of 1992, when hundreds of Chicana actresses in California protested the production of a film about Frida Kahlo because its producers refused to hire a Latina actress for the lead—claiming that "there weren't any big names"—many mainstream reports presented the protesters as having interfered with basic artistic freedoms. The Chicana position was seen as subjective and partisan and as a personal attack against the director. Such an analysis could not take into consideration that decades of absence of a substantial role for a Latina actress in Hollywood might not be the result of pure coincidence but of an unwritten and unchallenged policy. Nor could it, for that matter, stress an awareness of the sense of disempowerment provoked by the knowledge that rampant commodification of one's cultural heroes does not necessarily lead to gaining access to cultural resources for oneself or for one's community. On the contrary, the mainstream appropriation of subaltern *cultures* in this country has historically served as a substitute for ceding to those peoples any real political or economic power.

Had it been the 1960s, and had the protesters been male, they might have been lauded as the leaders of a new lobbying group in Hollywood and protagonists of a chapter on Chicano history. Instead, they have been largely represented outside the Chicano community as the latest in a line of politically correct feminists to appear on the horizon. The commercial impetus and concentration of wealth of the movie industry have made it perhaps the toughest cultural arena in which to fight, particularly for women artists of color, who have benefited the least from the latest round of invest- ment in commercial films about African-Americans and Latinos. This is perhaps the saddest lesson about identity politics that we have learned in the aftermath of the Civil Rights Movement and the backlash against the policies it inspired that the Reagan and Bush administrations have fueled: that superficial assimilation through consumerism and tokenism can be lauded as a sign of the mainstream's acquiescence, while the fundamental changes needed to bring out a more profound form of equity are still thwarted at every turn.

On the other hand, the world of the visual arts at times evinces more conciliatory signals. For example, amid the countless Native-American art showcases opening throughout the Midwest in the fall of 1992 as liberal-minded counter-quincentennial gestures, a conflict erupted at a Minneapolis art museum over the proposed exhibition of Native-American pipes that are considered sacred by many indigenous peoples. It was only after lengthy discussion

among Native elders, artists, activists, and museum staff that the institution was convinced of its error, a position that might not have been taken had it not been for years of debates about the ownership of Native artifacts, and for the fact that around the same time the American-Indian Movement filed a suit against the Washington Redskins for the team's use of a racial slur as its name.

Another indicator of this changing tide is that recent complaints in New York City over representations of blacks and Latinos in public art by white artists have been met with unprecedented willingness to pay them heed. Such communially oriented and ethnically divided discussions of the role and quality of public art strike at the core of the radical individualism that characterizes the mainstream's notion of the artist in this society. These discussions also test the limits of power of dominant cultural institutions and curators, whose long-standing authority to act as arbiters of taste is now being continually questioned by "lay" critiques of their notions of aesthetic value and realism. I cannot say that I have always found these criticisms to be devoid of extra-artistic motives—some have been used as indirect attacks on politicians, for example. Furthermore, these criticisms would be more convincing if they were more systematic, more clearly directed at perceived misrepresentations in the commercial media, and not only the arts. Nonetheless, these protests offer a critical opportunity to reconsider relationships among culture, art-making, community, and public space. However they may be manipulated by the press, these encounters are multicultural identity politics made manifest in everyday life. They speak to the complexities of negotiating diverse views on culture and identity in our society. Together with public actions by such groups as the AIDS activists of ACT UP (AIDS Coalition to Unleash Power), the feminists of WAC (Women's Action Coalition) and Guerrilla Girls, and the artists of color of PESTS, they constitute some of the most interactive public engagements with the media and the arts that have emerged in the past decade. Each, in its own way, seeks to redress inequities by taking its concerns to the street and other public spaces, merging activism with spectacle.

These conflicts over a person's right to define his or her culture and icons resonate with similar battles from the past, but in the late 1980s and early 1990s, they have become increasingly concentrated within the arts, the media, and education, and have taken on a par-ticularly strident tone. They signal a growing awareness of symbolic representation as a key site of political struggle. These conflicts also herald important shifts in how we must understand postmodernism and "difference." By giving abstract concepts and formal operations more overt social content, these conflicts localize, politicize, and

Fred Wilson, *Guarded View*, 1991, installation. Photo courtesy of the artist and Metro Pictures Gallery, New York. Art Matters grant recipient, 1990.

historicize postmodern cultural debates that had been at one time excessively formalist and ethnocentric, even in the characterization of difference itself.

At the heart of these other postmodernisms lies an insistence that art and politics are never truly extricable. While a more formalist approach to appropriation and pastiche characterized much of the art and art criticism of the early 1980s, the subaltern cultural strategies that have gained attention more recently foreground the connection between the political and the symbolic. The surrounding debates also involve explicit critiques of liberal humanist claims that legal equality ends significant difference between peoples, and of the relativist postures of certain strains of poststructuralism and their accompanying volunteerist propositions for understanding identity. Scores of feminists and postcolonial theorists have rejected formulations of poststructuralism that declare the death of the subject, the end of meaning, the decline of the social, and the failure of political resistance; these proclamations, they argue, speak only to the realities of those few who once could claim absolute right, absolute truth, and absolute authority. They also turn a skeptical eye to popular interpretations of the poststructuralist stress on the performative dimension of identity that reduce subjectivity to pure and self-determined artifice. Despite cataclysmic changes in the ways that communities are defined and information circulates, only an infinitely small sector of society actually chooses freely where they are, who

they are, and how they live. Even the limited ability one might acquire to alter aspects of one's identity cannot completely obfuscate the impact of outside social, political, and economic factors in the constitution of the self. To paraphrase the cultural theorist Stuart Hall, not all symbols and exchanges are interchangeable—there still are differences that make a difference. What emerges, however, is not a romantic form of essentialism, but a fluid notion of identity that is imbedded in, but not mechanistically determined by, history.

Within the realm of culture, then, two interrelated but seemingly contradictory struggles are in the foreground. One, waged in the realm of political representation, is an interracial, intercultural battle in the public sphere over appropriation, in which people of color are demanding the right to determine the meaning of their culture and delimit its identity—or, rather, to point to borders that still exist. This is a battle that seeks to resolve a legacy of inequity by addressing the power relations involved in symbolic representation. On the other hand, the artistic outpourings from these same communities in recent years have stressed hybridity as a cultural experience and as a formal strategy. Performance artist and musician Alvin Eng, for example, in his experimental video about being Asian, *Rock Me Gung Hey*, sets his story in rap idiom. Interestingly, rap music, which is often characterized as the expression of black male youth, is perhaps today's most resonant cross-cultural American language for defiant self-affirmation; its use has spread to Chicanos such as Keith Frost and the groups A Lighter Shade of Brown and Aztlan Nation, to Cuban-Americans such as Mellow Man Ace, and Nuyoricans such as Latin Empire—as well as dozens of young black women in the United States whose voices often counter the male-centeredness of the practice, and to other young people throughout the world.

Although some might cling to the idea that all artists are bound to a specific, group-oriented mandate, or a fixed notion of community, the most intriguing work takes these very assumptions apart and presents new possibilities for old terms. Adrian Piper's media installation *Cornered*, for example, is an indictment of American prejudice that demonstrates how the legal definition and social understanding of the term "black" are incompatible, compelling us to rethink our own understanding of our racial makeup. Rather than celebrating the survival of a "pure" tradition, James Luna's moving performance *The Shame Man* depicts some of the most saddening aspects of contemporary Native-American experience, inviting us to enter into a poignant and enriching process of redefining his culture.

Perhaps the best result of the cultural climate of the past decade has been the flourishing of a *variety* of artistic practices and perspectives, which testifies to the impossibility of reducing cultural identity to a simplistic paradigm. It appears that we have worked away from the once widely held belief that artists of color must all be engaged in what Stuart Hall has called the act of imaginative recovery of a singular, unifying past in order for their work to be valid. No longer bound to a sense of having to restrict one's focus, materials, or genre, many contemporary artists of color move back and forth between past and present, between history and fiction, between art and ritual, between high art and popular culture, and between Western and non-Western influence. In doing so, they participate in multiple communities. Artists such as Fred Wilson and Rénee Green excavate the European and Euro-American colonial past, drawing our attention to often horrifying elements many ignore or take for granted, but also underscoring our attraction to and even fascination with the artifacts and documents themselves. Pepón Osorio's ornate and intricately redesigned domestic objects and theater sets blur commonly held distinctions between original and copy, and between reliquary and sculpture, forcing us to redefine Euro-American notions of taste and originality.

These artists reflect the hybrid experiences that shape so much of contemporary life. They emerge from the dynamics of moving between worlds, and feeling at home and not at home in more than one. They use different languages, and cross-aesthetic genres as they follow ideas through multiple media. They express the ambivalence produced by being out of sync with dominant media constructs and yet being fascinated with images and with the creative possibilities for their recontextualization. Similarly, they look at Western history and art history not to excise its racism but to excavate and play with symptomatic absences and stereotypes, creating a counterhistory by bouncing off negative images and teasing out hidden stories. Rather than reject dominant culture for its exclusionary tendencies and retreating, literally or figuratively, many artists of color who have matured in the last decade are forcefully engaged with it in ways that make it new. I am reminded here of the New York-based filmmaker Elia Suleiman's description of his own strategy of creating a new visual syntax out of bits of footage from television: "In a war in which you have no weapons, you must take those of your enemy and use them for something better—like throwing them back at him."

The strategy of taking elements of an established or imposed culture and throwing them back with a different set of meanings

is not only key to guerilla warfare; the tactics of reversal, recycling, and subversive montage are aesthetics that form the basis of many twentieth-century avant-gardes. Nonetheless, a more profound understanding of the influences affecting many artists of color demands that we also perceive their connections to the semiotics characteristic of the colonial condition. Syncretism, or the fusion of different forms of belief or practice, enabled disempowered groups to maintain their outlawed or marginalized traditions. It also paved the way for a host of cultural recycling methods that infuse old icons with new meanings. Symbolic action, in the form of spirituality and art, has for centuries been a critical arena for self-definition by politically disenfranchised peoples. One might recall the importance of African-American spirituals in the Civil Rights Movement, or the role of the *corridos* for Chicanos in the Southwest as conveyors of a history suppressed by the dominant Anglo society. Culture and communal self-expression are perhaps most important sites of resistance, the signs in everyday life of an ongoing political struggle. Yet, resistance within a colonial context is rarely direct, overt, or literal; rather, it articulates itself through semantic reversals, and through the process of infusing icons, objects, and symbols with different meanings. As literary theorist Henry Louis Gates has argued in his analyses of the African-American practice of signifyin', it is in these dynamics that one finds echoes of the creative defense of the enslaved against his or her master. They are among the many ways oppressed peoples have developed to take their identity back.

However bittersweet, they are also, often, very humorous. Parody, satire, and carnivalesque unsettling of established orders continue to thrive as creative strategies for temporarily subverting authority. Not surprisingly, the sixteenth-century government of the Viceroyalty of Peru issued a law to outlaw comedy, out of fear of its potential political repercussions. Today, those who identify with the established order of things respond in a literal-minded manner to the playfulness and double entendres of subaltern creative expression by reading only at face value. They insist that art should not "offend," that sophisticated appreciation must be distanced and reverent, and that serious criticism be dispassionate and "objective." What these dismissive attitudes cannot understand is that the irreverence and exuberant energy of these aesthetic strategies is evidence of the survival of subaltern practices that have created the conditions for spiritual and cultural renewal, as well as critical reinterpretations of the world in which we live.

The identity battles of recent years are among the variety of ways that the peoples of this country are transforming our vision of

Coco Fusco, *La Chavela Realty Co.*, performance installation, 1991, dimensions variable. Photo courtesy of the artist.

America and its cultures. What are surfacing in the process are the histories that have circulated until now in marginalized communities. In the debates and art emerging from the tumult of the present are reflections of the many legacies of the conquest and colonization of the Americas, among them, its limiting views of art and culture. Although American society has defined progress as a focus on the future, we must now return to the past in order to place ourselves in that history and understand how we got to where we are. As we try to grasp at crucial parallels and tease new stories out of them, new alternative chronicles surface; these are the latest examples of how collective memories, those storehouses of identity, once activated, become power sites of cultural resistance.

Postcards from America: X-Rays from Hell (1989)

DAVID WOJNAROWICZ

Late yesterday afternoon a friend came over unexpectedly to sit at
my kitchen table and try and find some measure of language for his
state of mind. "What is left of life?," he asked, "What's left of living?"
He's been on AZT for six to eight months and his T-cells have
dropped from 100 plus to 30. His doctor says: "What the hell do you
want from me?" Now he's asking himself: "What the hell do I want?"
He's trying to answer this while in the throes of agitating FEAR.
I know what he's talking about as each tense description of his state
of mind slips out across the table. The table is filled with piles of
papers and objects: a boom-box, a bottle of AZT, a jar of Advil
(remember, you can't take aspirin or Tylenol while on AZT). There's
an old smiley mug with pens and scissors and a bottle of Xanax
for when the brain goes loopy; there's a Sony tape recorder that
contains a half-used cassette of late-night sex talk, fears of gradual
dying, anger, dreams and someone speaking Cantonese. In this
foreign language it says:

 "My mind cannot contain all that I see. I keep experiencing this
sensation that my skin is too tight: civilization is expanding inside
of me. Do you have a room with a better view? I am experiencing
the X-ray of civilization. The minimum speed required to break
through the earth's gravitational pull is seven miles a second. Since
economic conditions prevent us from gaining access to rockets or
spaceships we would have to learn to run awful fast to achieve
escape from where we are all heading. . ."

My friend across the table says, "There are no more people in their
30s. We're all dying out. One of my four best friends just went into
the hospital yesterday and he underwent a blood transfusion and
is now suddenly blind in one eye. The doctors don't know what it
is. . ." My eyes are still scanning the table; I know a hug or a pat on
the shoulder won't answer the question mark in his voice. And I
have a low threshold for this information. The AZT is kicking in
with one of its little side effects: increased mental activity which
in translation means I wake up these mornings with an intense

This essay first appeared in Nan Goldin, ed., *Witnesses: Against Our Vanishing*
(New York: Artists Space, 1989).

claustrophobic feeling of fucking doom. It also means that one word too many can send me to the window kicking out panes of glass, or at least that's my impulse (the fact that winter is coming holds me in check). My eyes scan the surfaces of walls and tables to provide balance to the weight of words. A 35mm camera containing the unprocessed images of red and blue and green faces in close-up profile screaming, a large postcard of a stuffed gorilla pounding its dusty chest in a museum diorama, a small bottle of hydrocortisone to keep my face from turning into a mass of peeling red and yellow flaking skin, an airline ticket to Normal, Illinois to work on a print, a small plaster model of a generic Mexican pyramid looking like it was made in Aztec kindergarten, a tiny motor car with a tiny Goofy driving at the wheel. . .

My friend across the table says, "The other three of my four best friends are dead and I'm afraid that I won't see this friend again." My eyes settle on a six-inch tall rubber model of Frankenstein from the Universal Pictures Tour gift shop, TM 1931; his hands are enormous and my head fills up with replaceable body parts; with seeing the guy in the hospital; seeing myself and my friend across the table in line for replaceable body parts; my wandering eyes aren't staving off the anxiety of his words; behind his words, so I say, "You know . . . he can still rally back . . . maybe . . . I mean people do come back from the edge of death . . ."

"Well," he says, "He lost thirty pounds in a few weeks. . ."

A boxed cassette of someone's interview with me in which I talk about diagnosis and how it simply underlined what I knew existed anyway. Not just the disease but the sense of death in the American landscape. How when I went out West this summer standing in the mountains of a small city in New Mexico I got a sudden and intense feeling of rage looking at those postcard-perfect slopes and clouds. For all I knew I was the only person for miles and all alone and I didn't trust that fucking mountain's serenity. I mean, it was just bullshit. I couldn't buy the con of nature's beauty; all I could see was death. The rest of my life is being unwound and seen through a frame of death. My anger is more about this culture's refusal to deal with mortality. My rage is really about the fact that WHEN I WAS TOLD THAT I'D CONTRACTED THIS VIRUS IT DIDN'T TAKE ME LONG TO REALIZE THAT I'D CONTRACTED A DISEASED SOCIETY AS WELL.

On the table is today's newspaper with a picture of Cardinal O'Connor saying he'd like to take part in Operation Rescue's blocking of abortion clinics but his lawyers are advising against it.

This fat cannibal from that house of walking swastikas up on Fifth Avenue should lose his church tax-exempt status and pay retroactive taxes from the last couple centuries. Shut down our clinics and we will shut down your 'church.' I believe in the death penalty for people in positions of power who commit crimes against humanity, i.e., fascism. This creep in black skirts has kept safer-sex information off the local television stations and mass-transit advertising spaces for the last eight years of the AIDS epidemic, thereby helping thousands and thousands to their unnecessary deaths.

My friend across the table is talking again. "I just feel so fucking sick. . . I have never felt this bad in my whole life. . . I woke up this morning with such intense horror; sat upright in bed and pulled on my clothes and shoes and left the house and ran and ran and ran. . ." I'm thinking maybe he got up to the speed of no more than ten miles an hour. There are times I wish we could fly; knowing that this is impossible, I wish I could get a selective lobotomy and rearrange my senses so that all I could see is the color blue; no images or forms, no sounds or sensations. There are times I wish this were so. There are times that I feel so tired, so exhausted. I may have been born centuries too late. A couple of centuries ago I might have been able to be a hermit, but the psychic and physical landscape today is just too fucking crowded and bought up. Last night I was invited to dinner upstairs at a neighbor's house. We got together to figure out how to stop the landlord from illegally tearing the roofs off our apartments. The buildings dept. had already shut the construction crew down twice, and yet they have started work again. The recent rains have been slowly destroying my western wall. This landlord some time ago allowed me to stay in my apart-ment without a lease only after signing an agreement that if there were a cure for AIDS I would have to leave within 30 days. A guy visiting the upstairs neighbor learned that I had this virus and said he believed that, although the government probably introduced the virus into the homosexual community, homosexuals were dying en masse as a reaction to centuries of society's hatred and repression of homosexuality. All I could think of when he said this was an image of hundreds of whales that beach themselves on the coastlines in supposed protest of the ocean's being polluted. He continued: "People don't die—they choose death. Homosexuals are dying of this disease because they have internalized society's hate. . ." I felt like smacking him in the head, but held off momen-tarily, saying, "As far as your theory of homosexuals dying of AIDS as a protest against society's hatred, what about the statistics that those people contracting the disease are intravenous drug users or

heterosexually inclined, and that this seems to be increasingly the case. Just look at the statistics for this area of the Lower East Side." "Oh," he said, "They're hated too. . ." "Look," I said, "After witnessing the deaths of dozens of friends and a handful of lovers, among them some of the most authentically spiritual people I have ever known, I simply can't accept mystical answers or excuses for why so many people are dying from this disease—really, it's on the shoulders of a bunch of bigoted creeps who at this point in time are in the positions of power that determine where and when and for whom government funds are spent for research and medical care."

I found that, after witnessing Peter Hujar's death on November 26, 1987, and after my recent diagnosis, I tend to dismantle and discard any and all kinds of spiritual and psychic and physical words or concepts designed to make sense of the external world or designed to give momentary comfort. It's like stripping the body of flesh in order to see the skeleton, the structure. I want to know what the structure of all this is in the way only I can know it. All my notions of the machinations of the world have been built throughout my life on odd cannibalizations of different lost cultures and on intuitive mythologies. I gained comfort from the idea that people could spontaneously self-combust and from surreal excursions into nightly dream landscapes. But all that is breaking down or being severely eroded by my own brain; it's like tipping a bottle over on its side and watching the liquid contents drain out in slow motion. I suddenly resist comfort, from myself and especially from others. There is something I want to see clearly, something I want to witness in its raw state. And this need comes from my sense of mortality. There is a relief in having this sense of mortality. At least I won't arrive one day at my 80th birthday and at the eve of my possible death and only then realize my whole life was supposed to be somewhat a preparation for the event of death and suddenly fill up with rage because, instead of preparation, all I had was a lifetime of adaptation to the pre-invented world—do you understand what I'm saying here? I am busying myself with a process of distancing myself from you and others and my environment in order to know what I feel and what I can find. I'm trying to lift off the weight of the pre-invented world so I can see what's underneath it all. I'm hungry and the pre-invented world won't satisfy my hunger. I'm a prisoner of language that doesn't have a letter or a sign or a gesture that approximates what I'm sensing. Rage may be one of the few things that binds or connects me to you, to our pre-invented world. My friend across the table says, "I don't know how much longer I can go on. . . Maybe I should just kill myself." I looked up from the

Frankenstein doll, stopped trying to twist its yellow head off and looked at him. He was looking out the window at a sexy Puerto Rican guy standing on the street below. I asked him, "If tomorrow you could take a pill that would let you die quickly and quietly, would you do it?"

"No," he said, "Not yet."

"There's too much work to do," I said.

"That's right," he said.

"There's still a lot of work to do . . ."

I am a bundle of contradictions that shift constantly. This is a comfort to me because to contradict myself dismantles the mental/ physical chains of the verbal code. I abstract this disease I have in the same way you abstract death. Sometimes I don't think about this disease for hours. This process lets me get work done, and work gives me life, or at least makes sense of living for short periods of time. But because I abstract this disease, it periodically knocks me on my ass with its relentlessness. With almost any other illness you take for granted that within a week or month the illness will end and the wonderful part of the human body called the mind will go about its job erasing evidence of the pain and discomfort previously experienced. But with AIDS or HIV infections one never gets that luxury and I find myself after a while responding to it for a fractured moment with my pre-AIDS thought processes: "Alright this is enough already; it should just go away." But each day's dose of medicine, or the intermittent aerosol pentamidine treatments, or the sexy stranger nodding to you on the street corner or across the room at a party, reminds you in a clearer-than-clear way that at this point in history the virus's activity is forever. Outside my window there are thousands of people without homes who are trying to deal with having AIDS. If I think my life at times has a nightmare quality about it because of the society in which I live and that society's almost total inability to deal with this disease in anything other than a conservative agenda, I think for a moment what it would be to be facing winter winds and shit menus at the limited shelters, and the rampant T.B. and the rapes, muggings, and stabbings in those shelters, and the overwhelmed clinics and sometimes indifferent clinic doctors, and the fact that drug trials are not open to people of color or the poor unless they have a private physician who can monitor the experimental drugs they would need to take, and they don't have those kinds of doctors in clinics because doctors in clinics are constantly rotated and intravenous drug users have to be clean of drugs for two years before they'll be considered for drug trials, and yet there are nine-month waiting periods just to get assigned to a treatment program, so picture yourself with a couple

of the 350 opportunistic infections and unable to respond to a few drugs released by the foot-dragging FDA and having to maintain a junk habit; or even having to try and kick that habit without any clinical help and also keep yourself alive two years to get a drug that you need immediately—thank you Ed Koch; thank you Stephen Josephs; thank you Frank Young; thank you AMA.

I scratch my head at the hysteria surrounding the actions of the repulsive senator from zombieland who has been trying to dismantle the NEA for supporting the work of Andres Serrano and Robert Mapplethorpe. Although the anger sparked within the art community is certainly justified and hopefully will grow stronger, the actions by Helms and D'Amato only follow standards that have been formed and implemented by the "arts" community itself. The major museums in New York, not to mention museums around the country, are just as guilty of this kind of selective cultural support and denial. It is a standard practice to make invisible any kind of sexual imaging other than white straight male erotic fantasies—sex in America long ago slid into a small set of generic symbols; mention the word sex and the general public seems to imagine a couple of heterosexual positions on a bed—there are actual laws in the South forbidding anything else, even between consenting adults. So people have found it necessary to define their sexuality in images, in photographs and drawings and movies in order not to disappear. Collectors have for the most part failed to support work that defines a particular person's sexuality, except for a few examples such as Mapplethorpe, and thus have perpetuated the invisibility of the myriad possibilities of sexual activity. The collectors' influence on what the museum shows continues this process secretly with behind-the-scenes manipulations of curators and money. Jesse Helms is, at the very least, making his attacks on freedom public; the collectors and museums responsible for censorship do theirs at elegant private parties or from the confines of their self-created closets.

It doesn't just stop at images—recently a critic/novelist had his novel reviewed by the *New York Times Book Review* and the reviewer took outrage at the novelist's descriptions of promiscuity, saying: "In this age of AIDS, the writer should show more restraint. . ." Not only do we have to contend with bonehead newscasters and conservative members of the medical profession telling us to "just say no" to sexuality itself rather than talk about safer sex possibilities, but we have people from the thought police spilling out from the ranks with admonitions that we shouldn't think about anything other than monogamous or safer sex. I'm beginning to believe that one

of the last frontiers left for radical gesture is the imagination.

At least in my ungoverned imagination I can fuck somebody with-out a rubber or I can, in the privacy of my own skull, douse Helms with a bucket of gasoline and set his putrid ass on fire or throw Rep. William Dannemeyer off the Empire State Building. These fantasies give me distance from my outrage for a few seconds. They give me momentary comfort. Sexuality defined in images gives me comfort in a hostile world. They give me strength. I have always loved my anonymity, and therein lies a contradiction because I also find com-fort in seeing representations of my private experiences in the public environment. They need not be representations of my experiences— they can be the experiences of and by others that merely come close to my own or else disrupt the generic representations that have come to be the norm in the various media outside my door. I find that when I witness diverse representations of "Reality" on a gallery wall or in a book or a movie or in the spoken word or performance, that the more diverse the representations, the more I feel there is room in the environment for my existence; that not the entire environment is hostile.

To make the *private* into something *public* is an action that has terrific repercussions in the pre-invented world. The government has the job of maintaining the day-to-day illusion of the ONE TRIBE NATION. Each public disclosure of a private reality becomes some-thing of a magnet that can attract others with a similar frame of reference; thus each public disclosure of a fragment of private reality serves as a dismantling tool against the illusion of ONE TRIBE NATION; it lifts the curtains for a brief peek and reveals the possible existence of literally millions of tribes; the term GENERAL PUBLIC disintegrates. If GENERAL PUBLIC disintegrates, what happens next is the possibility of an X-RAY OF CIVILIZATION, an examination of its foundations. To turn our private grief at the loss of friends, family, lovers and strangers into something public would serve as another powerful dismantling tool. It would dispel the notion that this virus has a sexual orientation or the notion that the government and medical community has done very much to ease the spread or advancement of this disease.

One of the first steps in making the private grief public is the ritual of memorials. I have loved the way memorials take the absence of a human being and make them somehow physical with the use of sound. I have attended a number of memorials in the last five years, and at the last one I attended I found myself suddenly experiencing something akin to rage. I realized halfway through the evening that

I had witnessed a good number of the same people participating in other previous memorials. What made me angry was realizing that the memorial had little reverberation outside the room it was held in. A TV commercial for Handiwipes unfortunately had a higher impact on the society at large. I got up and left because I didn't think I could control my urge to scream. There is a tendency for people affected by this epidemic to police each other or prescribe what the most important gestures for dealing with this experience of loss would be. I resent that, and at the same time worry that friends will slowly become professional pallbearers, waiting for each death of their lovers, friends, and neighbors and polishing their funeral speeches; perfecting their rituals of death rather than a rela- tively simple ritual of life such as screaming in the streets. I feel this because of the urgency of the situation, because of seeing death coming in from the edges of abstraction where those with the luxury of time have cast it. I imagine what it would be like if friends had a demonstration each time a lover or friend or stranger died of AIDS. I imagine what it would be like if, each time a lover, friend or stranger died of this disease, their friends, lovers, or neighbors would take their dead body and drive with it a hundred miles to Washington, DC and blast through the gates of the White House and come to a screeching halt before the entrance and then dump their lifeless forms on the front steps. It would be comforting to see those friends, neighbors, lovers, and strangers mark time and place and history in such a public way.

But, bottom line, this is my own feeling of urgency and need; bottom line, emotionally, even a tiny charcoal scratching done as a gesture to mark a person's response to this epidemic means whole worlds to me if it is hung in public; bottom line, each and every gesture carries a reverberation that is meaningful in its diversity; bottom line, we have to find our own forms of gesture and communication—you can never depend on the mass media to reflect us or our needs or our states of mind; bottom line, with enough gestures we can deafen the satellites and lift the curtains surrounding the control room.

Chapter 1:

"Art is not lofty. It can be painful, ugly, and difficult."

Linda: What makes the strongest statement about who we are is what we funded.

Laura: With AMI, the mission was just there off the bat. It was about artists making art. I wanted the money to go to supporting artists.

Laurence: *Money to make work, especially for younger artists, was very, very difficult to come by. There was a whole underculture of artists that was falling through the cracks and where $1,500 was just a lot of money.*

Bruce: One criterion at AMI was art that has some ability to transform. Another was art with the ability to look at something from a different, original, or controversial perspective.

David: I don't think that we as an organization said, "We want controversial subject matter." But the artists who applied knew that if there was nudity, if there was something about menstruation or about lesbians, that all we would be looking at is if the work was good. In another context, they could worry that it wouldn't get money because the funder didn't want to fund the content. The subject matter didn't matter, but the work did have to be—in our collective minds—interesting work.

Kathy: The language of our guidelines was there to say, "If you do activist work, if you do politically loaded work, if you do culturally loaded work or sociopolitical commentary, you can apply." Risk-taking was understood on a variety of levels: content, media, style. For instance, at a time when painting, generally, was very large and high-priced, we found a painter who was doing very beautiful, small pieces that were about AIDS. I'm trying to remember his name. . . . He had a beautiful series of teeny little paintings. The paintings themselves were. . . . There were Pierrot-like characters, dressed as court jesters. Beautiful little paintings. But the subject matter was difficult and New York galleries that need to make heavy-duty rent were not going to be interested in showing teeny little paintings. But the work was absolutely wonderful and we gave him some money. I think AMI was established with that mission.

Philip: *That was Patrick Webb.*

Laurence: All of us had an abiding concern for the welfare of artists, but the importance that artists had for each of us was different. It depended on our contexts, our own lives and the lives of our communities. There were no discussions in the beginning about sexual or political issues, or freedom of speech. Those concerns evolved as a result of the need, when it became clear that our resources could do the most good by supporting work dealing with issues that made it unfundable.

Laurence: John Kelly made $9,500 dollars the year we gave him his first grant—including our grant.

Cee: *Performance art still isn't supported by the market. And John still can't pay his rent.*

Bruce: *You're not going to support yourself selling videotapes either.*

Laurence: *The foundation community and major public funding entities in this country have essentially told artists that they have to prove themselves in the marketplace. It's publish or perish: if you publish you can be part of this community, with no thoughts of what the publishing is about.*

Laurence: One of the few clear, conscious decisions that we made was to funnel money to artists before they had been scarred by the marketplace. We wanted to give them an opportunity to have an edge before they had to pay the price demanded of so many successful artists whose work is almost entirely determined by the market.

Bruce: *The marketplace does not invite criticism.*

Mary: We wanted to fund artists that weren't getting support from other sources and who produced art that wasn't easily bought. That ranged from AIDS and gay-related art to installation art that was too unwieldy for homes and galleries, to artists who simply weren't big names.

Philip: We were interested in work that galleries didn't validate and couldn't sell and that artists couldn't support themselves with, which is true of video, performance, and conceptual work.

Linda: *Performance in the 1980s and early '90s was coming from outside theatrical traditions. The artists were in untried territory; they were making new forms and dealing with issues that weren't being dealt with in mainstream theater.*

Bruce: *With single-channel "video art" and installation art with a video component, a discourse was developing that involved a real critique of media—feminist and gender critique, political critique. That wasn't happening anywhere else.*

Lowery: *Electronic media and performance were controversial forms for more established funders.*

Marianne: As soon as the word got out, we also got a lot of applications from emerging artists doing critical and theoretical work, image/text and language-based work.

Linda: *What drove all of us crazy from the beginning were funders setting the tune and dividing up the world into different media.*

Philip: *Many forms and interests that had been marginalized were coming forward: multiculturalism and feminism, as well as new media like performance. At that point there was*

still incredible moral and ethical leadership that came from governmental bodies. There was tremendous commitment at the NEA and NYSCA to supporting marginalized artists, to being multicultural and open to new media. And they really put their money where their mouths were. The NEA was the first organization to create categories for new media. They cut ground and they did so by talking to people in the field. NYSCA was the first arts council in the country, and I joined the staff in 1965. We invented the peer-panel system as we now know it, for better or worse, in 1967.

Bruce: Public funding helped critical work to flourish. Gender and cultural politics and the politics of ethnicity were issues that people on peer panels were interested in discussing.

Linda: The process public funders worked with was a good process in that decisions made were based on certain criteria. Fairness came into play and was observed. We could articulate what we saw in terms of the quality of the project, not in terms of what we would like the world to look like. But most public agencies are set up basically to buy specific projects. Applicants have to make a case or not. There is almost no room for exploration which may not yield a product.

Philip: Almost everybody who got grants from governmental agencies had a reputation behind them. Grant-giving has basically been about recognizing accomplishment. Guggenheim also awarded according to distinction.

Bruce: That's not really about supporting artists. It's about symbols of art.

Philip: I think that there's a resistance to funding individuals to make art. It runs against the Protestant work ethic, like welfare: if you want money, earn a living.

Marianne: There are very few foundations that give directly to individuals.

Philip: It was made very difficult for foundations to get IRS approval to fund individuals directly, basically to prevent foundation trustees from giving money to relatives without it being taxed.

Philip: At first, we also allowed alternative spaces to apply and we tried to fund artist fees and honoraria. But by the late '80s, we saw that there was a need to concentrate our moneys on individual artists.

Philip: There was a period in the '80s when quite a lot of money was available for organizations, though individual artists were still getting fucked. Administrators were making decent salaries and got health insurance and could go to conferences. A lot of money was going for overhead. They had rich folks on their boards. Many organizations sustained themselves well beyond the life of their missions—there are some that could close with nobody caring, at this point.

Laura: Museums were always trying to get in the door by saying that they wanted us to fund a project. They really just wanted somebody else to pay for it.

Philip: Museums rarely give artists any money for showing their work. If you're having a show at the Museum of Modern Art, you and your dealer better be prepared to dig pretty deeply into your pockets because it's not going to be covered by the museum. They think that by showing you they're bestowing a huge honor—at the same time, of course, pretending that it has nothing to do with the market.

Laurence: *One of the great tragedies of museums in this country has been that so many still operate on the historical model of the Metropolitan Museum of Art. They still believe that the only good artist is a dead artist.*

Lowery: I work in a very conservative institution with very traditional values. Our exhibition program is for established, world-renowned artists. That's the nature of the beast. It's not going to change.

Cee: In 1984 I started a performance-art archive at the Museum of Modern Art and organized two evenings of performance there. When they were dismantling the big Picasso show I suggested that we rig some spotlights, put in a row of chairs, and have performances in the empty galleries. I was told categorically, "No, we need those rooms for the Picasso crates." The Picasso crates were more important than an art form that was really burgeoning! They were not ready to take that on.

Laurence: *A lot of institutions see artists as a liability, including organizations that were created specifically to support them.*

Lowery: *Many curators do feel that artists are idiots and have to be spoken for.*

Cee: *I do think that people fear the arts. Jesse Helms didn't crack down on the arts just because it was an easy target. He also understood the power of the arts and the power of individual artists.*

Mary: *People are becoming less tolerant, and that means that art is more and more important. Engaging something I don't understand can be frightening or sometimes fantastically beautiful, but what's important is trying to learn to look and ask, "What is this about?" It's not about liking it. It's about what you learn.*

Bruce: *There has to be a place where a discourse can develop about any subject, be it in painting or film or video or media: where you can discuss the merits or the social implications of work or give a voice to people of color. Individual artists add to the outlook of society and question values that people tend to just accept.*

Philip: We had a notion of art that changed people's lives: art that when you confronted it, you couldn't ignore, you couldn't simply pass by, art that attempted to make a difference, to communicate something important, that deserved a life. The underlying assumption is that art is somewhat like sleep and love. It's essential for human existence. You don't know exactly why you need it, but you can't be fully human without it. Modern life has tried to put art into a box, but it belongs in the intersections between people in real life.

Lowery: *Art is not lofty. It never was lofty. Art was meant to challenge and to bring people into connection with themselves. And that can be painful, ugly, and difficult.*

Adam: *We need to encourage voices that constantly challenge our perception of what is right and wrong, good and evil: our basic perceptions about civil society. We need to have people who constantly upset us with troubling questions. The questions that artists are asking about gender issues, sexual orientation, racism are defining how we go forward in our society.*

ACT UP
CHICAGO

ABORTION
ON DEMAND
& WITHOUT
APOLOGY

FIGHT

AIDS, Art,

chapter **2**

and Reaction

7

8

The PISS CHRIST Work of Art

The "work of art" is a very large, vivid photograph of Christ ha
crucifix submerged in urine. The work, by Andrea Serrano, was t
Christ". When asked, since he had worked with urine, what
expected next, Mr. Serrano said, "Semen."

Mr. Serrano was given a $15,000 grant by the sponsors of the e
The Rockefeller Foundation and The Equitable Foundation, f
Christ "work of art". To encourage acquisition of the works displ
exhibition, museums participating are given grants of $10,000. A
works) by one or more of the award recipients is purchased with t

The Piss Christ "work of art" was displayed at the Los Angel
Museum of Art May 26-July 17, the Carnegie-Mellon Univ
Gallery in Pittsburgh Sept. 11-October 9, and the Virginia Muse
Arts in Richmond Dec. 13-Jan. 29, 1989. As best AFA can dete
Piss Christ "work of art" is currently on display at the Stux Galle
York.

It was part of The Awards in the Visual Arts program fund
Rockefeller Foundation, The Equitable Foundation and the
Endowment for the Arts, a federal government agency in W
D.C., supported by tax dollars.

AFA was informed by The Equitable Foundation that they ar
of The Equitable Life Assurance Society of The United States. T
is Chrm. Richard H. Jenrette, The Equitable Life Assurance Sc
Seventh Avenue, New York, NY 10019, Phone 212-554-1234.

The address for the Rockefeller Foundation is Pres. Richard V
The Rockefeller Foundation, 1133 Avenue of the Americas, N
NY 10036, Phone 212-869-8500.

To discuss the use of tax dollars in funding this event, contact
Senator at U.S. Senate, Washington, DC 20510 and your U.S.
man at House of Representatives, Washington, DC 20515.

AFA has in our office a photo of the "work of art".

April 5, 1989

Albert Lee Smith, Jr.
Former Congressman, Alabama
4200 Stone River Circle
Birmingham, AL 35213

Dear Albert Lee:

We should have known it would come to this. In a recent art
exhibition displayed in several museums throughout the country, one
"work of art" was a very large, vivid photograph of a crucifix submerged
in urine. The work, by Andrea Serrano, was titled "Piss Christ". When
asked, since he had worked with urine, what could be expected next, Mr.
Serrano said, "Semen." And, of course, defecation will follow that.

The bias and bigotry against Christians, which has dominated
television and movies for the past decade or more, has now moved over to
the art museums.

We Christians must, in my opinion, accept part of the
responsibility that such has come to pass. For various and sundry
reasons, most of us have refused to publicly respond to the
anti-Christian bias and bigotry found in various parts of our society,
especially the media.

"The Last Temptation of Christ" presented Jesus as a tormented,
deranged, human-only sinner; Madonna represented Christ having sex with
a priest in her new video "Like A Prayer"; and now a crucifix submerged
in urine and titled "Piss Christ".

As a young child growing up, I would never, ever have dreamed that
I would live to see such demeaning disrespect and desecration of Christ
-in our country that is present today. Maybe, before the physical
persecution of Christians begins, we will gain the courage to stand
against such bigotry. I hope so.

Sincerely,

Donald E. Wildmon
Executive Director

DEW/wed

"I don't believe in participatory democracy in an art museum."[11]

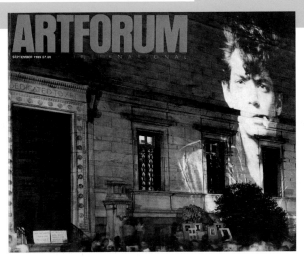

correspondence American Family Association; excerpts,

The Great Massacre of 1990 (Robert Hughes, Time, December 3, 1990)

SoHo Stares at Hard Times (James Servin, The New York Times, Sunday Magazine, January 20, 1991)

The Art Market: Back to Reality (Newsweek, January 13, 1992)

Off The Canvas. The Art of Julian Schnabel Survives the Wreckage of the Eighties. (Michael Stone, New York, May 18, 1992)

Schlock on the Block (James Gardner, National Review, June 8, 1992)

The Art World Bust. Hard times may be bad for artists, but not so bad for art. (Deborah Solomon, New York Times Magazine, February 28, 1993)

A Few Artless Minutes on '60 Minutes' (Michael Kimmelman, New York Times, October 17, 1993)

The Rube Tube "...On 60 Minutes, Safer set off after what he called the 'hype' around artists like Jeff Koons and Jean Michel Basquiat..." (Kay Larson, New York, November 8, 1993)

Art World Is Not Amused by Critique (Carol Vogel, New York Times, October 4, 1993)

Individualism and the Arts (Robert N. Bellah and Chris Adams, Christian Century, July 14-21, 1993)

Culture and Capitalism (Joseph Epstein, Commentary, November 1993)

ARS

FAMILY ALER

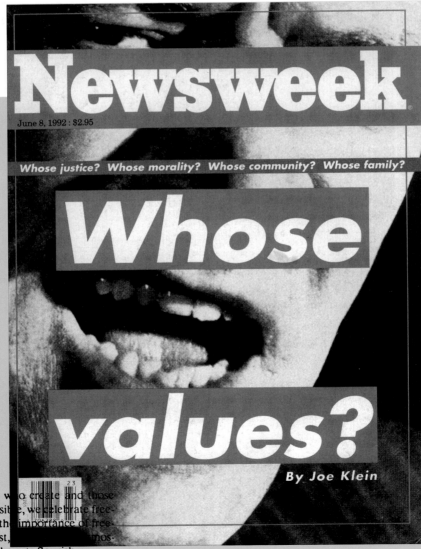

Newsweek

June 8, 1992 : $2.95

Whose justice? Whose morality? Whose community? Whose family?

Whose

values?

By Joe Klein

In recognizing those who create and those who make creation possible, we celebrate freedom. No one realizes the importance of freedom more than the artist, ... atmosphere of freedom can the arts flourish.

Few other words of former President Ronald Reagan ring so true.

I urge my colleagues to defeat these amendments.

Mr. Chairman, I yield to the gentleman from Texas.

What happened to that unquenchable demand?

STATE OF NEW YORK
SENATE SPECIAL COMMITTEE
ON THE ARTS AND CULTURAL AFFAIRS

SUITE 708, LEGISLATIVE OFFICE BUILDING, ALBANY, NEW YORK 12247 — (518) 455-2211

SENATOR ROY M. GOODMAN
CHAIRMAN
SENATOR TARKY LOMBARDI, JR.
VICE-CHAIRMAN

Dear Friend of the Arts:

"In America, artists are always on probation." [12]

The New York Ti

Copyright © 1989 The New York Times

NEW YORK, THURSDAY, JULY 27, 1989

Senate Votes to Bar U.S. Support Of 'Obscene or Indecent' Artwork

Measure, Backed by Helms, Angers Arts Groups

By MICHAEL ORESKES
Special to The New York Times

WASHINGTON, July 26 — Brushing aside objections that Congress should not be deciding what is art or who is an artist, the Senate voted today to bar the National Endowment for the Arts from supporting "obscene or indecent" work and to cut off Federal funds to two arts groups because they supported exhibitions of work by two provocative photographers.

In a voice vote, the Senate approved restrictions proposed by Senator Jesse Helms, Republican of North Carolina,

that would bar Federal arts funds from being used to "promote, disseminate or produce obscene or indecent materials, including but not limited to depictions of sadomasochism, homoeroticism, the exploitation of children, or individuals engaged in sex acts; or material which denigrates the objects or beliefs of the adherents of a particular religion or nonreligion."

The measure would also bar grants for artwork that "denigrates, debases or reviles a person, group or class of citizens on the basis of race, creed, sex, handicap,

Spokes[...]
cluding th[...]
tion — the[...]
Art at the[...]
and the S[...]
temporar[...]
— said th[...]
tion, which they described as the first time that Congress had tried to interfere directly in granting money to individual arts groups.

The officials said the endowment and the groups it supported had faithfully followed the grant-making system approved by Congress. In the system, known as peer review, members of the arts community pass on grant applications in their respective fields.

But Senator Helms said on the floor of the Senate, "No artist has a pre-emptive claim on the tax dollars of the

American people to put forward such trash."

Referring to one work, Mr. Helms said: "I don't even acknowledge the fellow who did it was an artist. I think he was a jerk."

"We're gradually approaching more and more the Congress telling the art world what is art," replied Senator Howard M. Metzenbaum, Democrat of Ohio, one of only two Senators to speak on the floor today against the measure. The other, Senator John H. Chaffee, Republican of Rhode Island, said, "We're getting into a slippery area here."

The Senate's measure was far more severe than one approved a few weeks

Agence France-Presse
Senator Jesse Helms, who proposed the arts funds restrictions.

"PEOPLE WHO SAY THE EIGHTIES WERE A DRAG DON'T KNOW WHAT THEY'RE TALKING ABOUT."

Julian Schnabel in *New York* magazine, May 18, 1992

PICASSO'S
AU LAPIN AGILE
$40.7 MILLION

ART MONEY

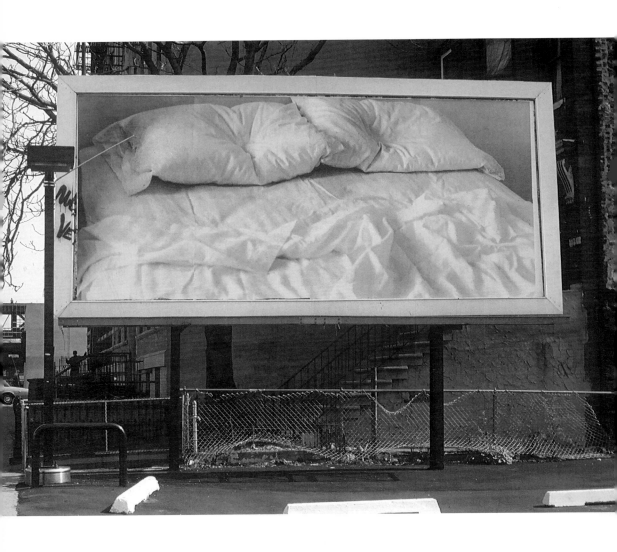

What Does Silence Equal Now?

DAVID DEITCHER

We live in a world of survivors—we hope—but also a world
of ghosts, who, like invisible housemates, invade our solitude
and complicate our lives.
— WALT ODETS

These are strange times to be writing about the relationship
between AIDS and American art. Almost a decade has passed since
galleries, museums, alternative spaces, and city streets teemed with
cultural projects that bore witness to the individual and collective
experience of the epidemic. From our quietest cultural perspective
at the end of the 1990s, the cultural activism of the late '80s and
early '90s seems decidedly remote. These days, according to critic
Peter Schjeldahl, "nice art rules," while "early '90s-style political
rancor has gone scarce."

Scarce indeed is the rancor—but also the acerbic style and wit—
of the AIDS activist graphics that once peppered public space to
incite anger about the government's neglect of AIDS. Gone as well
is the art that exploited the prestige and public reach of prominent
arts institutions to memorialize the dead, galvanize the living, and
counter the popular media construction of AIDS as the natural—
and inevitably fatal—consequence of behaviors that the majority
disdains to this day as sinful or antisocial.

To write about AIDS and its cultural consequences today is to
risk contributing further through historicization to the epidemic's
normalization, in which, as AIDS activist Douglas Crimp has pointed
out, AIDS assumes its place among the nation's chronic ills along
with poverty, homelessness, racism, crime, and drugs. Today we have
the luxury of distance, or so it seems. Our removal from the sense
of continuous crisis which marked the late 1980s and early '90s
reflects the transformation of the popular perception of AIDS from
a death sentence to a chronic but manageable disease, as it is said,
like diabetes. This shift in the popular perception of AIDS dates
from 1995 or 1996, when the first reports emerged regarding more
effective drug therapies combining protease inhibitors with other
antivirals and prophylaxes. Since then, articles trumpeting the end

Chapter opener:
Brian Weil, *ACT UP
Demonstration, Maryland*, 1990,
black-and-white gelatin silver
print. Photo courtesy of
the Center for Creative
Photography, Tucson, and
the Estate of Brian Weil.
Art Matters grant recipient,
1986, 1988, 1990.

Left:
Felix Gonzalez-Torres, *Untitled*,
1991, billboard, variable dimen-
sions, installation in twenty-four
locations throughout New York
City. Here, as installed for
Projects 34, The Museum of
Modern Art, New York. Photo
courtesy of Andrea Rosen
Gallery. Art Matters grant
recipient, 1988.

of AIDS have combined with statistical evidence of dramatically declining death rates to contribute to both a resurgence of high-risk behaviors and a precipitous decline in charitable donations to private research and AIDS service organizations.

To those whose lives have been unalterably changed by the epidemic, the public perception of HIV infection and AIDS as no-longer-a-death-sentence provides a welcome measure of relief from nearly two decades of relentless emotional trauma. Every day, it seems, one can find newspaper articles such as the following: "Chicago, February 2, 1999—'AIDS deaths plummeted by 48 percent last year, accelerating earlier gains attributed to improved drug therapies,' health officials said at a scientific meeting here today. They said the declines crossed sex and racial lines, suggesting that the new therapies were reaching all segments of the AIDS population." Yet, even if taken at face value, such good news can still feel like a betrayal of sorts as it exerts subtle pressure on survivors to leave behind cherished parts of themselves to live in the present more "normally"—though not necessarily more fully at the level of emotion.

Corresponding with these developments, the visibility of AIDS in the visual arts of the West has certainly diminished. Since the early '90s, many artists whose work was identified most closely with the epidemic succumbed to AIDS: David Wojnarowicz, Felix Gonzalez-Torres, Marlon Riggs, Derek Jarman, Stuart Marshal, Keith Haring, Tony Greene, Hugh Steers, Arnold Fern. Others, whose work had for years been informed by the omnipresence of the epidemic, its political causes, and human costs, have since moved on to other things, or so it seems.

The diminished prominence of AIDS in the visual arts assumes disturbing significance when considered in the context of infection rates that, while holding steady among the largely white and middle-class constituency of the art world, have continued to rise among communities of color. Along with the popular perception of AIDS as no-longer-a-crisis, the epidemic's lower cultural profile in the West also seems, at best, premature in the context of the estimated thirty million people now living with HIV worldwide, more than 90 percent of whom live in the developing world.[1] And if this were not reason enough to regard the relative invisibility of AIDS in contemporary Western art with profound skepticism, reports from the 1998 World AIDS Conference in Geneva have cautioned that the protease inhibitors are far from universally effective—even among the men and women who can afford to pay for them; that the effectiveness of these treatments frequently diminishes over time; that their prolonged use can generate bizarre and sometimes

dangerous side effects; that getting off the "cocktails"—or failing to adhere strictly to the terms of such regimens—can lead to the development of highly resistant strains of HIV.

I find it hard to determine the extent to which any or all of these conflicting circumstances have contributed to the problems I've had in writing this essay. I initially responded positively to the invitation from Art Matters to contribute a text about the role of AIDS in shaping American visual culture between 1985 (when sensationalistic media coverage of Rock Hudson's diagnosis and death endowed the epidemic with spectacular visibility) through the more hopeful, and confusing, circumstances of the recent past. From the late 1980s, I had written often about AIDS and its cultural consequences. This, after trying with little success to find my way as a writer for the better part of a decade. In retrospect, I understand that what then felt like a personal breakthrough was also part of a broader social transformation in which an unprecedented number of gay men and lesbians became both politicized and vocal as a result of the AIDS crisis and the homophobic backlash with which it was inextricably linked.

Yet, now I find it nearly intolerable to be writing on the subject. I feel weighted down by a sense of inertia, by the conviction that I have already said everything I have to say on the subject. In fact, I'd already felt this discomfort while preparing a catalogue essay about the response of contemporary artists to the pandemic for an exhibition titled *AIDS Worlds: Between Resignation and Hope*, which opened in Geneva during the summer of 1998. In that case, I found it hard to see exactly how contemporary artists have, in fact, been responding in their recent work to AIDS. Furthermore, I suspected that this perception of disinterest by others was bolstered by my own displeasure in having to deal with the subject again.

How is it, then, that AIDS, which arguably made it possible for me to write in the first place, has now become among the last things I want to be thinking and writing about? What has happened in the intervening years to induce this change? Just as my earlier ability to overcome writer's block to respond to the AIDS crisis was not just an individual matter, perhaps my desire now to not write about AIDS and to walk away from it is also not just about me.

Like many other gay men, I was slow to learn about AIDS when it first appeared at the beginning of the 1980s. What little I knew about the mysterious conditions that were then already afflicting gay men I had gleaned from the gay press and from conversations with friends. Together, this generated little more than a vague sense of foreboding—vague, no doubt, because of a desire not to

acknowledge the significance of what I had been reading and hearing about. It seemed unthinkable then that only gay men would be getting sick and dying, as if in answer to the prayers of Jerry Fallwell and his flock, providing them with the ultimate weapon in waging their propaganda war against queers. Similarly, it seemed unthinkable that there could be biological justification for the self-loathing that vexes gay men and lesbians in heterosexist societies. On the other hand, how surprised could I have been to learn that gay men were coming down with an array of increasingly exotic and grave illnesses? Hadn't I had my own run-ins with hepatitis B, amoebas, gonorrhea? Hadn't I found it necessary to make more than one visit to the shabby health clinic overlooking New York's Sheridan Square to be tested and treated for conditions that I regarded as little more than chemically reversible inconveniences?

I think it was in 1981 (could it have been even earlier?) that I learned for the first time of a friend who was suffering from what was not yet called AIDS. I'd bumped into John near his office on Manhattan's Upper East Side. I'd had great sex with him on a few occasions, though at that point not for some time. We had met at an East Side bar, and sex had been the basis for our friendship. So, even on that crisp autumn day, I proposed that we soon get together. And we did "get together"—for dinner at a restaurant on the Upper West Side, after which John took me home to see his new apartment.

I remember how strange it seemed that John rebuffed my come-ons that night as we sat together on his couch looking through snapshots of his recent trip down the Colorado River. I only came to understand his rejection about a month later when I bumped into him near his office again. On that occasion, John, who had always been an avid bodybuilder, looked uncharacteristically gaunt. When I asked him about his health, he told me he'd recently been diagnosed with the "gay cancer." Even then, I failed to recognize, or accept, the gravity of what he was saying. But this denial ended a few months later. One day, in my mail, I received an envelope with a return address I did not recognize. Enclosed was a sober engraved card informing me of John's death, somewhere in the Midwest. He had gone back to die with the family he had left so many years earlier in order to live as a gay man.

In the introduction to the 1989 exhibition catalogue *AIDS: The Artists' Response*, critic Jan Zita Grover observed that the epidemic "erupted into North American consciousness at roughly the same time that a generation of academically trained artists were confronting willy-nilly the exhaustion of modernist art practices."[2] As an educator at CalArts, the nation's leading "post-studio" art school, Grover had

herself helped the first generation of artists to be professionally trained as postmodernists to learn to "read" mass culture critically. She had helped to institute a model program of AIDS-related studies and projects at CalArts, and, as an activist writing at the peak of the mass mobilization in response to the AIDS crisis, she was in a position to discern the complex effects that the crisis was having on such young artists. From her perspective, the emerging health crisis challenged such artists to apply the critical skills they had learned in school to a situation that put the critical potential of those tools to the test.

In her essay, Grover belittled the taste for "pastiche and parody," as well as the devotion to the "simulacra of mass production"— preeminent characteristics of postmodernist art during the mid-'80s. Within the life-or-death context of the misrepresentation of AIDS and of people with AIDS in the media, she also dismissed postmodernism's "wan critiques of mass culture." In Grover's view, the AIDS crisis made it possible for artists to grasp the strengths and limitations of postmodernist critical theory as it had hitherto been applied within the parochial confines of the art world. But it also created a situation in which cultural practices that young artists had been trained to disregard as obsolete might prove useful once again.

Grover divided the artists' responses into two phases or "generations," each of which corresponded with a different grasp of the epidemic. The first generation bore witness to loss in memorializing works that were fundamentally declarative and descriptive: "Here was a life, this life is missed; here are its mourners."[3] Accordingly, such works were dominated by the traditional genre of portraiture, be it in painting, photography, video, or, for that matter, in the individual panels of the Names Project AIDS Memorial Quilt. Omitted from this account of the first generation of artists' responses to AIDS were works of art dating from the mid-'80s that attempted to give poetic form to the anxieties and fears that beset gay men who were then only beginning to grasp the enormity of the epidemic's impact on their lives. Thus, while some of Ross Bleckner's dark paintings from the mid-'80s featured memorial devices such as funerary urns, others described a blackness relieved (if that is the word) by sulfurous points of light that to some observers were less suggestive of memorial candles than erupting skin lesions.

According to Grover's periodization, the second-generation artists' responses emerged only after the political nature of the AIDS crisis became apparent. Corresponding with the mass mobilization of AIDS activism, the second-generation responses consisted of the "activist, largely collectivist work" that moved beyond expressions of loss to "make the social connections, touch the anger and harness

Ross Bleckner, *Poverty Bouquet*, 1986, oil on linen, 48 x 40 in. Photo courtesy of Mary Boone Gallery.

it to social purposes."[4] Here, too, Grover maintained that cultural practices dismissed as moribund within the context of the art world proved useful within that of the artists' response to AIDS. For example, she observed of video and filmmakers that, rather than adhering to the abstract or self-reflexive concerns that dominated vanguard practice since the late '60s, they exploited the narrative and documentary properties of their time-based mediums to bear witness to people living with AIDS and to provide the potentially life-saving educational information that the government and the media failed to supply—or, one might say, actively opposed.

From this aspect of Grover's account, one might well conclude that, confronted by AIDS, any cultural resource that helps people to deal with the crisis was deemed critically viable. But to draw such a conclusion would be to misrepresent the cultural situation of the late 1980s. Clearly the emergence of AIDS activism established a context in which cultural practitioners found themselves deploying creative means that were once regarded as off-limits; for example, to construct a counternarrative of AIDS, or to communicate urgent public messages regarding the activist response to the epidemic and

its neglect by the American government. But AIDS activism also revived and even intensified proscriptive aspects of earlier debates about the nature of postmodernist culture that had flourished at the dawn of the Reagan era.

Notwithstanding the fact that during the early 1980s the influence of the American left had effectively retreated to cultural and academic spheres, the articulation of "critical postmodernism" and the related American adaptation of continental critical theory inspired a sense of exhilaration and hopefulness among its supporters. Discussions of postmodernist art tended to move beyond the self-referential concerns of modernist cultural practice to shed light on the ways power is exercised through language and representation—in their capacity, for example, to shape identity and experience. In this context, it was possible to grasp at once both the erosion of modernism's exclusionary conception of culture and the potential for an expansion of cultural participation. And yet, given the political and social climate of conservatism triumphant and of liberalism under siege, it is not surprising that these debates about postmodernism included attacks—even from the left—on the ideological complicity of art that offered little resistance to commodification, or on works that appeared to shore up the modernist myth of the artist as autonomous creator. Thus, for example, amid the superabundance of painting practices during the early '80s—not all of them neoexpressionist— some critics were inclined to issue sweeping proclamations of the "end of painting."

Within the context of the AIDS crisis of the late 1980s, what had always been at stake in the cultural conflict with Reaganism assumed a new sense of urgency. Among artists, curators, and critics, the need to respond to this crisis in their midst helped to deepen their appreciation for the political consequences of cultural practices, and prompted a greater readiness to embrace the kind of collectively produced, activist work that Grover then identified with the second-generation artists' responses to AIDS. But, at the same time that the limits of cultural possibility were being expanded in this way, the struggle against AIDS, against government neglect, against public apathy, and against personal devastation served to justify intolerance for those art practices that could not be seen to contribute directly to that effort. Nor was this intolerance limited to cultural practice. Should gay people not act up to the standards of clarity, militancy, and bravery that were established by AIDS activists in New York, they might well feel a sense of personal failure, if not of outright shame. For gay artists and writers it was difficult not to feel as if continued engagement in independent artistic practices amid the

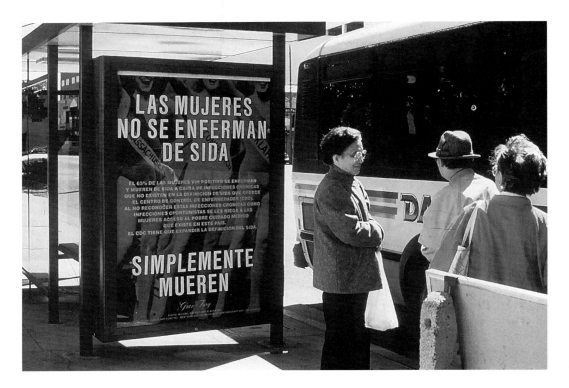

Gran Fury, *Women Don't Get AIDS (Spanish)*, (translation: *"Women Don't Get AIDS, They Just Die From It"*), bus stop sign, Los Angeles, CA. Photo courtesy of Tom Kalin. Art Matters grant recipients 1988, 1989, 1990, 1991.

devastation of plague was comparable to Nero fiddling while Rome burned. If it were not possible to transform one's art into a discernibly angry, articulate, and public response to AIDS, there seemed then to be little choice but to divide one's time between the demands of that art and those of bona fide activism or volunteerism or both.

In the catalogue accompanying *AIDS: The Artists' Response*, the artist/activist collective Gran Fury designed a centerfold that provides a vivid reminder of the tensions the epidemic provoked. The boldface text reads simply:

> WITH 47,524 DEAD, ART IS NOT ENOUGH. OUR CULTURE GIVES ARTISTS PERMISSION TO NAME OPPRESSION, A PERMISSION DENIED THOSE OPPRESSED./ OUTSIDE THE PAGES OF THIS CATALOGUE, PERMISSION IS BEING SEIZED BY MANY COMMUNITIES TO SAVE THEIR OWN LIVES./ WE URGE YOU TO TAKE COLLECTIVE DIRECT ACTION TO END THE AIDS CRISIS.

To some observers, Gran Fury's intervention amounted to little more than a highly inflammatory non sequitur. One of these critics, artist Felix Gonzalez-Torres, summed up this attitude when, on more than one occasion, he quipped, "Who ever said art *was* enough?" Revisited almost a decade later, the most striking feature of Gran Fury's centerfold is neither the boldness of its graphic design nor the acuteness of its analysis of art as a specially sanctioned zone of social "permission." Rather, it is their assertion of art's inadequacy

when confronted by a social crisis. In the context of the exhibition catalogue (or in its original context on a poster announcing a performance art festival at the Kitchen in New York), Gran Fury's assertion ("art is not enough") challenges the liberal notion of empathy as an adequate response to social injustice. Yet, with the benefit of hindsight, Gran Fury's design has the paradoxical effect of both eroding *and* reinforcing the boundary between art and social life, or between art and political activism. This is a key distinction that many cultural practitioners have been trying to dismantle since the 1970s (or considerably earlier, if one considers the historical avant-garde), either by fashioning unabashedly "political" works of art or by acting in ways that undermine the idealist view which holds that art and arts institutions are aloof from social and political life.

Only one month after *AIDS: The Artists' Response* closed in April 1989, the viability of this idealist view of art and arts institutions was put to a severe test. After rejecting a $10,000 grant to New York's Artists Space for another AIDS exhibition—*Witnesses: Against Our Vanishing*, curated by photographer Nan Goldin—National Endowment for the Arts chairman John Frohnmayer first claimed that the cancellation was necessary to ward off further attacks on the NEA from anti-Endowment zealots in Congress, such as Senator Jesse Helms. This was at least honest, inasmuch as the catalogue accompanying *Witnesses* contained a characteristically blistering attack by David Wojnarowicz on New York's immensely powerful and homophobic Cardinal John O'Connor, a man who made it his mission to oppose teaching HIV prevention or distributing condoms in New York's public school system. But Frohnmayer's explanation outraged AIDS activists, artists, and their supporters, who fully understood that it signalled his cowardice in opposing the right-wing attack on federal arts funding and on gay men and lesbians.

Confronted with expressions of anger by artists, writers, arts administrators, and other supporters of First Amendment rights, who mobilized to form such organizations as Art + (Art Positive), Frohnmayer then took another tack. "I believe," he explained, "that political discourse ought to be in the political arena and not in a show sponsored by the Endowment."[5] This language reiterated almost verbatim the idealist response of Thomas Messer, who, eighteen years earlier, as director of the Solomon R. Guggenheim Museum, had employed the same logic to justify his decision to suppress a scheduled Hans Haacke exhibition. From Messer's perspective, it was better to cancel the exhibition than to display works by Haacke that documented the shady business practices of a group of Manhattan slumlords. As Messer said, "Art may have social and political consequences, but these, we believe, are furthered by

indirection and by the generalized, exemplary force that works of art may exert upon the environment."[6] When Frohnmayer retreated from this position and reinstated the grant to Artists Space (with the proviso that the funds not be used to help pay for the offending exhibition catalogue), it was only a matter of time before the Bush administration forced him to resign.

Taken at face value, Gran Fury's "Art Is Not Enough" design can function either as art or as activism, but not as both. Notwithstanding the work's implicitly harsh judgment of its own artistic or political worth, even before the collective's formation in 1987, propagandistic projects like theirs were enthusiastically being claimed for "art" by vanguard critics and at least one museum curator. In July 1987, only four months after the formation of New York's AIDS Coalition to Unleash Power (ACT UP), William Olander, then curator at the New Museum of Contemporary Art, met with a group of ACT UP members—some self-identified artists, others not—in order to discuss how they might use the museum's window on lower Broadway to create an activist intervention.

In the flyer accompanying that intervention, a multimedium window installation titled *Let the Record Show...*, Olander was careful to claim *both* the political and the artistic status of that project as well as the "Silence=Death" posters that had begun appearing throughout lower Manhattan during the winter and spring of 1987. "There was no question," Olander observed, that the anonymous poster was designed "to provoke and heighten awareness of the AIDS crisis." Indeed, he claimed that the poster had first alerted him to the existence of AIDS activism. But, he added, "To me it was more than that: it was among the most significant works of art that had yet been done which was inspired and produced within the arms of the crisis." Olander went on to describe *Let the Record Show...* in similar terms, insisting once again upon the unity of its propagandistic function and of its status as art. "Throughout history," he observed, "all periods of intense crisis have inspired works of art whose functions were often extra-artistic. Let's cite just [one] of the more obvious modern examples: Jacques-Louis David's *La Mort de Marat*, painted in 1793."[7]

Certainly, then, Gran Fury's design for the centerfold of Grover's exhibition catalogue did not mark the first time that cultural practitioners have used their art for extra-artistic ends, or even to declare art inadequate as a response to a social crisis. Near the beginning of the Depression-era classic *Let Us Now Praise Famous Men*, author James Agee addresses his own writing, and declares, "Above all else: in God's name don't think of it as Art."[8] Agee had, after all, initiated the project with famed photographer Walker Evans, whose distinctive

What Does Silence Equal Now? DAVID DEITCHER

photographs appeared in an uncaptioned
section preceding the text. But Agee evi-
dently believed that any attempt to consider
their project "Art" would limit the book's
potential social or political effectiveness by
bracketing it off from the specific condi-
tions of rural poverty that Agee and Evans
sought to bring to the attention of the
American public. It would, in effect, neu-
tralize the materiality of their encounter
with three sharecropper families of Alabama
by subjecting their report to the abstract,
generalizing, and distancing effects of the
aesthetic gaze.

Gran Fury's design suggests an even
more insistent disavowal of its own status as
art, going beyond urging artists and their
public to become involved in the struggle
against AIDS to suggest that the only kind
of response to the epidemic that could real-
ly matter at that time was "collective direct
action to end the AIDS crisis." Given the
likelihood that Gran Fury's work would

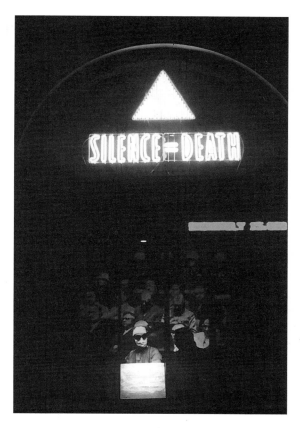

ACT UP, *Let the Record Show*,
1987, mixed-media installation,
window of the New Museum,
New York City. Photo courtesy
of Tom Kalin.

continue to inspire members of the contemporary art world in
which idealist aesthetics had already been challenged by the post-
modernist "social aesthetics" of the late 1970s and early '80s, it is
hardly surprising that, from its inception, Gran Fury was beset by
more than a hint of apprehension regarding the possibility of their
own project being taken for "Art." In fact, it has been reported that
these concerns were voiced at the meeting in which members of
the ACT UP subcommittee responsible for creating *Let the Record
Show...* resolved to continue working together under the rubric
Gran Fury. "We have to get out of SoHo," one member insisted,
"get out of the art world."9

Gran Fury did get out of SoHo; but even on those occasions
when its projects did manage to get out of the art world, their
public interventions rarely escaped the attention of critics, curators,
and art historians who had little difficulty embracing them as both
activism and art. Moreover, much of what Gran Fury produced
became economically feasible because prestigious contemporary arts
institutions helped to pay for them. It was not unusual for museums
to commission projects from the collective, given the eagerness of
such institutions to be (seen as) responsive to the epidemic. Thus,
Gran Fury's participation in the Whitney Museum's *Image World*

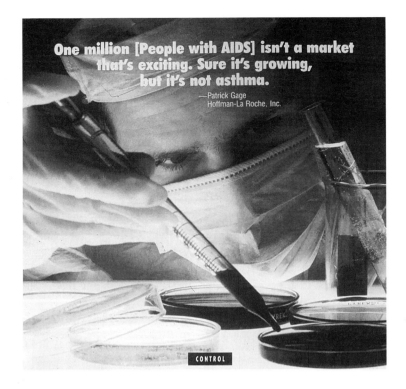

One million [People with AIDS] isn't a market that's exciting. Sure it's growing, but it's not asthma.

—Patrick Gage
Hoffman-La Roche, Inc.

CONTROL

Gran Fury, *New York Crimes* (detail), 1989, four-page newspaper, web offset, each page 22 3/4 x 15 in. Photo courtesy of Tom Kalin. Art Matters grant recipients 1988, 1989, 1990, 1991.

(1988–89), the New Museum's *The Decade Show* (1990), and the Venice Biennale (1990), to name only a few of the major art-world shows they joined, was in part a balm to the art world's growing sense of inadequacy in the face of the AIDS crisis.

Sometimes the sponsoring institutions got more than they bargained for, with the effect that Gran Fury's message did get well beyond the art world's confines. This occurred most spectacularly in the case of the 1990 Venice Biennale, to which Gran Fury sent *The Pope and the Penis*, a work consisting of two billboard designs, one challenging Catholic doctrine on AIDS education and featuring a photograph of the Pope John Paul II, the other urging condom use and featuring a photograph of an erect penis. Biennale director Giovanni Carandente vowed to resign if the work were exhibited, and Italian customs officials refused to release it from the airport in Venice. Gran Fury promptly held a press conference in their empty exhibition space, and this resulted, predictably, in nationwide headlines trumpeting "Scandalo alla Biennale." Within two days, the work was released from customs and installed at the Bienniale. Carendente never resigned. As has often happened in the course of the American culture wars, in this instance, the threat of censorship actually broadened the public discussion of issues that might otherwise have been contained.[10]

During the AIDS crisis of the late 1980s, arts institutions became accustomed, if not necessarily committed, to the political engagement

of social aesthetics. In fact, they became so comfortable with the idea that on September 5, 1988, ACT UP (NY) became the recipient of a "Bessie," the Village Voice's "Oscar" for distinction in the performing arts. Its actions were thereby lauded as street theater, which is to say, taken as a form of art.[11] From the vantage point of groups like Gran Fury, it was most assuredly worth the risk of having their projects be taken for art. That risk was more than compensated for by the valuable resources and unprecedented visibility that could be provided by contemporary arts institutions during the late 1980s.

Though the polemical debates and critical practices that marked the emergence of postmodernist art during the late 1970s and early '80s paved the way for the institutional support of the second-generation artists' responses to AIDS, the extent of that institutional embrace for cultural activism would have been unthinkable outside of the immediate context of the state of emergency that took hold during the AIDS crisis of the late 1980s. Yet, that same sense of emergency, which prompted artists and arts administrators to devise innovative forms of cultural activism, also had the polarizing effect of intensifying disregard for cultural practices that some activists considered irrelevant to the struggle against AIDS.

For example, *Against Nature* was an exhibition (and accompanying catalogue) devoted to art and writing by gay men. It opened at Los Angeles Contemporary Exhibitions (LACE) in January 1988 amid threats of a hostile demonstration by local AIDS activists. Writing seven years later about their controversial project, artist Richard Hawkins (a student at CalArts when Jan Zita Grover was teaching there) and writer Dennis Cooper recalled the pressure to conform to a standard of cultural activism that coalesced as the mass movement of AIDS activism emerged in 1987:

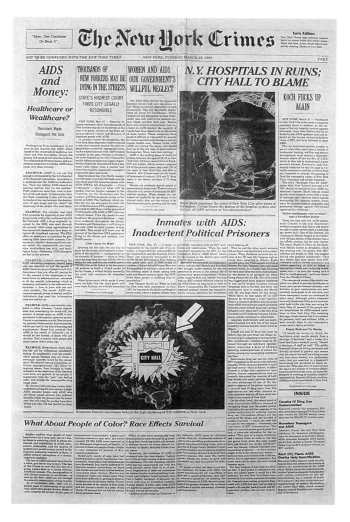

Gran Fury, *New York Crimes*, 1989, four-page newspaper, web offset, each page 22 3/4 x 15 in. Photo courtesy of Tom Kalin. Art Matters grant recipients 1988, 1989, 1990, 1991.

105

Ingrained in "Against Nature" was a reaction against contemporary art-hating activism, the kind heralded by such critics as Douglas Crimp and entrenched in a kind of "put down your paintbrushes; this is war" production. A practice we perceived as growing progressively more pervasive, more conservative, more essentialist, more predictably arid and photo-text-based, more dependent on the conveyance of supposed hard fact and indisputable truth, and more and more accusatory to the point that all work outside of such prescribed practices was condemned as phobic, unengaged and removed from social significance or import. [12]

As much as any other individual, Douglas Crimp (who was, significantly, one of the most forceful advocates throughout the early 1980s of "critical" postmodernism) helped to establish the theoretical rationale for the proscriptiveness that Hawkins and Cooper describe. That theoretical justification was evident in an impassioned introductory essay to a special 1987 issue of the journal *October* devoted to "AIDS: Cultural Analysis/Cultural Activism." In that essay, Crimp described the presiding cultural situation in which a number of apparently concerned and publicly prominent individuals described AIDS as a tragedy, though not a political scandal. Crimp quoted Elizabeth Taylor, gay journalist Richard Goldstein, and art historian Robert Rosenblum, all of whom had suggested in different ways that art could transcend the tragedy of AIDS, but could do nothing to end it. The only possible exception, according to Rosenblum, was through the sale of art works to provide financial support for scientific research and AIDS service organizations. Crimp responded to these statements in a manner that was notably consistent with his response to the continued (and, from his perspective, irrational) proliferation of conventional cultural practices throughout the early '80s: he condemned them as the inevitable effect of an "idealist" view of art, whose eradication he consistently advocated. "Art *does* have the power to save lives," Crimp insisted, "and it is this very power that must be recognized, fostered, and supported in every way possible." "But if we are to do this," he continued, in a restatement of the position he had occupied before the AIDS crisis, "we will have to abandon the idealist conception of art. We don't need a cultural renaissance; we need cultural practices actively participating in the struggle against AIDS and its cultural consequences." (In Grover's catalogue, this frequently cited passage appears as one of ten "statements" on AIDS, in bold type under hefty Roman numerals on a double-page spread, appearing like nothing so much as the Ten Commandments of AIDS.)

There was a critical precedent for this kind of either/or account, in which art that has "the power to save lives" must be supported "in every way possible," including, necessarily, the abandonment

of the "idealist conception of art." Crimp's formulation explicitly recalls Roland Barthes's influential proposition that "the birth of the reader must be at the cost of the death of the Author." Of course, Barthes's proposition—which is so redolent of the emancipatory ideals of the late 1960s—undergirded all aspects of American critical postmodernism in the late 1970s and early '80s. But its specific application within the context of contemporary art did more to cast aspersions on the imaginary coherences and sensual pleasures of art than it did to erode the mystique of artist/authors like Sherrie Levine, Richard Prince, Jenny Holzer, and Barbara Kruger, whose work it effectively described. Similarly, Crimp's statement, and the essay that contained it, inspired the work of cultural activists in their struggle against AIDS. But even as it empowered some, this critical position posed problems for others, who, notwithstanding the AIDS crisis (indeed, perhaps because of it), continued to seek whatever comfort could be gained in aesthetic experiences that might well be identified with the idealist conception of art. However, by the end of the 1980s, the responses of some artists to the epidemic made it possible to see how altogether inappropriate it was to feel obliged to choose between supporting art that has "the power to save lives" and art that by virtue of its imaginary coherence and symbolic pleasures merely helps people to get by.

Donald Moffett, *Safe Journey To Some Safe Place*, 1989, backlit cibatransparency, 25 ½ x 56 x 4 in. Photo courtesy of the artist. Art Matters grant recipient, 1990.

David Wojnarowicz, *Sex Series (house)*, 1988–89, silver print, 31 x 34 in. Photo courtesy of the Estate of David Wojnarowicz and P.P.O.W. Gallery, New York. Art Matters recipient 1989, 1990, 1991.

There was certainly a mutually supportive correlation of what Grover described as the second-generation artists' response to AIDS and the activist mobilization surrounding AIDS, but not all second-generation artists' responses were collectively produced or overtly political. nor were they always encountered outside or on the margins of the art world, or in what is widely understood to be "public" space. To cite only two of the most well-known examples, David Wojnarowicz and Felix Gonzalez-Torres created art for the "private" confines of the domestic interior, the art gallery, and the museum. Their work, however, demonstrated how problematic it could be to presume the existence of "privacy" from the vantage point of social subjects whose sexuality the Supreme Court had declared a public matter (in *Bowers* v. *Hardwick*, 1986). Their works often conveyed the political stakes in the AIDS crisis while also attending to the epidemic's psychic dimensions and emotional burdens. This is evident, for example, in Wojnarowicz's paintings "from sleep," and in his group of photomontages titled *The Sex Series (for Marion Scemama)* (1988–89).

In the latter works, the artist began with negatively printed images of powerful natural and man-made forces (such as a tornado,

a freight train, a storm-tossed ship at sea, a flooded forest, or parachutists diving from military aircraft) onto which he then superimposed circular, peepholelike views onto pornographic vignettes (gay and straight), or images of money, microbes, a child's skeleton, a street demonstration, the multiply pierced torso of St. Sebastian, etc. Overlaying this imagery, he placed one or more screens of text, including fragments from newspaper articles (reporting, for example, the intensification of antigay violence) or his own forceful and poetic writings about love, sex, and memory in the age of AIDS. The *Sex Series* remains one of the most unsettling and moving evocations of the anxieties produced by living through the most desperate years of the AIDS crisis.

Gonzalez-Torres also created works that highlighted the ideological instrumentality of the unevenly applied boundary between the "private" and "public" aspects of American social life. This is evident especially in his unprepossessing framed photostats in which a few rows of white-lettered names and dates set against a matte black ground describe the profound privacy of free association amid the saturation of psychic life with public concerns. Thus, a work from 1987 reads: "*Alabama 1964 Safer Sex 1985 Disco/Donuts 1979 Cardinal O'Connor 1987/Klaus Barbie 1944 Napalm 1972 C.O.D.*"

But the art world's response to AIDS was not limited to agitprop and, by turns, poetic and politically acute works of art. During the winter of 1988, four gay New Yorkers—curators Gary Garrels, William Olander, Thomas Sokolowski, and art writer Robert Atkins—met at Sokolowski's Greenwich Village apartment to discuss what might be done to enlist arts institutions like their own in the struggle against AIDS. According to Sokolowski, the four participants each agreed to invite five more like-minded cultural practitioners to attend a second meeting. That meeting, which took place at New York University's Grey Art Gallery (where Sokolowski was director), led to the formation of Visual AIDS, an organization whose initial purpose Sokolowski has characterized as "public relations." By that phrase, he means that the organization was created to help coordinate AIDS-related arts programming while taking full advantage of the membership's art-world and media connections to ensure that such events received as much press coverage as possible.[13]

Given the inherent resistance to political programming at New York's prestigious arts institutions, the members of Visual AIDS adopted a proactive position. They developed the concept for the "Day Without Art" (which was observed for the first time on World AIDS Day, December 1, 1989) as a way for museums to memorialize AIDS deaths by dimming lights, draping their spaces, or closing altogether; the mode of commemoration was left to the individual

Lyle Ashton Harris, *Embrace*,
1993, duraflex print, 48 x 40 in.
Photo courtesy of Jack Tilton
Gallery. Art Matters grant
recipient, 1990, 1992.

institutions. Inspired by the Vietnam-era moratoriums on museums organized by the Art Workers' Coalition and the Guerrilla Art Action Group, the Day Without Art was a political protest of a different sort. Unlike its historic predecessors, however, this action had a metaphoric dimension, inasmuch as the shuttered galleries and draped works of art suggested the disappearances that AIDS was effecting in and out of the art world.

True to the mandate of Visual AIDS, the first Day Without Art attracted a good deal of press attention, mostly uncritical pieces like the one I wrote for the *Village Voice* at the suggestion of its art editor, Jeff Weinstein. Rereading that article now, its relentlessly affirmative tone revives in me the embarrassment I felt soon after the article was published. Those feelings first surfaced when I sat in the audience at a panel discussion sponsored by the Dia Art Foundation listening to one panelist, Douglas Crimp, as he expressed puzzlement regarding the concept of the Day Without Art, and, in particular, the method that the Metropolitan Museum of Art had chosen to observe the event. Regarding the museum's decision to temporarily remove Picasso's *Portrait of Gertrude Stein* from display, Crimp wondered wryly if this gesture was supposed to symbolize lesbian invisibility. Clearly, within the context of the AIDS crisis, every institutional gesture, every public utterance, was subject to such scrutiny.

Despite Crimp's withering critique of the Day Without Art, the event did succeed according to one standard applied to it by members of Visual AIDS: it established an effectively replicable model that functioned nationally and internationally to bring a modicum of AIDS awareness where little might otherwise have existed. Even more successful in this sense, and ultimately far more controversial, was the Ribbon Project which was also inaugurated by members of Visual AIDS as a means of heightening AIDS awareness. First sported on the gowns and tuxedos of celebrities on the occasion of the nationally telecast Tony Awards in 1991, the red ribbon proliferated to such an extent that it became the most visible symbol of what cultural critic Daniel Harris denounced as "the kitschification of AIDS."

Early in the '90s, the collectively produced, publicly situated, graphic evidence of the AIDS activist struggle (Grover's second-generation artists' responses) began to disappear from public space.

This diminished cultural profile corresponded with the gradual erosion of the mass movement of AIDS activism. Among the most frequently cited causes for that shift are the many deaths among ACT UP members and the ensuing dissension, exhaustion, and frustration among survivors—characteristic signs of the "burnout" that would only intensify as the years passed without any prospect of an end to the crisis. Mary Patten, a Chicago-based cultural activist, recently identified another, less widely acknowledged and decidedly more paradoxical factor in the enervation of the mass movement of AIDS activism. Patten noticed a strategic faultline where one might least be expected: within ACT UP's much-vaunted success "in seizing the public space of spectacle in the media to articulate, and indeed reframe, the debate and crisis about AIDS." Patten argues that ACT UP's grasp of the power of representation contained within it "some of the very contradictions that contributed to the demoralization of the movement." "Despite our sophisticated manipulation of the broader culture's media through our direct actions, street theater, and counter-information," she wrote, "we neither fully anticipated the 'public's' eventual lack of interest in us and in the AIDS crisis, nor the ease with which our theater, our images, and our political subculture would get absorbed as 'queer style.'"[14]

To say that the visual manifestations of AIDS activist art became less visible during the early '90s is not to say that public space was stripped of all signs of cultural activism. Posters by activist collectives such as Fierce Pussy and Dyke Action Machine provided ample public evidence of the determination of lesbians to end their long-standing invisibility, and to protest the violence that inevitably accompanied their increased visibility. Similarly, posters and street actions by the Women's Action Coalition (WAC) and the Women's Health Action Mobilization (WHAM) offered evidence of women's

Womens' Action Coalition (WAC), New York City Gay Pride March, June 28, 1992, blueprint poster multiples designed by Bethany Johns. Photo courtesy of Teri Slotkin.

Arnold Fern, *It Is Beautiful There*, 1992, oil paint on canvas, 72 x 54 in. Courtesy of Feature Gallery.

determination to defend reproductive rights from conservative assault and to protest inadequate research of breast cancer and other conditions that adversely affect the health of women.

Neither did the diminished visibility of AIDS activist art mean that artists who were involved in the collective cultural response to AIDS simply retreated to apolitical cultural practices. Many artists who had participated in the collective cultural response to AIDS did, in fact, return to the studio. In producing individual works of art, though, they were now responding in part to another epidemic: antigay violence. Coinciding as it did with the continued perception of AIDS as the fault of sexually insatiable gay men, antigay violence constituted one aspect of the backlash against the heightened visibility of gay men and lesbians with nothing left to lose. Indeed, by the end of the 1980s, physical assaults on gay men and lesbians increased both in incidence and severity in urban and rural settings. Ultimately, the situation reached the point where urban-dwelling queers were compelled to organize to form civil defense groups like New York's Pink Panthers to protect themselves in their own neighborhoods.[15]

Seemingly random acts of antigay brutality were fueled by another form of violence: the discrete and programmatic form of homophobia embodied in the U.S. government's neglect of the epidemic and in the messages emanating from the Church, the State, and the media. How else is one to describe the Supreme Court's ruling in *Bowers* v. *Hardwick* but in terms of an assault— on the rights of gay men and lesbians to the most rudimentary form of privacy? How else is one to describe the 1987 Helms Amendment that prohibited federal support for the production and distribution of HIV-prevention education materials that "promote, encourage or condone homosexual sexual activities" but in terms of an assault—on the very lives of gay men? How else is one to describe Senator Helms's exploitation of the Gay Men's Health Crisis's (GMHC) publication *Safer Sex Comix* to promote the virtually unanimous adoption of his legislative prohibitions than as an assault—on gay representation?

Lesbian and gay artists also responded to the attempted suppression of queer representations with an outpouring of works in every medium that were more uncompromising in their confrontational (homo-)sexual content than anything ever before seen in contemporary art galleries, museums, performance spaces, as well as on the walls of city streets. Between 1989 and 1992, artists went well

beyond the discreetly coded references to same-sex affection in the (gay) art of Jasper Johns, Robert Indiana, Andy Warhol, and David Hockney to embody the ethos of the "queer nationalism" that erupted in 1990 among younger members of ACT UP.[16]

Attempting to characterize the cultural consequences of AIDS— to impose an order onto its disorderly unfolding, let alone to outline what is a complex and contradictory cultural process— is a hazardous business. This is not only because of the scope and complexity of such an undertaking, but also because the circumstances of an epidemic that claims so many individual lives demand that attention be paid to the concrete, individual experience. To assert that the "second-generation," or activist, responses to AIDS gradually disappeared in the early 1990s is to risk misleading the reader. While the claim is true as far as it goes, it must be qualified. It would be inaccurate to suggest, for example, that the gradual disappearance of the activist cultural responses to AIDS was symptomatic of a diminished cultural prominence of AIDS. For, in film and video, in literature and the performing arts, AIDS continued to dominate American culture well into the 1990s. To cite one particularly prominent example, Tony Kushner's play *Angels in America: Part One: Millenium Approaches*, which only opened on Broadway in April 1993.

In a recent interview, filmmaker and activist Gregg Bordowitz pointed out that in the play's final act, Kushner effects a significant transformation in the spectator's view of the person with AIDS (PWA). Bordowitz's remark stems from his own long-standing concern over the significant historical transformations in the culturally constructed image of the PWA. Since the epidemic's emergence, the PWA has moved from being a demonized, powerless victim to being a heroic activist street guerrilla; from being the angelic conscience of a nation to being, in the last act of *Angels in America*, simply one citizen addressing another.[17] Bordowitz's observations seem especially noteworthy in this context inasmuch as they suggest another model for periodizing the cultural consequences of AIDS, one that is neither more nor less arbitrary nor potentially insightful than the model Grover adopted in 1989.

AIDS activism did not disappear during the early 1990s. Rather, the methods of many of its practitioners merely changed. Increasingly, members of ACT UP found themselves working within or alongside mainstream AIDS service organizations and the medical research establishment that ACT UP had hounded for years. For example, during the winter of 1991-92, members of the Treatment Data Group, an ACT UP subcommittee that had tracked the progress

(and lack of progress) of new treatment options for people with HIV/AIDS, formed a new entity called the Treatment Action Group (TAG). Although TAG members retained ties to ACT UP, the new collective identity enabled them to participate independently within advisory and oversight groups, some of which (like the Office of AIDS Research) were directly tied to the research establishment.[18]

In 1995, Gran Fury, its membership depleted since 1992, criticized such developments in a document that marked the artist/activist collective's own official dissolution. Reflecting on the altered circumstances of the mid-'90s relative to the peak of AIDS activism a half-decade earlier, the statement charged that "by including activists in the inner circles of the research establishment, the system which activists set out to change neutralized their dissent." What Gran Fury failed to mention was the extent to which such activists had already helped to change "the system."[19] The same might be said about the gradual disappearance of AIDS activist graphics from public spaces. That, too, reflected the success of such practices in fulfilling the related goals of helping to maintain the energy and focus of the mass movement of AIDS activism and to advance the terms of the counternarrative opposing the media constructions of AIDS and people with AIDS.

Also contributing to the erosion of the mass movement of AIDS activism by 1993 was the election of a President who had campaigned on a platform that included gay-friendly pledges. After a dozen years of openly hostile and unapologetically homophobic Republican rule, it was a relief to have a Democrat in the White House, who at least hoped to end the military's ban on lesbians and gay men, and to respond more generously to AIDS research. The fact that President Clinton made such a mess of these pledges, that he was ultimately no more willing to take political risks than he was of acting on political principle, did little to counter the pacifying effect of his benign, empathetic presence.

Outside of the political preconditions for the waning of the second-generation artists' responses to AIDS was the growing realization among artist/activists that their commitment to political struggle and collective process had come at a cost: the neglect of other cultural practices that—unlike agitprop—were better suited to contending with the sadness and uncertainty that deepened as the epidemic descended into its darkest and most hopeless period.

Partly overlapping with the inundation of erotomania during the early '90s was a class of art that makes it possible to extend Grover's periodization to encompass a third generation of artists' responses to AIDS. In the more measured work typical of this "generation," reflection and metaphor predominate. While the first-generation

responses had attempted to give poetic shape to the grief, isolation, terror, and confusion of the epidemic's earliest years, the second-generation responses had embodied the hope implicit in the mass mobilization of AIDS activism. But the third-generation responses corresponded with the mounting sense of exhaustion and hopelessness regarding the epidemic which culminated in 1993 with the 10th International Conference on AIDS. In the unremittingly bleak reports from Berlin, scientists testified to the ineffectuality of existing drug treatments and to a pandemic with no end in sight.

But, again, it seems important to hold back on this attempt to impose an orderly schema by noting that all three "generations" of artists' responses to AIDS coexist and to some extent even survive to this day. The Archive Project, formed in 1994, continues to provide ample evidence of the depth and qualitative range of the art that has been, and is still being, produced in the shadow of the epidemic. Conceived by artist Frank Moore, and administered under the auspices of Visual AIDS, the Archive Project documents—and in that sense preserves—the works of any artist living with HIV/AIDS, who, for whatever reason, wants help in documenting his or her work.

Further proof of the limited utility of the periodizing system is evident in the case of Moore's own art. His paintings only achieved prominence during the mid-1990s, despite their use of traditional figuration and genres (characteristic of the first-generation artist's responses to AIDS) to articulate the political as well as the personal dimensions of the epidemic (as was characteristic of a second-generation responses). Yet, by the time Moore's alternately angry and at times whimsical magic realism received the kind of attention it deserved, it had in some ways become the exception to the rule of art that was alluding to the epidemic in more abstract, allusive, and poetic ways.

In very different ways, artists such as Jim Hodges, Tony Feher, Michael Jenkins, John Lindell, Felix Gonzalez-Torres, Siobian Liddel, and Zoe Leonard have each employed ephemeral materials and processes to convey and, in some cases, to enact symbolically, transitoriness, vulnerability, privation, loss, and need. In Gonzalez-Torres's accumulations of candies and stacks of offset posters from the late 1980s and early '90s, gradual disappearance (viewers are invited to remove the work's constituent parts) is countered by the artist's stipulation that such works (can) be replenished. Though often interpreted as a challenge to traditional methods of distributing works of art, or as proof of the artist's "generosity," another way to read this strategy is as a symbolic suggestion of immortality. Other works by Gonzalez-Torres, as well as some by Lindell, Jenkins, Donald Moffett, Arnold Fern, Robert Flack, and Brett Reichman,

Felix Gonzalez-Torres, *Untitled (Perfect Lovers)*, 1987–90, clocks, 14 x 28 x 2 3/4. Photo courtesy of Andrea Rosen Gallery. Art Matters grant recipient, 1988.

employ more traditional symbolisms to evoke ideas and emotions that pertain to mortality and loss in the context of queer sexual identity.

Thus, Gonzalez-Torres poetically revises Minimalist seriality in *Untitled (Perfect Lovers)*, 1989, in which a pair of battery-operated Seth Thomas clocks imply the sameness in same-sex love, and the end that awaits even perfect couples as the health of one or the other fails. And, while Reichman's paintings of Baroque mirrors and clocks suggest the fussy aestheticism of stereotypically gay male "sensibility," the fact that these objects are so often depicted as if caught in a pendulumlike, stop-action motion suggests the passage of time, which these paintings symbolically arrest. Such works give poetic form to the experience of loss, but the extent to which they are memorial in purpose (or in some other way are meant to assist in the process of grieving) means that they could just as easily be identified with the first-generation artists' response to AIDS. (Consider as well, for example, Gonzalez-Torres's jigsaw-puzzle photographs of fragments of love letters, Donald Moffett's *E. Eichelberger* (1990), Jim Hodges's handsewn cascades of flowers, Zoe Leonard's similarly sewn pieces of fruit, etc.)

Even in film and video—the preferred mediums among many cultural activists—one can detect a third-generation artists' response to AIDS. Many works stand in stark contrast to the assiduously upbeat messages of earlier AIDS-related works. Peter Friedman's harrowing documentary, *Silverlake Life: The View from Here* (1993), conveys an early '90s despair, as well as rage, in its selections from Tom Joslin's video diary documenting his own decline. Finally, Joslin can no longer continue the video record, and it is picked up by Friedman, who unblinkingly continues right through the moment of Joslin's death. Somewhat similarly, Marlon Riggs's final work, *Black Is. . . Black Ain't* (1995), combines documentary

Gregg Bordowitz, *Fast Trip, Long Drop*, 1993. Film stills courtesy of the artist. Art Matters grant recipient, 1990, 1995, 1997.

footage—including the first-person testimony of a notably enfeebled Riggs in his hospital bed—with archival footage and allegorical sequences to address the painful tension between gay and black identities, which Riggs had explored in his ground-breaking film *Tongues Untied* (1989). Other films that embodied the pessimism of the early '90s include Derek Jarman's final film, the imageless *Blue* (1993), and Gregg Bordowitz's otherwise very different work, *Fast Trip, Long Drop* (1993). In addition to reflecting on his fate as a person with AIDS, Bordowitz departs in *Fast Trip* from his earlier AIDS-activist videos with dramatic sequences in which his alter-ego, Altes Allesman, mocks the upbeat view of people "surviving and thriving" with AIDS—a view that he and other media activists had done so much for years to promote as an indispensable element in the construction of an empowering AIDS counternarrative.

Outside of film and video, the extreme discretion of the third-generation artists' responses to AIDS suggests the extent to which a still broader range of works might be understood in terms of the epidemic. Indeed, to those whose lives have been unalterably transformed by AIDS, the range of cultural experiences that can bring the epidemic to mind can seem as limitless as encounters with it are unpredictable. On the other hand, given the third-generation artist's tendency to work in abstraction and allegory, one might well comprehend much of this work in vague terms as, say, a function of millennial dread. This possibility highlights the way in which the third-generation artists' responses to AIDS has stripped such art of the kind of specificity that did so much to foreground the distinctly political dimensions of a death from AIDS, as distinct from the death of a Nicaraguan child in a mudslide, or the abstract notion of "death" as a natural and universal fact of life. The ability to read so many poetic and abstract works in relation to AIDS throughout the early 1990s was highly dependent upon such contingencies as the atmo-

sphere of pervasive gloom that shaped them and into which
they emerged.

It had been an article of faith among AIDS activists since the late
1980s that gay men radically transformed their sexual practices,
incorporating the use of condoms to greatly reduce the rate of
HIV-infection. Yet, during the early 1990s, the publication of a
number of studies in the United States suggested that safer sex
education had been less than a complete success. These studies
revealed that a substantial proportion of gay men had been engaging
in unsafe sex all along, that others were putting themselves at risk
of infection, and that the lives of gay men of color and younger
gay men were especially endangered. Coming shortly after the
news from Berlin, the first reports of the so-called "second wave"
of HIV-infection appeared in the American press.[20] After reviewing
the latest studies, members of the San Francisco-based Gay and
Lesbian Medical Association found the data sufficiently alarming
to convene a national summit to address the problem. In July 1994,
physicians, HIV-prevention educators, psychologists and activists
met in Dallas and concluded that gay men are "in crisis, a crisis
that is largely unacknowledged."[21]

One of the leading figures in breaking the silence about the
alarming rates of HIV-infection among gay men was Berkeley-
based clinical psychologist Walt Odets. At the Dallas conference
he declared that existing methods of HIV-prevention education—
essentially unchanged since the late 1980s—had become as much
a part of the problem as they had been of the solution. Odets
based his argument on his evaluation of the HIV-negative gay
male patients in his clinical practice. He isolated a number of psycho-
logical and social factors that contribute to the fact that such men
might knowingly put themselves at risk of infection. Among these
factors were feelings of guilt about surviving the deaths of lovers
and friends, envy of the support and respect that gay communities
accorded people with AIDS, desire to be punished for sexual desires
that gay men had been raised to despise, fear of losing one's sense
of connection to those who have died, and eagerness to be done
with waiting for a seroconversion that is perceived as inevitable.
Odets criticized HIV-prevention campaigns for ignoring the emo-
tionally devastating context in which HIV-negative gay men have
been told to practice safe sex for the rest of their lives. Such methods,
he found, implicitly devalue gay experience by failing to distinguish
between the degrees of risk in different kinds of gay sex.

Odets also had the courage to take issue with what he calls, after
William James, the "deification of survival." Survival, Odets told the

audience in Dallas, must mean something more than just staying alive; it must include the "capacity for love, intimacy, and a sexual expression of such feelings."[22] Near the end of his book, *In the Shadow of the Epidemic*, Odets examines the widespread tendency to condemn gay men who have seroconverted relatively recently, despite the fact that more than a decade into the epidemic they know full well how HIV is transmitted. In the book's penultimate chapter—devoted to exploring the meaning of survival and its alternatives—Odets recounts a tense conversation with a colleague and friend in which the two gingerly approach, and finally explore, their feelings about such belated seroconversions among their sophisticated and well-informed clientele. Is it true, as conventional belief would have it, that there is nothing worse that can occur to a patient (and to the patient's psychotherapist) than for the patient to become HIV-positive?

After some hesitation, which manifests the fear of departing from this de facto rule of psychotherapeutic ethics in the age of AIDS, Odets and his friend realize that they both share in the belief that it is worse for a patient to remain HIV-negative if such biological well-being comes at the cost of an emotional and sexual demise. For Odets, the tendency to judge such seroconversions as a failure of mental health provides vivid evidence of the homophobia in het-erosexist societies. Moreover, he writes that it reflects the sweeping negation of "the erotic life" that has been promulgated in the West since the sixteenth century by Judeo-Christian traditions. Such traditions, he writes, are "the instruments of society, not its antago-nists," concerned, as they are, with

> conformity, social contribution, and thus survival per se. As Jeffersonian democrats—and as Puritans—we envision erotic life as misinformed, selfish, or pathological. Despite the life-affirming meanings of eroticism, it brings to most of us who have in the name of society destroyed so much on Earth, nothing but a vision of beastliness and social annihilation.[23]

Outside of a study like Odets's, or a memoir such as Mark Doty's extraordinary *Heaven's Coast*, it would be difficult to imagine such a provocative account of the challenges that AIDS posed to gay men between 1992 and 1996. Odets's book transcends its function as a clinical study to bear witness to the plague—a goal that the author acknowledges by invoking the model of Holocaust survivor Primo Levi in an epilogue that addresses the idea and the practice of "bearing witness."

The political pressure to prize biological survival even at the cost of one's emotional well-being informed one aspect of the divisive debate that erupted within gay communities as gay men absorbed the news of the "second wave"—or perhaps merely adjusted to the

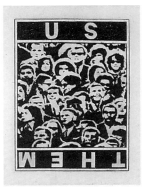
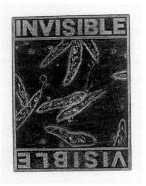
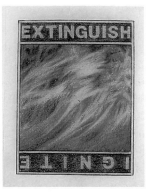

Brad Melamed, *Crowd*, *Euglena*, *Fire*, 1988, crayon on vellum, each 12 x 9 in. Photo courtesy of the artist. Art Matters grant recipient, 1990.

fact that the "first wave" of HIV-infection had never really crested after all. During the fall and winter of 1994–95, both gay journalist Michelangelo Signorile and queer theorist Michael Warner published articles (in *Out Magazine* and the *Village Voice*, respectively) in which they recounted their personal experiences of engaging in unprotected anal sex. Though both articles were prompted as much by Odets's work as by personal alarm about their own unsafe sexual experiences, they represented strikingly different perspectives on the cause and significance of having put themselves at risk of infection.

Writing from the perspective of someone who found it irresistible to fuck a "classic gay hunk" without a condom, Signorile responded to this situation by indicting the gay cultural obsession with sex and the oppressively defined gay male physical ideal. Such a culture undermines self-esteem, he argued, thereby creating the preconditions for the high rates of suicide, alcohol and drug abuse, and unsafe sex among gay men. Warner, on the other hand, engaged in an Odets-style examination of the social, cultural, and psychological factors that undermined his ability to sustain risk-reduction practices. Rather than chastising himself or gay culture for taking such risks, Warner insisted upon the importance of gay male sexual expression. In the different perspectives of these authors—one condemning the commercialized legacy of gay male sexual liberation; the other eager to defend sexual freedom and to understand how it might be that gay men might risk their lives for sexual contact—one can find the fundamental opposing positions of what became an acrimonious debate over how to reinvent HIV-prevention education for gay men, and how to define the terms by which gay community might be revitalized after the devastation of AIDS.

The principles at stake in this debate extend well beyond the confines of the gay communities in which it first surfaced. They apply wherever conservatives seek to reverse the emancipatory personal and political legacy of the 1960s and early '70s. Thus, on one side are those who claim that gay culture should be redefined

to promote long-term monogamous relationships and the development of a gay sexual ethic or "ecology."[24] On the other side are those (including the activists who came together during the spring of 1997 to form a new group, Sex Panic!) who decry this position as an acquiescence to (straight) social norms, and advocate a radical queer opposition to the limitations and inhibitions that are imposed by normative social and sexual roles.[25] Prominent on both sides of this debate, however, were some of the very same individuals who had been key participants within ACT UP. This suggests the persistence of the kind of internal political divisions that had always been present within the coalition and that finally had contributed to its collapse.

In the midst of this debate, news of effective drug therapies and the resulting reconstruction of AIDS in the media as a "chronic manageable disease" prompted more than a few claims that the AIDS crisis was over.[26] The emergence of the debate concerning the future of gay community and sexuality presumes, if not the end of AIDS, then at least the prospect of a future worth fighting over.

But how do artists respond in their work to dramatically declining death rates? And how might they respond to the fact that declining death rates do not mark the epidemic's end, not here in New York, not in North America nor in Western Europe, and certainly not elsewhere—as has been made abundantly clear with every update in the United Nations/World Health Organization reports on the pandemic?[27]

Perhaps the declining art-world visibility of AIDS is like a collective sigh of relief upon the renewal of hope—at least where "we" live. Perhaps it reflects the justifiable desire of artists, patrons, and the public to get on with life. Perhaps it merely provides evidence of a collective hunger for amnesia among those for whom the thought of AIDS has become intolerable. In the current climate, perhaps silence no longer equals death; but neither does it equal a state of well-being.

Caught between AIDS and the media's reports of its impending aftermath, we are living in an interregnum, one that is not without its own distinctive and confusing features. People don't talk very much about AIDS anymore. And when they do, as often as not it is in passing reference to a friend who is doing so well on protease inhibitors that he or she is about to get off disability and go back to work. For sixteen years, GMHC expanded as it assisted clients in preparing wills, getting on disability, fighting discrimination in housing and employment, dealing with treatment issues, with the emotional burdens of bereavement or the prospect of impending

death. Now, GMHC is restructuring and downsizing as it responds to a dramatic decline in charitable donations; prospective donors evidently consider the crisis over. Increasingly, the organization now focuses on HIV-prevention education, on helping clients to get off disability and adjust to the challenges of having a future to plan for.

It's been almost three years since I personally have had to visit a dying friend; two years since I last attended a memorial service. This, after more than a decade in which those harrowing visits and awkward rituals were a common aspect of contemporary gay life in New York. The same might be said of the daily survey of the *Times* obituary column. It's strange to see that the obits have reverted back to the (relatively) benign status of listing death notices for elderly people who have led long lives. This is undoubtedly good news, and yet somehow nothing feels quite right, not even work. Three years ago I wrote critically about the abundance of cultural circumstances that brought AIDS and loss to mind. It then seemed to me as if the market culture was profiting from the ubiquity of works of art, theater, dance, and performance that in one way or another seemed to address death and loss, thereby lending a certain gravity to art that otherwise appeared trivial. Today, it is the paucity of cultural circumstances that brings AIDS to mind that feels alienating. Perhaps this estrangement will never go away; perhaps it's not just a function of the dis-ease that seems characteristic of life in this American interregnum.

Like the people in Albert Camus's *The Plague*, I don't seem able to feel anything more positive than ambivalence in the face of hopeful developments. I don't trust in hope, and I'm in no mood to party; and not just because I objectively know that this would be premature. I seem unwilling to put the epidemic behind me. The thought of doing so creates a knot of anxiety, as if even the prospect of a "normalized" life threatens to sever the bonds I maintain to friends who have died; to the memory of their lives and their deaths; and to the anger I still harbor about the fact that all this has taken place as the majority of Americans went about raising families with a smug, middle-class sense of entitlement that Reagan and Bush and so many others have done so much to normalize.

These are familiar thoughts and feelings, some of which date back to the earliest years of the epidemic. Their persistence in the very different circumstances of the present imposes isolation. At a time when other people seem intent on proceeding with their lives, if not on repulsing any reminder of AIDS, its political significance, and its legacy of loss and separation, to whom can one speak about being unwilling to "let go" without being considered morbid? From this perspective, the perception of the contemporary artists'

response to AIDS as one of absence and quietism seems the cultural expression of an anxious silence that is imposed by the not-so-subtle pressure to move on and conduct business as usual. This, despite all that has happened; and despite the fact that somewhere—whether on the far side of the earth or on the other side of town—AIDS has not surrendered its grip.

Nearing the end of this essay, the fact that I don't now know of any satisfactory, tidy, resolved way to extricate myself from it seems related to my ongoing inability to gauge, let alone to understand, the impact of the past twenty years. Having lived through the AIDS crisis to date and, to my knowledge, remaining HIV-negative, I can be no more equipped to describe in writing what this feels like than I am able privately to comprehend what AIDS has left in its wake. It seems clear that my reluctance to write this essay (and now to complete it) relates directly to the glacial pace of actually doing so; and that the result of this process, not surprisingly, is more than the usual amount of conflict concerning what is actually, finally on the page. In his essay "Mourning and Melancholia," Freud addresses a not unrelated immobilization that results from mixed feelings on the part of the bereaved for the person who has died. This paralysis, "melancholia," is the product of a sense of guilt that is so powerful, so insupportable, that the mourner prefers immobilization to life. Perhaps it would not be too much to say that the difficulty I've had in writing this essay is a consequence of guilt that I (unconsciously) feel as a survivor of the plague. And what about the fact that I don't want to be addressing these issues? There is in this something subtly different: an element of will that belongs to more conscious thought processes, and in this I suspect the need to live as if none of this had ever happened, as if it is not still happening now.

1. "Global Estimates: HIV: Close to 16,000 new infections a day. New estimates show that infection with the human immunodeficiency virus (HIV) which causes AIDS is far more common in the world than previously thought. UNAIDS and WHO estimate that over 30 million people are living with HIV-infection at the end of 1997. That is one in every 100 adults in the sexually active ages 15 through 49 worldwide. Included in the 30 million figure are 1.1 million children under the age of 15. The overwhelmingly majority of HIV-infected people—more than 90%—live in the developing world, and most of these do not know that they are infected." *UNAIDS Report on the Global HIV/AIDS Epidemic* (November 26, 1997), p. 3.

2. One of the first exhibitions of its kind, *AIDS: The Artists' Response* opened at the Hoyt T. Sherman Galleries at Ohio State University in Columbus in February 1989. See Jan Zita Grover, "Introduction," in *AIDS: The Artists' Response* (Columbus: Ohio State University, 1989), p. 2.

3. Ibid., p. 3.

4. Ibid.

5. William H. Honan, "Arts Endowment Withdraws Grant for AIDS Show," *New York Times*, November 9, 1989, pp. A1, C28.

6. The titles of Haacke's works foreground their investigative nature: *Shapolsky et al. Manhattan Real Estate Holdings, a Real-Time Social System, as of May 1, 1971*, and Sol Goldman and Alex DiLorenzo *Manhattan Real Estate Holdings, a Real-Time Social System, as of May 1, 1971*. See Rosalyn Deutsche, "Property Values: Hans Haacke, Real Estate, and the Museum," in Brian Wallis, ed., *Hans Haacke: Unfinished Business* (New York: New Museum of Contemporary Art, 1996), pp. 20-37.

7. "On View at the New Museum," brochure (New York: New Museum of Contemporary Art, 1997), n.p.

8. James Agee and Walker Evans, *Let Us Now Praise Famous Men* (New York: Houghton Mifflin, 1988), p. 15.

9. Quoted in Douglas Crimp, "AIDS: Cultural Analysis, Cultural Activism," in Crimp, ed., *AIDS: Cultural Analysis, Cultural Activism* (Cambridge, Mass.: MIT Press, 1988), p. 12.

10. As Loren McAlpin, a member of Gran Fury, recalled, "In the end, the director's posturing backfired. There was lots of negative publicity for him, and it just escalated the attention the piece got, something we hadn't counted on. He became, in effect, our partner." Quoted in Richard Meyer, "This Is to Enrage You: Gran Fury and the Graphics of AIDS Activism," in Nina Felshin, ed., *But Is It Art? The Spirit of Art as Activism* (Seattle: Bay Press, 1995), p. 77.

11. Gran Fury designed a flyer that was distributed in the program of the awards ceremony at the Brooklyn Academy of Music. It added a note of gravity to the festivities: "During this program at least six people with AIDS will die."

12. Richard Hawkins and Dennis Cooper, "Against Nature," in Nayland Blake et al., eds., *In a Different Light: Visual Culture, Sexual Identity, Queer Practice* (San Francisco: City Lights Books, 1995), p. 57.

13. I have depended for this account of the inception of Visual AIDS on a telephone conversation with Tom Sokolowski during the summer of 1998.

14. Mary Patten, "The Thrill Is Gone: An ACT UP Post-Mortem (Confessions of a Former AIDS Activist)," in Deborah Bright, ed., *The Passionate Camera: Photography and Bodies of Desire* (New York: Routledge, 1998), pp. 400-1.

15. See Mab Segrest, "Visibility and Backlash," in David Deitcher, ed., *The Question of Equality: Lesbian and Gay Politics in America Since Stonewall* (New York: Scribner, 1995), pp. 83-122.

16. Among the many exhibitions that celebrated this outpouring, the one that received perhaps the most attention was *Erotophobia: A Forum on Sexuality*, organized by Simon Watson, and on view at his gallery on Lafayette Street in New York, June 4-July 28, 1989.

17. See Gregg Bordowitz and David Deitcher, "Art, Activism, and Everyday Life," *Documents*, no. 11 (Winter 1998): 36.

18. Telephone interview with Joy Episalla, Spring 1998.

19. Gran Fury, "Good Luck," flyer produced for *Temporarily Possessed* at the New Museum of Contemporary Art, New York, 1995.

20. Robert A. Jones, "Dangerous Liaisons: Young Gay Men Know All About AIDS and HIV, Yet They Persist in Having Unprotected Sex," *Los Angeles Times Magazine*, July 25, 1993; and "Second Wave of AIDS Feared by Officials in San Francisco," *New York Times*, December 11, 1993, p. A1.

21. See Benjamin Schatz, Josh Schechtel et al., eds., *The Silent Crisis: Ongoing HIV Infections Among Gay Men Bisexuals and Lesbians at Risk* (San Francisco: Gay and Lesbian Medical Association, 1995). A number of scholarly studies provided the initial data suggesting the second wave; these included Donald Hoover et al., "Estimating the 1978–1990 and Future Spread of Human Immunodeficiency Virus Type 1 in Subgroups of Homosexual Men," *American Journal of Epidemiology* 134, no. 10 (1991): 1190-1205; and Jeffrey A. Kelly et al., "Acquired Immunodeficiency Syndrome/ Human Immunodeficiency Virus Risk Behavior Among Gay Men in Small Cities (abstract)," *Archives of Internal Medicine* 152 (1991): 2293.

22. Schatz, *The Silent Crisis*, p. 16.

23. Walt Odets, *In the Shadow of the Epidemic: Being HIV-Negative in the Age of AIDS* (Durham: Duke University Press, 1995), pp. 256-57.

24. Two books, both published during Spring 1997, represent the conservative position: Gabriel Rotello, *Sexual Ecology: AIDS and the Destiny of Gay Men* (New York: Dutton, 1997); and Michelangelo Signorile, *Life*

Outside: The Signorile Report on Gay Men: Sex, Drugs, Muscles, and the Passages of Life (New York: HarperCollins, 1997).

25. In November 1997, Sex Panic! issued a "Declaration of Sexual Rights," which champions "the principles of sexual self-determination."

26. See, for example, Andrew Sullivan, "Fighting the Death Sentence," *New York Times*, November 21, 1995, p. A21; and "When AIDS Ends: Notes on the Twilight of an Epidemic," *New York Times Magazine*, November 10, 1996, sec. 6, pp. 52–62, 76–77, 84. Nationally syndicated gay sex columnist Dan Savage provoked angry responses to a piece he published in October 1997 that provocatively declared "The AIDS Crisis Is Over," and questioned the motives of those who might disagree with him.

27. Laurence K. Altman, "AIDS Deaths Drop 48% in New York," *New York Times*, February 3, 1998, pp. A1, B6.

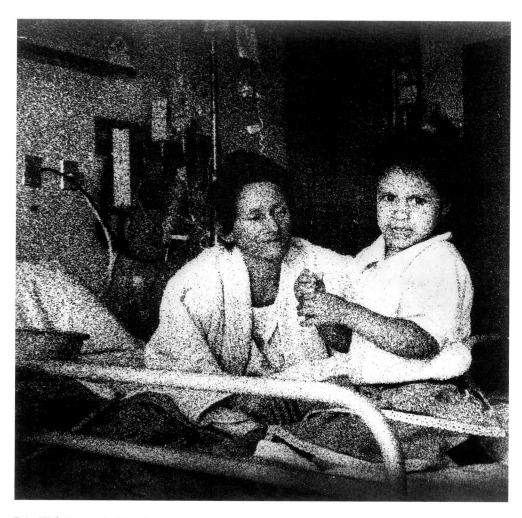

Brian Weil, *Maria and Adriana Saying Good-bye, Memorial Sloan-Kettering Hospital, NYC*, 1991, black-and-white gelatin silver print. Courtesy of the Center for Creative Photography, Tucson, and the Estate of Brian Weil. Art Matters grant recipient, 1986, 1988, 1990.

How to Have Promiscuity in an Epidemic (1988)

DOUGLAS CRIMP

—AIDS: Questions and Answers
—AIDS: Get the Facts
—AIDS: Don't Die of Ignorance

The sloganeering of AIDS education campaigns suggests that
knowledge about AIDS is readily available, easily acquired, and
undisputed. Anyone who has sought to learn the "facts," however,
knows just how hard it is to get them. Since the beginning of the
epidemic, one of the very few sources of up-to-date information
on all aspects of AIDS has been the gay press, but *this* is a fact
that no education campaign (except those emanating from gay
organizations) will tell you. As Simon Watney has noted, the British
government ban on gay materials coming from the U.S. until late
in 1986 meant, in effect, that people in the U.K. were legally pro-
hibited from learning about AIDS during a crucial period. The
ban also meant that the British Department of Health had to sneak
American gay publications into the country in diplomatic pouches
in order to prepare the Thatcher government's bullying "Don't Die
of Ignorance" campaign.[1]

Among information sources, perhaps the most acclaimed is the
New York Native, which has published news about AIDS virtually
every week since 1982. But, although during the early years a
number of leading medical reporters wrote for the newspaper and
provided essential information, the *Native*'s overall record on AIDS
is not so admirable. Like other tabloids, the *Native* exploits the
conflation of sex, fear, disease, and death in order to sell millions of
newspapers. Banner headlines with grim predictions, new theories
of "cause" and "cure," and scandals of scientific infighting combine
with soft-core shots of hot male bodies to insure that we will rush
to plunk down our two dollars for this extremely thin publication.
One curious aspect of these headlines over the past few years is that
they nearly always refer not to a major news or feature story, but
to a short editorial column by the newspaper's publisher Charles
Ortleb. These weekly diatribes against the likes of Robert Gallo of
the National Cancer Institute and Anthony Fauci of the National
Institute for Allergy and Infectious Diseases might appear to be

This essay first appeared in Douglas Crimp, ed., *AIDS: Cultural Analysis, Cultural Activism*
(Cambridge, Mass: MIT Press, 1988, pp. 237-71).

manifestations of a healthy skepticism toward establishment science, but Ortleb's distrust takes an odd form. Rather than performing a political analysis of the ideology of science, Ortleb merely touts the crackpot theory of the week, championing whoever is the latest outcast from the world of academic and government research. Never wanting to concede that establishment science could be right about the "cause" of AIDS—which is now generally (if indeed skeptically) assumed to be the retrovirus designated HIV—Ortleb latches onto any alternative theory: African Swine Fever Virus, Epstein-Barr Virus, reactivated syphilis.[2] The genuine concern by informed people that a full acceptance of HIV as *the* cause of AIDS limits research options, especially regarding possible cofactors, is magnified and distorted by Ortleb into ad hominem vilification of anyone who assumes for the moment that HIV is the likely primary causal agent of AIDS and ARC. Among the *Native*'s maverick heroes in this controversy about origins is the Berkeley chemist Peter Duesberg, who is so confident that HIV is harmless that he has claimed to be unafraid of injecting it into his veins. When asked by *Village Voice* reporter Ann Giudici Fettner what he *does* think is causing the epidemic, Duesberg replied, "We don't have a new disease. It's a combination of [old] diseases caused by a lifestyle that was criminal 20 years ago. Combined with bathhouses, all these infections go with lifestyles that enhance them."[3] As Fettner notes, this is "a stunning regression to 1982," when AIDS was presumed to be a consequence of "the gay life-style."

A scientist pushing "the gay life-style" as the cause of AIDS in 1987 might seem a strange sort of hero for a gay newspaper to be celebrating, but then anyone who has read the *Native* regularly will have noted that, for Ortleb is not alone among powerful gay journalists. He is joined in his belief not only by right-wing politicians and ideologues, but by Randy Shilts, AIDS reporter for the *San Francisco Chronicle* and author of *And the Band Played On*, the bestselling book on AIDS.[4] That this book is pernicious has already been noted by many people working in the struggle against AIDS. For anyone suspicious of "mainstream" American culture, it might seem enough simply to note that the book *is* a bestseller, that it has been highly praised throughout the dominant media, or, even more damning, that the book has been optioned for a TV miniseries by Esther Shapiro, writer and producer of *Dynasty*. For some, the fact that Larry Kramer is said to be vying for the job of scriptwriter of the series will add to these suspicions (whoever reads the book will note that, in any case, the adaptation will be an easy task, since it is already written, effectively, *as* a miniseries). The fact that Shilts

places blame for the spread of AIDS equally on the Reagan Administration, various government agencies, the scientific and medical establishments, *and the gay community*, is reason enough for many of us to condemn the book.

And the Band Played On is predicated on a series of oppositions: it is, first and foremost, a story of heroes and villains, of common sense against prejudice, of rationality against irrationality; it is also an account of scientific advance versus political maneuvering, public health versus civil rights, a safe blood supply versus blood-banking industry profits, homosexuals versus heterosexuals, hard cold facts versus what Shilts calls AIDSpeak.

We might assume we know what is meant by this neologism: AIDSpeak would be, for example, "the AIDS test," "AIDS victims," "promiscuity." But no, Shilts employs these imprecise, callous, or moralizing terms just as do all his fellow mainstream journalists, without quotation marks, without apology. For Shilts, AIDSpeak is, instead, a language invented to cover up the truth. An early indication of what Shilts thinks this language is appears in his account of the June 5, 1981 article in the *Morbidity and Mortality Weekly Report* about cases of *Pneumocystis* pneumonia in gay men. Shilts writes:

> *The report appeared . . . not on page one of the MMWR, but in a more inconspicuous slot on page two. Any reference to homosexuality was dropped from the title, and the headline simply read:* Pneumocystis pneumonia—Los Angeles.
>
> *Don't offend the gays and don't inflame the homophobes. These were the twin horns on which the handling of this epidemic would be torn from the first day of the epidemic. Inspired by the best intentions, such arguments paved the road toward the destination good intentions inevitably lead.* (pp. 68-69)

It was a great shock to read this in 1987, after six years of headlines about "the gay plague" and the railing of moralists about God's punishment for sodomy, or, more recently, statements such as "AIDS is no longer just a gay disease." Language destined to offend gays and inflame homophobia has been, from the very beginning—in science, in the media, and in politics—the main language of AIDS discussion, although the language has been altered at times in order that it would, for example, offend Haitians and inflame racism, or offend women and inflame sexism. But to Shilts, AIDSpeak is not this language guaranteed to offend and inflame. On the contrary, it is

> *. . . a new language forged by public health officials, anxious gay politicians, and the burgeoning ranks of "AIDS activists." The linguistic roots of AIDSpeak sprouted not so much from the truth as from what was politically facile and psychologically reassuring. Semantics was the major*

How to Have Promiscuity in an Epidemic DOUGLAS CRIMP

denominator of AIDSpeak jargon, because the language went to great lengths never to offend.

A new lexicon was evolving. Under the rules of AIDSpeak, for example, AIDS victims could not be called victims. Instead, they were to be called People With AIDS, or PWAs, as if contracting this uniquely brutal disease was not a victimizing experience. "Promiscuous" became "sexually active," because gay politicians declared "promiscuous" to be "judgmental," a major cuss word in AIDSpeak. . . .

. . . The new syntax allowed gay political leaders to address and largely determine public health policy in the coming years, because public health officials quickly mastered AIDSpeak, and it was a fundamentally political tongue. (p. 315)

Shilts's contempt for gay political leaders, AIDS activists, and people with AIDS, and his delusions about their power to influence public health policy, are deeply revealing of his own politics. But to Shilts, politics is something alien, only common sense; he speaks only the "truth," even if the truth is "brutal," like being "victimized" by AIDS.

As an immediate response to this view, I will state my own political position: *Anything said or done about AIDS that does not give precedence to the knowledge, the needs, and the demands of people living with AIDS must be condemned.* The passage from *And the Band Played On* quoted above—and indeed the entire book—is written in flagrant disregard for these people. Their first principle, that they not be called victims, is flaunted by Shilts. I will concede that people living with AIDS *are* victims in one sense; they have been and continue to be victimized by all those who will not listen to them, including Randy Shilts. But we cannot stop at condemnation. Shilts's book is too full of useful information, amassed in part with the help of the Freedom of Information Act, simply to dismiss it. But while it may be extremely useful, it is also extremely dangerous—and thus has to be read very critically.

In piecing together his tale of heroes and villains—which intersperses vignettes about scientists from the Centers for Disease Control in Atlanta, the National Institutes of Health in Bethesda, and the Pasteur Institute in Paris; doctors with AIDS patients in New York, San Francisco, and Los Angeles; blood-banking industry executives; various people with AIDS (always white, usually gay men living in San Francisco); officials in the Department of Health and Human Services and the Food and Drug Administration; gay activists and AIDS service organization volunteers—Shilts always returns to a single complaint. With all the people getting sick and dying, and with all the scandals of inaction, stonewalling, and infighting that are arguably the primary cause of their illness and

death, journalists never bothered to investigate. They always bought the government's lies, never looked behind those lies to get to the "truth." There was, of course, one exception, the lonely journalist for the *San Francisco Chronicle* assigned full-time to the AIDS beat. He is never named, but we know his name is Randy Shilts, the book's one unqualified hero, who appears discreetly in several of its episodes. Of course, that journalist knows the reason for the lack of investigative zeal on the part of his fellows: the people who were dying were gay men, and mainstream American journalists don't care what happens to gay men. Those journalists would rather print hysteria-producing, blame-the-victim stories than uncover the "truth."

So Shilts would print that truth in *And the Band Played On*, "investigative journalism at its best," as the flyleaf states. The book is an extremely detailed, virtually day-by-day account of the epidemic up to the revelation that Rock Hudson was dying of AIDS, the moment, in 1985, when the American media finally took notice.[5] But taking notice of Rock Hudson was, in itself, a scandal, because by the time the Rock Hudson story captured the attention of the media, Shilts notes, "the number of AIDS cases in the United States had surpassed 12,000 . . . of whom 6,079 had died" (p. 580). Moreover, what constituted a story for the media was only scandal itself: a famous movie star simultaneously revealed to be gay and to be dying of AIDS.

How surprised, then, could Shilts have been that, when his own book was published, the media once again avoided mention of the six years of political scandal that contributed so significantly to the scope of the AIDS epidemic? That they were instead intrigued by an altogether different story, the one they had been printing all along—the dirty little story of gay male promiscuity and irresponsibility?

In the press release issued by Shilts's publisher, St. Martin's, the media's attention was directed to the story that would ensure the book's success:

PATIENT ZERO: *The Man Who Brought AIDS to North America*
What remains a mystery for most people is where AIDS came from and how it spread so rapidly through America. In the most bizarre story of the epidemic, Shilts also found the man whom the CDC dubbed the "Patient Zero" of the epidemic. Patient Zero, a French-Canadian airline steward, was one of the first North Americans diagnosed with AIDS. Because he traveled through the gay communities of major urban areas, he spread the AIDS virus [sic] throughout the continent. Indeed, studies later revealed 40 of the first 200 AIDS cases in America were documented either to have had sex with Patient Zero or have had sex with someone who did.

The story of Gaetan Dugas, or "Patient Zero," is woven through-
out the book in over twenty separate episodes, beginning on page
11 and ending only on page 439, where the young man's death is
recounted. "At one time," Shilts writes in a typically portentous
tone, "Gaetan had been what every man wanted from gay life;
by the time he died, he had become what every man feared." It
is interesting indeed that Shilts, a gay man who appears *not* to
have wanted from gay life what Gaetan Dugas may or may not
have been, should nevertheless assume that what all gay men want
is identical.

The publisher's ploy worked, for which they appear to be proud.
Included in the press kit sent to me were xeroxes of the following
news stories and reviews:

— *New York Times*: Canadian Said to Have Had Key Role in
 Spread of AIDS
— *New York Post*: THE MAN WHO GAVE US AIDS
— *Time*: The Appalling Saga of Patient Zero
— *McClean's*: "Patient Zero" and the AIDS virus

People magazine made "Patient Zero" one of its "25 most
intriguing people of '87," together with Ronald Reagan, Mikhail
Gorbachev, Oliver North, Fawn Hall, Princess Diana, Vincent
van Gogh, and Baby Jessica. Shilts's success in giving the media
the scandalous story that would overshadow his book's other
"revelations"—and that would ensure that the blame for AIDS
would remain focused on gay men—can be seen even in the way
the story appeared in Germany's leading liberal weekly, *Der Spiegel*.
Underneath a photograph of cruising gay men at the end of
Christopher Street in New York City, the story's sensational title
reads "Ich werde sterben, und du auch" ("I'm going to die, and so
are you"), a line the Canadian airline steward is supposed to have
uttered to his bathhouse sex partners as he turned up the lights
after an encounter and pointed to his KS lesions.

Shilts's painstaking efforts at telling the "true" story of the
epidemic's early years thus resulted in two media stories: the story
of the man who brought us AIDS, and the story of the man who
brought us the story of the man who brought us AIDS. Gaetan
Dugas and Randy Shilts became overnight media stars. Being fully
of the media establishment, Shilts's criticism of that establishment
is limited to pitting good journalists against bad. He is apparently
oblivious to the economic and ideological mechanisms that largely
determine how AIDS will be constructed in the media, and he thus
contributes to that construction rather than to its critique.

The criticism most often leveled against Shilts's book by its gay
critics is that it is a product of internalized homophobia. In this

view, Shilts is seen to identify with the heterosexist society that loathes him for his homosexuality, and through that identification to project his loathing onto the gay community. Thus, "Patient Zero," the very figure of the homosexual as imagined by heterosexuals—sexually voracious, murderously irresponsible—is Shilts's homophobic nightmare of himself, a nightmare that he must constantly deny by making it true only of others. Shilts therefore offers up the scapegoat for his heterosexual colleagues in order to prove that he, like them, is horrified by such creatures.

It is true that Shilts's book reproduces virtually every cliché of homophobia. Like Queen Victoria's proverbial inability to fathom what lesbians do in bed, Shilts's disdain for the sexual habits of gay men extends even to finding certain of those habits "unimaginable." In one of his many fulminations against gay bathhouses, Shilts writes, "Just about every type of unsafe sex imaginable, and many variations that were unimaginable, were being practiced with carefree abandonment [*sic*] at the facilities" (p. 481).

Shilts's failure of imagination is in this case merely a trope, a way of saying that certain sexual acts are beyond the pale for most people. But in resorting to such a trope, Shilts unconsciously identifies with all those who would rather see gay men die than allow homosexuality to invade their consciousness.

And the Band Played On is written not only as a chronology of events, but also as a cleverly plotted series of episodes. Hundreds of narrative threads are woven around individual characters described in conventional novelistic fashion. Often Shilts uses people's regional accents and physiques metonymically to stand for their characters: "Everyone cheered enthusiastically when Paul Popham [president of the Gay Men's Health Crisis] addressed the crowd in his broad, plainspoken Oregon accent" (p. 139). A hundred pages earlier, Popham is introduced with the sentence, "At the Y, Larry [Kramer] had told Paul that he had such a naturally well-defined body that he didn't need to work out, and Paul responded with a shy aw-shucks ingenuousness that reminded Larry of Gary Cooper or Jimmy Stewart" (p. 26). Shilts's choice of novelistic form allows him these tricks of omniscient narration. Not only does he tell us what Paul said and Larry thought, he also reveals his characters' dreams and nightmares, and even, in a few cases, what people with AIDS were thinking and feeling at the moment of death. These aspects of bourgeois writing would seem to represent a strange choice indeed for the separation of fact from fiction,[6] but I want to argue that it is precisely this choice that determines Shilts's homophobia. For it is my contention not simply that Shilts has internalized homophobia, but that he has sought to escape the effects of homophobia by

employing a particular cultural form, one that is thoroughly out-moded but still very much with us in its vulgarized variants. In *Writing Degree Zero*, Roland Barthes writes:

> Until [the 1850s], it was bourgeois ideology itself which gave the measure of the universal by fulfilling it unchallenged. The bourgeois writer, sole judge of other people's woes and without anyone else to gaze on him, was not torn between his social condition and his intellectual vocation.[7]

"Sole judge of other people's woes and without anyone else to gaze on him," Shilts adopted a no-longer-possible universal point of view—which is, among other things, the *heterosexual* point of view—and thus erased his own social condition, that of being a gay man in a homophobic society. Shilts wrote the story of Gaetan Dugas not because it needed telling—because, in the journalist's mind it was true and factual—but because it was required by the bourgeois novelistic form that Shilts used as his shield. The book's arch-villain has a special function, that of securing the identity of his polar opposite, the book's true hero. Shilts created the character of "Patient Zero" to embody everything that the book purports to expose: irresponsibility, delay, denial—ultimately murder.[8] "Patient Zero" stands for all the evil that is "really" the cause of the epidemic, and Shilts's portrait of "Patient Zero" stands for Shilts's own heroic act of "exposing" that evil.

If I have dwelt for so long on *And the Band Played On*, it is not only because its enthusiastic reception demands a response. It is also because the book demonstrates so clearly that cultural conventions rigidly dictate what can and will be said about AIDS. And these cultural conventions exist everywhere the epidemic is constructed: in newspaper stories and magazine articles, in television documentaries and fiction films, in political debate and healthcare policy, in scientific research, in art, in activism, and in sexuality. The way AIDS is understood is in large measure predetermined by the forms these discourses take. Randy Shilts provided the viciously homophobic portrait of "Patient Zero" because his thriller narrative demanded it, and the news media reported that story and none of the rest because what is news and what is not is dictated by the form the news takes in our society. In a recent op-ed piece about his recognition that AIDS is now newsworthy, A.M. Rosenthal, executive editor of the *New York Times* during the entire five-year period when the epidemic was a *non*story for the *Times*, offered the following reflection on the news-story form: "Journalists call events, trivial or historic, 'stories' because we really are tellers of tales and to us there is no point in knowing or learning if we can't run out and tell somebody. That's just the way we are; go ask a psychiatrist why."[9]

"Patient Zero" is a news story while the criminal inaction of the

Reagan Administration is not—"go ask a psychiatrist why." Rock Hudson is a story, but the thousands of other people with AIDS are not—"go ask a psychiatrist why." Heterosexuals with AIDS is a story; homosexuals with AIDS is not—"go ask a psychiatrist why." Shilts laments this situation. His book contributes nothing to understanding and changing it.

Among the heroes of *And the Band Played On* is Larry Kramer, who shares Shilts's negative view of gay politics and sexuality. Here is how Shilts describes the reception of Kramer's play about AIDS, *The Normal Heart*:

April 21 [1985]

PUBLIC THEATER

New York City

> *A thunderous ovation echoed through the theater. The people rose to their feet, applauding the cast returning to the stage to take their bows. Larry Kramer looked to his eighty-five-year-old mother. She had always wanted him to write for the stage, and Kramer had done that now. True,* The Normal Heart *was not your respectable Neil Simon fare, but a virtually unanimous chorus of reviewers had already proclaimed the play to be a masterpiece of political drama. Even before the previews were over, critics from every major news organization in New York City had scoured their thesauruses for superlatives to describe the play. NBC said it "beats with passion";* Time *magazine said it was "deeply affecting, tense and touching"; the* New York Daily News *called it "an angry, unremitting and gripping piece of political theater." One critic said* Heart *was to the AIDS epidemic what Arthur Miller's* The Crucible *had been to the McCarthy era. New York Magazine's critic John Simon, who had recently been overheard saying that he looked forward to when AIDS had killed all the homosexuals in New York theater, conceded in an interview that he left the play weeping.* (p. 556)

How is it that for four years the deaths of thousands of gay men could leave the dominant media entirely unmoved, but Larry Kramer's play could make them weep? Shilts offers no explanation, nor is he suspicious of this momentary change of heart. *The Normal Heart* is a *pièce à clef* about the Gay Men's Health Crisis, the AIDS service organization Kramer helped found and which later expelled him—because, as the play tells it, he, like Shilts, insisted on speaking the truth.[10] In one of his many fights with his fellow organizers, Ned Weeks, the character that represents Kramer, explodes, "Why is anything I'm saying compared to anything but common sense?" (p.100). Common sense, in Kramer's view, is that gay men should stop having so much sex, that promiscuity kills. But this common sense, is, of course, conventional moral wisdom: it is not safe sex, but

TREAT A COMPLETE STRANGER AS A LOVER, HUG THEM AS GOOD FRIENDS, AS THEY ARE OR AS 10 YEARS AGO YOU MIGHT HAVE HAD FABULOUS SEX WITH ABSOLUTE ABANDON WITH THE SAME STRANGER. NOW LIFE IS RAVAGED AND WE OFFER LOVE FROM THE SAME ROOT OF BOUNDLESS COMPASSION

JOHN GIORNO for VISUAL AIDS • NEW YORK • DAY WITHOUT ART • 1993
Funded in part by the Lannan Foundation and the Andy Warhol Foundation for the Visual Arts Inc. © 1993 John Giorno

John Giorno for VisualAIDS, *"Treat a Complete Stranger as a Lover..."*, 1993, poster. Photo courtesy of Visual AIDS. Art Matters grant recipient, 1988, 1989, 1991, 1992, 1993.

monogamy that is the solution. The play's message is therefore not only reactionary, it is lethal, since monogamy per se provides no protection whatsoever against a virus that might already have infected one partner in a relationship.

"I am sick of guys who can only think with their cocks" (p. 57), says Ned Weeks, and later, "Being defined by our cocks is literally killing us." (p. 115). For Kramer, being defined by sex is the legacy of gay politics; promiscuity and gay politics are one and the same:

NED: [*to Emma, the doctor who urges him to tell gay men to stop having sex*]: *Do you realize that you are talking about millions of men who have singled out promiscuity to be their principal political agenda, the one they'd die before abandoning?* (pp. 37-38)

BRUCE: [*the president of GMHC*]: *. . . the entire gay political platform is fucking.* (p. 57)

NED: *. . . the gay leaders who created this sexual liberation philosophy in the first place have been the death of us. Mickey, why didn't you guys fight for the right to get married instead of the right to legitimize promiscuity?* (p. 85)

This is the view of someone who did not participate in the gay movement, and who has no sense of its history, its complexities, its theory and practice (was he too busy taking advantage of its gains?). Kramer's ignorance of and contempt for the gay movement are demonstrated throughout the play:

> NED: *Nobody with a brain gets involved in gay politics. It's filled with the great unwashed radicals of any counterculture.* (p. 37)
>
> MICKEY: *You know, the battle against the police at Stonewall was won by transvestites. We all fought like hell. It's you Brooks Brothers guys who*—
>
> BRUCE: *That's why I wasn't at Stonewall. I don't have anything in common with those guys, girls, whatever you call them.*
>
> MICKEY: *. . . and . . . how do you feel about Lesbians?*
>
> BRUCE: *Not very much. I mean, they're . . . something else.*
>
> MICKEY: *I wonder what they're going to think about all of this? If past history is any guide, there's never been much support by either half of us for the other. Tommy, are you a Lesbian?* (pp. 54-55)

I want to return to gay politics, and specifically to the role lesbians have played in the struggle against AIDS, but first it is necessary to explain why I have been quoting Kramer's play as if it were not fictional, as if it could be unproblematically taken to represent Kramer's own views. As I've already said, *The Normal Heart* is a *pièce à clef*, a form adopted for the very purpose of presenting the author's experience and views in dramatic form. But my criticism of the play is not merely that Kramer's political views, as voiced by his characters, are reactionary—though they certainly are—but that the genre employed by Kramer will dictate a reactionary content of a different kind: because the play is written within the most traditional of conventions of bourgeois theater, its politics are the politics of bourgeois individualism. Like *And the Band Played On*, *The Normal Heart* is the story of a lonely voice of reason smothered by the deafening chorus of unreason. It is a play with a hero, Kramer himself, for whom the play is an act of vengeance for all the wrong done him by his ungrateful colleagues at the Gay Men's Health Crisis. *The Normal Heart* is a purely personal—*not* a political—drama, a drama of a few heroic individuals in the AIDS movement. From time to time, some of these characters talk "politics":

> EMMA: *Health is a political issue. Everybody's entitled to good medical care. If you're not getting it, you've got to fight for it. Do you know this is the only industrialized country in the world besides South Africa that doesn't guarantee healthcare for everyone?* (p. 36)

But this is, of course, politics in the most restricted sense of the word. Such a view refuses to see that power relations invade and shape all discourse. It ignores the fact that the choice of the bourgeois

form of drama, for example, is a political choice that will have necessary political consequences. Among these is the fact that the play's "politics" sound very didactic, don't "work" with the drama. Thus in *The Normal Heart*, even these "politics" are mostly pushed to the periphery; they become décor. In the New York Shakespeare Festival production of the play, "the walls of the set, made of construction-site plywood, were whitewashed. Everywhere possible, on this set and upon the theater wall too, facts and figures and names were painted, in black, simple lettering." (p. 19) These were such facts as

—MAYOR KOCH: *$75,000* —MAYOR FEINSTEIN: *$16,000,000. (For public education and community services.)*

—*During the first nineteen months of the epidemic,* The New York Times *wrote about it a total of seven times.*

—*During the first three months of the Tylenol scare in 1982,* The New York Times *wrote about it a total of 54 times.* (pp. 20-21)

No one would dispute that these facts and figures have political significance, that they are part of the political picture of AIDS. But in the context of *The Normal Heart*, they are absorbed by the personal drama taking place on the stage, where they have no other function than to prove Ned Weeks right, to vindicate Ned Weeks's—Larry Kramer's—rage. And that rage, the play itself, is very largely played out against other gay men.

Shilts's book and Kramer's play share a curious contradiction: they blame the lack of response to the epidemic on the misrepresentation of AIDS as a gay disease even as they themselves treat AIDS almost exclusively as a gay problem. Both display indifference to the other groups drastically affected by the epidemic, primarily, in the U.S., IV-drug users, who remain statistics for the two writers, just as gay men do for the people the two authors rail against.

The resolution of this contradiction, which is pervasive in AIDS discourse, would appear to be simple enough. AIDS is not a gay disease, but in the U.S. it affected gay men first and, thus far, has affected us in greater proportion. But AIDS probably did *not* affect gay men first, even in the U.S. What is now called AIDS was first *seen* in middle-class gay men in America, in part because of our access to medical care. Retrospectively, however, it appears that IV-drug users—whether gay or straight—were dying of AIDS in New York City throughout the '70s and early '80s, but a class-based and racist healthcare system failed to notice, and an epidemiology equally skewed by class and racial bias failed to begin to look *until* 1987.[11] Moreover, AIDS has never been restricted to gay men in Central Africa, where the syndrome is a problem of apocalyptic dimensions, but to this day receives almost no attention in the U.S.

What is far more significant than the real *facts* of HIV transmission in various populations throughout the world, however, is the initial conceptualization of AIDS as a syndrome affecting gay men. No insistence on the facts will render that discursive construction obsolete, and not only because of the intractability of homophobia. The idea of AIDS as a gay disease occasioned two *interconnected* conditions in the U.S.: that AIDS would be an epidemic of stigmatization rooted in homophobia, and that the response to AIDS would depend in very large measure on the very gay movement Shilts and Kramer decry.

The organization Larry Kramer helped found, the Gay Men's Health Crisis, is as much a part of the early construction of AIDS as were the first reports of the effects of the syndrome in the *Morbidity and Mortality Weekly Report* . Though it may be true that few, if any, of the founders of GMHC were centrally involved in gay politics, everything they were able to accomplish—from fundraising and recruiting volunteers to consulting with openly gay healthcare professionals and getting education out to the gay community— depended on what had already been achieved by the gay movement. Moreover, the continued life of GMHC as the largest AIDS service organization in the U.S. has necessarily aligned it with other, considerably more radical grass-roots AIDS organizations both in the gay community and in other communities affected by the epidemic. The Gay Men's Health Crisis, whose workforce comprises lesbians and heterosexual women as well as gay men (heterosexual men are notably absent from the AIDS movement), is now an organization that provides services for infants with AIDS, IV-drug users with AIDS, women with AIDS. It is an organization that every day puts the words *gay men* in the mouths of people who would otherwise never speak them. More importantly, it is an organization that has put the words *gay men* in the mouths of non-gay people living with the stigma attached to AIDS by those very words. The Gay Men's Health Crisis is thus a symbol, in its very name, of the fact that the gay movement is at the center of the fight against AIDS. The limitations of this movement—especially insofar as it is riven by race and class differences—are therefore in urgent need of examination.

In doing this, we must never lose sight of the fact that the gay movement is responsible for virtually every positive achievement in the struggle against AIDS during the epidemic's early years. These achievements are not only those of politically organized response— of fighting repressive measures; of demanding government funding, scientific research, and media coverage; of creating service organizations to care for the sick and to educate the well. They are also the

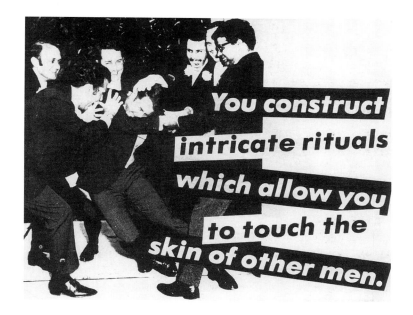

Barbara Kruger, *Untitled
(You Construct Intricate Rituals
Which Allow You to Touch the
Skin of Other Men)*, 1983,
photograph, 50 x 38 in.

achievements of a sexual community whose theory and practice of
sex made it possible to meet the epidemic's most urgent requirement:
the development of safe sex practices. But who counts as a member
of this community? Who will be protected by the knowledge of
safe sex? Kramer's character Mickey was right in saying that it was
transvestites who fought back at Stonewall. What he did not say
was that those "guys in Brooks Brothers suits" very soon hounded
transvestites out of the movement initiated by Stonewall, because
the "gay good citizens"[12] didn't want to be associated with "those
guys, girls, whatever you call them." Now, in 1988, what AIDS service
organizations are providing transvestites with safe sex information?
Who is educating hustlers? Who is getting safe sex instructions,
printed in Spanish, into gay bars in Queens that cater to working-
class Colombian immigrants?[13] It is these questions that cannot be
answered by a gay community that is far from inclusive of the vast
majority of people whose homosexual practices place them at risk.
It is also these questions that we must ask even more insistently of
AIDS education programs that are now being taken out of the
hands of gay people—AIDS education programs devised by the
state, outside of any existing community, whatever its limitations.

Kramer's summary dismissal of transvestites in *The Normal Heart*
is followed by his assumption that lesbians will show no interest in
the AIDS crisis. Not only has Kramer been proven dead wrong, but
his assumption is grounded in a failure to recognize the importance
of a gay *political* community that has always included both sexes. In
spite of the very real tensions and differences between lesbians and
gay men, our common oppression has taught us the vital necessity
of forming a coalition. And having negotiated and renegotiated this

coalition over a period of two decades has provided much of the groundwork for the coalition politics necessitated by the shared oppression of all the radically different groups affected by AIDS. But the question Larry Kramer and other gay men should be asking in any case is not "What are lesbians doing to help us?" but rather "What are we doing to help lesbians?" Although it is consistently claimed that lesbians, as a group, are the least vulnerable to HIV transmission, this would appear to be predicated, once again, on the failure to understand what lesbians do in bed. As Lee Chiaramonte wrote in an article entitled "The Very Last Fairy Tale,"

> In order to believe that lesbians are not at risk for AIDS, or that those who have already been infected are merely incidental victims, I would have to know and agree with the standards by which we are judged to be safe. Meaning, I would have to believe we are either sexless or olympically monogamous; that we are not intravenous drug users; that we do not sleep with men; that we do not engage in sexual activities that could prove as dangerous as they are titillating. I would also have to believe that lesbians, unlike straight women, can get seven years' worth of honest answers from their lovers about forgotten past lives.[14]

Chiaramonte goes on to cite a 1983 *Journal of Sex Research* study in which it was determined that lesbians have almost twice as much sex as straight women and that their numbers of partners are greater than straight women's by nearly fifteen to one. In a survey conducted by Pat Califia for the *Journal of Homosexuality*, over half the lesbians questioned preferred nonmonogamous relationships.[15] And, in addition to the risks of HIV infection, which only compound women's problems with a sexist healthcare system, lesbians have, along with gay men, borne the intensified homophobia that has resulted from AIDS.

Not surprisingly it was a lesbian—Cindy Patton—who wrote one of the first serious political analyses of the AIDS epidemic and who has more recently coauthored a safe sex manual for women.[16] "It is critical," says Patton, "that the experience of the gay community in AIDS organizing be understood: the strategies employed before 1985 or so grew out of gay liberation and feminist theory."[17] The most significant of these strategies was—again—the development of safe sex guidelines, which, though clearly the achievement of the organized gay community, are now being reinvented by "experts."

> At the 1987 lesbian and gay health conference in Los Angeles, many longtime AIDS activists were surprised by the extent to which safe sex education had become the province of high-level professionals. The fact that safe-sex organizing began and is highly successful as a grass-roots, community effort seemed to be forgotten. . . . Heterosexuals—and even gay people only beginning to confront AIDS—express panic about how

to make appropriate and satisfying changes in their sex lives, as if no one had done this before them. It is a mark of the intransigence of homophobia that few look to the urban gay communities for advice, communities which have an infrastructure and track record of highly successful behavior change.[18]

As Patton insists, gay people invented safe sex. We knew that the alternatives—monogamy and abstinence—were *unsafe*, unsafe in the latter case because people do not abstain from sex, and if you only tell them "just say no," they will have unsafe sex. We were able to invent safe sex because we have always known that sex is not, in an epidemic or not, limited to penetrative sex. Our promiscuity taught us many things, not only about the pleasures of sex, but about the great multiplicity of those pleasures. It is that psychic preparation, that experimentation, that conscious work on our own sexualities that has allowed many of us to change our sexual behaviors—something that brutal "behavioral therapies" tried unsuccessfully for over a century to force us to do—very quickly and very dramatically. It is for this reason that Shilts's and Kramer's attitudes about the formulation of gay politics on the basis of our sexuality is so perversely distorted, why they insist that our promiscuity will destroy us when in fact *it is our promiscuity that will save us.*

The elaborateness of gay male sexual culture, which may have once contributed to the spread of AIDS, has been rapidly transformed into one that inhibits spread of the disease, still promotes sexual liberation (albeit differently defined), and is as marvelously fringe and offensive to Middle America as ever.[19]

All those who contend that gay male promiscuity is merely sexual *compulsion* resulting from fear of intimacy are now faced with very strong evidence against their prejudices. For if compulsion were so easily overcome or redirected, it would hardly deserve the name. Gay male promiscuity should be seen instead as a positive model of how sexual pleasures might be pursued by and granted to everyone if those pleasures were not confined within the narrow limits of institutionalized sexuality.

Indeed, it is the lack of promiscuity and its lessons that suggests that many straight people will have a much harder time learning "how to have sex in an epidemic" than we did.[20] This assumption follows from the fact that risk-reduction information directed at heterosexuals, even when not clearly antisex or based on false morality, is still predicated upon the prevailing myths about sexuality in our society. First among these, of course, is the myth that monogamous relationships are not only the norm but ultimately everyone's deepest desire. Thus, the message is often not about safe sex at all, but how to find a safe partner.

As Art Ulene, "family physician" to the *Today Show*, put it:

I think it's time to stop talking about "safe sex." I believe we should be talking about safe partners instead. A safe partner is one who has never been infected with the AIDS virus [sic]. With a safe partner, you don't have to worry about getting AIDS yourself—no matter what you do sexually, and no matter how much protection you use while you do it.[21]

The agenda here is one of maintaining the us/them dichotomy that was initially performed by the CDC's "risk group" classifications— "Only gay men and IV drug users get AIDS." But now that neat classifications of otherness no longer "protect" the "general population,"[22] how does one go about finding a safe partner? One obvious way of answering this question is to urge HIV antibody testing. If you and your partner both test negative, you can still have unbridled fun.[23] But Dr. Ulene has an additional solution:

One way to find safe partners—though a bit impractical for most— is to move to a place where the incidence of AIDS is low. There are two states that have reported only four cases of AIDS since the disease was discovered, while others are crowded with AIDS patients. Although this near-freedom from AIDS cannot be expected to last forever, the relative differences between states like Nebraska and New York are likely to last.[24]

Dr. Ulene then graciously provides a breakdown of AIDS cases by state.

Most safe sex education materials for heterosexuals, however, presume that their audience consists of people who feel themselves to be at some risk, perhaps because they do not limit themselves to a single sex partner, perhaps because they are unable to move to Nebraska. Still, in most cases, these safe sex instructions focus almost exclusively on penetrative sex and always make it a woman's job to get the condom on the cock. It appears to be a foregone conclusion that there is no use even trying to get straight men to take this responsibility themselves (the title of a recent book is *How to Persuade Your Lover to Use a Condom . . . And Why You Should*). The one exception is a segment of the video aired on PBS entitled *AIDS: Changing the Rules*, in which Rubén Blades talks to men directly, though very coyly, about condoms, but shows them only how to put one on a banana. Evidently condoms have now become too closely associated with gay men for straight men to talk straight about them. In addition, they have become too closely associated with AIDS for the banana companies to approve of *Changing the Rules*'s choice of props. The following letter was sent by the president of the International Banana Association to the president of PBS: I cite it to give some idea of how hilarious—if it weren't so deadly—the condom debate can be.

How to Have Promiscuity in an Epidemic DOUGLAS CRIMP

Dear Mr. Christiansen,

In this program, a banana is used as a substitute for a human penis in a demonstration of how condoms should be used.

I must tell you, Mr. Christiansen, as I have told representatives of WETA, that our industry finds such usage of our product to be totally unacceptable. The choice of a banana rather than some other inanimate prop constitutes arbitrary and reckless disregard for the unsavory association that will be drawn by the public and the damage to our industry that will result therefrom.

The banana is an important product and deserves to be treated with respect and consideration. It is the most extensively consumed fruit in the United States, being purchased by over 98 percent of households. It is important to the economies of many developing Latin American nations. The banana's continued image in the minds of consumers as a healthful and nutritious product is critically important to the industry's continued ability to be held in such high regard by the public and to discharge its responsibilities to its Latin American hosts. . . .

Mr. Christiansen, I have no alternative but to advise you that we intend to hold PBS fully responsible for any and all damages sustained by our industry as a result of the showing of this AIDS program depicting the banana in the associational context planned. Further, we reserve all legal rights to protect the industry's interests from this arbitrary, unnecessary, and insensitive action.

<div align="right">

Yours very truly,

Robert M. Moore

</div>

The debate about condoms, and safe sex education generally, is one of the most alarming in the history of the AIDS epidemic thus far, because it will certainly result in many more thousands of deaths that could be avoided. It demonstrates how practices devised at the grass-roots level to meet the needs of people at risk can be demeaned, distorted, and ultimately destroyed when those practices are co-opted by state power. Perhaps no portion of this controversy is as revealing as the October 14, 1987, debate over the Helms amendment.[25]

In presenting his amendment to the Senate, Helms made the off-hand remark, "Now we had all this mob over here this week-end, which was itself a disheartening spectacle." He was referring to the largest civil rights demonstration in U.S. history, in which over half a million people, lead by PWAs and their friends, marched on Washington for lesbian and gay rights. Early in the morning before the march, the Names Project inaugurated its memorial quilt, whose panels with the names of people who had died of AIDS occupied

a space on the Mall equivalent to two football fields. As the three-by-six-foot cloth panels made by friends, family, and admirers of the dead were carefully unfurled, 1,920 names were solemnly read to a crowd of weeping spectators. Though representing only a small percentage of the people who have died in the epidemic, the seemingly endless litany of names, together with the astonishing size of the quilt, brought home the enormity of our loss so dramatically as to leave everyone stunned. But to Helms and his ilk, this was just a "mob" enacting a "disheartening spectacle." In the following month's issue of the right-wing *Campus Review*, a front-page article by Gary Bauer, assistant to President Reagan and spokesperson for the Administration's AIDS policy, was accompanied by a political cartoon entitled "The AIDS Quilt." It depicts a faggot and a junkie sewing panels bearing the words *sodomy* and *IV Drugs*. Bauer's article explains:

> *"Safe sex" campaigns are not giving students the full story about AIDS. Indeed many students are arguably being denied the information that is most likely to assist them in avoiding the AIDS virus [sic]. . . . Many of today's education efforts are what could be called "sexually egalitarian." That is, they refuse to distinguish or even appear to prefer one type of sexual practice over another. Yet medical research shows that sodomy is probably the most efficient method to transfer the AIDS virus [sic] as well as other diseases—for obvious reasons. Why is this information censored on so many campuses? Does it illustrate the growing power of gay rights activists who not only want to be tolerated, but want the culture at large to affirm and support the legitimacy of the gay lifestyle?*[26]

Three days after the historic march on Washington and the inauguration of the Names Project, Jesse Helms would seek to ensure that such affirmation and support would never occur—at least in the context of AIDS. The senator from North Carolina introduced his amendment to a Labor, Health and Human Services, and Education bill allocating nearly a billion dollars for AIDS research and education in fiscal 1988. Amendment no. 956 began:

> PURPOSE: *To prohibit the use of any funds provided under this Act to the Centers of Disease Control from being used to provide AIDS education, information, or prevention materials and activities that promote, encourage, or condone homosexual sexual activities or the intravenous use of illegal drugs.*

The "need" for the amendment and the terms of the ensuing debate (involving only two other senators) were established by Helms in his opening remarks:

> *About 2 months ago, I received a copy of some AIDS comic books that are being distributed by the Gay Men's Health Crisis, Inc., of New York City, an organization which has received $674, 679 in*

Federal dollars for so-called AIDS education and information. These comic books told the story, in graphic detail, of the sexual encounter of two homosexual men.

The comic books do not encourage and change [sic] any of the perverted behavior. In fact, the comic book promotes sodomy and the homosexual lifestyle as an acceptable alternative in American society. . . . I believe that if the American people saw these books, they would be on the verge of revolt.

I obtained one copy of this book and I had photostats made for about 15 or 20 Senators. I sent each of the Senators a copy—if you will forgive the expression—in a brown envelope marked "Personal and Confidential, for Senator's Eyes Only." Without exception, the Senators were revolted, and they suggested to me that President Reagan ought to know what is being done under the pretense of AIDS education.

So, about 10 days ago, I went down to the White House and I visited with the President.

I said, "Mr. President, I don't want to ruin your day, but I feel obliged to hand you this and let you look at what is being distributed under the pretense of AIDS educational material. . ."

The President opened the book, looked at a couple of pages, and shook his head, and hit his desk with his fist.

Helms goes on to describe, with even greater disdain, the grant application with which GMHC sought federal funds (none of which were, in any case, spent on the production of the safe-sex comics). GMHC 's proposal involved what any college-level psychology student would understand as a prerequisite to the very difficult task of helping people change their sexual habits. Helms read GMHC 's statement of the problem:

As gay men have reaffirmed their gay identity through sexual expression, recommendations to change sexual behavior may be seen as oppressive. For many, safe sex has been equated with boring, unsatisfying sex. Meaningful alternatives are often not realized. These perceived barriers must be considered and alternatives to high-risk practices promoted in the implementation of AIDS risk-reduction education.

After reading this thoroughly *un*extraordinary statement, Helms fumes:

This Senator is not a goody-goody two shoes. I have lived a long time. I have seen a lot of things. I have served 4 years in the Navy. I have been around the track. But every Christian, religious, moral ethic within me cries out to do something. It is embarrassing to stand on the Senate floor and talk about the details of this travesty.

Throughout the floor debate, Helms continued in this vein:

— We have got to call a spade a spade and a perverted human being a perverted human being.

—Every AIDS case can be traced back to a homosexual act.

—It [the amendment] will force this country to slam the door on the wayward, warped sexual revolution which has ravaged this Nation for the past quarter of a century.[27]

—I think we need to do some AIDS testing on a broad level and unless we get around to that and stop talking about all of this business of civil rights, and so forth, we will not stop the spread of AIDS. We used to quarantine for typhoid fever and scarlet fever, and it did not ruin the civil liberties of anybody to do that.

There were, all told, two responses on the Senate floor to Helm's amendment. The first came from Senator Chiles of Florida, who worried about the amendment's inclusion of IV-drug users among those to whom education would be effectively prevented by the legislation—worried because this group includes heterosexuals:

I like to talk about heterosexuals. This is getting into my neighborhood. That is getting into where it can be involved with people that I know and love and care about, and that is where it is getting to children. And again, these children, when you think about a child as an AIDS victim, there is just no reason in the world that should happen. And so we have to try to do what we can to prevent it.

The ritual hand-wringing sentiments about innocent children with AIDS pervade the debate, as they pervade the discussion of AIDS everywhere. This unquestioned sentiment must be seen for what it is: *a vicious apportioning of degrees of guilt and innocence to people with AIDS.* It reflects, in addition, our society's extreme devaluation of life and experience. (The hypocrisy of this distorted set of values does not, however, translate into funding for such necessities for the welfare of children as prenatal care, child care, education and so forth.)

Because Chiles only liked to talk about heterosexuals, it was left to Senator Weicker of Connecticut to defend safe-sex education for gay people. "It is not easy to stand up in the face of language such as this and oppose it," said Weicker, "but I do." Weicker's defense was not made any easier by the fact that he knew what he was talking about: "I know exactly the material that the Senator from North Carolina is referring to. I have seen it. I think it is demeaning in every way." And later, ". . . this is as repugnant to me as it is to anybody else." Because Weicker finds innocuous little drawings of gay male sex as demeaning and repugnant as the North Carolina senator does, he must resort to "science" to oppose Helms's "philosophy": "We better do exactly what we have been told to do by those of science and medicine, which is, No. 1, put our money into research and, No. 2, put our money into education."[28] "The comic book," says Weicker, "has nothing to do with the issue at hand."

But, of course, the comic book has everything to do with the issue at hand—because it is precisely the sort of safe-sex education that has produced the greatest amount of safe-sex education material of any in the country, including, of course, the federal government.[29]

GMHC, *Safer Sex Comix #4*. Artwork by Donelan, story by Greg. Courtesy GMHC.

Given the degree of Senate agreement that gay men's safe-sex education material was "garbage," in Helms's word, it seemed possible to compromise enough on the amendment's language to please all three participants in the debate. The amendment was thus reworded to eliminate any reference to IV-drug users, thereby assuaging Senator Chiles's fears that someone he knows and cares about—or someone in his neighborhood, or at least someone he doesn't mind talking about—could be affected. Helms very reluctantly agreed to strike the word *condone*, but managed to add *directly or indirectly* after *promote or encourage* and before *homosexual sexual activity*. Thus the amendment now reads:

> . . . none of the funds made available under this Act to the Centers for Disease Control shall be used to provide AIDS education, information, or prevention materials and activities that promote or encourage, directly or indirectly, homosexual sexual activities.

After further, very brief debate, during which Weicker continued to oppose the amendment, a roll-call vote was taken. Two senators—Weicker and Moynihan—voted against: *ninety-four senators voted for the Helms amendment*, including all other Senate sponsors of the federal gay and lesbian civil rights bill. Senator Kennedy perhaps voiced the opinion of his fellow liberal senators when he said, "The current version [the reworded amendment] is toothless and it can in good conscience be supported by the Senate. It may not do any good, but it will not do any harm." Under the amendment, as passed, most AIDS organizations providing education and services to gay men, the group most affected and, thus far, at the highest risk in the epidemic, would no longer qualify for federal funding.[30] Founded and directed by gay men, the Gay Men's Health Crisis is hardly likely to stop "promoting or encouraging, directly or indirectly, homosexual sexual activity." Despite the fact that GMHC is the oldest and largest AIDS service organization in the US; despite the fact that it provides direct services to thousands of people living with AIDS, whether gay men or not; despite the fact that GMHC's safe sex comics are nothing more scandalous than simple, schematically depicted scenarios of gay male safe sex; despite the fact that they have undoubtedly helped save thousands of lives—GMHC is considered unworthy of federal funding.

When we see how compromised any efforts at responding to AIDS

will be when conducted by the state, we are forced to recognize that all productive practices concerning AIDS will remain at the grass-roots level. At stake is the cultural specificity and sensitivity of these practices, as well as their ability to take account of psychic resistance to behavioral changes, especially changes involving behaviors as psychically complex and charged as sexuality and drug use.[31] Government officials, school board members, public health officers, Catholic cardinals insist that AIDS education must be sensitive to "community values." But the values they have in mind are those of no existing community affected by AIDS. When "community values" are invoked, it is only for the purpose of *imposing* the purported values of those (thus far) unaffected by AIDS on the people (thus far) most affected. Instead of the specific, concrete languages of those whose behaviors put them at risk for AIDS, "community values" require a "universal" language that no one speaks and many do not understand. "Don't exchange bodily fluids" is nobody's spoken language. "Don't come in his ass" or "pull out before you come" is what *we* say. "If you have mainlined or skinpopped now or in the past you may be at risk of getting AIDS. If you have shared needles, cookers, syringes, eyedroppers, water, or cotton with anyone, you are at risk of getting AIDS."[32] This is not abstract "community values" talking. This is the language of members of the IV-drug-using community. It is therefore essential that the word *community* be reclaimed by those to whom it belongs, and that abstract usages of such terms be vigorously contested. "Community values" are, in fact, just what we need, but they must be the values of our actual communities, not those of some abstract, universalized community that does not and cannot exist.

One curious aspect of AIDS education campaigns devised by advertising agencies contracted by governments is their failure to take into account any aspect of the psychic but fear. An industry that has used sexual desire to sell everything from cars to detergents suddenly finds itself at a loss for how to sell a condom. This paralysis in the face of sex itself on the part of our most sophisticated producers of propaganda is perhaps partially explained by the strictures placed on the industry by the contracting governments—by their notion of "community values"—but it is also to be explained by advertising's construction of its audience only as a group of largely undifferentiated consumers.

In *Policing Desire*, Watney writes of the British government's AIDS propaganda campaign, produced for them by the world's largest advertising firm, Saatchi and Saatchi:

Advertisements spelled out the word "AIDS" in seasonal gift-wrapping paper, together with the accompanying question: "How many people will

get it for Christmas?" Another advert conveys the message that "Your next partner could be that very special person"—framed inside a heart like a Valentine—with a supplement beneath which tersely adds, "The one that gives you AIDS." The official line is clearly anti-sex, and draws on an assumed rhetoric from previous AIDS commentary concerning "promiscuity" as the supposed "cause" of AIDS.[33]

Similar ploys were used for ads paid for by the Metropolitan Life Insurance Company and posted throughout the New York City Subway system by the city health department. One is a blow-up of a newspaper personals section with an appealing notice circled (intended to be appealing, that is, to a heterosexual woman) and the statement "I got AIDS through the personals." The other is a cartoon of a man and woman in bed, each with a thought bubble saying "I hope he [she] doesn't have AIDS!" And below: "You can't live on hope."

"What's the big secret?" asked the poster that was pasted over the city's worse-than-useless warnings, "You can protect yourself from AIDS." And, below, carefully designed and worded safe sex and clean works information. This was a guerrilla action by an AIDS activist group calling itself the Metropolitan Health Association (MHA), whose members also pasted strips printed with the words *government inaction* over *the personals* or *hope* to work the changes "I got AIDS from government inaction" or "You can't live on government inaction." But saving lives is clearly less important to the city than protecting the transit authority's advertising space, so MHA's "reinformation" was quickly removed.[34]

The city health department's scare tactics were next directed at teenagers—and specifically teenagers of color—in a series of public service announcements made for television. Using a strategy of enticement followed by blunt and brutal admonishment, one of these shows scenes of heavy petting in cars and alleys over a sound track of the pop song "Boom Boom": "Let's go back to my room so we can do it all night and you can make me feel right." Suddenly the music cuts out and the scene changes to a shot of a boy wrapped in a blanket, looking frightened, miserable, and ill. A voice-over warns, "If you have sex with someone who has the AIDS virus [*sic*], you can get it, too. So before you do it, ask yourself how bad you really want it. Don't ask for AIDS, don't get it." The final phrase serves as a title for the series—"AIDS: Don't get it." The confusion of antecedents for *it*—both sex and AIDS—is, of course, deliberate. With a clever linguistic maneuver, the health department tells kids that sex and AIDS are the same thing. But the ability of these PSAs to shock their intended audience is based not only on this manipulative language and quick edit from the scenes of sexual pleasure to

the close-up of a face with KS lesions on it—the media's standard "face of AIDS." The real shock comes because images of sexy teenagers and sounds of a disco beat are usually followed on TV by Pepsi-Cola and a voice telling you to get it. One can only wonder about the degree of psychic damage that might result from the PSAs' substitution. But AIDS will not be prevented by psychic damage to teenagers caused by ads on TV. It will only be stopped by respecting and celebrating their pleasure in sex and by telling them exactly what they need and want to know in order to maintain that pleasure.

> The ADS epidemic
> Is sweeping the nation
> Acquired dread of sex
>
> Fear and panic
> In the whole population
> Acquired dread of sex
>
> This is not a Death in Venice
> It's a cheap, unholy menace
> Please ignore the moral message
> This is not a Death in Venice

This is the refrain of John Greyson's music-video parody of *Death in Venice*. The plague in Greyson's version of the tale is ADS, acquired dread of sex—something you can get from, among other things, watching TV. Tadzio is a pleasure-loving blonde who discovers that condoms are "his very favorite thing to wear," and Aschenbach is a middle-class bigot who, observing the sexy shenanigans of Tadzio and his boyfriend, succumbs to acquired dread of sex. Made for a thirty-six-monitor video wall in the Square One shopping mall in Mississauga, a suburb of Toronto, *The ADS Epidemic*, like the PSAs just described, is directed at adolescents and appropriates a format they're used to, but in this case the message is both pro-sex and made for the kids most seriously at risk—sexually active gay boys. The playfulness of Greyson's tape should not obscure this immensely important fact: not a single piece of government-sponsored education about AIDS for young people, in Canada or the U.S., has been targeted at a gay audience, even though governments never tire of emphasizing the statistics showing that the overwhelming numbers of reported cases of AIDS occur in gay and bisexual men.

The impulse to counteract the sex-negative messages of the advertising industry's PSAs also informs British filmmaker Isaac Julien's *This is Not an AIDS Advertisement*.[35] There is no hint of a didactic

message here, but, rather, an attempt to give voice to the complexities of gay subjectivity and experience at a critical historical moment. In Julien's case, the specific experience is that of a black gay man living in the increasingly racist and homophobic atmosphere of Thatcher's Britain.[36] Using footage shot in Venice and London, *This is Not an AIDS Advertisement* is divided into two parts, the first elegiac, lyrical; the second, building upon and repeating images from the first, paced to a Bronski Beat rock song. Images of gay male sexual desire are coupled with the song's refrain, "This is not an AIDS advertisement. Feel no guilt in your desire."

Greyson's and Julien's videos signal a new phase in gay men's responses to the epidemic. Having learned to support and grieve for our lovers and friends; having joined the fight against fear, hatred, repression, and inaction; having adjusted our sex lives so as to protect ourselves and one another—we are now reclaiming our subjectivities, our communities, our culture . . . and our promiscuous love of sex.

1. See Simon Watney, *Policing Desire: Pornography, AIDS, and the Media* (Minneapolis: University of Minnesota Press, 1987), p. 13.

2. For an overview of theories of the cause of AIDS, see Robert Lederer, "Origin and Spread of AIDS: Is the West Responsible?" *Covert Action*, no. 28 (Summer 1987): 43-54; and no. 29 (Winter 1988): 52-65.

3. Quoted in Ann Giudici Fettner, "Bad Science Makes Strange Bedfellows," *Village Voice*, February 2, 1988, p. 25.

4. Randy Shilts, *And the Band Played On: Politics, People, and the AIDS Epidemic* (New York: St. Martin's Press, 1987). Page numbers for all citations from the book appear in parentheses in the text.

5. The fact that Shilts chose this moment as the end point of his narrative suggests that the book's central purpose is indeed to prove the irresponsibility of all journalists but Shilts himself, making him the book's true hero.

6. Shilts writes in his "Notes on Sources," "This book is a work of journalism. There has been no fictionalization. For purposes of narrative flow, I reconstruct scenes, recount conversations and occasionally attribute observations to people with such phrases as 'he thought' or 'she felt.' Such references are drawn from either the research interviews I conducted for the book or from research conducted during my years covering the AIDS epidemic for the *San Francisco Chronicle*" (p. 607).

7. Roland Barthes, *Writing Degree Zero*, trans. Annette Lavers and Colin Smith, (Boston: Beacon Press, 1967), p. 60.

8. I say *created* because, though Gaetan Dugas was a real person, his character—in both senses of the word—was invented by Shilts. Moreover, contrary to the St. Martin's press release, Shilts did not "discover" "Patient Zero." The story about how various early AIDS researchers were able to link a number of early cases of the syndrome—which was done not to locate the "source" of the epidemic and place blame, but simply to verify the transmissibility of a causal agent—was told earlier by Ann Giudici Fettner and William A. Check. Dugas is called "Eric" in their account, and his character is described significantly differently: "He felt terrible about having made other people sick," says [Dr. William] Darrow [a CDC sociologist]. "He had come down with Kaposi's but no one ever told him it might be infectious. Even at CDC, we didn't know then that it was contagious. It is a general dogma that cancer is not transmissible. Of course, we now know that the underlying immune-system deficiency that allows the cancer to grow is most likely transmissible." (*The Truth About AIDS* [rev.ed.: New York: Henry Holt, 1985], p. 86). Thanks to Paula Treichler for calling this passage to my attention.

9. A.M. Rosenthal, "AIDS: Everyone's Business," *New York Times*, December 29, 1987, p. A19.

10. Larry Kramer, *The Normal Heart* (New York and

Scarborough, Ont.: New American Library, 1985). Page numbers for citations are given in the text.

11. In October 1987, the *New York Times* reported that the New York City Department of Health conducted a study of drug-related deaths from 1982 to 1986, which found an estimated 2,520 AIDS-related deaths that had not been reported as such. As a result, "AIDS-related deaths, involving intravenous-drug users accounted for 53 percent of all AIDS-related deaths in New York City since the epidemic began, while deaths involving sexually active homosexual and bisexual men accounted for 38 percent." Even these statistics are based on CDC epidemiology that continues to see the beginning of the epidemic as 1981, following the early reports of illnesses in gay men, in spite of anecdotal reporting of a high rate of deaths throughout the 1970s from what was known as "junkie pneumonia" and was likely *Pneumocystis* pneumonia. Moreover, the study was undertaken not through any recognition of the seriousness of the problem posed to poor and minority communities, but, as New York City Health Commissioner Stephen Joseph was reported as saying, because "the higher numbers . . . showed that the heterosexual 'window' through which AIDS could presumably jump to people who were not at high risk was 'much wider than we believed.'" Ronald Sullivan, "AIDS in New York City Killing More Drug Users," *New York Times*, October 22, 1987, p. B1.

12. I borrow the phrase from Guy Hocquenghem who used it to describe a gay movement increasingly devoted to civil rights rather than to the more radical agenda issuing from the New Left of the 1960s.

13. I do not want to suggest that there are no gay community organizations for or including transvestites, sex workers, or Latino immigrants, but rather that no organization representing highly marginalized groups has the funding or the power to reach large numbers of people with sensitive and specific AIDS information.

14. Lee Chiaramonte, "Lesbian Safety and AIDS: The Very Last Fairy Tale," *Visibilities* 1, no. 1 (January–February 1988): p. 5.

15. Ibid., p.7.

16. Cindy Patton, *Sex and Germs: The Politics of AIDS* (Boston: South End Press, 1985); and Cindy Patton and Janis Kelly, *Making It: A Woman's Guide to Sex in the Age of AIDS* (Ithaca: Firebrand Books, 1987).

17. Cindy Patton, "Resistance and the Erotic: Reclaiming History, Setting Strategy as We Face AIDS," *Radical America* 20, no.6 (1986): p. 68.

18. Ibid., p. 69.

19. Ibid., p. 72.

20. *How to Have Sex in an Epidemic* is the title of a forty-page pamphlet produced by gay men, including PWAs, as early as 1983. See ibid., p. 69.

21. Art Ulene, *Safe Sex in a Dangerous World* (New York: Vintage Books, 1987), p. 31.

22. In fact there continue to be concerted efforts to deny that everyone is at risk of HIV infection. The *New York Times* periodically prints updated epidemiological information editorially presented so as to reassure its readers — clearly presumed to be middle-class, white, and heterosexual — that they have little to worry about. Two recent articles that resurrect old myths to keep AIDS away from heterosexuals are Michael A. Fumento, "AIDS: Are Heterosexuals at Risk?" *Commentary* (November 1987); and Robert E. Gould, "Reassuring News About AIDS: A Doctor Tells Why You May Not Be at Risk," *Cosmopolitan* (January 1988). That such articles are based on racist and homophobic assumptions goes without saying. The "fragile anus/rugged vagina" thesis is generally trotted out to explain not only the differences between rates of infection in gays and straights, but also between blacks and whites, Africans and Americans (blacks are said to resort to anal sex as a primitive form of birth control). But Gould's racism takes him a step further. Claiming that only "rough" sex can result in transmission through the vagina, Gould writes, "Many men in Africa take their women in a brutal way, so that some heterosexual activity regarded as normal by them would be closer to rape by our standards and therefore be likely to cause vaginal lacerations through which the AIDS virus [*sic*] could gain entry into the bloodstream."

23. Cindy Patton tells of similar advice given to gay men by a CDC official at the 1985 International AIDS conference in Atlanta: "He suggested that gay men only have sex with men of the same antibody status, as if gay male culture is little more than a giant dating service. This advice was quickly seen as dehumanizing and not useful because it did not promote safe sex, but renewed advice of this type is seen as reasonable within the heterosexual community of late." Patton, "Resistance and the Erotic," p. 69.

24. Ulene, *Safe Sex*, p.49.

25. Unless otherwise stated, all quotations of this debate are taken from the *Congressional Record*, October 14, 1987, pp. S14202–S14220.

26. Gary Bauer, "AIDS and the College Student," *Campus Review* (November 1987), pp. 1, 12.

27. Compare Larry Kramer's character Ned Week's statement: "You don't know what it's been like since the sexual revolution hit this country. It's been crazy, gay or straight" (p. 36).

28. In the Senate debate, positions such as Helms's are referred to as philosophical. Thus Senator Weicker: "This education process has been monkeyed around with long enough by this administration. This subcommittee over 6 months ago allocated $20 million requested by the Centers for Disease Control for an educational mailer to be mailed to every household in the United States That has yet to be done. It is yet to be done not because of anybody in the Centers for Disease

Control, or not anybody in Secretary [of Health and Human Services] Bowen's office, but because the philosophers in the White House decided they did not want a mailer to go to every household in the United States. So the education effort is set back." *Congressional Record*, October 14, 1987, p. S14206.

29. George Rutherford of the San Francisco Department of Public Health last year told a U.S. Congressional Committee investigating AIDS that the spread of the virus dramatically slowed in 1983, when public health education programmes directed at gay men began. The year before, 21 percent of the unexposed gay population had developed antibodies to HIV, indicating that they had been exposed to the virus over the previous three months. But in 1983, that figure plummeted to 2 percent. In 1986 it was 0.8 percent, and researchers expect that it will continue to fall. . . . The campaigns to promote safe sex among gay men, and educate them about AIDS have been almost totally successful in less than four years. Such rapid changes in behaviour contrast sharply with the poor response over the past 25 years from smokers to warning about the risks to their health from cigarettes." "'Safe Sex' Stops the Spread of AIDS," *New Science* (January 7, 1988), p. 36.

In a study of the efficacy of various forms of safe-sex education materials, commissioned by GMHC and conducted by Dr. Michael Quadland, professor of psychiatry at Mount Sinai School of Medicine, it was determined that explicit, erotic films are more effective than other techniques. Dr. Quadland was quoted as saying, "We know that in trying to get people to change risky behavior, stopping smoking, for example, or wearing seat belts, that fear is effective. But sex is different. People cannot just give sex up." Gina Kolata, "Erotic Films in AIDS Study Cut Risky Behavior," *New York Times*, November 3, 1987.

30. After the House of Representatives passed the amendment by a vote of 368-47, a full-scale lobbying effort was undertaken by AIDS organizations and gay activists to defeat it in House-Senate Conference Committee. Ultimately, the amendment was retained as written, although *indirectly* was stricken and the following rider added: "The language in the bill should not be construed to prohibit descriptions of methods to reduce the risk of HIV transmission, to limit eligibility for federal funds of a grantee or potential grantee because of its nonfederally funded activities, nor shall it be construed to limit counseling or referrals to agencies that are not federally funded."

31. Richard Goldstein has written about the necessity to take account of the social and psychic dimensions of IV-drug use in trying to bring about behavior changes: "Rescuing the IV user may involve some of the same techniques that have worked in the gay community. The sharing of needles must be understood in the same context as anal sex—as an ecstatic act that enhances social solidarity." Richard Goldstein, "AIDS and the Social Contract," *Village Voice*, December 29, 1987, p.19.

32. Quoted from a pamphlet issued by ADAPT (Association for Drug Abuse Prevention and Treatment), Brooklyn, New York.

33. Watney, *Policing Desire,* p. 136.

34. I borrow the term *reinformation* from Michael Isenmenger and Diane Neumaier, who coined it to describe cultural practices whose goal is to counter the disinformation to which we are all constantly subject.

35. Available through Third World Newsreel, New York City.

36. In late 1987, a Helms-style anti-gay clause was inserted in Britain's Local Government Bill. Clause 28 says, "A local authority shall not (a) promote homosexuality or publish material for the promotion of homosexuality; (b) promote the teaching in any maintained school of the acceptability of homosexuality as a pretended family relationship by the publication of such material or otherwise; and (c) give financial assistance to any person for either of the purposes referred to in paragraphs (a) and (b) above." Unlike the Helms Amendment, however, the British bill, though a more sweeping prohibition of pro-gay materials, specifically forbids the use of the bill "to prohibit the doing of anything for the purpose of treating or preventing the spread of the disease."

Chapter 2:

"Working hours and hours and hours and hours and hours and hours just organizing."

Laurence: We began to focus on the AIDS crisis as all of us, and Philip in particular, began losing friends at such a rapid pace. AMI was able to support Visual AIDS and the Red Ribbon Project. We didn't even intend to be the primary funders of those organizations, although we were for a long time.

Mary: *We were socially conscious and tried to be responsive and responsible to issues that were out there.*

Philip: We were phasing out our funding for organizations in order to focus on individual artists, but we looked at the amount of money we'd given to organizations in '89, about $100,000, and assigned that amount of money to just two organizations. Half of it went to two fellowships, one to Patrick O'Connell and one to Alexander Gray, to run Visual AIDS.

Kathy: There was a question as to whether it would be better to support individual artists or to engage in a lobbying effort. Less and less money was going to be available for the type of artists that we were funding. The mission of AMI was to support excellence but also to support difficult artwork. We always understood that it wasn't just about giving grants but was also about doing education and activism and lobbying to encourage individual artists to keep making their difficult work.

Cee: Some of us felt that these were the issues that were at hand right now, these were things we've always been interested in, and this is a way we can make an impact. It's different from what we'd been doing but, so what? Others were saying, "That's like thirty grants." Yeah, it could be thirty grants, but if these issues aren't handled now, what difference does it make? It's about safeguarding an environment in which art can be created safely and treated with respect.

Laura: I wanted the money to go to artists—and that was probably where we started to have divergence. From '89 into '90 there were powerful, powerful, issues that were permeating every aspect of art-making. They had to do with AIDS and with First Amendment rights. I understood that. I really got it. But that didn't mean that I felt that was where we should be directing our funding. I didn't want AMI to become a political instrument or another radicalized organization, and I didn't feel right doing that personally. I certainly had a lot of concern about AIDS. I don't think anybody at that time who related to people in the art world didn't. There were just so many people dying. I just didn't want to set a course for myself and AMI that had all involved so much confrontation and politicizing.

Mary: Laura was always a little bit uneasy with some of the violent and the angry art, and the advocacy was related to that.

Laura: There were times that I didn't like the art that was getting made, but it really wasn't about that. And I wasn't against what informed that art. I just didn't want AMI to become about those issues. AMI was established to support art-making, including political art-making, but with the emphasis on the making of art, not the politics. It's not that I wasn't willing to entertain some controversy. I can, and believe me I did, consider a lot of points of view. But when we were giving a total of $150,000 and they wanted to give $50,000 to a person to do a residency in Washington, basically as a lobbyist. . . I didn't want to go there. Even though we had an incredibly egalitarian format at AMI, at the last minute it always came down to, Was I willing to put money on the table for that? That was very difficult for them and for me. It was always really difficult. . . You look like you want to cry.

Marianne: Laura would never ask anyone to renege on a grant because of her opinion. But it was the midst of the AIDS crisis and Philip was ripped apart and half-crazy from grief most of the time because so many of his friends all over the country were dying every day. Some of the discussion that took place at AMI was just too painful for him. I think it was very sad for everyone, very sad.

Laura: I loved the process and really didn't want to let go, but I knew I had to let them do what was important to them.

Mary: After Laura left we asked ourselves, What will our role be now? We have nobody to answer to but ourselves. We can do things without hesitation. I have to say we felt freer. We never worried that Laura wouldn't write the check at the end of the day, but we did want her to feel good about doing something worthwhile.

David: *Legally, we ultimately got a clear answer that our advocacy activities were not a problem. Lobbying and advocacy are two different things. If you meet with elected officials but there's no legislation, that's advocacy. If there is pending legislation, it's lobbying. Nonprofits are forbidden to get involved in electoral campaigns, but can still spend up to 20 percent of their budget on advocacy that relates to their program. I don't think Laura's concern had to do with what we were doing advocacy about. I think it had more to do with her philanthropic background. In the context of foundation-giving, money for lobbying is like a little red light going off. With Laura, there was not an opposition in political viewpoints at all. It had, however, become her philosophy that being oppositional or negative was not good.*

Laurence: It never occurred to me that we were funding against something. I think that we would have funded pretty much the same way had there not been Jesse Helms and homophobia, because the nature of the foundation was to be extremely empathetic and concerned. There may be some artists who would not have been funded without the AIDS crisis. I'm not certain.

Marianne: There is a point where polemical work can become purely didactic and not necessarily that interesting. We certainly saw a lot of work like that in the early '90s. The best examples of work which excited the board most were works that had both aesthetic sophistication and a message. Everything from Gran Fury to the Guerrilla Girls. The Donald Moffett grant, which we gave him before Gran Fury, occasioned the argument with Laura about being negative. The text was violent, but it was also beautiful, and it went with a image of a daisy which was also quite beautiful. It was odd that that argument happened over that specific image.

Adam: *It's a role of the artist to be confrontational, to challenge, but it's not the only function of contemporary art. The way I put it was, If I spit on your foot, I'm going to get your attention, but I'm not sure I'll put you in the frame of mind where you want to engage in a dialogue. There are times to spit on people's feet but I think we also have to spend time engaging people.*

Philip: *Just because I was concerned and stood up and spoke about issues; I was seen as an activist. And it scared people. Even just defending Mapplethorpe—not that I think he's such a great artist. The only thing that he made that was close to art, really, were those images that transgressed. The rest of it is just decorative.*

David: *There were times when I was very resentful and angry about the hesitancy and lack of support for advocacy and political activism around the issues that were affecting all of us—and not just from the foundations, but from arts organization, as well.*

Mary: I felt great about the advocacy AMI did, I thought it was really important. Although there were moments when it seemed like we were overdoing it or were being pushed so strongly in that direction that other voices weren't being heard.

Kathy: There was a discussion at one time about whether or not to make a further commitment to activist work, advocacy, and even lobbying. If we had honestly felt that advocacy was the best way to go, that would have been an option for us.

Cee: As AMI became inextricably entwined by several of its personalities in activities that were important to its board, AMI became associated with advocacy. Sometimes it was difficult for people to distinguish between the different entities. Two of the founders of Visual AIDS, Philip and I, were board members of AMI, and I was also on the board of the Campaign. It was a wonderful little beehive.

Marianne: *Starting in about 1986, Philip became very politicized in every aspect of his life. So did Cee, who joined the Gay and Lesbian Task Force very early on.*

Cee: AMI gave us a vehicle to provide support. If I was sitting around a table and there was a need for money to get the Red Ribbon Project off the ground, I could say, AMI will put in $2,500 if Warhol will put in $2,500 and if New York Community Trust will put in $2,500 and J.P. Morgan will put in $2,500. By opening my big mouth and spending $2,500 without even having board approval, I could get foundations to ante up money even when they didn't want to and bring in $10,000—enough money to get things off the ground. AMI enabled us to put a little money where our mouths were. Philip would do the same thing. David would do the same thing working on issues of freedom of expression. They needed $1,500 to get some people that were geographically repressed somewhere to a meeting. Once in a while he would take a leap and say, I think AMI will put up the few hundred dollars for that. We were small-fries in the foundation community— we had no financial clout. But what we did do was stir up the waters.

Philip: *I was not at the first meeting for Visual AIDS. Bill Olander from the New Museum, Tom Sokolowski from the Grey Art Gallery, Robert Atkins from the Village Voice, and a few other people began it. They got together out of concern that there were so many people in the visual arts world who were dying of AIDS. They wanted to create an information center to keep a record of the art of the people who died. At the first general meeting I attended,*

John Perrault said, "Why don't we ask museums to participate in a moratorium, like the Vietnam War moratorium in 1972?" My hand shot into the air immediately. "Oh, don't be ridiculous, they may have done that then, but they would never do that now. Actually, most of them didn't even do it then." That put an end to the conversation. Then I felt tremendously guilty. Who the fuck are you? How do you know? I kept thinking about it. Then the idea of the title, Day Without Art, flashed into my head. So I went back and said, "I think I was out of line." I volunteered to contact ten or twelve museums and other arts organizations across the country to see if they would participate. I contacted people I knew and I got yesses back from everybody. They said, "We would not do a moratorium, that's too negative, but we would do something." We chose December 1st.

Cee: *AMI was supporting Visual AIDS, but Visual AIDS was also just a lot of people power. The first two Days Without Art, Philip and I were working hours and hours and hours and hours and hours and hours just organizing. It was voluntary, and it came about through diligence and time spent—basically, just out of desperation. What can we do to make a difference? I think the first Day Without Art got quite a bit of visibility for the organization. It did capture people's imaginations. Imagine, if you will, that all the creative people in the world were gone due to AIDS. How that would impact you? Even if you don't particularly think of yourself as someone in the art world.*

Philip: *Patrick O'Connell volunteered to set up mailing lists—on AMI computers. Out of the 3,000 notices we sent maybe 1,000 organizations agreed to participate. It was more successful in commercial galleries and university museums. A lot of municipal museums were too conservative to participate until two or three years down the road. But it really snowballed after the second year. It became like folk art, with people choosing their own way of doing it. There was no necessary form.*

Cee: *One year a cable station wanted to do a moment without television, thirty seconds when the screen just went black. And they gave free subscriptions for that evening to an extra three million people.*

Philip: *Some places took work down. The Metropolitan Museum ended up taking down Picasso's portrait of Gertrude Stein, which is funny because, of course, she's one of the few out dykes they had a picture of. How they chose to do that. . . . What was that? Weird. But it was amazing that they did anything at all. The Museum of Modern Art became the centerpiece despite the fact that the director of the Modern, Dick Oldenberg, did not want to participate. But he couldn't say no. He just hated me after that. Agnes Gund gave us money to cover the expenses of having a kind of memorial service. David Wojnarowicz and Jane Smith read statements. Leonard Bernstein played songs he had written for people who died. It was well attended and very touching—although it couldn't be all that touching because the Garden Hall of the Modern is like the middle of a shopping mall. The second year we added Night Without Light and tried to get the skyline of New York turned off for fifteen minutes in recognition of those who had died. And it worked! We did it! One could adopt the position, "Who am I? I can't change anything so why should I even bother? My vote doesn't count. My voice won't be heard." We discovered that four or five people with some time and some ideas and some energy could get the skyline of New York turned off. It was incredible. A lot of people scoffed at a Day Without Art because it was a way for a museum that didn't give a shit about anybody the rest of the year to cleanse its conscience. One of my points was that if you got museums to consider participating, you got to the boardrooms eventually. And in the boardrooms sit the people who run insurance companies and hospitals and so on and so forth. At the first or second Day Without Art, Elizabeth Taylor came and spoke at*

MoMA. It was to an audience of celebs, but it got a lot of media. It was all about gestures. The Red Ribbon Project, too. ACT UP got pissed because they thought the whole thing was silly. But what happened is really about power. That Ribbon ended up on a stamp. That was the brainchild of two or three people. The idea was to get everybody at the Tony Awards ceremony one year to wear red ribbons. And then it got on the Grammy Awards and then it got on the Academy Awards. It was beg, borrow, and steal. It was cottage industry. A lot of it was donated ribbon and groups of guys would just sit there, night after night, making them.

Cee: *We would also have people in women's shelters, for example, making ribbons. Organizations around the city or around the country were calling. We need six hundred ribbons for the Oscars. Can you get us that? And we'd provide them by buying the ribbon and taking it over to the women's shelter and getting people actively involved because they liked the cause. It was all voluntary work.*

Philip: *It was the same thing with needle exchange. During the activist late '80s and early '90s, there were people around who were willing to put in the time.*

Cee: *Another thing Philip and I started was* Future Safe. *It was a booklet we developed to get information out to artists who are living with AIDS and other life-threatening diseases on how they can control their legacy.*

> **Philip:** I got labeled as a fag-activist, which ultimately had ramifications for AMI.

Cee: *Visual AIDS also did the Electric Blanket at different locations around the world, usually in conjunction with World AIDS Day. It was a slide-projection with music for an exterior space about people that had died of AIDS or were living with AIDS, with images about activism as well as remembrance. I'm not sure if it's still going. I've lost touch.*

> **Marianne:** AMI became known as a political entity, which is frowned upon for private foundations.

Philip: *By '92 I was completely burnt out and practically everyone I knew was dying. So I pulled back. About the only thing I didn't quit doing was AMI.*

Demanding Presence

chapter 3

Identity Politics

CH-46 aircraft right now.

MIKE WALLACE: I'm Mike Wallace.

SAFER: I'm Morley Safer.

BRADLEY: I'm Ed Bradley.

STEVE KROFT: I'm Steve Kroft.

STAHL: I'm Lesley Stahl. Those stories and Andy Rooney tonight on 60 MINUTES.

(Announcements)

Art World Is Not Amused by Critique (Carol Vogel, New York Times, October 4, 1993)

YES...BUT IS IT ART?

MORLEY SAFER: Without question, this story, YES, BUT IS IT ART?, first broadcast last September, generated more mail than anything we've broadcast for years, and it's still coming. Art seem to strike a powerful nerve in the American psyche, especially when a vacuum cleaner like this

The Great Massacre of 1990

"What happened? Luxury spending is the first thing to fail when the oxygen goes out of the economy; art is the canary in the mine shaft. But behind that lies something more basic. The art market is inherently volatile because, unlike other markets, it is tied to no intrinsic value. The price of art is determined purely and solely by desire."[13]

last November; the long-anticipated winter sale of contemporary art, and here it is, folks.

Unidentified Woman #1: Lot 242, the Gerhard Richter. Please note that the measurements for this work are reversed. It's actually a horizontal painting--I'm sorry, it's actually a vertical painting, 78 X 59 inches. And we start here at $50,000 as bid for this.

And we start here at--$10,000 it's bid for this. Now at $10,000.

Unidentified Man #1: ...$1,800,000. Down it goes then at $1,800,000--9. At 1,900,000. I have $1,900,000. Now say $2 million.

(Painting shown)

SAFER: *(Voiceover)* This one, a canvas of scrawls done with the wrong end of a paint brush, bears the imaginative title of "Untitled." It's by Cy Twombly, and was sold for 2,145,000. And that's dollars, not Twomblys.

Man #1: And $20,000 to start this. Now $20,000.

(Painting shown)

SAFER: *(Voiceover)* There were bargains. `Rat' repeated three times reached $30,000.

Man #1: Sold at $30,000. Yours, sir.

(Painting shown)

$13,000.

Man #1: ~~Subtracted $650,000 for its I have seven~~

(Footage of attendees at the auction)

SAFER: *(Voiceover)* The auction itself was a glittering affair. A bank of phones connected Paris, Geneva, Frankfurt and London. Among the hottest items:

Man #1: Lot number 72. This is sold from the catalogue.

(Three basketballs in a fish tank shown)

SAFER: Jeff Koons' inspired work, three basketballs su~~b~~ tank, $150,000, giving new meaning to slam dunk.

Mr. JEFF KOONS (Artist): Wow, Dr. J.

(Footage of Safer with Koons; Spalding basketball show~~n~~

SAFER: *(Voiceover)* And back in his New York studi~~o~~ more where that came from, and a slightly shaky versi~~on~~ means.

Mr. KOONS: This is an ultimate state of being. I_I wanted__I wanted to

> "For the contemporary art market, then, the fall 1990 sales were a massacre. Scared by the descent of the Nikkei stock index, the Japanese—who in 1988 accounted for more than half the total recorded sales volume of all art bought at auction worldwide—bid sluggishly or sat on their hands."[14]

> "Is the age of artist as rock star over? The crowd at Sotheby's laughed when a Julian Schnabel failed to sell."[15]

ction prices plunge, overhyped contemporary works are hit the hardes~~t~~

SAFER: *(Voiceover)* What did he say? The language is artspeak. The same pitch that convinced the emperor to buy new clothes, or waterlogged basketballs.

Mr. KOONS: I was giving a definition of life and death. This is the eternal. That is what life is like also, after-death. Aspects of the eternal.

(Footage of Koons and Safer, artworks)

SAFER: *(Voiceover)*: Jeff Koons is a genuine phenomenon. Still in his 30s, he's become a millionaire since he moved from commodity brokering on Wall Street to art-mongering to the world. He doesn't actually paint or sculpt. He commissions craftsmen to do that or he goes shopping for basketballs and vacuum cleaners.

What makes them art, Jeff?

Mr. KOONS: I always liked the anthropomorphic quality. They're like lungs. So this object now is just free to eternally just display its newness, its integrity of birth.

SAFER: So what do you say to the man who said, `F~~o~~ paid $100,000; I just got a genuine Koons for $80.'

Mr. KOONS: This work would be signed work by myse~~lf~~ a letter of authenticity.

> "But anyone who thinks the market decline will instantly produce saner relations between art and the public ought to think again. In the long run, in art as in nature, the fittest will survive."[16]

(San Francisco Museum of Modern Art shown)

SAFER: *(Voiceover)* He's already had a retrospective at the San Francisco Museum of Modern Art.

SOLD

It went crazy, it stays crazy, but don't ask what the art market is doing to museums and the public

headline, *Time*, November 27, 1989

"The anemic art market the 1990's is casting a on the downtown scene."

In November 1990 Congress amended the NEA authorization requiring artistic merit be judged "with consideration of general standards of decency and respect for the diverse beliefs and values of the American public." The NEA announced intent to implement the "decency and respect clause" by insuring representation of diverse beliefs and values on NEA peer review panels.

"I don't know why it always annoys people to imagine artists doing well."[18]

tearsheet, *People* magazine, November 29, 1993

CONTROVERSY

ROGUES' GALLERY?

Morley Safer gleefully trashes modern art— and critics bite back

Too much museum fare, says Safer (looking askance at works by Mike Kelley on display at the Whitney), is "really a case of the emperor's new clothes."

O N A BLUSTERY FALL DAY OUTSIDE NEW York City's Whitney Museum of American Art stands Morley Safer, prepared, once again, to invade enemy territory. For two months the veteran *60 Minutes* correspon- | with cries of "philistine" and "moron" ringing in his ears. His attackers are outraged members of New York City's art establishment. But it was Safer himself who fired the shot heard 'round the gal- | Safer, 62, his gravelly voice rumbling with contempt, proceeded to savage such high-priced contemporary artists as Cy Twombly (one of whose $2 million paintings Safer described as "a canvas of scrawls done

"A strict capitalist, the economic equivalent of a fundamentalist in religion, might argue that the inability of art forms to survive in the marketplace is the best indication that they probably do not deserve to survive."[19]

"Morely Safer was spotted at the Whitney's black-tie gala in late October, sitting down to dinner with the same trustees whose collections he scorned and whose intelligence he mocked not a month earlier. Safer mingled with the trustees for an hour, then sat at a table paid for by the Hearst Corporation. (...) Naturally, Hilton Kramer also attended the benefit...he sat at the table of Whitney trustee Charles Simon, of Salomon Brothers."[20]

THE NEW YORK TIMES **WASHINGTON TALK** FRIDAY, JUNE 30, 1989

Juggling Money, Taste And Art on Capitol Hill

By BARBARA GAMAREKIAN
Special to The New York Times

WASHINGTON, June 29 — Representative Bob Carr, the Michigan Democrat who is chairman of the Congressional Arts Caucus, thinks it odd that the Bush Administration has requested an appropriation of $193 million for military bands but only $170 million for the National Endowment for the Arts.

"It doesn't seem right that the Pentagon gets more money for its musical purposes than we budget for support of the arts in the whole rest of the country," Mr. Carr said. "I'm not quarreling with military bands, as some of our country's best musicians are in uniform, but it graphically demonstrates our screwy priorities."

This is the point the caucus has been making since it was founded in 1981 by Representative Frederick W. Richmond, a Brooklyn Democrat.

The primary purpose of the 250-member caucus is the support of

Gallery of Art. The show was canceled by the gallery on the ground that an uproar over the next appropriation for the arts endowment might result.

The uproar came anyway, over the cancellation as well as the financing. The House Appropriation Committee today approved new guidelines to make the endowment more accountable for where its money goes. The proposal now goes to the floor of the House.

"I've talked to some members and urged them not to get too excited," Mr. Carr said. "Not that they aren't entitled to be offended, but if we get into a situation where a Congressman or some group in society takes offense at something some artist does and that is used as a reason not to fund the endowment, or limit its funding, or require that some sort of censure board on what is good art and what is bad art be set up, then I think we are going down a very troubled road."

At Mr. Downey noted, the arts caucus has been witness to other attempts to cut endowment financing. Early on, caucus members successfully fought a proposal by the Reagan

The Congressional Arts Caucus is

t everyone had come to bid, but everyone had come on serious business.

he republic of Art this was the equivalent of a joint session of Congress.

contemporary market had been read the riot act at November's sales,

ch, it was feared, had finally put paid to the floating opera of the eighties."[21]

Congressional Record

United States
of America

PROCEEDINGS AND DEBATES OF THE *101*[st] CONGRESS, FIRST SESSION

Vol. 135 WEDNESDAY, JULY 12, 1989 No. 92

House of Representatives

Exerpts from Debate on Funding for the National Endowment for the Arts.

WHICH OF THE PROPOSALS IN CONGRESS FOR FUNDING THE ARTS DO YOU FAVOR?

Cutting federal funding of the NEA 5% a year for the next five years.

37%

Continuing federal funding of the NEA at current levels.

30%

Eliminating all federal funding of the NEA within two years.

21%

From a telephone poll of 1,000 adult americans taken for TIME/CNN on July 19-20, by Yankelovich Partners Inc. Sampling error is ±3%. "Not sures" omitted.

oppositi- e floor. HOLM's e dam- by Mr. tleman CHER's f these ica and ically a ow one

enuous M is en- mend

ing to State and local governments have squeezed their own cultural funding budgets, and corporate mergers are eliminating corporate arts programs. Meanwhile, rising real estate and insurance costs have crippled small creative arts groups, while changes in tax law have resulted in fewer private charitable contributions to the arts.

This last point is important because it directly addresses a fallacy offered by the gentleman from California who is opposing all funding of the arts. He has stated, that 'There is no shortage of private financial support for the arts.' This is a patently false assertion, and I would invite anyone who disagrees to visit the hundreds of artists in my district who are finding the search for funds, private or public, to be a nearly impossible quest. Clearly, we should be here today debating how much to increase the NEA's budget, not whether to cut it further.

of controversy over two recent artistic exhibits partially subsidized by Federal funds. Critics of the NEA have expressed outrage over two objectional works which received small amounts of NEA support. They argue that we should send a message to the NEA, not only by changing their procedures to ensure Government control over the grants that organization makes, but also by cutting their funding even further.

But the issue of what type of art the NEA awards grants for brings up some perhaps obvious questions. And let me stress here that the issue we are debating here today, contrary to assertions from the other side, is definitely cen-

"Even if the public's hostility were just a whim, so what? Artists who peddle their whims as art, counting on an absence of critical standards, cannot suddenly claim to have standards superior to the public's and incomprehensible to the public. And they cannot hide behind this crashing non sequitur: great innovations in art often have met hostility, therefore whatever provokes hostility must be a great innovation."[22]

orts or ed gen- sful. If mply to 1980, it ad, last and we duce it

drastic. to issue al fund-

works banned. Should libraries which carry these and other objectional classics be prevented from receiving Federal funds?

There are other nations around the world which have standards for acceptable and unacceptable artistic expression. We call them totalitarian. In these nations, writers or artists who challenge the boundaries of acceptable expression are imprisoned or worse. Witness the death sentence decreed by the Ayatollah Khomeini on the writer Salman Rushdie because of perceived offense to the prophet Mohammed. Clearly, the U.S. Government must continue to stay out of the business of defining boundaries for acceptable artistic expression.

During this entire debate, son that artistic freedom is fine, but i are used for a project, it must n or objectionable. But it is folly Federal funds are used for a pr ect must be acceptable to all tax who make this argument might able with its ramifications. For found the design of the Viet Memorial in Washington, DC, but few would now argue that should not have been used to s struction on account of those o

The NEA's current grantmak were carefully designed to lim control over or political intervention in the

where it leads.

It seems to me that what we ought to really do is to have faith in ourselves and the ideals for which America stands. Let Members, indeed, exult in the fact that we are a country that is free enough to allow artistic expressions, even if we find them offensive and objectionable.

I would hope we would defeat all of these amendments, and let the work of the committee stand.

Mr. Chairman, I would like to close with a quote which expresses the most important point to remember in this debate:

In recognizing those who create and those who make creation possible, we celebrate free

Mr. ARMEY. Mr. Chairman, I appreciate the gentleman yielding, since he made reference to me within the context of his remarks. Let me make two points: One, the gentleman from Texas (Mr. STENHOLM) has offered an amendment for a $45,000 reduction, $30,000 in direct reprisal for the grant that funded this book, and I will not show Members the prints within this book, $15,000 for the money that funded the Serrano grant.

Now, if that is not specific targeting of a pecuniary reprisal in the person of the particular products, then I do not know what is.

Mr. WEISS. Mr. Chairman, if I may reclaim my time, the gentleman from Texas has said that his cut, his proposed cut of $14 million is to

ional y for two tially

ually an is ticu- nt of man

ment er a aking gres-

"Even if grants to artists had been ten times larger, would the artists concerned have changed their views of capitalism or of their society? Not very likely. For yet another of our cultural traditions holds that the artist is disenfranchised from birth, a citizen only of his own imagination—the original, and perennial, man without a country."[23]

sions. These two are only the most clear and

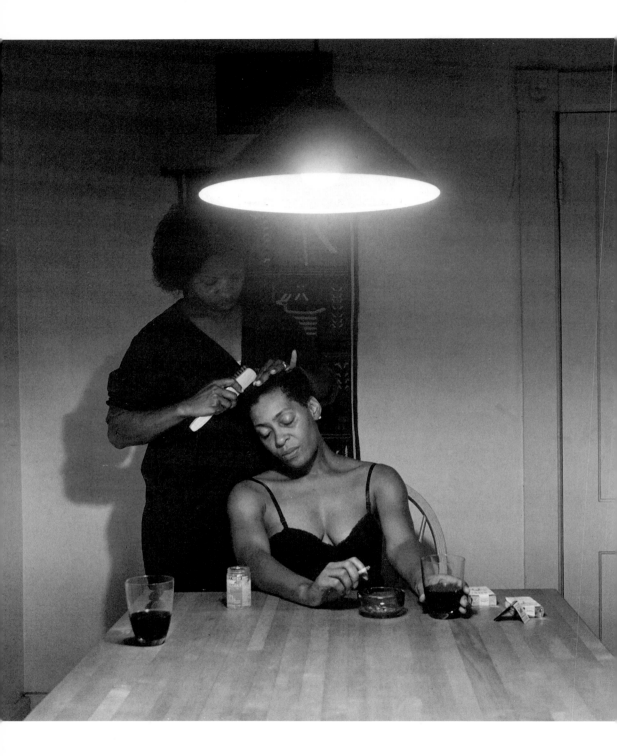

The Culture War Within the Culture Wars: Race

MICHELE WALLACE

Everybody knows that "war" means the situation is pretty bad. A war is a fight, or a series of battles, over something about which people have agreed to disagree; at least temporarily, peace is out of the question. I first heard the term "culture wars" in the late 1980s, around the time I first discovered Robert Mapplethorpe's extraordinary photographic nudes, which were then causing all the fuss. The photographs were beautifully made compositions of mostly nude black and white men. Serene, fluid, and formally well-executed, these photos were at the same time surprisingly and precisely pornographic. Given this particular context, I wondered what "culture wars" meant for black people, or even for people like myself—black cultural workers, intellectuals, artists, and academics. Just exactly who was at war, over what, and how many sides were there? Were we (black people) participants, and, if so, whose side were we on?

According to then-current usage, the phrase "culture wars" was limited to the immediate ramifications of the successful effort by the Christian right and conservative politicians to censure and decimate the National Endowment for the Arts (NEA). "Culture Wars" was, for example, the title of a book, edited by Richard Bolton (New Press, 1992), that referred specifically to the series of published attacks on works of "high culture" that the right considered religiously blasphemous or too salacious. The most famous examples were Andres Serrano's *Piss Christ*, which Sen. Alfonse D'Amato denounced on the floor of Congress in the spring of 1989, and Robert Mapplethorpe's photographs of gay black and white men engaging in sex acts. Many progressive commentators noted at the time that a recurrent theme of these assaults on culture was a thinly veiled attack on gay sex. Yet, at the same time, very little was made of the insistent denigration of nonwhite races in censoring these works.

In this broader frame, the specifically targeted campaign aimed at the heart of the National Endowment for the Arts seemed all of a piece with the contemporaneous strengthening of the flagging right-wing political agenda. Attacks on art were part of a general but well-calibrated opposition to other "objectionable" materials in

Carrie Mae Weems, *Untitled (Woman Brushing Hair)*, 1990, gelatin silver print, 28 $\frac{1}{4}$ x 28 $\frac{1}{4}$ in. Photo courtesy of PPOW Gallery, New York. Art Matters grant recipient, 1989.

the public realm, such as passages in school textbooks that were perceived to be anti-American or anti-Christian, or "pornographic" or homosexual imagery in magazines, films, and television programming. The year before the assault on visual art began, the American Family Association, led by its executive director Rev. Donald Wildmon, had sharpened its teeth on popular culture with an attack on Martin Scorsese's film *The Last Temptation of Christ* (1988). Wildmon complained that the picture was "immoral" and "anti-Christian" because Christ was portrayed by Willem Dafoe as an imperfect and sexual human being.

In other ongoing battles, often on a local level, the right repeatedly sought to overturn liberal "victories," such as the right to abortion, the provision of bilingual education, and the very existence of Aid for Families with Dependent Children (AFDC). The consistent theme of such policies, to say the least, was that the right wasn't feeling generous. That the right was unwilling at the moment to tolerate some of the more nihilistic impulses of modern art was, in other words, a minor symptom of a much more extensive disease. Unprecedented fortunes were being amassed in the U.S., even as government policies cut away at the monies devoted to ameliorating the problems of the poor and beefed up funding for prison construction (along with promoting arguments supporting the death penalty). Nevertheless, a U.S.-engineered global capitalism, depleting and exploiting the resources of the rest of the planet, had turned the United States into the port of choice for the increasingly impoverished and dislocated masses of Asia, Africa, South America, the Caribbean, and Eastern Europe.

In her 1989 article "The War on Culture," anthropologist Carole S. Vance suggested another possible explanation for the timing of the attack on the fine arts in Congress. As she pointed out, both legislative houses were under Democratic control, and Reaganomics had peaked, which left the conservative right casting around for more vulnerable chinks in the armor of public opinion. Since "high culture" seemed so central to white liberal hegemony, edgy work such as that of Mapplethorpe and Serrano was perfect for their purposes. But what, if anything, did this rarefied arts dispute have to do with the ongoing and bloody struggles of the race wars in which this country had been engaged since the first Africans stepped off the boat onto the coast of Virginia in 1619?

In one sense, it seems too obvious to point out that artists of color have always been especially dependent upon public funding such as that provided by the NEA, since they continue to lack the kind of private sector patronage that even moderately successful white artists take for granted. In every conceivable sector of the

arts, "successful black artists" either earn proportionately less (as musicians, movie actors, or stage performers), have substantially fewer success stories (as painters, dancers, photographers, and sculptors), or both (as architects, film and theater directors, as well as in other kinds of management positions, such as museum directors, curators, and book editors).

Nevertheless, in the so-called black community, or even among black artists and cultural workers generally, the culture wars as defined by Bolton and Vance were perceived as having little relative consequence.[1] The reason was not that such battles were considered trivial or unimportant, and, therefore, subordinate to more serious racial problems. Rather, the trouble was that black artists rarely (actually, never) occupied the hallowed berths reserved for art world stars like Robert Mapplethorpe or Martin Scorsese. The Corcoran Gallery of Art, the Museum of Modern Art, and the Walter Reade Theater at Lincoln Center are still relatively new venues in terms of the exhibition of black culture. The fact is, the culture wars represent a pitched battle among hegemonic white insiders only. The two contenders in the game are the reigning liberal bourgeoisie and the conservative nouveau-riche wannabes.

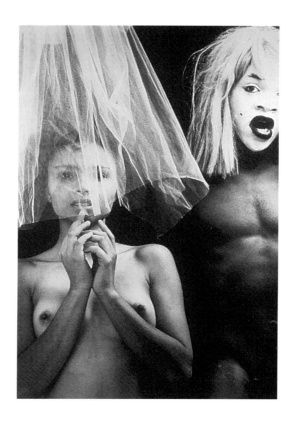

Lyle Ashton-Harris, *Kym, Lyle and crinoline*, 1992, black-and-white photograph, 60 x 40 in. Photo courtesy of Thomas Erben Gallery. Art Matters grant recipient 1990, 1992.

Since blacks rarely get to be contenders, except for some rare and comparatively recent instances in sports (e.g., Tiger Woods, Michael Jordan Inc.) and entertainment (e.g., Michael Jackson, Bill Cosby, and Oprah Winfrey), we have little input in this arena, and most of us seem to know it. For the black visual artist, then, the paramount problem is not too much controversy and censure. No matter how successful she appears to be, the big hurdle for the black visual artist is too much public neglect—that is, too small an audience, too few collectors, too little access to the few powerful dealers, too little media coverage, and too little fame. The reasons for this studied neglect have everything to do with the programmatic suppression of African-American culture.

So, for me, the larger and more interesting issue, beyond this particular culture war between bourgeois liberalism and the nouveau yahoos, is the longer and more protracted culture war over race. This is, of course, a vast and vastly sad story. But it may suffice here to delineate some of the main lines of what is really a long-standing

and globally deployed conflict. We might recall, for instance, that at least since the American Revolution, the institution of slavery required a complex set of relations among an international cartel of slaveholders and slavetraders who freely traveled from place to place to avoid compliance with local abolitionist tendencies, liberalization of slave laws, or gradual emancipation. For instance, when the Haitian Revolution occurred at the turn of the nineteenth century, Haitian slaveholders fled with their "property" to Louisiana or Florida or South Carolina, where the institution of slavery was more stable. By the time slaves in the United States were emancipated nationally in 1865, some slaveowners who had anticipated this development had already fled with their slaves to such places as Brazil or Cuba, where slavery had not yet ended. Despite these wholesale relocations to alien environments, Africans, even as slaves, retained and grafted onto new practices much of their original cultures in the form of religions, performative rituals, and belief systems.

Later in the century, during the brief Spanish-American War of 1898, race and cultural domination were central, if largely unacknow-ledged, issues. The struggle of still-enslaved Cubans for freedom and independence was a key factor in precipitating the conflict. When the U.S. "liberated" the Philippines, Puerto Rico, and the Dominican Republic from the Spanish, inhabitants of these places hoped this meant that they would now be free citizens, as was true, presumably, of the former slaves of the South. Yet, they might have realized that their hopes were in vain if they had known that at that very moment the South was undergoing a brutal struggle to deny the former slaves their civil rights.

In retrospect, we can see that there was a relatively seamless replacement of transatlantic slavery by a well-oiled international system of European and U.S. imperialism. This led to the continuous exploitation of native and diasporic populations in South Asia, the Pacific, Africa, the Caribbean, and the Americas. American politicians like Theodore Roosevelt told the public that Europe was carving up Africa (with the support and cooperation of U.S. missionaries and journalists) to stop the slave trade internal to the continent. And yet, Europe's modus operandi in ravaging Africa's peoples and resources entailed forced labor, torture, murder, and even genocide. Whereas the slave trade had once linked the Eurocentric world in its relation to the African diaspora, now the new Darwinian concept of "race," as commodity and artifact, provided the common thread of moral ideology. According to King Leopold, H.M. Stanley, and other imperialist adventurers, the tabula rasa of African culture needed inscription by those who were wiser, more civilized, and more technologically advanced.

Daring Sensible Severe Long & Silly Boyish Ageless Silly Magnetic Country Fresh Sweet

Today, we continue to live in the moral, spiritual, economic, and psychological shadows of these policies toward Africans and their descendants. Yet, next to nothing about these histories is known or considered relevant by Americans. Witness the thousands of black youth packing U.S. prisons. They are affected daily by this history, yet they know virtually nothing about it. How do I know they know virtually nothing about it? Because this aspect of our past is so deeply buried that almost no one except academics and serious aficionados of American history is in any position to know much about slavery and its aftermath. Such topics have little place in the curricula of our high schools or colleges, except perhaps in the romanticized and heroic terms of Black History Month. I respect-fully submit that the problem here continues to be "race," that shadowy, nebulous concept that has so little empirical meaning, yet whose symbolism continues to tower over representation in the West. In recognizing the current political conflicts as a culture war of race, we must first acknowledge that African Americans have never had any kind of a chance to recover from the traumatic wounds of slavery. Nor has the African continent even begun to recover from European imperialism. Psychological trauma which remains unaddressed by the conscious mind does not just go away, it just hangs around, continually fucking up lives.

On the other hand, it is possible to cite a variety of starting points for our current stage of multiculturalism in the art world, the

Lorna Simpson, *Stereo Styles*, 1988, ten 20 x 24 in. Polaroid prints. Photo courtesy Josh Baer Gallery, New York. Art Matters grant recipient, 1991.

beginnings of an attempt to confront the syncretic cultures of the African diaspora in America. Some would begin this rather limited art history with the notorious *Harlem on My Mind* exhibition, held at the Metropolitan Museum of Art in New York in 1968. I remember attending this show more than once as a sixteen-year-old. The works of James Van Der Zee and other photographers of black subjects were a revelation to me. But there was little or nothing about black fine artists, painters, and sculptors, although the Metropolitan is ostensibly an art museum. Contemporary black artists, led by Benny Andrews and Romare Bearden, protested that the show was too sociological, that it was better suited to a natural history museum, and, worst of all, that it had failed to include or even consult the existing community of black artists. The show had made a lot of white midtown art patrons suddenly aware of the rich cultural past of black Harlem, had put black photography on the map, and had boosted the reception of black fine arts overall, but these "victories" were small consolation to the living African-American painters and sculptors who simply wanted in.

Next, black artists decided to focus on the issue of underrepresentation at the museum that claimed to represent the entire national spectrum of art: the Whitney Museum of American Art. My mother, Faith Ringgold, and I participated in a picket line there in 1970. At the same time, we were working with and involved with the struggles of the Art Workers' Coalition and the Art Strike, protesting the segregation and apartheid of the museums, as well as the war in Vietnam. There were weekly, riotous demonstrations at the museums, full of ad hoc street theater and bacchanalian shenanigans. Then, the rampant sexism of the male artists forced us to form a separate feminist organizing of women artists and their supporters, including WSABAL (Women Students and Artists for Black Art Liberation), Women Artists in Revolution, and Lucy Lippard's Ad Hoc Women Artist's Committee. The Ad Hoc Women organized a protest against the exclusion of women from the 1972 sculpture biennial. At the opening of the show, Lippard's group planted white eggs with "50%" written on them; the WSABAL planted cooked eggs, painted black.

While the late 1960s and early '70s were colorful times, full of Panthers, Back to Africa Movements, Flag Shows, Carl Andres, Valerie Solanases, and other extremists, the conservative retrenchments of the 1980s led to some important things for multiculturalism in the arts, as well. I feel, for instance, that the *"Primitivism" in 20th Century Art* show at the Museum of Modern Art in 1984 was a pivotal turning point in preparing the way for the consideration of artists of color in relation to the mainstream art world. Although

David Hammons, *How Ya Like Me Now?*, 1989, installation, dimensions variable. Commissioned by Washington Project for the Arts for the exhibition *The Blues Aesthetic: Black Culture and Modernism.* Photo courtesy of the Corcoran Museum of Art, Washington, D.C. Art Matters grant recipient, 1987.

the purpose of the stultifying double catalogue might have been otherwise, it does nevertheless serve to establish some important cross-influences between Native American, Oceanic, and African visual arts and modernist American and European art. In fact, this case is made so convincingly that it almost de-Europeanizes, or, at the very least, exoticizes modernism itself. The so-called primitive art, which supported and underwrote twentieth-century modern art, was generally exhibited at the Modern without acknowledgment of its authorship or its historical or cultural context. This gave the impression that much of it was produced by an ancient, distant, and inscrutable people. But the fact is that most of it was probably made by artists who were alive when Picasso painted his *Demoiselles d'Avignon*. In other words, many of these "primitive" artists were contemporaries of the European artists who were borrowing ideas from them. So, in effect, the only essential component of global multiculturalism that was missing was the bricolage art of the African diaspora itself. To do such a show would still be a wonderful idea.

Another prescient show, which corrected the art world's ethnic tunnel vision with great panache, was *The Decade Show*, which was jointly organized by the Museum of Contemporary Hispanic Art, the New Museum of Contemporary Art, and the Studio Museum

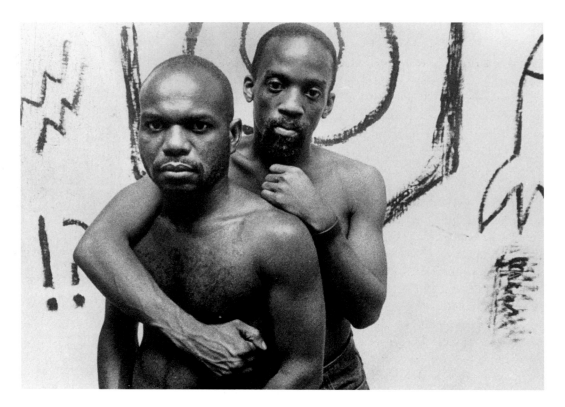

Marlon Riggs, *Tongues Untied*, 1989. Pictured: Marlon Riggs and Essex Hemphill. Film still courtesy of Frameline.

in Harlem in 1990. This show openly addressed the issues of racial, ethnic, sexual, and even class identity that were then being explored by visual artists. But the translation of these issues across different cultural communities was not always smooth. Even in the catalogue's introductory dialogue between the three museums' directors, Studio Museum head Kinshasha Conwill openly conceded that none of the work addressing sexuality (one of the main themes of the show) would be welcome at her museum. She pointed out that works containing nudity, references to AIDS, and explicit sexuality would not raise an eyebrow in the downtown art world, but in Harlem would be intolerable. When performance artist Robbie McCauley, whose event was inadvertently scheduled for the Studio Museum, proceeded to take her clothes off in a reenactment of the ordeal of a black woman slave on the auction block, Conwill was reportedly outraged. In black communities, especially among mixed audiences, censorship of any kind of explicit display of sexuality—or even the naked body—goes without saying.

There is a great deal more than explicit sexuality that is automatically censored in the black community as a matter of course. As organizer of the Black Popular Culture Conference in 1991, I was told that it would be impossible to display the conference poster in Harlem. The Studio Museum, which helped to sponsor the conference, even tried to suppress the poster altogether on the slim pretext

that the conference was already sold out and that the poster would therefore constitute false advertising. The poster had no apparent or explicit sexual content but featured photographic images of Supreme Court nominee Clarence Thomas and his accuser Anita Hill in the act of testifying at Thomas's Senate confirmation hearings. The composition had been montaged by the designer to appear as though Thomas and Hill were directly arguing with one another. What the Studio Museum officials considered offensive about this image is difficult, perhaps impossible, to articulate, although I understand it on a gut level, and even, at the time, expected it.[2]

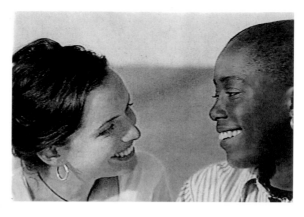

Cheryl Dunye, *The Watermelon Woman*, 1996. Pictured: Guinevere Turner and Cheryl Dunye. Film still courtesy of First Run Features.

When all is said and done, black people just aren't suppose to raise such issues or to aspire to become masters of fine art. They just aren't. This was the major problem in the misinterpretation of the genius of Jean-Michel Basquiat as a painter, and the same problems plagued discussions of Bob Thompson's retrospective at the Whitney. What is more, the belief that blacks are not supposed to aspire to be master painters is as true now as it was in the 1920s or the 1960s. In fact, it is perhaps more so now, since the canon of modern art in the latter half of the twentieth century really has more (white) painters in good standing than it can ever possibly use. If Basquiat had been white—even with all his neuroses, drug use, and instability—his work, which is brilliant, would have been heralded as a critical turning point in high culture. But because he was black, Basquiat has to be constantly and ritualistically discredited by the likes of Morley Safer. As late as 1992, the proposed tour of Basquiat's Whitney retrospective was abruptly canceled when no other museums would take it, and the curator who was responsible for the show was immediately retired.

In those rare instances in which a black artist is positioned in an adversarial yet privileged position in relation to the dominant culture—such as Marlon Riggs, director of the controversial documentary film *Tongues Untied* (1989), or Cheryl Dunye, director and star of her first feature film, *Watermelon Woman* (1996)—fame and fortune are not the consequences, but silencing and near-total invisibility. After both films were denounced on the floor of the Senate and in the *Washington Times* for their NEA-sponsored queer content, *Tongues Untied* was withdrawn from showing in many PBS markets and Dunye's film was a commercial failure despite critical acclaim. Most blacks have never seen or heard of either of these films, and wouldn't like them if they had. As these works show,

Kara Walker, *World's Exposition*, 1997, cut paper and adhesive on wall, 10 x 16 ft. Collection Jeanne Greenberg. Photo courtesy of Wooster Gardens Gallery, New York. Art Matters grant recipient, 1994.

homosexuality remains a conflicted topic among African Americans. I will never forget the occasion in 1988 when I accompanied black British filmmaker Isaac Julien to a screening of his *Passion of Remembrance* for a black Brooklyn audience. As I recall, there was no male nudity at all in this highly political indictment of Margaret Thatcher's racial policies. Yet, in the one scene in which two men briefly kiss, there were loud ejaculations from the audience, many of whom proceeded to walk out.

A more recent example of the same type of attempted censorship within the black community is the case of Kara Walker, a young African-American woman who recently won a MacArthur fellowship. Walker makes large-scale silhouettes that are sexually explicit and sadomasochistic. Often they portray masters and slaves in such a frenzy of comic sexual activity that they are almost attacking one another's bodies. Again, the controversy over this work is basically among black artists; in this instance, between two older black female artists, Howardina Pindell and Betye Saar. Pindell and Saar, whose own wonderful works have been unjustly neglected, were so offended by the attention being paid to Walker's work that they sent around a petition condemning it. They argued that her depictions of black women were demeaning and that that was in fact the reason for their celebration in the white male art world. Although I could never agree with censorship, particularly of work as delightful and diverting as Walker's, I have some sense of what Pindell and Saar are complaining about. As one woman artist suggested to me, if

Walker's work were more preoccupied with demeaning sexual relations between black men and white women, the art world might not be so enamored of her product.

My point is that these debates over what is allowable in the form of public expression have a cultural specificity that is not often taken into account. What is unacceptable in the black community is not necessarily contested elsewhere. The culture wars are often seen as a universal struggle over censorship in the abstract, a boorish conservative attempt to limit the overall liberalization in civil society around issues of sexual preference, gender, race, and ethnicity. For visual artists, this means no explicit sex, no antisocial behavior, no "immoral" views or scenarios. And certainly I feel that such prohibitions, wherever they originate, should be opposed. But when we try to apply this opposition equally to all artists in all situations, we run up against some fundamental cultural differences that pertain to the very ethnic, sexual, gender, and class issues being struggled over.

Betye Saar, *Sojourn*, multimedium assemblage, 1995, 12 x 8 ¹/₄ x 2 ¹/₄ in. Courtesy of the artist. Art Matters grant recipient 1995.

Moreover, when we try to compare the censorship of artists to the kind of intolerance of multiculturalism and diversity that is so common among conservatives in this society, the comparison quickly becomes thin. There really isn't a lot of comparison. The culture wars over art are really battles that the dominant culture stages with itself, over which strain of the mainstream—the liberal bourgeoisie or the conservative yahoo "lumpen proletariat"—will have hegemony over contemporary values and mores. But the culture wars over race are more about whether former outsiders will ever be given a new status, either inside the mainstream or, at least, closer to the inside.

I would say that the censorship of an artist's free expression poses precisely the same threat to the bourgeoisie that religious blasphemy poses to religious fundamentalism. Modern art and high culture long ago became a kind of secular religion for the white liberal bourgeoisie, a sacred sphere in which their most exalted values are trotted out. To tamper with this realm, to artificially limit its aspirations to the incommensurable, through censorship or any other means, is to engage in the ultimate immorality. White bourgeois liberalism, especially in its appeals to the aesthetic, provides what is in effect a kind of demilitarized zone, where it is possible to invoke all kinds of otherwise reprehensible or visionary behavior without

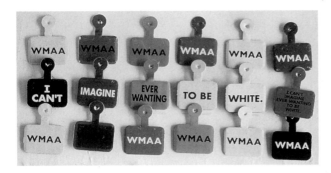

Daniel Martinez, *Untitled (Whitney Biennial)*, 1993, metal lapel pins. Photo courtesy of the artist. Art Matters grant recipient, 1990.

judgment or censure. Thus, pieties about freedom of expression coexist with unremarked yet systematic racial exclusions.

I can pinpoint the exact moment when I first I became aware of the intersection of the culture war of race and culture war of representation. It was linked again to the contentious Clarence Thomas confirmation hearings in the fall of 1991. The key event was when Thomas described himself as the victim of a "high-tech lynching." This succinct phrase (undoubtedly suggested to Thomas by one of his many media advisors) telegraphed through the media a complex racial image. And, predictably, it raised the most complicated attitudes about "race" for all the ideological factions among progressives; between left, right, and liberal feminists; between people of color of various hues and classes; and for the various socioeconomic divisions among blacks themselves. Of course, as a black man, Thomas was a prime example of the successes of affirmative action, a poor boy who went to Yale Law School and grew up to become a Supreme Court nominee. On the other hand, he was also an arch-conservative and a strong supporter of the right wing in Congress. So, when his former employee, Anita Hill, a black woman, hit him in his weakest spot—sexual harassment—it was to be expected that he would invoke the history of black men being lynched, ostensibly for raping or expressing sexual intentions towards women. Except that in this case, the woman wasn't white, she was black, a point that proved intensely confusing for feminists.

Being white and conservative, the right is hugely invested in challenging both blacks and feminists, the two groups that pose the greatest threat to their hegemony. In the Thomas-Hill case, the white media fell all over itself trying to point up the contradictions. They provided a mouthpiece for every antipornography feminist they could find, which stirred confusion in both black and white feminist circles. Which side were you supposed to be on? Who was the enemy? Some black women, a fair number of them academics and intellectuals, hastily organized themselves into a group called "Black Women in Defense of Ourselves," and took out an ad in the *New York Times* supporting Anita Hill's right to publicly declaim her harassment. But the ad was also meant to let it be known that no matter what some white feminists said, large numbers of black women did not support Thomas's nomination. Suddenly, progressives were pitted against one another in an endless series of irresolvable quandaries, revolving around the definition of sexual harassment

and how much should be tolerated. These debates bumped up
against similar quandaries having to do with freedom of expression,
namely, is sexual harassment more akin to pornography (which
involves a consensual freedom of expression) or more like rape
(that is, a form of violence)? In a kind of reversal that the right
wing has perfected, the debate over Clarence Thomas was turned
on its head, and once-progressive issues about sexuality and repre-
sentation were appropriated to divide and confuse the left.

The real deal, though, is that the shift taking place in my mind
did not happen all at once with Thomas whining about being
strung up by the media. It had been happening gradually all along,
perhaps consistently since the demise of Black Power, through the
emergence of black feminism, and especially under the crushing
social and cultural consequences of the Reagan revolution. It is just
that it was only then, in the midst of the Thomas hearings, that I
began to see something of a pattern. Other events, before and since,
have featured a similar sort of cannibalism, in which progressives
of different stripes and colors attack one another, while ceding the
field to the right. One such event was the response to the trial of
the white Los Angeles policemen beating black motorist Rodney
King in 1992. The televised trial, in which the police were acquitted
by a nearly all-white Simi Valley jury, was followed closely by the
first major multicultural riot in Los Angeles. And, of course, the
super-event in this category was the year-long O.J. Simpson trial,
starting with the car chase, followed by the doctored (darkened) mug-
shot of O.J. on the cover of *Time*, extending through the televised
trial with its celebrity lawyers, and ending, more or less, with the
much-awaited verdict. The critical moment for me was the response
to the verdict as portrayed by the media: black women celebrating
O.J.'s acquittal while white women wept. Such occasions demon-
strate vividly how much the dominant media suffers from a lack of
"approved" black female voices. Virtually no one spoke up for the
thousands of prominent black women who weren't overjoyed over
O.J.'s acquittal and were deeply distressed over his possible guilt.

At the center of each of these conflicts was debate about the
nature of "race," whether or not it exists, what its essential meaning
or significance might be, and how it is constructed or shaped by
visual representations. In fact, there isn't anything about "race" in
the progressive agenda that isn't open to debate and interrogation.
Public show trials, like the Thomas-Hill one or the O.J. one, merely
serve as persistent demonstrations of the potential incoherence of
various once-conventional legal, moral, and aesthetic codes. All
such occasions are invariably played out in cultural productions
that range far beyond the hallowed precincts of the art world into

popular cinema, television, music, theater, literature. At the same
time, however, the art world serves a particularly important function
within this constellation, which is why it has so often been a favorite
target of the right. The artist's insistent claim to an absolute right
to freedom of expression, which underwrites the authority of the
entire mainstream of liberal cultural production in the United States,
obviously sticks in the craw of the right. It is an ongoing sign of
the conservative's fundamental impotency at a time when the racist
right appears to believe that no one should ever be entirely free to
do or say anything.

And, a far as artworks themselves go, the right appears to view
them as merely pedagogical and instrumental, a mode of rote in-
struction. So, when it comes to public funding for art, the right is
trapped in a losing battle of having to articulate publicly its outmoded
notions of aesthetic quality, which rely upon limitations, such as
"realism," "commonsense," and "decency," that have no real currency
in any segment of the art world or art-viewing public. Anyone who
knows anything about art knows that the object hasn't been the
primary thing in visual culture for some time, even in the most sub-
stantial and concrete artwork being done today. Since we globally
oriented cultural workers have become, in a sense, both churchless
and stateless, we look to art for its transient, ephemeral, and even
transcendent qualities. I am, therefore, not opposed to the idea of
art as the new religion, except that if it is to be the new object of
faith and spirit, its magic can't be how high its price is. Rather, art
needs to take us on a journey, and almost often enough, it does—
although the institutionalized factions of the (white) art world tend
to serve more as obstacles than aids.

Still, the right-wing challenge to define art's "values" suitably
confused many progressive artists' notions of purpose and commit-
ment. This confusion briefly bolstered the faltering struggle of the
right, and allowed them to connect their moral crusade with the
long-standing suppression of nonwhite cultural expressions. The
clear goal of the conservative movement is to discredit progressive
reform on all fronts and shore up a hopelessly obsolete "white"
patriarchal status quo against the tide of demographic changes in
U.S. populations. Meanwhile, those of us who think of ourselves as
progressive are stuck in a process of becoming, because, unlike the
right, we don't see where we would like to end up as a fixed point.

1. I call it the "so-called black community" because it is largely a virtual phenomenon at this point, marked as much by its indigenous media (black magazines such as *Emerge*, *Jet*, *Ebony*, and *Essence*; black newspapers such as the *Amsterdam News* and the *Sun*; and even Black Entertainment TV [BET]) as by ostensible black working-class enclaves in urban centers or black middle-class pockets in the suburbs. Also, I specify "black artists and cultural workers" separately from the "so-called black community" because there is little, if any, relation between the two. Black artists, in general, either depend for their livelihood on the corporate sector or the public sector, as defined by the parameters of the culture wars. In either case, the black audience is secondary to their survival, which is quite a problem actually. It is not the case, however, that only black visual artists are not essentially linked with the "black community." This is also a problem for commercial rap, reggae, jazz, and blues artists. There are some signs of potential change occurring in the field, however. The two that I have noticed are: 1) Prince's successful struggle to regain economic control over his product, and his inroads into producing black talent on his own label; and 2) the new young female music stars, like Lauryn Hill, who, by writing, performing, and producing their own material and by developing black audiences, are making definite moves toward economic autonomy.

2. On a previous occasion, I related the sort of primal scene that this poster depicted to conflicts over changing perceptions of the traditional family, traditional gender relations, and patriarchy itself. See my "Afterword: 'Why Are There No Great Black Artists?': The Problem of Visuality in African-American Culture," in Gina Dent, ed., *Black Popular Culture* (Seattle: Bay Press, 1992), pp. 336-46.

Kara Walker, *Presenting Negro Scenes Drawn Upon My Passage Through the South and Reconfigured for the Benefit of Enlighted Audiences Wherever Such May Be Found, By Myself, Missus K.E.B. Walker, Colored,* (detail), 1997, cut paper and adhesive on wall, approximately 12 x 155 ft. Photo courtesy of Wooster Gardens Gallery, New York. Art Matters grant recipient, 1994.

Skin Head Sex Thing: Racial Difference and the Homoerotic Imaginary (1991)

KOBENA MERCER

In this article I want to explore the experience of aesthetic ambivalence in visual representations of the black male nude. The photographs of Robert Mapplethorpe provide a salient point of entry into this complex "structure of feeling," as they embody such ambivalence experienced at its most intense.[1]

My interest in this aspect of Mapplethorpe's work began in 1982, when a friend lent me his copy of *Black Males*. It circulated between us as a kind of illicit object of desire, albeit a highly problematic one. We were fascinated by the beautiful bodies, as we went over the repertoire of images again and again, drawn in by the desire to look and enjoy what was given to be seen. We wanted to look, but we didn't always find what we wanted to see: we were shocked and disturbed by the racial discourse of the imagery, and above all, we were angered by the aesthetic equation that reduced these black male bodies to abstract visual "things," silenced in their own right as subjects, serving only to enhance the name and reputation of the author in the rarefied world of art photography. But, still, we were struck, unable to make sense of our own implication in the emotions brought into play by Mapplethorpe's imaginary.

I've chosen to situate the issue of ambivalence in relation to these experiences because I am now involved in a partial revision of arguments made in an earlier reading of Mapplethorpe's work.[2] This revision arises not because those arguments were wrong, but because I've changed my mind, or, rather, I should say that I still can't make up my mind about Mapplethorpe. In returning to my earlier essay, I want to suggest an approach to ambivalence not as something that occurs "inside" the text (as if cultural texts were hermetically sealed or self-sufficient), but as something that is experienced across the relations between authors, texts, and readers, relations that are always contingent, context-bound, and historically specific.

Posing the problem of ambivalence and undecidability in this way not only underlines the role of the reader, but also draws attention to the important, and equally undecidable, role of context in

Robert Mapplethorpe, *Thomas, 1986*, 1986, gelatin silver print. Photo courtesy of The Estate of Robert Mapplethorpe. Copyright © The Estate of Robert Mapplethorpe. Used by permission.

This essay was first published in Bad Object-Choices, ed., *How Do I Look? Queer Film and Video* (Seattle: Bay Press, 1991), pp. 169–210.

determining the range of different readings that can be produced from the same text. In this respect, it is impossible to ignore the crucial changes in context that frame the readings currently negotiated around Mapplethorpe and his work. Mapplethorpe's death in 1989 from AIDS; a major retrospective of his work at the Whitney Museum in New York; the political "controversy" over federal arts policy initiated by the fundamentalist right in response to a second Mapplethorpe exhibition organized by the Institute of Contemporary Art in Philadelphia: these events have irrevocably altered the context in which we perceive, argue about, and evaluate Mapplethorpe's most explicitly homoerotic work.

The context has also changed as a result of another set of contemporary developments: the emergence of new aesthetic practices among black lesbian and gay artists in Britain and the United States. Across a range of media, such work problematizes earlier conceptions of identity in black cultural practices. This is accomplished by entering into the ambivalent and overdetermined spaces where race, class, gender, sexuality, and ethnicity intersect in the social construction and lived experiences of individual and collective subjectivities. Such developments demand acknowledgment of the historical contingency of context and, in turn, raise significant questions about the universalist character of some of the grand aesthetic and political claims once made in the name of cultural theory. Beginning with a summary of my earlier argument, I want to identify some of the uses and limitations of psychoanalytic concepts in cultural theory, before mapping a more historical trajectory within which to examine the constitutive ambivalence of the identifications we actually inhabit in living with difference.

Revising

The overriding theme of my earlier reading of Mapplethorpe's photographs was that they inscribe a process of objectification in which individual black male bodies are aestheticized and eroticized as objects of the gaze. Framed within the artistic conventions of the nude, the bodies are sculpted and shaped into artifacts that offer an erotic source of pleasure in the act of looking. Insofar as what is represented in the pictorial space of the photograph is a "look," or a "certain way of looking," the pictures say more about the white male subject behind the camera than they do about the black men whose beautiful bodies we see depicted. This is because the invisible or absent subject is the actual agent of the look, at the center and in control of the apparatus of representation, the I/eye at the imaginary origin of the perspective that marks out the empty space to which the viewer is invited as spectator. This argument was based

on a formal analysis of the codes and conventions brought to bear on the pictorial space of the photographs, and, equally important, on an analogy with feminist analyses of the erotic objectification of the image of women in Western traditions of visual representation.

Three formal conventions interweave across the photographic text to organize and direct the viewer's gaze into its pictorial space: a sculptural code, concerning the posing and posture of the body in the studio enclosure; a code of portraiture concentrated on the face; and a code of lighting and framing, fragmenting bodies in textured formal abstractions. All of these help to construct the *mise en scène* of fantasy and desire that structures the spectator's disposition toward the image. As all references to a social or historical context are effaced by the cool distance of the detached gaze, the text enables the projection of a fantasy that saturates the black male body in sexual predicates.

These codes draw from aspects of Mapplethorpe's oeuvre as a whole and have become the signs by which we recognize his authorial signature. Their specific combination, moreover, is punctuated by the technical perfection—especially marked in the printing process—that also distinguishes Mapplethorpe's presence as an author. Considering the way in which the glossy allure of the photo-graphic print becomes cosubstantial with the shiny texture of black skin, I argued that a significant element in the pleasures the photographs make available consists in the fetishism they bring into play. Such fetishism not only eroticizes the visible difference the black male nude embodies, it also lubricates the ideological reproduction of racial otherness as the fascination of the image articulates a fantasy of power and mastery over the other.

Before introducing a revision of this view of racial fetishism in Mapplethorpe's photographs, I want to emphasize its dependence on the framework of feminist theory initially developed in relation to cinematic representation by Laura Mulvey.[3] Crudely put, Mulvey showed that men look and women are looked at. The position of "woman" in the dominant regimes of visual representation says little or nothing about the historical experiences of women as such, because the female subject functions predominantly as a mirror image of what the masculine subject wants to see. The visual depiction of women in the *mise en scène* of heterosexual desire serves to stabilize and reproduce the narcissistic scenario of a phallocentric fantasy, in which the omnipotent male gaze sees but is never seen. What is important about this framework of analysis is the way it reveals the symbolic relations that structure dominant codes and conventions of visual representations of the body. The field of visibility is thus organized by the subject–object dichotomy that

associates masculinity with the activity of looking and femininity with the subordinate, passive role of being that which is looked at.

In extrapolating such terms to Mapplethorpe's black nudes, I suggested that because both artist and models are male, a tension arises that transfers the frisson of difference to the metaphorically polarized terms of racial identity. The black-white duality overdetermines the subject-object dichotomy of seeing and being seen. This metaphorical transfer underlines the erotic investment of the gaze in the most visible element of racial difference—the fetishization of black skin. The dynamics of this tension are apparently stabilized within the pictorial space of the photographs by the ironic appropriation of commonplace stereotypes—the black man as athlete, as savage, as mugger. These stereotypes, in turn, serve to regulate and fix the representational presence of the black subject, who is thereby "put into his place" by the power of Mapplethorpe's gaze.

The formal work of the codes essentializes each model into the homogenized embodiment of an ideal type. This logic of typification in dominant regimes of racial representation has been emphasized by Homi Bhabha, who argues that "an important feature of colonial discourse is its dependence on the concept of 'fixity' in the ideological construction of otherness."[4] The scopic fixation on black skin thus implies a kind of "negrophilia," an aesthetic idealization and eroticized investment in the racial other that inverts and reverses the binary axis of the fears and anxieties invested in or projected onto the other in "negrophobia." Both positions, whether they devalue or overvalue the signs of racial difference, inhabit the representational space of what Bhabha calls colonial fantasy. Although I would now qualify the theoretical analogies on which this analysis of Mapplethorpe's work was based, I would still want to defend the terms of a psychoanalytic reading of racial fetishism, a fetishism that can be most tangibly grasped in a photograph such as *Man in Polyester Suit* (1980).

The scale and framing of this picture emphasizes the sheer size of the black dick. Apart from the hands, the penis and the penis alone identifies the model as a black man. As Frantz Fanon said, diagnosing the figure of "the Negro" in the fantasies of his white psychiatric patients, "One is no longer aware of the Negro, but only of a penis: the Negro is eclipsed. He is turned into a penis. He *is* a penis."[5] The element of scale thus summons up one of the deepest mythological fears and anxieties in the racist imagination, namely, that all black men have huge willies. In the fantasmatic space of the supremacist imaginary, the big black phallus is a threat not only to the white master (who shrinks in impotence from the thought that the subordinate black male is more potent and sexually powerful

than he), but also to civilization itself, since the "bad object" represents a danger to white womanhood and therefore miscegenation and racial degeneration.

The binarisms of classical racial discourse are emphasized in Mapplethorpe's photograph by the jokey irony of the contrast between the black man's private parts and the public respectability signified by the business suit. The oppositions exposed/ hidden and denuded/clothed play upon the binary oppositions nature/ culture and savage/civilized to bring about a condensation of libidinal investment, fear, and wish-fulfillment in the fantasmatic presence of the other. The binarisms repeat the assumption that sex is the essential "nature" of black masculinity, while the cheap, tacky polyester suit confirms the black man's failure to gain access to "culture." The camouflage of respectability cannot conceal the fact that, in essence, he originates, like his prick, from somewhere anterior to civilization. What is dramatized in the picture is the splitting of levels of belief, which Freud regarded as the key feature of the logic of disavowal in fetishism.[6] Hence, the implication: "*I know* it's not true that all black men have big penises, *but still*, in my photographs, they do."

Robert Mapplethorpe, *Man in Polyester Suit*, 1980, gelatin silver print. Photo courtesy of The Estate of Robert Mapplethorpe. Copyright © The Estate of Robert Mapplethorpe. Used by permission.

It is precisely at this point, however, that the concept of fetishism threatens to conceal more than it reveals about the ambivalence the spectator experiences in relation to the "shock effect" of Mapplethorpe's work. Freud saw the castration anxiety in the little boy's shock at discovering the absence of a penis in the little girl (acknowledged and disavowed in the fetish) as constitutive of sexual difference. The clinical pathology or perversion of the fetishist, like a neurotic symptom, unravels for classical psychoanalysis the "normal" developmental path of oedipal heterosexual identity: it is the point at which the norm is rendered visible by the pathological. The concept of fetishism was profoundly enabling for feminist film theory because it uncovered the logic of substitution at work in all regimes of representation, which make present for the subject what is absent in the real. But although analogies facilitate cognitive connections with important cultural and political implications, there is

also the risk that they repress and flatten out the messy spaces in between. As Jane Gaines has pointed out concerning feminist film theory, the inadvertent reproduction of the heterosexual presumption in the orthodox theorization of sexual difference also assumed a homogeneous racial and ethnic context, with the result that racial and ethnic differences were erased from or marginalized within the analysis.[7] Analogies between race and gender in representation reveal similar ideological patterns of objectification, exclusion, and "othering." In Mapplethorpe's nudes, however, there is a subversive homoerotic dimension in the substitution of the black male subject for the traditional female archetype. This subversive dimension was underplayed in my earlier analysis: my use of the theoretical analogy minimized the homosexual specificity of Mapplethorpe's eroticism, which rubs against the grain of the generic high-art status of the traditional female nude.

To pose the problem in another way, one could approach the issue of ambivalence by simply asking: do photographs like *Man in a Polyester Suit* reinscribe the fixed beliefs of racist ideology, or do they problematize them by foregrounding the intersections of difference where race and gender cut across the representation of sexuality? An unequivocal answer is impossible or undecidable, it seems to me, because the image throws the question back onto the spectator, for whom it is experienced precisely as the shock effect. What is at issue is not primarily whether the question can be decided by appealing to authorial intentions, but, rather, the equally important question of the role of the reader and how he or she attributes intentionality to the author. The elision of homoerotic specificity in my earlier reading thus refracts an ambivalence not so much on the part of Mapplethorpe the author, or on the part of the text, but on my part as a reader. More specifically, it refracted the ambivalent "structure of feeling" that I inhabit as a black gay male reader in relation to the text. Indeed, I've only recently become aware of the logical slippage in my earlier reading, which assumed an equivalence between Mapplethorpe as the individual agent of the image and the empty, anonymous, and impersonal ideological category I described as "the white male subject" to which the spectator is interpellated. Paradoxically, this conflation undermined the very distinction between author-function and ideological subject-position that I drew from Michel Foucault's antinaturalist account of authorship.[8]

In retrospect, I feel this logical flaw arose as a result of my own ambivalent positioning as a black gay spectator. To call something fetishistic implies a negative judgment, to say the least. I want to take back the unavoidably moralistic connotation of the term,

Skin Head Sex Thing: Racial Difference and the Homoerotic Imaginary KOBENA MERCER

because I think what was at issue in the rhetoric of my previous argument was the encoding of an ambivalent structure of feeling, in which anger and envy divided the identifications that placed me somewhere always already inside the text. On the one hand, I emphasized objectification because I felt identified with the black males in the field of vision, an identification with the other that might best be described in Fanon's terms as a feeling that "I am laid bare. I am overdetermined from without. I am a slave not of the 'idea' that others have of me but of my own appearance. I am being dissected under white eyes. I am *fixed*. . . . Look, it's a Negro."[9] But on the other hand, and more difficult to disclose, I was also implicated in the fantasy scenario as a gay subject. That is to say, I was identified with the author insofar as the objectified black male was also an image of the object chosen by my own fantasies and erotic investments. Thus, sharing the same desire to look as the author-agent of the gaze, I would actually occupy the position that I said was that of the "white male subject."

I now wonder whether the anger in that earlier reading was not also the expression and projection of a certain envy. Was it not, in this sense, an effect of a homosexual identification on the basis of a similar object-choice that invoked an aggressive rivalry over the same unattainable object of desire, depicted and represented in the visual field of the other? According to Jacques Lacan, the mirror-stage constitutes the "I" in an alienated relation to its own image, as the image of the infant's body is "unified" by the prior investment that comes from the look of the mother, always already in the field of the other.[10] In this sense, the element of aggressivity involved in textual analysis—the act of taking things apart—might merely have concealed my own narcissistic participation in the pleasures of Mapplethorpe's texts. Taking the two elements together, I would say that my ambivalent positioning as a black gay male reader stemmed from the way in which I inhabited two contradictory identifications at one and the same time. Insofar as the anger and envy were an effect of my identifications with both object and subject of the gaze, the rhetorical closure of my earlier reading simply displaced the ambivalence onto the text by attributing it to the author.

Rereading

If this brings us to the threshold of the kind of ambivalence that is historically specific to the context, positions, and experiences of the reader, it also demonstrates the radically polyvocal quality of Mapplethorpe's photographs and the way in which contradictory readings can be derived from the same body of work. I want to suggest, therefore, an alternative reading that demonstrates this

textual reversibility by revising the assumption that fetishism is necessarily a bad thing.

By making a 180-degree turn, I want to suggest that the articulation of ambivalence in Mapplethorpe's work can be seen as a subversive deconstruction of the hidden racial and gendered axioms of the nude in dominant traditions of representation. This alternative reading also arises out of a reconsideration of poststructuralist theories of authorship. Although Romantic notions of authorial creativity cannot be returned to the central role they once played in criticism and interpretation, the question of agency in cultural practices that contest the canon and its cultural dominance suggest that it really *does* matter who is speaking.

The question of enunciation—who is speaking, who is spoken to, what codes do they share to communicate?—implies a whole range of important political issues about who is empowered and who is disempowered in the representation of difference. It is enunciation that circumscribes the marginalized positions of subjects historically misrepresented or underrepresented in dominant systems of representation. To be marginalized is to have no place from which to speak, since the subject positioned in the margins is silenced and invisible. The contestation of marginality in black, gay, and feminist politics thus inevitably brings the issue of authorship back into play, not as the centered origin that determines or guarantees the aesthetic and political value of a text, but as a question about agency in the cultural struggle to "find a voice" and "give voice" to subordinate experiences, identities, and subjectivities. A relativization of authoritative poststructuralist claims about decentering the subject means making sense of the biographical and autobiographical dimension of the context-bound relations between authors, texts, and readers without falling back on liberal humanist or empiricist common sense. Quite specifically, the "death of the author" thesis demands revision because the death of the author in *our* case inevitably makes a difference to the kinds of readings we make.

Comments by Mapplethorpe, and by some of the black models with whom he collaborated, offer a perspective on the questions of authorship, identification, and enunciation. The first of these concerns the specificity of Mapplethorpe's authorial identity as a gay artist and the importance of a metropolitan gay male culture as a context for the homoeroticism of the black male nudes.

In a British Broadcasting Corporation documentary in 1988, Lynne Franks pointed out that Mapplethorpe's work is remarkable for its absence of voyeurism. A brief comparison with the avowedly heterosexual scenario in the work of photographers such as Edward

Weston and Helmut Newton would suggest similar aesthetic conventions at the level of visual fetishization; but it would also highlight the significant differences that arise in Mapplethorpe's homoeroticism. Under Mapplethorpe's authorial gaze, there is a tension within the cool distance between subject and object. The gaze certainly involves an element of erotic objectification, but like a point-of-view shot in gay male pornography, it is reversible. The gendered hierarchy of seeing/being seen is not so rigidly coded in homoerotic representations, since sexual sameness liquidates the associative opposition between active subject and passive object. This element of reversibility at the level of the gaze is marked elsewhere in Mapplethorpe's oeuvre, most notably in the numerous self-portraits, including the one of him with a bullwhip up his bum, in which the artist posits himself as the object of the look. In relation to the black male nudes and the S&M pictures that preceded them, this reversibility creates an ambivalent distance measured by the direct look of the models, which is another salient feature of gay male pornography. In effect, Mapplethorpe implicates himself in his field of vision by a kind of participatory observation, an ironic ethnography whose descriptive clarity suggests a reversible relation of equivalence, or identification, between the author and the social actors whose world is described. In this view, Mapplethorpe's homoeroticism can be read as a form of stylized reportage that documented aspects of the urban gay subcultural milieu of the 1970s. One can reread Mapplethorpe's homoerotica as a kind of photographic documentary of a world that has profoundly changed as a result of AIDS. This reinterpretation is something Mapplethorpe drew attention to in the BBC television interview:

> I was part of it. And that's where most of the photographers who move in that direction are at a disadvantage, in that they're not part of it. They're voyeurs moving in. With me it was quite different. Often I had experienced some of those experiences which I later recorded, myself, firsthand, without a camera. . . . It was a certain moment, and I was in a perfect situation in that most of the people in the photographs were friends of mine and they trusted me. I felt almost an obligation to record those things. It was an obligation for me to do it, to make images that nobody's seen before and to do it in a way that's aesthetic.

In this respect, especially in the light of the moral and ethical emphasis by which Mapplethorpe locates himself as a member of an elective community, it is important to acknowledge the ambivalence of authorial motivation suggested in his rationale for the black male nude studies:

> At some point I started photographing black men. It was an area that hadn't been explored intensively. If you went through the history of nude

Above and right (detail):
Glenn Ligon, *Notes on the margins of the 'Black Book,'* 1991–93, installation at the 1993 Whitney Biennial, New York. Photos courtesy of the artist.

male photography, there were very few black subjects. I found that I could take pictures of black men that were so subtle, and the form was so photographical.

On the one hand, this could be interpreted as the discovery and conquest of "virgin territory" in the field of art history; but, alternatively, Mapplethorpe's acknowledgment of the exclusion and absence of the black subject from the canonical realm of the fine-art nude can be interpreted as the elementary starting point of an implicit critique of racism and ethnocentrism in Western aesthetics.

Once we consider Mapplethorpe's own marginality as a gay artist, placed in a subordinate relation to the canonical tradition of the nude, his implicitly critical position on the presence/absence of the race in dominant regimes of representation enables a reappraisal of the intersubjective collaboration between artist and model. Whereas my previous reading emphasized the apparent inequality between the famous, author-named white artist and the anonymous and interchangeable black models, the biographical dimension reveals an important element of mutuality. In a magazine interview that appeared after his death in 1989, Mapplethorpe's comments about the models suggest an intersubjective relation based on a shared social identity: "Most of the blacks don't have health insurance and therefore can't afford AZT. They all died quickly, the blacks. If I go through my *Black Book,* half of them are dead."[11] In his mourning, there is something horribly accurate about the truism that death is the great leveler, because his pictures have now become *memento mori,* documentary evidence of a style of life and a sexual ethics in the metropolitan gay culture of the 1970s and early 1980s that no longer exist in the way they used to. As a contribution to the historical formation of urban gay culture, Mapplethorpe's homoeroticism is invested with memory, with the intense emotional residue Barthes described when he wrote about the photographs of his mother.[12]

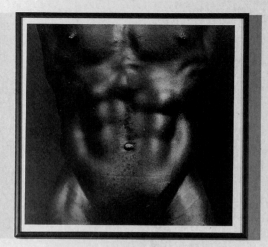

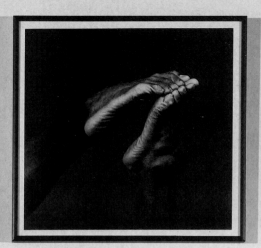

It is the way that black people are marked as black (are not just "people") in representation that has made it relatively easy to analyse their representation, whereas white people—not there as a category and everywhere everything as a face—are difficult, if not impossible, to analyse *qua* white. The subject seems to fall apart in your hands as soon as you begin.

—Richard Dyer

Mapplethorpe appropriates the conventions of porn's racialized codes of representation, and by abstracting its stereotypes into "art," he makes racism's phantasms of desire respectable. The use of glossy photographic textures and surfaces serves to highlight the visible difference of black skin: Coupled with the use of porn conventions in body posture, framing devices like cropping, and the fragmentation of bodies into details, his work reveals an underlying fetishism.

—Isaac Julien and Kobena Mercer

What one's imagination makes of other people is dictated, of course, by the laws of one's own personality and it is one of the ironies of black-white relations that, by means of what the white man imagines the black man to be, the black man is enabled to know who the white man is.

—James Baldwin

It is not that Mapplethorpe is unaware of the political implications of a white man shooting physically magnificent black men, and such implicit tensions lend a piquancy to these pictures. But the stereotypes are transcended by a potent mood of celebration and sex, in which the artist reacts towards his subject with as much feeling as the camera allows.

—Alan Hollinghurst

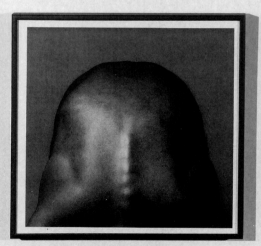

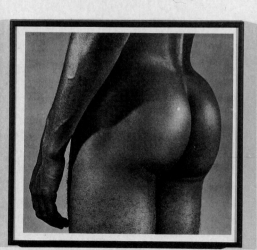

The element of mutual identification between artist and models undermines the view that the relation was necessarily exploitive simply because it was interracial. Comments by Ken Moody, one of the models in the *Black Book*, suggest a degree of reciprocity. When asked in the BBC television interview whether he recognized himself in Mapplethorpe's pictures, he said, "Not always, not most of the time. . . . When I look at it as me, and not just a piece of art, I think I look like a freak. I don't find that person in the photograph necessarily attractive, and it's not something I would like to own." The alienation of not even owning your own image might be taken as evidence of objectification, of being reduced to a "piece of art"; but, at the same time, Moody rejects the view that it was an unequivocal relation, suggesting instead a reciprocal gift relationship that further underlines the theme of mutuality:

> *I don't honestly think of it as exploitation. . . . It's almost as if—and this is the conclusion I've come to now, because I really haven't thought about it up to now—it's almost as if he wants to give a gift to this particular group. He wants to create something very beautiful and give it to them. . . . And he is actually very giving.*

I don't want to over- or underinterpret such evidence, but I do think that this biographical dimension to the issues of authorship and enunciation enables a rereading of the textual ambivalence in Mapplethorpe's artistic practice. Taking the question of identification into account, as that which inscribes ambivalent relations of mutuality and reversibility in the gaze, enables a reconsideration of the cultural policies of Mapplethorpe's black male nudes.

Once grounded in the context of contemporary urban gay male culture in the United States, the shocking modernism that informs the ironic juxtaposition of elements drawn from the repository of high culture—where the nude is indeed one of the most valued genres in Western art history—can be read as a subversive recoding of the normative aesthetic ideal. In this view, it becomes possible to reverse the reading of racial fetishism in Mapplethorpe's work, not as a repetition of racist fantasies but as a deconstructive strategy that lays bare psychic and social relations of ambivalence in the representation of race and sexuality. This deconstructive aspect of his homoeroticism is experienced, at the level of audience reception, as the disturbing shock effect.

The Eurocentric character of the liberal humanist values invested in classical Greek sculpture as the original model of human beauty in Western aesthetics is paradoxically revealed by the promiscuous intertextuality whereby the filthy and degraded form of the commonplace racist stereotype is brought into the domain of aesthetic purity circumscribed by the privileged place of the fine-art nude.

This doubling within the pictorial space of Mapplethorpe's black nudes does not reproduce either term of the binary relation between "high culture" and "low culture" as it is; it radically decenters and destabilizes the hierarchy of racial and sexual difference in dominant systems of representation by folding the two together within the same frame. It is this ambivalent intermixing of textual references, achieved through the appropriation and articulation of elements from the "purified" realm of the transcendental aesthetic ideal and from the debased and "polluted" world of the commonplace racist stereotype, that disturbs the fixed positioning of the spectator. One might say that what is staged in Mapplethorpe's black male nudes is the return of the repressed in the ethnocentric imaginary. The psychic-social boundary that separates "high culture" and "low culture" is transgressed, crossed, and disrupted precisely by the superimposition of two ways of seeing, which thus throws the spectator into uncertainty and undecidability, precisely the experience of ambivalence as a structure of feeling in which one's subject-position is called into question.

In my previous argument, I suggested that the regulative function of the stereotype had the upper hand, as it were, and helped to "fix" the spectator in the ideological subject-position of the "white male subject." Now I'm not so sure. Once we recognize the historical and political specificity of Mapplethorpe's practice as a contemporary gay artist, the aesthetic irony that informs the juxtaposition of elements in his work can be seen as the trace of a subversive strategy that disrupts the stability of the binary oppositions into which difference is coded. In social, economic, and political terms, black men in the United States constitute one of the "lowest" social classes: disenfranchised, disadvantaged, and disempowered as a distinct collective subject in the late capitalist underclass. Yet, in Mapplethorpe's photographs, men who in all probability came from this class are elevated onto the pedestal of the transcendental Western aesthetic ideal. Far from reinforcing the fixed beliefs of the white supremacist imaginary, such a deconstructive move begins to undermine the foundational myths of the pedestal itself.

The subaltern black social subject, who was historically excluded from dominant regimes of representation—"invisible men" in Ralph Ellison's phrase—is made visible within the codes and conventions of the dominant culture whose ethnocentrism is thereby exposed as a result. The mythological figure of "the Negro," who was always excluded from the good, the true, and the beautiful in Western aesthetics on account of his otherness, comes to embody the image of physical perfection and aesthetic idealization in which, in the canonical figure of the nude, Western culture constructed its own

self-image. Far from confirming the hegemonic white, heterosexual subject in his centered position of mastery and power, the deconstructive aspects of Mapplethorpe's black male nude photographs loosen up and unfix the commonsense sensibilities of the spectator, who thereby experiences the shock effect precisely as the affective displacement of given ideological subject-positions.

To shock was always the key phrase of the avant-garde in modernist art history. In Mapplethorpe's work, the shock effected by the promiscuous textual intercourse between elements drawn from opposite ends of the hierarchy of cultural value decenters and destabilizes the ideological fixity of the spectator. In this sense, his work begins to reveal the political unconscious of white ethnicity. It lays bare the constitutive ambivalence that structures whiteness as a cultural identity whose hegemony lies, as Richard Dyer suggests, precisely in its "invisibility."[13]

The splitting of the subject in the construction of white identity, entailed in the affirmation and denial of racial difference in Western humanism, is traced in racist perception. Blacks are looked down upon and despised as worthless, ugly, and ultimately unhuman creatures. But in the blink of an eye, whites look up to and revere the black body, lost in awe and envy as the black subject is idolized as the embodiment of the whites' ideal. This schism in white subjectivity is replayed daily in the different ways black men become visible on the front and back pages of tabloid newspapers, seen as undesirable in one frame—the mugger, the terrorist, the rapist— and highly desirable in the other—the athlete, the sports hero, the entertainer. Mapplethorpe undercuts this conventional separation to show the recto-verso relation between these contradictory "ways of seeing" as constitutive aspects of white identity. Like a mark that is legible on both sides of a sheet of paper, Mapplethorpe's aesthetic strategy places the splitting in white subjectivity under erasure: it is crossed out but still visible. In this sense, the anxieties aroused in the exhibition history of Mapplethorpe's homoerotica not only demonstrate the disturbance and decentering of dominant versions of white identity, but also confront whiteness with the otherness that enables it to be constituted as an identity as such.

In suggesting that this ambivalent racial fetishization of difference actually enables a potential deconstruction of whiteness, I think Mapplethorpe's use of irony can by recontextualized in relation to pop art practices of the 1960s. The undecidable question that is thrown back on the spectator—do the images undermine or reinforce racial stereotypes?—can be compared to the highly ambivalent aura of fetishism that frames the female body in the paintings of Allen Jones. Considering the issues of sexism and misogyny at stake,

Laura Mulvey's reading from 1972 suggests a contextual approach to the political analysis of fetishism's "shocking" undecidability:

> By revealing the way in which fetishistic images pervade not just specialist publications but the whole of mass media, Allen Jones throws a new light on woman as spectacle. Women are constantly confronted with their own image . . . yet, in a real sense, women are not there at all. The parade has nothing to do with woman, everything to do with man. The true exhibit is always the phallus The time has come for us to take over the show and exhibit our own fears and desires.[14]

Left and above:
Renée Green, *Mise en Scène* (details), 1992, mixed media installation. Photos courtesy of the artist.

This reading has a salutary resonance in the renewal of debates on black aesthetics insofar as contemporary practices that contest the marginality of the black subject in dominant regimes of representation have gone beyond the unhelpful binarism of so-called positive and negative images. We are now more aware of the identities, fantasies, and desires that are coerced, simplified, and reduced by the rhetorical closure that flows from that kind of critique. But Mulvey's reading also entails a clarification of what we need from theory as black artists and intellectuals. The critique of stereotypes was crucial in the women's and gay movements of the 1960s and 1970s, just as it was in the black movements that produced aesthetic-political performative statements such as Black Is Beautiful. As the various movements have fragmented politically, however, their combined and uneven development suggests that analogies across race, gender, and sexuality may be useful only insofar as we historicize them and what they make possible. Appropriations of psychoanalytic theory arose at a turning point in the cultural politics of feminism; in thinking about the enabling possibilities this has opened up for the study of black representation, I feel we also need to acknowledge the other side of ambivalence in contemporary cultural struggles, the dark side of the political predicament that ambivalence engenders.

In contrast to the claims of academic deconstruction, the moment of undecidability is rarely experienced as a purely textual event; rather, it is the point where politics and the contestation of power are felt to be at their most intense. According to V.N. Volosinov, the social multiaccentuality of the ideological sign has an "inner dialectical quality [that] comes out only in times of social crises or revolutionary changes," because "in ordinary circumstances . . . an established dominant ideology . . . always tries, as it were, to stabilize the dialectical flux."[15] Indeterminacy means that multiaccentual or polyvalent signs have no necessary belonging and can be articulated and appropriated into the political discourse of the right as easily as they can into that of the left. Antagonistic efforts to fix the multiple connotations arising from the ambivalence of the key signs of ideological struggle demonstrate what in Gramsci's

terms would be described as a war of position whose outcome is *never* guaranteed in advance one way or the other.

We have seen how, despite their emancipatory objectives, certain radical feminist antipornography arguments have been taken up and translated into the neoconservative cultural and political agenda of the right. For my part, I want to emphasize that I've reversed my reading of racial signification in Mapplethorpe not for the fun of it, but because I do *not* want a black gay critique to be appropriated to the purposes of the right's antidemocratic cultural offensive. Jesse Helms's amendment to public funding policies in the arts—which was orchestrated in relation to Mapplethorpe's homoerotic work— forbids the public funding of art deemed "obscene or indecent." But it is crucial to note that a broader remit for censorship was originally articulated on the grounds of a moral objection to art that "denigrates, debases, or reviles a person, group, or class of citizens on the basis of race, creed, sex, handicap, or national origin."[16] In other words, the discourse of liberal and social democratic antidis- crimination legislation is being appropriated and rearticulated into a right-wing position that promotes a discriminatory politics of cultural censorship and ideological coercion.

Without a degree of self-reflexivity, black critiques of Mapplethorpe's work can be easily assimilated into a politics of homophobia. Which is to say, coming back to the photographs, that precisely on account of their ambivalence, Mapplethorpe's photographs are open to a range of contradictory readings whose political character depends on the social identity that different audiences bring to bear on them. The photographs can confirm a racist reading as easily as they can produce an antiracist one. Or again, they can elicit a homophobic reading as easily as they can confirm a homoerotic one. Once ambivalence and undecidability are situated in the contextual relations between author, text, and readers, a cultural struggle ensues in which antagonistic efforts seek to articulate the meaning and value of Mapplethorpe's work.

What is at issue in this "politics of enunciation" can be clarified by a linguistic analogy, since certain kinds of performative state- ments produce different meanings not so much because of what is said but because of who is saying it. As a verbal equivalent of Mapplethorpe's visual image, the statement "the black man is beau- tiful" takes on different meanings depending on the identity of the social subject who enunciates it. Does the same statement mean the same thing when uttered by a white woman, a black woman, a white man, or a black man? Does it mean the same thing whether the speaker is straight or gay? In my view, it cannot possibly mean the same thing in each instance because the racial and gendered

identity of the enunciator inevitably "makes a difference" to the social construction of meaning and value.

Today, we are adept at the all-too-familiar concatenation of identity politics, as if by merely rehearsing the mantra of "race, class, gender" (and all other intervening variables) we have somehow acknowledged the diversified and pluralized differences at work in contemporary culture, politics, and society. Yet, the complexity of what actually happens "between" the contingent spaces where each variable intersects with the others is something only now coming into view theoretically, and this is partly the result of the new antagonistic cultural practices by hitherto marginalized artists. Instead of analogies, which tend to flatten out these intermediate spaces, I think we need to explore theories that enable new forms of dialogue. In this way, we might be able to imagine a dialogic or relational conception of the differences we actually inhabit in our lived experiences of identity and identification. The observation that different readers produce different readings of the same cultural texts is not as circular as it seems: I want to suggest that it provides an outlet onto the dialogic character of the political imaginary of difference. To open up this area for theoretical investigation, I want to point to two ways in which such relational differences of race, gender, and sexuality do indeed "make a difference."

Different Readers Make Different Readings

Here, I simply want to itemize a range of issues concerning reader-ship and authorship that arise across the intertextual field in which Mapplethorpe "plays." To return to *Man in Polyester Suit*, one can see that an anonymous greeting card produced and marketed in a specifically gay cultural context works on similar fantasies of black sexuality. The greeting card depicts a black man in a business suit alongside the caption "Everything you ever heard about black men . . . is true"—at which point one unfolds the card to reveal the black man's penis. The same savage-civilized binarism that I noted in Mapplethorpe's photograph is signified here by the con-trast between the body clothed in a business suit, then denuded to reveal the penis (with some potted plants in the background to emphasize the point about the nature-culture distinction). Indeed, as the card replays the fetishistic splitting of levels of belief as it is opened: the image of the big black penis serves as the punchline of the little joke. But because the card is authorless, the issue of attributing racist or antiracist intentions is effectively secondary to the context in which it is exchanged and circulated, the context of an urban, commercial, gay male subculture. My point is that gay readers in this vernacular sign-community may share access to a

range of intertextual references in Mapplethorpe's work that other readers may not be aware of.

Returning to the "enigma" of the black models in Mapplethorpe's work, the appearance of black gay video porn star Joe Simmons (referred to as Thomas in *The Black Book*) on magazine covers from *Artscribe* to *Advocate Men*, offers a source of intertextual pleasure to those "in the know" that accentuates and inflects Mapplethorpe's depiction of the same person. Repetition has become one of the salient pleasures of gay male pornography, as photographic reproduction and video piracy encourage the accelerated flow by which models and scenarios constantly reappear in new intertextual combinations. By extending this process into "high art," circulating imagery between the streets and the galleries, Mapplethorpe's promiscuous textuality has a sense of humor that might otherwise escape the sensibilities of nongay or antigay viewers.

The mobility of such intertextual moves cannot be arrested by recourse to binary oppositions. The sculpted pose of Joe Simmons in one frame immediately recalls the celebrated nude studies of Paul Robeson by Nicholas Muray in 1926. Once the photograph is situated in this historical context, which may or may not be familiar to black readers in particular, one might compare Mapplethorpe to Carl Van Vechten, the white photographer of black literati in the Harlem Renaissance. In this context, Richard Dyer has retrieved a revealing instance of overwhelming ambivalence in racial-sexual representations. In the 1920s, wealthy white patrons in the Philadelphia Art Alliance commissioned a sculpture of Robeson by Antonio Salemme. Although they wanted it to embody Robeson's "pure" beauty in bronze, they rejected the sculpture because its aesthetic sensuality overpowered their moral preconceptions.[17]

The historical specificity of this reference has a particular relevance in the light of renewed interest in the Harlem Renaissance in contemporary black cultural practices. The rediscovery of the past has served to thematize questions of identity and desire in the work of black gay artists such as Isaac Julien. In *Looking for Langston* (1988), Julien undertakes an archeological inquiry into the enigma of Langston Hughes's sexual identity. Insofar as the aesthetic strategy of the film eschews the conventions of documentary realism in favor of a dialogic combination of poetry, music, and archival imagery, it does not claim to discover an authentic or essential homosexual identity (for Langston Hughes or anyone else). Rather, the issue of authorial identity is invested with fantasy, memory, and desire, and serves as an imaginative point of departure for speculation and reflection on the social and historical relations in which black gay male identity is lived and experienced in diaspora societies such

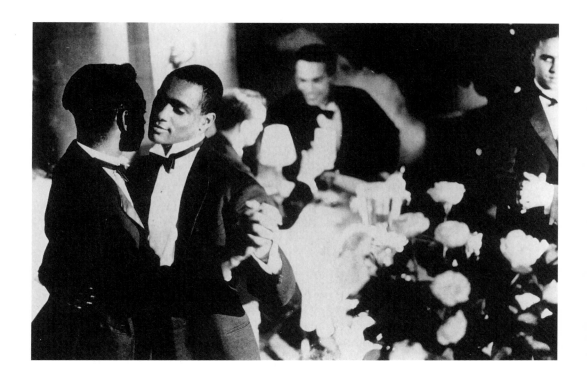

as Britain and the United States. In this sense, the criticism that the film is not about Langston Hughes misses the point. By showing the extent to which our identities as black gay men are historically constructed in and through representations, Julien's film interrogates aspects of social relations that silence and repress the representability of black gay identities and desires. The search for iconic heroes and heroines has been an important element in lesbian, gay, and feminist cultural politics, and the process of uncovering identities previously "hidden from history" has had empowering effects in culture and society at large. Julien is involved in a similar project, but his film refuses, through its dialogic strategy, to essentialize Hughes into a black gay cultural icon. This strategy focuses on the question of power at issue in the ability to make and wield representations. Above all, it focuses on who has the "right to look" by emphasizing both interracial and intraracial looking relations that complicate the subject–object dichotomy of seeing and being seen.

Hence, in one key scene, we see the white male protagonist leisurely leafing through *The Black Book*. Issues of voyeurism, objectification, and fetishization are brought into view not in a didactic confrontation with Mapplethorpe, but through a seductive invitation into the messy spaces in between the binary oppositions that dominate the representation of difference. Alongside visual quotations from Jean Cocteau, Jean Genet, and Derek Jarman, the voices of James Baldwin, Toni Morrison, and Amiri Baraka combine to emphasize the relational conception of "identity" that Julien's dialogic

Isaac Julien, *Looking for Langston*, 1988. Film still courtesy of Third World Newsreel.

strategy makes possible. It is through this relational approach that the film reopens the issue of racial fetishism. An exchange of looks between "Langston" and his mythic object of desire, a black man called "Beauty," provokes a hostile glare from Beauty's white partner. In the daydream that follows, Langston imagines himself coupled with Beauty, their bodies intertwined on a bed in an image reappropriated and reaccentuated from the homoerotic photography of George Platt-Lynes. It is here that the trope of visual fetishization makes a subversive return. Close-up sequences lovingly linger on the sensuous mouth of the actor portraying Beauty, with the rest of his face cast in shadow. As in Mapplethorpe's photographs, the strong emphasis on chiaroscuro lighting invests the fetishized fragment with a powerful erotic charge, in which the "thick lips" of the Negro are hypervalorized as the emblem of Beauty's impossible desirability. In other words, Julien takes the artistic risk of replicating the stereotype of the "thick-lipped Negro" in order to revalorize that which has historically been devalorized as emblematic of the other's ugliness. It is only by operating "in and against" such tropes of racial fetishism that Julien lays bare the ambivalence of the psychic and social relations at stake in the relay of looks between the three men.

Historically, black people have been the objects of representation rather than its subjects and creators because racism often determines who gets access to the means of representation in the first place. Through his dialogic textual strategy, Julien overturns this double-bind as the black subject "looks back" to ask the audience who or what *they* are looking for. The motif of the "direct look" appeared in Julien's first film with the Sankofa Collective, *Territories* (1984), which involved an "epistemological break" with the realist documentary tradition in black art. Similarly, what distinguishes current work by black lesbian and gay artists—such as the film and video of Pratibha Parmar or the photography of Rotimi Fani-Kayode— is the break with static and essentialist conceptions of identity. The salient feature of such work is its hybridity; it operates on the borderlines of race, class, gender, nationality, and sexuality, investigating the complex overdetermination of subjective experiences and desires as they are historically constituted in the ambivalent spaces in between.

Elsewhere I suggested that, in relation to black British film, such hybridized practices articulate a critical dialogue about the constructed character of black British identities and experiences.[18] Something similar informs the hybridized homoerotica of Nigerian-British photographer Rotimi Fani-Kayode. The very title of his first publication, *Black Male/White Male*,[19] suggests an explicitly intertex-

tual relationship with Mapplethorpe. However, salient similarities in Fani-Kayode's construction of pictorial space—the elaborate body postures enclosed within the studio space, the use of visual props to stage theatrical effects, and the glossy monochrome texture of the photographic print—underline the important differences in his refiguration of the black male nude. In contrast to Mapplethorpe's isolation-effect, whereby only one black man occupies the field of vision at any one time, in Fani-Kayode's photographs, bodies are coupled and contextualized. In pictures such as *Technique of Ecstasy*, the erotic conjunction of two black men suggests an Afrocentric imaginary in which the implied power relations of the subject-object dichotomy are complicated by racial sameness. In *Bronze Head*, what looks like a Benin mask appears beneath a black man's splayed buttocks. This shocking contextualization places the image in an ambivalent space, at once an instance of contemporary African art, referring specifically to Yoruba iconography, and an example of homoerotic art photography that recalls Mapplethorpe's portrait of Derrick Cross, in which the black man's bum resembles a Brancusi.

If such dialogic strategies do indeed "make a difference" to our understanding of the cultural politics of identity and diversity, does this mean the work is different *because* its authors are black? No, not necessarily. What is at issue is not an essentialist argument that the ethnic identity of the artist guarantees the aesthetic or political value of the text, but on the contrary, how commonsense conceptions of authorship and readership are challenged by practices that acknowledge the diversity and heterogeneity of the relations in which identities are socially constructed. Stuart Hall helped to clarify what is at stake in this shift when he argued that such acknowledgment of difference and diversity in black cultural practices has brought the innocent notion of the essential black subject to an end. Once we recognize blackness as a category of social, psychic, and political relations that have no fixed guarantees in nature but only the contingent forms in which they are constructed in culture, the questions of value cannot be decided by recourse to empirical common sense about "color" or melanin. As Stuart Hall put it, "Films are not necessarily good because black people make them. They are not necessarily 'right on' by virtue of the fact that they deal with the black experience."[20]

In this view, I would argue that black gay and lesbian artists are producing exciting and important work not because they happen to be black lesbians and gay men, but because they have made cultural and political choices out of their experiences of marginality that situate them at the interface between different traditions. Insofar as they speak *from* the specificity of such experiences, they overturn

the assumption that minority artists speak *for* the entire community from which they come. This is an important distinction in the relations of enunciation because it bears upon the politics of representation that pertain to all subjects in marginalized or minoritized situations, whether black, feminist, lesbian, or gay. In a material context of restricted access to the means of representation, minoritized subjects are charged with an impossible "burden of representation." Where subordinate subjects acquire the right to speak only one at a time, their discourse is circumscribed by the assumption that they speak as "representatives" of the entire community from which they come.

It is logically impossible for any one individual to bear such a burden, not only because it denies variety and heterogeneity within minority communities, but also because it demands an intolerable submission to the iron law of the stereotype, namely, the view from the majority culture that every minority subject is "the same." In the master codes of the dominant culture, the assumption that "all black people are the same" reinforces the view that black communities are monolithic and homogeneous and that black subjectivity is defined exclusively by race and nothing but race. The dialogic element in contemporary black artistic practices begins to interrupt this restricted economy of representation by making it possible to imagine a democratic politics of difference and diversity. The work of black gay and lesbian artists participates in what has been called "postmodernism" in terms of practices that pluralize available representations in the public sphere. To the extent that their aesthetic of critical dialogism underlines their contribution to the "new cultural politics of difference," as Cornel West has put it,[21] it seems to me that rather than mere "celebration," their work calls for a critical response that reopens issues and questions we thought had been closed.

As I suggested in rereading Mapplethorpe, one of the key questions on the contemporary agenda concerns the cultural construction of whiteness. One of the signs of the times is that we really don't know what "white" is. The implicitly ethnocentric agenda of cultural criticism, since the proliferation of poststructuralist theories in the 1970s, not only obscured the range of issues concerning black authorship, black spectatorship, and black intertextuality that black artists have been grappling with, but also served to render invisible the constructed, and contested, character of "whiteness" as a racial/ethnic identity. Richard Dyer has shown how difficult it is to theorize whiteness, precisely because it is so thoroughly naturalized in dominant ideologies as to be invisible as an ethnic identity: it simply goes without saying. Paradoxically then, for all our rhetoric about "making ourselves visible," the real challenge in the new

cultural politics of difference is to make "whiteness" visible for the first time, as a culturally constructed ethnic identity historically contingent upon the disavowal and violent denial of difference. Gayatri Spivak has shown that it was only through the "epistemic violence" of such denial that the centered subject of Western philosophy posited itself as the universalized subject—"Man"— in relation to whom others were not simply different but somehow less-than-human, dehumanized objects of oppression. Women, children, savages, slaves, and criminals were all alike insofar as their otherness affirmed "his" identity as the subject at the center of logocentrism and indeed all the other centrisms—ethnocentrism and phallocentrism—in which "he" constructed his representations of reality.[22] But who is "he"? The identity of the hegemonic white male subject is an enigma in contemporary cultural politics.

Different Degrees of Othering

Coming back to Mapplethorpe's photographs, in the light of this task of making "whiteness" visible as a problem for cultural theory, I want to suggest that the positioning of gay (white) people in the margins of Western culture may serve as a perversely privileged place from which to reexamine the political unconscious of modernity. By negotiating an alternative interpretation of Mapplethorpe's authorial position, I argued that his aesthetic strategy lays bare and makes visible the "splitting" in white subjectivity that is anchored, by homology, in the split between "high culture" and "low culture." The perverse interaction between visual elements drawn from both sources begins to subvert the hierarchy of cultural value, and such subversion of fixed categories is experienced precisely as the characteristic shock effect.

Broadening this theme, one can see that representations of race in Western culture entail different degrees of othering. Or, to put it the other way around: different practices of racial representation imply different positions of identification on the part of the white subject. Hollywood's iconic image of the "nigger minstrel" in cinema history, for example, concerns a deeply ambivalent mixture of othering and identification. The creation of the minstrel mask in cinema, and in popular theater and the music hall before it, was really the work of white men in blackface. What is taking place in the psychic structures of such historical representations? What is going on when whites assimilate and introject the degraded and devalorized signifiers of racial otherness into the cultural construction of their own identity? If imitation implies identification, in the psychoanalytic sense of the word, then what is it about whiteness that makes the white subject want to be black?

"I Wanna Be Black," sang Lou Reed on the album *Street Hassle* (1979), which was a parody of a certain attitude in postwar youth culture in which the cultural signs of blackness—in music, clothes, and idioms of speech—were the mark of "cool." In the American context, such a sensibility predicated on the ambivalent identification with the other was enacted in the bohemian beatnik subculture and became embodied in Norman Mailer's literary image of "the White Negro" stalking the jazz clubs in search of sex, speed, and psychosis. Like a photographic negative, the white negro was an inverted image of otherness, in which attributes devalorized by the dominant culture were simply revalorized or hypervalorized as emblems of alienation and outsiderness, a kind of strategic self-othering in relation to dominant cultural norms. In the museum without walls, Mailer's white negro, who went in search of the systematic derangement of the senses, merely retraced an imaginary pathway in the cultural history of modernity previously traveled by Arthur Rimbaud and Eugene Delacroix in nineteenth-century Europe. There is a whole modernist position of "racial romanticism" that involves a fundamental ambivalence of identifications. At what point do such identifications result in an imitative masquerade of white ethnicity? At what point do they result in ethical and political alliances? How can we tell the difference? [23]

My point is that white ethnicity constitutes an "unknown" in contemporary cultural theory: a dark continent that has not yet been explored. One way of opening it up is to look at the ambivalent coexistence of the two types of identification, as they figure in the work of (white) gay artists such as Mapplethorpe and Jean Genet. In *Un Chant d'amour* (1950), Genet's only foray into cinema, there is a great deal of ambivalence, to say the least, about the black man, the frenzied and maniacal negro seen in the masturbatory dance through the scopophilic gaze of the prison guard. In another context, I wrote, "The black man in Genet's film is fixed like a stereotype in the fetishistic axis of the look. . . . , subjected to a pornographic exercise of colonial power." [24] Yes, I know . . . but. There is something else going on as well, not on the margins but at the very center of Genet's film. The romantic escape into the woods, which is the liberated zone of freedom in which the lover's utopian fantasy of coupling is enacted, is organized around the role of the "dark" actor, the Tunisian, the one who is not quite white. In this view, the ambivalence of ethnicity has a central role to play in the way that Genet uses race to figure the desire for political freedom beyond the prison house of marginality. Once located in relation to his plays, such as *The Balcony* and *The Blacks*, Genet's

textual practice must be seen as his mode of participation in the "liberation" struggles of the postwar era.

The word *liberation* tends to stick in our throats these days because it sounds so deeply unfashionable; but we might also recall that in the 1950s and 1960s it was precisely the connections between movements for the liberation from colonialism and movements for the liberation from the dominant sex and gender system that underlined their radical democratic character. In the contemporary situation, the essentialist rhetoric of categorical identity politics threatens to erase the connectedness of our different struggles. At its worst, such forms of identity politics play into the hands of the Right as the fundamentalist belief in the essential and immutable character of identity keeps us locked into the prisonhouse of marginality in which oppressions of race, class, and gender would have us live. By historicizing the imaginary identifications that enable democratic agency, we might rather find a way of escaping this ideological Bantustan.

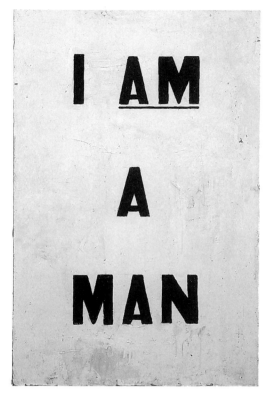

Glenn Ligon, *Untitled (I Am A Man)*, 1988. Oil and enamel on canvas, 40 x 25 inches. Photo courtesy of the artist.

Instead of giving an answer to the questions that have been raised about the ambivalence of ethnicity as a site of identification and enunciation, I conclude by recalling Genet's wild and adventurous story about being smuggled across the Canadian border by David Hilliard and other members of the Black Panther Party in 1968. He arrived at Yale University to give a May Day speech, along with Allen Ginsberg and others, in defense of imprisioned activist Bobby Seale. Genet talks about this episode in *Prisoner of Love*, where it appears as a memory brought to consciousness by the narration of another memory, about the beautiful fedayeen, in whose desert camps Genet lived between 1969 and 1972. The memory of his participation in the elective community of the Palestinian freedom fighters precipitates the memory of the Black Panther "brotherhood," into which he was adopted—this wretched, orphaned, nomadic homosexual thief. I am drawn to this kind of ambivalence, sexual and political, that shows through, like a stain, in his telling:

> In white America the Blacks are the characters in which history is written. They are the ink that gives the white page its meaning. . . . [The Black Panthers' Party] built the black race on a white America that was splitting. . . . The Black Panthers' Party wasn't an isolated

*phenomenon. It was one of many revolutionary outcrops. What made
it stand out in white America was its black skin, its frizzy hair, and,
despite a kind of uniform black leather jacket, an extravagant but elegant
way of dressing. They wore multicoloured caps only just resting on their
springy hair; scraggy moustaches, sometimes beards; blue or pink or gold
trousers made of satin or velvet, and cut so that even the most shortsighted
passer-by couldn't miss their manly vigour.*[25]

Under what conditions does eroticism mingle with political
solidarity? When does it produce an effect of empowerment? And
when does it produce an effect of disempowerment? When does
identification imply objectification, and when does it imply equality?
I am intrigued by the ambivalent but quite happy coexistence of
the fetishized big black dick beneath the satin trousers and the ethical
equivalence in the struggle for postcolonial subjectivity. Genet's
affective participation in the political construction of imagined
communities suggests that the struggle for democratic agency and
subjectivity always entails the negotiation of ambivalence.
Mapplethorpe worked in a different context, albeit one shaped by
the democratic revolutions of the 1960s, but his work similarly draws
us back into the difficult questions that Genet chose to explore,
on the "dark side" of the political unconscious of the postcolonial
world. The death of the author doesn't necessarily mean mourning
and melancholia, but, rather, mobilizing a commitment to counter-
memory. In the dialogue that black gay and lesbian artists have
created in contemporary cultural politics, the exemplary political
modernism of Mapplethorpe and Genet, "niggers with attitude"
if there ever were, is certainly worth remembering as we begin
thinking about our pitiful "postmodern" condition.

1. References are made primarily to *Black Males*, introduction by Edmund White (Amsterdam: Gallerie Jurka, 1982), and *The Black Book*, foreword by Ntozake Shange (New York: St. Martin's Press, 1986).

2. Kobena Mercer, "Imaging the Black Man's Sex," in *Photography/Politics: Two*, ed. Pat Holland, Jo Spence, and Simon Watney (London: Comedia/Methuen, 1987), pp. 61-69.

3. Laura Mulvey, "Visual Pleasure and Narrative Cinema," in *Feminism and Film Theory*, ed. Constance Penley (New York: Routledge, 1988), pp. 57-68.

4. Homi Bhabha, "The Other Question: The Stereotype and Colonial Discourse," *Screen* 24, no.6 (November-December 1983): 18-36.

5. Frantz Fanon, *Black Skin, White Masks* (London: Paladin, 1970), p. 120.

6. Sigmund Freud, "Fetishism" (1927), in *The Standard Edition of the Complete Psychological Works of Sigmund Freud*, ed. James Strachey (London: Hogarth Press, 1953-74), vol.21 (1961), pp.147-57.

7. Jane Gaines, "White Privilege and Looking Relations: Race and Gender in Feminist Film Theory," *Screen* 29, no. 4 (Autumn 1988): 12-27.

8. Michel Foucault, "What Is an Author?" in *Language, Counter-Memory, Practice*, ed. Donald F. Bouchard (Ithaca, N.Y.: Cornell University Press, 1977), pp.113-38; see also Roland Barthes, "The Death of the Author," in *Image-Music-Text* (New York: Hill and Wang, 1977): pp.142-48.

9. Fanon, *Black Skin, White Masks*, p.82.

10. Jacques Lacan, "The mirror stage as formative of the function of the I," in *Ecrits: A Selection* (London: Tavistock 1977), pp. 1-7.

11. "The Long Good-bye," interview by Dominick Dunne, *Blitz* (London, May 1989): 67-68.

12. Roland Barthes, *Camera Lucida* (New York: Hill and Wang, 1981).

13. Richard Dyer, "White," *Screen* 29, no. 4 (Autumn 1988): 44-64.

14. Laura Mulvey, "Fears, Fantasies and the Male Unconscious, or, You don't know what is happening, do you, Mr. Jones?'" in *Visual and Other Pleasures* (London: Macmillan, 1989), p 13.

15. V.N. Volosinov, *Marxism and the Philosophy of Language* (Cambridge, Mass.: Harvard University Press, 1973), p.24.

16. *New York Times*, July 27, 1989, p. A1.

17. Richard Dyer, "Paul Robeson: Crossing Over," in *Heavenly Bodies: Film Stars and Society* (New York: St. Martin's Press, 1986), pp. 67-139.

18. Kobena Mercer, "Diaspora Culture and the Dialogic Imagination: The Aesthetics of Black Independent Film in Britain," in *Blackframes: Critical Perspectives on Black Independent Cinema*, ed. Mbye B. Cham and Claire Andrade-Watkins (Cambridge, Mass.: MIT Press, 1988), pp. 50-61.

19. Rotimi Fani-Kayode, *Black Male/White Male* (London: Gay Men's Press, 1987); see also Rotimi Fani-Kayode, "Traces of Ecstasy," *Ten. 8*, no. 28 (Summer 1988): 36-43.

20. Stuart Hall, "New Ethnicities," in *Black Film/British Cinema*, ICA Document 7 (London: Institute of Contemporary Art/ British Film Institute, 1988), p. 28.

21. Cornel West, "The New Cultural Politics of Difference," in *Out There: Marginalization and Contemporary Cultures*, ed. Russell Ferguson, Martha Gever, Trinh T. Minh-ha, and Cornel West (Cambridge, Mass.: MIT Press, 1990), pp. 19-36.

22. Gayatri Chakravorty Spivak, "Feminism and Critical Theory," in *In Other Worlds: Essay in Cultural Politics* (New York and London: Methuen, 1987), pp. 77-92.

23. See Norman Mailer, "The White Negro: Superficial Reflections on the Hipster," in *Advertisements for Myself* (New York: Putnam, 1959), pp. 337-58. The fantasy of wanting to be black is discussed as a masculinist fantasy in Suzanne Moore, "Getting a Bit of the Other: The Pimps of Postmodernism," in *Male Order: Unwrapping Masculinity*, ed. Rowena Chapman and Jonathan Rutherford (London: Lawrence and Wishart, 1988), pp. 165-92.

24. See "Sexual Identity: Questions of Difference," a panel discussion with Kobena Mercer, Gayatri Spivak, Jacqueline Rose, and Angela McRobbie, *Undercut*, no. 17 (Spring 1988): 19-30.

25. Jean Genet, *Prisoner of Love* (London: Picador, 1989), p. 213.

Chapter 3:

"We were a pretty WASPy group."

Philip: AMI was established to help a lot of young people in smaller ways. But we were also very concerned with making our program geographically diverse and media diverse. And we always counted the grants to make sure there was a balance of women versus men—but that was really easy because work by women remains vastly more interesting than work by men.

Cee: *We all knew how peer panels worked: if the peers don't think of you as a peer, you're not going to get funding. If you're making work out in Bumfuck, Iowa, and nobody's been there and nobody knows who you are, your chances of getting funding elsewhere are limited.*

Cee: That was one of the reasons we wanted to focus on geographic distribution and to have a national board of people who were active in the artists' communities reaching out within those communities.

Mary: We tried to encourage applications from different areas. Rather than just sit in a loft in New York and give out money, we felt we should educate ourselves about what was going on elsewhere. We went to Chicago, Seattle, San Diego.

Cee: We had nominators distribute the applications and then we called the nominators to ask about the impact the applicants had on the community or just to ask them what we weren't seeing in the really shitty slides. If we were told the work was good, we funded it.

Laurence: AMI did become well-enough known that the people who needed us got to us somehow. Artists that had gotten grants from outside the centers would start referring other artists and slowly we began to build up a network. Eventually, however, we probably did become comfortable with the fact that the predominant amount of money was going to end up in New York.

Mary: It always seemed that the best stuff was done in a few places, like New York and Los Angeles. We'd say, it's Oklahoma, for heaven's sake, give it a break. But you can't support schlock just because it's from Oklahoma when there's a lot of good work in New York and a really crying need.

Mary: Then, of course, multicultural waves started hitting our consciousness. We realized that we were a pretty WASPy group and that we needed to put our money where our mouth was if we were going to talk about ethnic diversity as well as geographic diversity. We needed to get some representation on the board that spoke to that. We always had guest panelists like Adrian Piper, Joe Harvey Allen, bell hooks, Nayland Blake. Bruce Yonemoto was one.

David: When AMI decided to expand the board, I think they felt they needed more diversity, not the capital-D diversity, but lower-case diversity. It wasn't about being multicultural so much as wanting a broader reach in terms of vision and governance and policies than existed within the original core of people.

Bruce: Linda Earle and I were asked to come onto the board because they needed advice and experience about media.

Linda: I was invited to join the board because I had a really big, multidisciplinary overview and was in contact with a lot of artists. But I think part of it was also demographic: they wanted a person of color.

Kathy: The reason I was asked to join the board had to do with coming from a different part of the universe, in a sense. I was the director of a Latino arts program at San Antonio, Texas, so I was part of the art world, but I was also part of the, or of a, Latin community—part of a Latino art world. I was in touch with different geographic regions: Texas, Arizona, New Mexico, Colorado and California, as well as some Native-American peoples. I'm also a photographer. And I was also a curator who saw a lot of work. I had geographic diversity, I had cultural diversity, I had disciplinary diversity. . . .

Linda: *There's always a question of what's expected of the people of color—or the people from Texas. Are you expecting that to be all they will contribute? Everybody is more complicated than that.*

Linda: I didn't see my role at AMI as advocating for African-American artists, but I do happen to know a lot of them and was able to speak to their work and give some perspective on what they were doing.

Kathy: AMI did not make a specific point about diversity in its guidelines before 1993, but I think that's because we were covering it all along. We didn't have to make it a separate concern. We were always supporting gender- and sexual preference-related work. We were always looking at Latino work, but we were looking at incredibly good Latino work. We were rewarding incredibly good Latino work, rewarding incredibly good African-American work, incredibly good Asian-American work. We didn't have to run out to find culture we hadn't covered.

Mary: *It's about providing access. I believe in affirmative action. I also understand that some people see it as another stamp. But people also have to recognize that they have privilege for reasons that are not in and of themselves, and that may be harder still.*

Linda: *When I got into arts administration over twenty years ago, there were very few people like myself. It was a very class-specific line of work. Being an artist, past a certain point, was also very class-specific. I don't see class as an issue of need versus merit, but an element in the decision to support a broader group of people to pursue artistic expression. It's also about the idea of what an artist is, of whose work is valuable, or professional.*

David: *Two things started happening in the early 1960s: the Civil Rights Movement really advanced and public support for culture appeared. In 1960 the New York State Council on the Arts was formed. The Free Speech Movement emerged. And in 1965 the NEA was*

founded. Those were parallel, even intertwined, developments. With public support came a push for more democratic, more diverse support. That was the direction we were going in as a country. Diverse communities—be they women, Latinos, or gays and lesbians—started to gain political will and power. There were complaints that NYSCA wasn't supportive enough of communities of color, but they did a lot more than anybody else was doing, and that pot of money at NYSCA was a couple of million dollars more going in to fund community groups than ever existed before. It was not enough, but it was a beginning. Slowly, foundations started to follow NEA and NYSCA in that regard. Eventually, every state and city got its own arts council. And, over the years, that money eventually built an infrastructure of organizations that made the cultural community quite different than it was before 1960. Before 1960 the only places to get money were from a rich person, a foundation, or ticket sales. And the individuals and foundations giving money were not, for the most part, interested in diversity. It was like a private club.

Lowery: When I came to the Met, I perceived it as an interesting place to follow through on an agenda of diversity that I had set for my career. I've spent the last twenty years trying to push the limits of the perimeters here. But all throughout my career I've also recognized that I have interests that are outside of this museum. That's why I wanted to join the AMI board.

Linda: This is a board of real frontline arts people. I suppose people outside of AMI may have looked at us and wondered why we didn't have the kind of people who are on other boards, people with big bucks. Maybe that's the kind of diversity other people thought we ought to have had more of.

Adam: *Foundations are started by people with money. And whom do they know? They know other captains of industry. They know the attorneys and accountants who serve their industry. They know their associates. They know the people at the opera and the ballet, the people they have over for dinner and socialize with. They don't know people who are working in culture in communities of color. Those are the people on foundation boards, and they bring their biases to that board, including a pretty narrow conception of art.*

David: *The basic message about diversifying funding that was coming from public agencies was that everyone puts money into this government and therefore, as a distribution system, in a democratic society, everybody should get a little back. Public agencies that support the arts are places where we're all shareholders, where we can go and make requests. If you go to a private foundation or corporation for funding, you have a harder case to make.*

Adam: *A study done by the Foundation Center about funding in the arts from 1983 to 1993 showed that over 30 percent of all foundation dollars went to one percent of the arts institutions. That one percent probably reflects the composition of the boards of foundations, and that's what's wrong. You don't have trustees going to. . . I mean, forget the Caribbean Cultural Center. They don't even go to the Studio Museum in Harlem. Of course, if you say you support the arts and you give to Lincoln Center, you are indeed supporting the arts. The problem is when that foundation doesn't state in their guidelines that they only support major institutions, that they only support certain kinds of art. They hide behind vague guidelines, and there's no accountability.*

David: *If I went to a foundation and said, You need to have some more diversity on your board because as a member of the public I think there should be, I wouldn't get anywhere.*

It remains to be seen whether there is legal recourse; whether foundations have to meet the standard of nondiscrimination because of their tax-exempt status. They don't look at it that way now.

Adam: All boards have a responsibility to look at all grantees equitably, respecting their own guidelines and applying them equally to all applicants. I do think AMI shares some of the sins of the foundation community around the issue of equity. We did have the propensity to support our friends. Everybody has agendas, be they conservative or progressive, that can come into play in ways that don't relate to the guidelines. I just think that we have to leave that at the door.

Adam: *I also think we have to do a better job in contemporary arts at engaging communities.*

Kathy: *When we talk about community, we often forget that we have gay and lesbian communities, we have AIDS communities, we have disenfranchised communities, we have impoverished communities, we have communities from many different ethnic backgrounds and many different languages, and that those communities have many different outlooks and many different needs, and are going to react positively to many different types of art, and all of those communities are going to, at one point or another, want to see themselves reflected on that so-called American canvas. We really need to remember that we are communities, plural. We are many. And who I mean by "we" is every single body in the US.*

Kathy: When we start talking about the needs of all of these different communities, often the funders themselves, or the public itself, becomes offended and challenged and frightened. Maybe the greatest thing that AMI did was to say, "We're not afraid of difference, we're not afraid of any type of diversity, political, ethnic, gender, sexual preference. We're not afraid. We're going to look at all this different art and we're going to fund the best work we can find and we're not going to be afraid of what we might learn about ourselves by funding it."

Lowery: *Within the diversity community there are many ways in which cutting-edge issues are shied away from—I'll speak for the African-American community.*

Bruce: I never shared the pure PC view of history or what art means. There was a tendency to limit the scope of art to documentary form: documenting identity politics, without humor, without irony. AMI was unique because we weren't just focused on the PC agenda of that particular period. . . . Well, there was definitely a gay agenda at AMI. Sure.

Censorship and

the Chilling Effect

A Graphic Picture Is Worth a Thousand Vo
Photo Table of Contents
Prepared by Christian Action Network

Purpose

"A Graphic Picture is Worth a Thousand Votes," is a collection of w
have received either direct or indirect funding from the National Endowment
exhibit was compiled by the Christian Action Network (CAN). When CAN at
the exhibit in the Capitol two years ago, Members of the Democratic m
influence to shut down the exhibit and censor it to prevent themselves from b
CAN more recently showed the exhibit in the Rayburn House Office Building

The following artists we included exhibit contains
artwork. This is by no means a when ection outr
supported by the NEA.

1. **Joel-Peter Witkin** -- *Le Baiser (The Ki*

Mr. Witkin had a pathologist sever this head vertically in half from a
at a morgue. The two halves of the same head were then turned together so t
kiss himself. It is evident from the picture that the head was not neatly sever
A relative identified the man and complained to Mr. Witkin who subseque
photo negative.

Joel-Peter Witkin is the recipient of four NEA fellowship grants F
1981, $12,500 FY 1980, $11,000 FY 1982, $20,000.

2. **Joel-Peter Witkin** -- *Woman Castrating a Man*, 1982

Mr. Witkin is the recipient of four NEA fellowship grants totaling $5

3. **Joel-Peter Witkin** -- *Journeys of the Mask: Phrenologist*, 1983

The religious imagery used in this photo consists of an image of Chri

Mr. Witkin is the recipient of four NEA fellowship grants totaling $5

4. **Joel-Peter Witkin** -- *Hermaphrodite with Christ*, 1985

Religious imagery is used in this photo with Christ displayed on the

In October 1994, the NEA abolished the practice of allowing grantees to subgrant to other organizations and artists.

"As a malaise settles into the galleries of SoHo, dealers with uncertain futures in the market are plagued with feelings of paranoia and vertigo. 'It's like a virus,' one dealer says of the galleries closing around him. 'As it spreads, chances are that it will happen to you.' Although more than 250 galleries remain in SoHo, many are looking to economize and consolidate."[24]

hich
The
play
their
sed.
995.

s of
vork

ody
ould
ody.

II th

"Fiscal discipline? In fact, the project is cultural defoliation—an attempt to destroy 'liberal' habitat."[25]

FY *dollars ha* *er*

Christian Action Network

SECRETS OF
WASHINGTON

Restore America
Home Lobbyist Kit

IN THE HOUSE OF REPRESENTATIVES

January 7, 1997

Mr. Crane (for himself, Mr. Sam Johnson of Texas, and Mr. Norw
introduced the following bill; which was referred to the Commit
Education and the Workforce

A BILL

"Audiences, already goaded by the fundamen
right, rise up in wrath. Museums, on a delica
mission to bring culture to the wastelands, a
caught between the aroused public, the waffl
legislators, and the professional demolition te
The 31 million are confirmed in their suspici
that contemporary art is a con job foisted off
shysters. Mass hysteria expresses itself—not
being gulled by artists—but by being afraid o
being gulled."[26]

"I truly believe that this type of 'art' will simply vanish if the NEA stops funding it. Then we can all breathe a sigh of relief.
... Martin Mawyer

"There is a recurring tendency in American culture to undervalue the arts—to think of them as decorative, recreational or therapeutic."[27]

ent on "art" that o

To amend the National Foundation on the Arts and the Humanities
1965 to abolish the National Endowment for the Arts and the Nat
Council on the Arts.

Be it enacted by the Senate and House of Representatives of
United States of America in Congress assembled,

SECTION 1. SHORT TITLE.

This Act may be cited as the ``Privatization of Art Act''.

SEC. 2. TERMINATION OF THE NATIONAL ENDOWMENT FOR THE ARTS.

"Conservatives know that the subsidized, nonprofit art world is of vital importance to artists. This situation is feared precisely because it gives the artist independence, and, furthermore, some means to critically examine the marketplace and its social and ethical underpinnings. Restriction on the nonprofit world can only force artists to become more dependent on the marketplace.

WHY AMERICA SHOULDN'T KILL CULTURAL FUNDING

BY ROBERT HUGHES

The result is a privatization of art production that reduces encounters between critical artists and the public."[28]

"A deep ambivalence, if not hypocrisy, runs through the contemporary artist's view of capitalism. (...) In a capitalist society, in fact, one probably feels one has truly arrived as an artist only when one has had a large-public kind of success, which includes recognition as well as financial reward."[29]

The War on Culture (1989)

CAROLE S. VANCE

This article was written at the beginning of the fundamentalist attack on the National Endowment for the Arts in 1989. At that moment, the campaign against the NEA might have seemed to some an impulsive, irrational, and quixotic assault. The specter of legislators denouncing art exhibitions which they had never seen or ripping up photographic catalogues on the Senate floor suggested surrealistic moments from the yet-to-be-made video The Marx Brothers Meet Foucault.

Despite these farcical moments, the fundamentalist campaign has consistently used sexual images very cleverly and strategically as both the target of the attack and the mechanism to foment a large-scale and persistent sexual panic. In the ensuing decade, the panic gained momentum and scope, exploiting the slippage between terms like "erotic," "sexual," "pornographic," "indecent," and "obscene," to eventually and successfully mainstream the previously extremist convention that all erotic depictions were, by definition, obscene and therefore illegal, or, at the very least, dangerous and unbearably controversial.

Sex panics are politics by other means, and the recent campaigns against and through sexual imagery achieved significant and disturbing results. Long-standing efforts to defund and reduce the scope of the NEA, largely unsuccessful during the Reagan presidency when framed in terms of cost-cutting and anti-elitism, achieved real success in the 1990s through the strategy of "add sex and stir." In addition, the endlessly circulated image of the fuming taxpayer, outraged at the use of public monies for allegedly offensive art, suggested that there was a singular and uniform standard of public taste. Amid growing gender and sexual nonconformity, this sleight of hand erased actual diversity and real taxpayers, substituting the fiction that all citizens shared the same sexual subjectivity. In public debates, the sexual image underwent similar consolidation, with its meaning framed as obvious, stable, and literally read.

Sexual images, however, are slippery in more ways than one. They are highly context-dependent, subject to multiple readings, and always in play with viewers' sensibilities and life histories. This war on culture, then, attempted not only to remove funding and resources, but also to shrink visibility, language, and memory. — C.S.V., January 1999

Chapter opener:
Jenny Holzer, *Sign on a Truck*, 1984, moving video installation. Photo courtesy of the artist. Art Matters grant recipient, 1987.

Left:
Andres Serrano, *Untitled X (Ejaculate in Trajectory)*, 1989, Cibachrome, silicone, plexiglass, wood frame, 40 x 60. Courtesy of Paula Cooper Gallery. Art Matters grant recipient, 1986, 1988.

This essay was first published in *Art in America*, 47 (September 1989), pp. 39–43.

The storm that had been brewing over the National Endowment for the Arts (NEA) funding broke on the Senate floor on May 18, as Senator Alfonse D'Amato rose to denounce Andres Serrano's photograph *Piss Christ* as "trash." "This so-called piece of art is a deplorable, despicable display of vulgarity," he said. Within minutes, over 20 senators rushed to join him in sending a letter to Hugh Southern, acting chair of the NEA, demanding to know what steps the agency would take to change its grant procedures. "This work is shocking, abhorrent and completely undeserving of any recognition whatsoever," the senators wrote.[1] For emphasis, Senator D'Amato dramatically ripped up a copy of the exhibition catalogue containing Serrano's photograph.

Not to be outdone, Senator Jesse Helms joined in the denunciation: "The Senator from New York is absolutely correct in his indignation and in his description of the blasphemy of the so-called artwork. I do not know Mr. Andres Serrano, and I hope I never meet him. Because he is not an artist, he is a jerk." He continued, "Let him be a jerk on his own time and with his own resources. Do not dishonor our Lord."[2]

The object of their wrath was a 60-by-40-inch Cibachrome print depicting a wood-and-plastic crucifix submerged in yellow liquid—the artist's urine. The photograph had been shown in an uneventful three-city exhibit organized by the Southeastern Center for Contemporary Art (SECCA), a recipient of NEA funds. A juried panel appointed by SECCA had selected Serrano and nine others from some 500 applicants to win $15,000 fellowships and appear in the show *Awards in the Visual Arts 7*. How the senators came to know and care about this regional show was not accidental.

Although the show had closed by the end of January 1989, throughout the spring the right-wing American Family Association, based in Tupelo, Mississippi, attacked the photo, the exhibition, and its sponsors. The association and its executive director, United Methodist minister Rev. Donald Wildmon, were practiced in fomenting public opposition to allegedly "immoral, anti-Christian" images and had led protests against Martin Scorsese's film *The Last Temptation of Christ* the previous summer. The AFA newsletter, with an estimated circulation of 380,000, including 178,000 churches, according to association spokesmen,[3] urged concerned citizens to protest the artwork and demand that the NEA officials responsible be fired. The newsletter provided the relevant names and addresses, and letters poured in to congressmen, senators and the NEA. A full-fledged moral panic had begun.

Swept up in the mounting hysteria was another photographic exhibit scheduled to open on July 1 at the Corcoran Gallery

of Art in Washington, D.C. The 150-work retrospective, *Robert Mapplethorpe: The Perfect Moment*, was organized by the University of Pennsylvania's Institute of Contemporary Art (ICA), which had received $30,000 for the show from the NEA. The show included the range of Mapplethorpe's images: formal portraiture, flowers, children, and carefully posed erotic scenes—sexually explicit, gay, and sadomasochistic. The show had been well-received in Philadelphia and Chicago, but by June 8, Representative Dick Armey (R.-Tex.) sent Southern a letter signed by over 100 congressmen denouncing grants for Mapplethorpe as well as Serrano, and threatening to seek cuts in the agency's $170-million budget soon up for approval. Armey wanted the NEA to end its sponsorship of "morally reprehensible trash,"[4] and he wanted new grant guidelines that could "clearly pay respect to public standards of taste and decency."[5] Armey claimed he could "blow their budget out of the water"[6] by circulating the Mapplethorpe catalogue to fellow legislators prior to the House vote on the NEA appropriation. Before long, about 50 senators and 150 representatives had contacted the NEA about its funding.[7]

Amid these continuing attacks on the NEA, rumors circulated that the Corcoran would cancel the show. Director Christina Orr-Cahall staunchly rejected such rumors one week, saying, "This is the work of a major American artist who's well known, so we're not doing anything out of the ordinary."[8] But by the next week she had caved in, saying, "We really felt this exhibit was at the wrong place at the wrong time."[9] The director attempted an ingenious argument in a statement issued through a museum spokesperson: far from being censorship, she claimed, the cancellation actually protected the artist's work. "We decided to err on the side of the artist, who had the right to have his work presented in a non-sensationalized, non-political environment, and who deserves not to be the hostage for larger issues of relevance to us all," Orr-Cahall stated. "If you think about this for a long time, as we did, this is not censorship; in fact, this is the full artistic freedom which we all support."[10] Astounded by the Corcoran decision, artists and arts groups mounted protests, lobbied and formed anti-censorship organizations, while a local alternative space, The Washington Project for the Arts (WPA), hastily arranged to show the Mapplethorpe exhibition.

Karen Finley, *We Keep Our Victims Ready*, 1990, performance at The Kitchen, New York City. Photo courtesy of the artist. Art Matters grant recipient, 1987, 1988, 1990, 1992.

The Corcoran cancellation scarcely put an end to the controversy, however. Instead, attacks on NEA funding intensified in the House and Senate, focusing on the 1990 budget appropriations and on new regulations that would limit or possibly end NEA subcontracts to arts organizations.[11] Angry representatives wanted to gut the budget, though they were beaten back in the House by more moderate amendments which indicated disapproval of the Serrano and Mapplethorpe grants by deducting their total cost ($45,000) from next year's allocation. By late July, Sen. Jesse Helms introduced a Senate amendment that would forbid the funding of "offensive," "indecent," and otherwise controversial art, and transfer monies previously allocated for visual arts to support "folk art" and local projects. The furor is likely to continue throughout the fall, since the NEA will be up for its mandated, five-year reauthorization, and the right-wing campaign against images has apparently been heartened by its success. In Chicago, for example, protestors assailed an Eric Fischl painting of a fully clothed boy looking at a naked man swinging at a baseball, on the grounds that it promotes "child molestation" and is, in any case, not "realistic," and therefore, bad art.[12]

The arts community was astounded by this chain of events—artists personally reviled, exhibitions withdrawn and under attack, the NEA budget threatened, all because of a few images. Ironically, those who specialize in producing and interpreting images were surprised that any image could have such power. But what was new to the art community is, in fact, a staple of contemporary right-wing politics.

In the past ten years, conservative and fundamentalist groups have deployed and perfected techniques of grass-roots and mass mobilization around social issues, usually centering on sexuality, gender, and religion. In these campaigns, symbols figure prominently, both as highly condensed statements of moral concern and as powerful spurs to emotion and action. In moral campaigns, fundamentalists select a negative symbol which is highly arousing to their own constituency, and which is difficult or problematic for their opponents to defend. The symbol, often taken literally, out of context, and always denying the possibility of irony or multiple interpretations, is waved like a red flag before their constituents. The arousing stimulus could be an "un-Christian" passage from an evolution textbook, explicit information from a high school sex-education curriculum, or "degrading" pornography said to be available in the local adult bookshop. In the anti-abortion campaign, activists favor images of late-term fetuses, or, better yet, dead babies displayed in jars. Primed with names and addresses of relevant elected and appointed officials, fundamentalist troops fire off volleys of letters, which cowed politi-

Erika Rothenberg, *Have You Attacked America Today*, billboard, 1989-90. Courtesy of the artist. Art Matters grant recipient, 1990.

cians take to be the expression of popular sentiment. Right-wing politicians opportunistically ride the ground swell of outrage, while centrists feel anxious and disempowered to stop it—now a familiar sight in the political landscape. But here, in the NEA controversy, there is something new.

Fundamentalists and conservatives are now directing mass-based symbolic mobilizations against "high culture." Previously, their efforts had focused on popular culture—the attack on rock music led by Tipper Gore, the protests against *The Last Temptation of Christ*, and the Meese Commission's war against pornography.[13] Conservative and neoconservative intellectuals have also lamented the allegedly liberal bias of the university and the dilution of the classic literary canon by including "inferior" works by minority, female, and gay authors, but these complaints have been made in books, journals, and conferences, and have scarcely generated thousands of letters to Congress. Previous efforts to change the direction of the NEA had been made through institutional and bureaucratic channels— by appointing more conservative members to its governing body, the National Council on the Arts, by selecting a more conservative chair and in some cases by overturning grant decisions made by

professional panels. Although antagonism to Eastern elites and upper-class culture has been a thread within fundamentalism, the NEA controversy marks the first time that this emotion has been tapped in mass political action.

Conservative columnist Patrick Buchanan sounded the alarm for this populist attack in a *Washington Times* column last June, calling for "a cultural revolution in the '90s as sweeping as the political revolution of the '80s."[14] Here may lie a clue to this new strategy: the Reagan political revolution has peaked, and with both legislatures under Democratic control, additional conservative gains on social issues through electoral channels seem unlikely. Under these conditions, the slower and more time-consuming—though perhaps more effective—method of changing public opinion and taste may be the best available option. For conservatives and fundamentalists, the arts community plays a significant role in setting standards and shaping public values. Buchanan writes, "The decade has seen an explosion of anti-American, anti-Christian, and nihilist 'art' [Many museums] now feature exhibits that can best be described as cultural trash,"[15] and "as in public television and public radio, a tiny clique, out of touch with America's traditional values, has wormed its way into control of the arts bureaucracy."[16] In an analogy chillingly reminiscent of Nazi cultural metaphors, Buchanan writes, "As with our rivers and lakes, we need to clean up our culture: for it is a well from which we must all drink. Just as a poisoned land will yield up poisonous fruits, so a polluted culture, left to fester and stink, can destroy a nation's soul."[17] Let the citizens be warned: "We should not subsidize decadence."[18] Amid such archaic language of moral pollution and degeneracy, it was not surprising that Mapplethorpe's gay and erotic images were at the center of controversy.

The second new element in the right's mass mobilization against the NEA and high culture has been its rhetorical disavowal of censorship per se, and the cultivation of an artfully crafted distinction between absolute censorship and the denial of public funding. Senator D'Amato, for example, claimed, "This matter does not involve freedom of artistic expression—it does involve the question whether American taxpayers should be forced to support such trash."[19] In the battle for public opinion, "censorship" is a dirty word to mainstream audiences, and hard for conservatives to shake off because their recent battles to control school books, libraries, and curricula have earned them reputations as ignorant book-burners. By using this hairsplitting rhetoric, conservatives can now happily disclaim any interest in censorship, and merely suggest that no public funds be used for "offensive" or "indecent" materials.[20] Conservatives had employed the "no public funds" argument before to deny federal

The War on Culture CAROLE S. VANCE

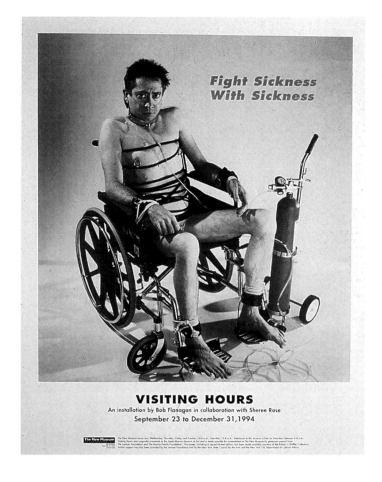

VISITING HOURS
An installation by Bob Flanagan in collaboration with Sheree Rose
September 23 to December 31,1994

Left: Bob Flanagan and Sheree Rose, poster from *Visiting Hours*, 1992, installation, dimensions variable. Photo courtesy of Sheree Rose. Art Matters grant recipient, 1994, 1995.

Above: Bob Flanagan and Sheree Rose, *Sick: The Life and Death of Bob Flanagan, Sadomasochist*, 1991. Film still courtesy of Sheree Rose. Art Matters grant recipient, 1994, 1995.

funding for Medicaid abortions since 1976 and explicit safe-sex education for AIDS more recently. Fundamentalists have attempted to modernize their rhetoric in other social campaigns, too — antiabortionists borrow civil rights terms to speak about the "human rights" of the fetus, and antiporn zealots experiment with replacing their language of sin and lust with phrases about the "degradation of women" borrowed from antipornography feminism. In all cases, these incompatible languages have an uneasy coexistence. But modernized rhetoric cannot disguise the basic, censorious impulse which strikes out at NEA public funding precisely because it is a significant source of arts money, not a trivial one.

NEA funding permeates countless art institutions, schools and community groups, often making the difference between survival and going under; it also supports many individual artists. That NEA funds have in recent years been allocated according to formulas designed to achieve more democratic distribution — not limited to elite art centers or well-known artists — makes their impact all the more significant. A requirement that NEA-funded institutions and

Tim Miller, *Some Golden States*, 1991, performance at P.S. 122, New York City. Photo courtesy of the artist. Art Matters grant recipient, 1989.

artists conform to a standard of "public taste," even in the face of available private funds, would have a profound impact. One obvious by-product would be installing the fiction of a singular public with a universally shared taste and the displacement of a diverse public composed of many constituencies with different tastes. In addition, the mingling of NEA and private funds, so typical in many institutions and exhibitions, would mean that NEA standards would spill over to the private sector, which is separate more in theory than in practice. Although NEA might fund only part of a project, its standards would prevail, since noncompliance would result in loss of funds.

No doubt the continuous contemplation of the standards of public taste that should obtain in publicly funded projects—continuous, since these can never be known with certainty—will itself increase self-censorship and caution across the board. There has always been considerable self-censorship in the art world when it comes to sexual images, and the evidence indicates that it is increasing: reports circulate about curators now examining their collections anew with an eye toward "disturbing" material that might arouse public ire, and increased hesitation to mount new exhibitions that contain unconventional material. In all these ways, artists have recognized the damage done by limiting the types of images that can be funded by public monies.

But more importantly, the very distinction between public and private is a false one, because the boundaries between these spheres are very permeable. Feminist scholarship has shown how the most seemingly personal and private decisions—having a baby, for example—are affected by a host of public laws and policies, ranging from available tax benefits to health services to day care. In the past century in America and England, major changes in family form, sexuality, and gender arrangements have occurred in a complex web spanning public and private domains, which even historians are hard put to separate.[21] In struggles for social change, both reformers and traditionalists know that changes in personal life are intimately linked to changes in public domains—not only through legal

regulation, but also through information, images, and even access to physical space available in public arenas.

This is to say that what goes on in the public sphere is of vital importance for both the arts and for political culture. Because American traditions of publicly supported culture are limited by the innate conservatism of corporate sponsors and by the reduction of individual patronage following changes in the tax laws, relegating controversial images and artwork to private philanthropy confines them to a frail and easily influenced source of support. Even given the NEA's history of bureaucratic interference, it is paradoxically public funding—insulated from the day-to-day interference of politicians and special-interest groups that the right wing would now impose—that permits the possibility of a heterodox culture. Though we might reject the overly literal connection conservatives like to make between images and action ("When teenagers read sex education, they go out and have sex"), we too know that diversity in images and expression in the public sector nurtures and sustains diversity in private life. When losses are suffered in public arenas, people for whom controversial or minority images are salient and affirming suffer a real defeat. Defending private rights—to behavior, to images, to information—is difficult without a publicly formed and visible community. People deprived of images become demor- alized and isolated, and they become increasingly vulnerable to attacks on their private expressions of nonconformity, which are inevitable once sources of public solidarity and resistance have been eliminated.

For these reasons, the desire to eliminate symbols, images, and ideas they do not like from public space is basic to contemporary conservatives' and fundamentalists' politics about sexuality, gender, and the family. On the one hand, this behavior may signal weakness, in that conservatives no longer have the power to directly control, for example, sexual behavior, and must content themselves with controlling a proxy, images of sexual behavior. The attack on Mapplethorpe's images, some of them gay, some sadomasochistic, can be understood in this light. Indeed, the savage critique of his photographs permitted a temporary revival of a vocabulary— "perverted, filth, trash"—that was customarily used against gays but has become unacceptable in mainstream political discourse, a result of sexual liberalization that conservatives hate. On the other hand, the attack on images, particularly "difficult" images in the public domain, may be the most effective point of cultural inter- vention now—particularly given the evident difficulty liberals have in mounting a strong and unambivalent response and given the

way changes in public climate can be translated back to changes in legal rights—as, for example, in the erosion of support for abortion rights, where the image of the fetus has become central in the debate, erasing the image of the woman.

Because symbolic mobilizations and moral panics often leave in their wake residues of law and policy that remain in force long after the hysteria has subsided,[22] the fundamentalist attack on art and images requires a broad and vigorous response that goes beyond appeals to free speech. Free expression is a necessary principle in these debates, because of the steady protection it offers to all images, but it cannot be the only one. To be effective and not defensive, the art community needs to employ its interpretive skills to unmask the modernized rhetoric conservatives use to justify their traditional agenda, as well as to deconstruct the "difficult" images fundamentalists choose to set their campaigns in motion. Despite their uncanny intuition for culturally disturbing material, their focus on images also contains many sleights of hand (Do photographs of nude children necessarily equal child pornography?), and even displacements,[23] which we need to examine. Images we would allow to remain "disturbing" and unconsidered put us anxiously on the defensive and undermine our own response. In addition to defending free speech, it is essential to address why certain images are being attacked—Serrano's crucifix for mocking the excesses of religious exploitation[24] (a point evidently not lost on the televangelists and syndicated preachers who promptly assailed his "blasphemy") and Mapplethorpe's photographs for making minority sexual subcultures visible. If we are always afraid to offer a public defense of sexual images, then even in our rebuttal we have granted the right wing its most basic premise: sexuality is shameful and discrediting. It is not enough to defend the principle of free speech, while joining in denouncing the image, as some in the art world have done.[25]

The fundamentalist attack on images and the art world must be recognized not as an improbable and silly outburst of Yahoo-ism, but as a systematic part of a right-wing political program to restore traditional social arrangements and reduce diversity. The right wing is deeply committed to symbolic politics, both in using symbols to mobilize public sentiment and in understanding that, because images do stand in for and motivate social change, the arena of representation is a real ground for struggle. A vigorous defense of art and images begins from this insight.

1. Senator D'Amato's remarks and the text of the letter appear in the *Congressional Record*, vol. 135, no. 64 (May 18, 1989), p. S 5594.

2. Senator Helms's remarks appear in the *Congressional Record*, vol. 135, no. 64 (May 18, 1989), p. S 5595.

3. William H. Honan, "Congressional Anger Threatens Arts Endowment's Budget," *New York Times*, June 20, 1989, p. C20.

4. "People: Art, Trash, and Funding," *International Herald Tribune*, June 15, 1989, p. 20.

5. Ibid.

6. Honan, "Congressional Anger," p.C20.

7. Elizabeth Kastor, "Funding Art that Offends," *Washington Post*, June 7, 1989, p.C1.

8. Ibid., p.C3.

9. Elizabeth Kastor, "Corcoran Cancels Photo Exhibit," *Washington Post*, June 13, 1989, p. C1.

10. Elizabeth Kastor, "Corcoran Decision Provokes Outcry," *Washington Post*, June 14, 1989, p. B1.

11. Barbara Gamarekian, "Legislation Offered to Limit Grants by Arts Endowment," *New York Times*, June 21, 1989; Carla Hall, "For NEA, an Extra Step," *Washington Post*, June 22, 1989; Elizabeth Kastor, "Art and Accountability," *Washington Post*, June 30, 1989.

12. The Fischl painting *Boys at Bat*, 1979, was part of a traveling exhibition, *Diamonds Are Forever*, on view at the Chicago Public Library Cultural Center. Ziff Fistrunk, executive director of the Southside Chicago Sports Council, organized the protest. He objected that "I have trained players in Little League and semi-pro baseball, and at no time did I train them naked." *In These Times*, Aug. 1, 1989, p. 5. Thanks to Carole Tormollan for calling this incident to my attention.

13. Carole S. Vance, "The Meese Commission on the Road: Porn in the U.S.A.," *Nation*, Aug. 29, 1986, pp.65-82.

14. Patrick Buchanan, "How Can We Clean Up Our Art Act?" *Washington Post*, June 19, 1989.

15. Ibid.

16. Ibid.

17. Ibid.

18. Ibid.

19. *Congressional Record*, vol. 135, no. 64, (May 18, 1989), p. S 5594.

20. Another ploy is to transmute the basic objection to Serrano's photograph, the unfortunately medieval-sounding "blasphemy," to more modern concerns with prejudice and civil rights. Donald Wildmon, for example, states, "Religious bigotry should not be supported by tax dollars." *Washington Times*, Apr. 26, 1989, p. A5.

The slippage between these two frameworks, however, appears in a protest letter written to the *Richmond News-Leader* concerning Serrano's work: "The Virginia Museum should not be in the business of promoting and subsidizing hatred and intolerance. Would they pay the KKK to do work defaming blacks? Would they display a Jewish symbol under urine? Has Christianity become fair game in our society for any kind of blasphemy and slander?" (Mar. 18, 1989).

21. For nineteenth-century American history regarding sex and gender, see John D'Emilio and Estelle Freedman, *Intimate Matters*, (New York: Harper and Row, 1988); for British history, see Jeffrey Weeks, *Sex, Politics and Society: the Regulation of Sexuality Since 1800* (New York: Longman, 1981).

22. The nineteenth-century Comstock Law, for example, passed during a frenzied concern about indecent literature, was used to suppress information about abortion and birth control in the United States well into the 20th century. For accounts of moral panics, see Weeks, *Sex, Politics and Society*; Judith Walkowitz, *Prostitution and Victorian Society: Women, Class, and the State* (Cambridge: Cambridge University Press, 1980); and Gayle Rubin, "Thinking Sex: Notes for a Radical Theory of the Politics of Sexuality," in Carole S. Vance, ed., *Pleasure and Danger: Exploring Female Sexuality* (Boston: Routledge & Kegan Paul), 1984, pp.267-319.

23. Politically, the crusade against the NEA displaces scandal and charges of dishonesty from the attackers to those attacked. Senator Alfonse D'Amato took on the role of the chief NEA persecutor at a time when he himself was the subject of embarrassing questions, allegations and several inquiries about his role in the misuse of HUD low-income housing funds in his Long Island hometown.

The crusade against "anti-Christian" images performs a similar function of diverting attention and memory from the recent fundamentalist religious scandals involving Jim and Tammy Bakker and Jimmy Swaggart, themselves implicated in numerous presumably "un-Christian" acts. Still-unscathed fellow televangelist Pat Robertson called upon followers to join the attack on the NEA during a June 9 telecast on the Christian Broadcasting Network.

24. Andres Serrano described his photograph as "a protest against the commercialization of sacred imagery." See Honan, "Congressional Anger," p. C20.

25. For defenses of free speech that agree with or offer no rebuttal to conservative characterizations of the image, see the comments of Hugh Southern, acting chair of the NEA, who said, "I most certainly can understand that the work in question has offended many people and appreciate the feelings of those who have protested it. . . . I personally found it offensive" (quoted in Kastor, "Funding Art that Offends," p. C3), and artist Helen Frankenthaler, who stated in her op-ed column, "I, for one, would not want to support the two artists mentioned, but once supported, we must allow them to be shown" ("Did We Spawn an Arts Monster?" *New York Times*, July 17, 1989, p. A17).

Homophobia at the N.E.A. (1990)

HOLLY HUGHES AND RICHARD ELOVICH

John Frohnmayer, chairman of the National Endowment for the Arts, has taken the unprecedented step of overturning four solo performance art fellowships that had been strongly recommended for funding by the peer panel.

The artists whose fellowships were denied—Karen Finley, John Fleck, Holly Hughes and Tim Miller—all create works that deal with the politics of sexuality. Three are highly visible gays.

The overturning of these grants represented Mr. Frohnmayer's and President Bush's attempt to appease the homophobic, misogynist and racist agenda of Senator Jesse Helms and company.

Mr. Frohnmayer apparently believes he can make sacrificial lambs out of gay artists and that no one will care, that no one will speak up for us. Unfortunately, he may be right.

Where was the outcry when the word "homoerotic" was included in the list of restrictions attached to National Endowment for the Arts funding contracts by Congress? No other group was so blatantly and prejudicially targeted.

There was no outcry. For there to be one, the gay and lesbian community would have to speak up with an informed voice. Nobody else will do so on the community's behalf.

Even well-intentioned arts organizations leading the anti-censorship battle are reluctant to speak up for us. They are afraid of turning off Middle America by embracing these artists' unapologetic efforts to make their sexual orientation visible.

And because we gay artists, particularly lesbian artists, are so invisible, our problems are invisible as well. So we must demand visibility, or the issue will be lost. This is a First Amendment issue that affects all Americans.

The overturning of the NEA grants must be understood in the context of the Government's continued indifference to the AIDS crisis and inaction toward it—and the 128 percent increase in reported gay-bashing incidents in New York City this year. The homophobes in the Government don't think we're being killed off at a fast-enough rate.

Holly Hughes, *World Without End*, 1988, performance at P.S. 122, New York City. Photo courtesy of the artist. Art Matters grant recipient, 1988.

Richard Elovich, Needle Exchange Arrest, action, March 6, 1990, Lower East Side, New York City. Photo courtesy of the artist. Art Matters grant recipient 1987, 1988, 1990.

The gay and lesbian community must embrace the Endowment defunding issue because there is no direct-action group in the cluster of arts organizations to do this work with us.

We two writers don't claim to represent the gay community, or even all lesbian performance artists who live on St. Mark's Place. But the right wing sees us—and artists like us—this way.

In attacking the lesbian poets Audre Lorde, Minnie Bruce Pratt, and Chrystos in Jesse Helms's direct-mail campaigns and defunding the four performance artists, the right is trying to blacklist all gays. The right wants to force all of us back into the closet, where it hopes we will suffocate and die in silence.

Gays and lesbians need to direct their outrage at Jesse Helms and anyone else who would cater to this agenda—and that means Congress, the President, Mr. Frohnmayer, and fundamentalists.

The gay and lesbian community knows from its experience in the AIDS crisis that lobbying—letters, postcards, telegrams to Congress—is not enough. Jesse Helms must be confronted through demonstrations in Washington.

Gay men and lesbians must confront the nation's arts institutions— from the galleries to the theaters, from the downtown alternative spaces to the mainstream museums—and demand that they publicly support these blacklisted artists, that they increase their presentations of open lesbian and gay artists, that they condemn Mr. Frohnmayer's actions and demand their reversal. To do anything less would be complicity.

The gay and lesbian community has insisted again and again that homophobia be specifically addressed when dealing with the Endowment crisis. Such support must come primarily from the gay and lesbian community. The community must get behind the various anticensorship organizations and insist that they openly include the homophobia issue in their efforts.

Are Content Restrictions Constitutional? (1992)

KATHLEEN M. SULLIVAN

In June of 1991, I was invited by Representative Barbara Boxer, chair of the Government Activities subcommittee of the House Committee on Government Operations, to testify at oversight hearings on the state of the National Endowment for the Arts (NEA). One of the aims of the hearings was to check the temperature of the arts community: had the battle over content restrictions on NEA grants exerted a chilling effect? Another aim of the hearings was to assess the implications for arts content restrictions of the Supreme Court's recent decision upholding a ban on abortion counseling by federally funded clinics (*Rust* v. *Sullivan*, 111 S. Ct. 1759 [1991]). If the federal government could restrict the speech of the doctors and healthcare workers it subsidizes, could it do the same to artists? My edited testimony on these questions follows.

When government acts as art patron, it is bound by the First Amendment. Private art patrons may impose whatever content restrictions they wish on their protégés, for the Constitution in no way fetters private taste or fancy. But government is not so free. When it enters the business of funding the production and dissemination of art, the First Amendment places certain kinds of content restrictions off limits.

The most clearly unconstitutional conditions on government grants are those aimed at unpopular or unorthodox viewpoints. Government may have no hit list of forbidden ideas, whether it enforces that list by bludgeon or by bribe. In a free society, government may not enforce conformity. It may neither punish those who espouse unconventional ideas nor reward only those who promise to give them up. Over and over again since the 1950s, the Supreme Court has reiterated this point, stating that government may not "discriminate invidiously in its subsidies in such a way as to 'ai[m] at the suppression of dangerous ideas'" (*Regan* v. *Taxation With Representation*, 461 U.S. 540, 548 (1983) [quoting *Cammarano* v. *United States*, 358 U.S. 498, 513 (1959)]).

Commendably, Congress for the most part steered clear of this constitutional prohibition during the controversies of 1989 and 1990. As members of the subcommittee will no doubt recall, much

This essay was first published in *The Journal of Arts Management and Law* 21, no. 4 (Winter 1992), pp. 323–27.

clamor arose when the NEA helped fund the display of various Mapplethorpe and Serrano photographs that some deemed "filth" and others "blasphemy." A parade of proposals for content restrictions followed. Some members of Congress urged laws that would have expressly forbidden NEA funding of "indecent" art, art that "denigrates" religious symbols, art that "reviles" racial or ethnic groups, or art that "deliberately denigrates the cultural heritage of the United States."

It was a victory for the NEA and for the First Amendment that these and like proposals were defeated, either in committee or on the floor. The 1989 NEA appropriations legislation limited its target to "obscene" art, which the Supreme Court has held unprotected by the First Amendment (*Miller* v. *California*, 413 U.S. 15 [1973]). Bannable obscenity is defined as work that appeals to the "prurient interest," is "patently offensive," and lacks "serious artistic" or other value. What government may ban, it may equally choose not to fund, so an anti-obscenity condition poses no problem in theory under existing First Amendment law. In practice, however, the 1989 law proved both vague and chilling to artists, for it left discretion about what was obscene in the hands of the NEA, and added a gratuitous hit list of disfavored sexual categories such as "sadomasochism" and "homoeroticism"—even though art in such categories is by no means all legally "obscene."

These problems were compounded when the NEA gratuitously proceeded to require 1989-90 grant recipients to certify in advance that they would not produce "obscene" art. This requirement was recently struck down as unconstitutional by a United States District Court in California in the case of *Bella Lewitzky Dance Foundation* v. *Frohnmayer* (754 F. Supp. 774 [C.D. Cal. 1991]), and the NEA has since rescinded it. I believe that decision was correct and the NEA's subsequent rescission wise.

The 1990 reauthorization legislation ameliorated these problems somewhat by replacing the prospective obscenity bar with sanctions that are solely retrospective—payback provisions for NEA-funded artists who are adjudged in court to have produced an obscene work. In my view, it would have been better to eliminate such restrictions altogether, for art deemed excellent by expert NEA panels by definition cannot be "obscene"—it will necessarily have the "serious artistic value" that takes it out of that category; and even in its milder form, such a restriction will chill much non-obscene art that artists fear, even if mistakenly, will come too close to the line. The problem with "a sword of Damocles is that it hangs—not that it drops" (*Arnett* v. *Kennedy*, 416 U.S. 134, 231 [1974] [Marshall, J., dissenting]). Moreover, the promise that no pay-

back will be required unless one loses the obscenity battle in court is surely cold comfort to a struggling artist—although Cincinnati Art Museum director Dennis Barrie was ultimately acquitted after trial of obscenity charges for showing an exhibition of Mapplethorpe photographs, he no doubt is still paying off his legal bills.

Troubling, too, in the 1990 NEA (P.L. 101-512) legislation is the language calling upon the NEA Chairman to ensure that "artistic excellence and artistic merit are the criteria by which applications are judged, taking into consideration general standards of decency and respect for the diverse beliefs and values of the American public."

To be sure, this language is a relative improvement over proposals that would have barred outright any NEA funding of so-called indecent art—proposals that if enacted, I believe would be unconstitutional. "Indecent" speech, unlike obscenity, is protected by the First Amendment except in narrow circumstances not presented by arts funding (*Sable Communications* v. *FCC*, 109 S. Ct. 2829 [1989] a decision striking down congressional ban on "indecent" telephone messages such as so-called "dial-a-porn"). A ban on protected speech is unconstitutional whether attached to a carrot or a stick. Moreover, the term "indecency" standing alone is overly vague.

While an exhortation to consider "decency" less obviously offends the First Amendment than does an "indecency" ban, the 1990 language is vague and chilling nonetheless. True, the NEA chairman is free to consider general standards of decency and give them whatever weight he or she deems fit, and even to find an artwork's "indecency" outweighed by its excellence. True, too, the 1990 legislation permits the NEA chairman to presume consideration of general standards of decency from the representative nature of the NEA peer-review process—as Chairman Frohnmayer, guided by his National Council, has done.

Still, the "decency" language creates two very real dangers. The first is that artists might steer too far clear of what they think the public might find indecent, which is a far broader category than "obscenity" as defined in *Miller*. This will exact a great toll in innovation and creativity—promotion of which is a large part of the NEA's reason to be. The second danger is that viewpoint discrimination might be driven invisibly behind the scenes. Impermissible judgments about "indecency" might be masked behind the rhetoric of "excellence." Smoking out evidence of such illicit motive will necessarily prove difficult or impossible in any particular case. Better to cut off temptation at the pass—freedom of expression would be better served if the "decency" language were removed.

Does the Supreme Court's decision in *Rust* v. *Sullivan* change any of what I've argued so far? No. In *Rust*, doctors and other health-

care workers challenged Health and Human Services regulations that forbade recipients of federal family-planning subsidies from counseling, referring women for, or providing information about abortion. The Court held, by a vote of 5-4, that these refutations did not violate the First Amendment. I believe that this decision was deeply wrong (the subcommittee should know that I was one of the lawyers representing the losing parties), and that it amounted to a setback for the First Amendment; but the decision in *Rust* should *not* be viewed as a carte blanche for a new round of content restrictions on the NEA.

Three crucial features of *Rust* make clear that new content restrictions on arts funding would likely still be struck down in court despite that decision. First, the Court left fully intact the law that even in subsidy schemes, government may not engage in viewpoint discrimination. The Court simply held that there was no viewpoint discrimination in the family-planning regulations on their facts: by finding advice about family planning and childbirth but not abortion, "the Government has not discriminated on the basis of viewpoint; it has merely chosen to fund one activity to the exclusion of another" (*Rust* v. *Sullivan*, Nos. 89-1392, slip op. at 16 [May 23, 1991]).

As Chief Justice Rehnquist put the point for the majority, "When Congress established a National Endowment for Democracy. . . it was not constitutionally required to fund a program to encourage competing lines of political philosophy such as Communism and Fascism" (*Ibid.*, slip op. at 17). True enough; and likewise the establishment of a National Endowment for the Arts does not oblige Congress to establish as well a National Endowment for Sports.

But such a metaphor simply does not apply to the NEA content restrictions that some proposed in 1989 and 1990. Those restrictions would have allocated funds selectively *within* the category of art otherwise deemed excellent, depending on whether or not it embodied an approved point of view. Nothing in *Rust* vindicates that sort of content restriction. The First Amendment surely *would* bar the National Endowment for Democracy from offering grants for "democracy projects"—but saying that only Republicans (or Democrats) need apply. Similarly, the First Amendment bars government from establishing a National Endowment for the Arts and saying that only the orthodox and the conformist need apply.

Second, *Rust* relied heavily on reading the abortion counseling regulations to apply only to the use of federal funds, permitting recipient clinics to continue counseling and referring for abortion so long as those activities were privately funded and physically separate. The Court expressly noted, however, that where such

segregation of activity is impossible, the First Amendment bars
the attachment of a content restriction to a grant. The Court cited
and reaffirmed *FCC* v. *League of Women Voters* (468 U.S. 364 [1984]),
which held that Congress could not bar non-commercial television
and radio stations that receive federal grants from engaging in
"editorializing." As the Court reiterated in *Rust*, that law was invalid
because "a recipient of federal funds was 'barred absolutely from all
editorializing' because it 'is not able to segregate its activities according
to the source of its funding and thus has no way of limiting the
use of its federal funds to all non-editorializing activities'" (*Rust*,
slip op. at 20 [quoting *FCC* v. *LWV*]).

Almost by definition, such segregation of federally funded
from privately funded activity is impossible for an artist engaged in
creative work. Perhaps a family-planning organization can erect a
wall of separation between two clinics—one where abortion can
be spoken of and one where its mention is taboo. But an artist
can hardly draw a similar boundary between the right and left
hemispheres of the brain—ensuring that no federal overhead will
cross over to support a forbidden "indecent" impulse. In the arts
context as in the broadcasting context in *FCC* v. *LWV*, a content
restriction on a grant cannot be confined; it will necessarily spill
over from a nonsubsidy to a penalty.

Third, the Court in *Rust* expressly cautioned that its decision
should "not [be read] to suggest that funding by the Government . . .
is invariably sufficient to justify government control over the content
of expression" (Slip op. at 23). Like public forums and universities,
the NEA is an agency charged with facilitating free expression,
and the Court noted that in such arenas, "the Government's ability
to control speech . . . by means of conditions attached to the
expenditure of Government funds is restricted . . ." (*Id.*).

Some no doubt will see *Rust* as a laid-down hand—as an invita-
tion to revive throughout the length and breadth of government
the notion that he who takes the king's shilling becomes the mouth-
piece of the state. But in light of the features that narrowly confine
Rust to its facts, none who value free expression should be quick
to fold.

Chapter 4:

"The big boys were not going to march to the front lines."

Laura: . . . and these are Mapplethorpes I gave to my parents for my fortieth birthday. They're portraits of my children. Most of my friends can't understand why I like them, but I love them. They're really portraits of Mapplethorpe in disguise.

David: *With the public-funding crisis, we were challenged in a way we haven't been since the McCarthy era, where the integrity, the ethics, the value of art and intellectual inquiry were coming under attack. We were being scapegoated by the Christian right and we weren't prepared for it. I still can remember April 1989 when I got a call, "Did you hear that they're complaining about SECCA's fellowship to Andres Serrano?" Then, just a couple weeks later, the Mapplethorpe exhibit at the Corcoran was canceled. Starting that May, I was in the midst of it almost every day for years. We were caught off guard. The Corcoran's decision definitely sent a message to people like Jesse Helms. We can scare the shit out of these cultural folks and get them to do whatever we want.*

Bruce: Things deteriorated quickly after the Corcoran canceled the Mapplethorpe exhibition. AMI definitely took a proactive position. The need became even more critical. There wasn't any support for radical gay art or sexually explicit art. We could give to Karen Finley and Holly Hughes and other people of the world whose work was treading on turf that made it hard for government to fund it.

Kathy: We gave grants to many artists who might easily have their First Amendment rights violated.

Linda: *I was the director of the individual artists program at NYSCA, and had been since its inception in 1984. We had had a crisis in 1988–89 with potential censorship but had defended the Council's position not to judge content: if the project was good we were going to support it. It was not and has not been a factor in our appropriation. But that experience, along with what was happening at the NEA, definitely created a different atmosphere. It had a chilling effect. Our board members became more nervous about support for individual artists and there were artists who didn't want to go through a big deal with the state. The budget was halved in the space of a year. Then, in 1990, visual arts as a category was cut from the individual artist program entirely. Our board felt it was too troublesome an area. The perception was that individual artists had started the problems that we were having. Mapplethorpe and Serrano were all they could think about.*

Cee: *I was very unpopular when I ran Creative Time because I would not take NEA money with the Helms Amendment barring support for work that dealt with homosexuality. I wouldn't sign it. We waited for almost a year but in the end it was ruled unconstitutional. Most organizations did sign it.*

Philip: AMI was phasing out its funding for organizations in 1990 in order to focus on individual artists and advocacy. In addition to funding Visual Aids, we also gave a fellowship to Joy Silverman to create the National Campaign for Freedom of Expression.

Cee: *The National Campaign for Freedom of Expression started in order to disseminate information to make the arts community aware that something had to be done. Joy Silverman, Charlotte Murphy, Ann Folkes, and I launched NCFE when we went down to Washington to have the first press conference. We basically just made it up on the train!*

David: *As you can probably figure out, there was both a tight and loose network of people in the national community who worked together on NCFE. I was involved in the development of the Campaign after Joy Silverman received her AMI fellowship to create the organization, and hired Alex Grey to help. I became the first executive director in '91. The first money for NCFE was from AMI, then the Warhol Foundation, then the Unitarian Universalists. Subsequently, we were able to get money from the Nathan Cummings Foundation and the Robert Sterling Clark Foundation, and they are funders to this day. Very few foundations would touch it. Foundations are inherently conservative institutions, regardless of the programs they support. Funding Lincoln Center does not mean that you're going to be thrilled about Mapplethorpe or Finley. When I took over the job of director at NCFE, funders told me, "My board won't agree to fund the Campaign. It's too political."*

Cee: *We did little zaps, like when Ana Imelda Radice was speaking at the Metropolitan Museum. We all came as invited guests and while people were milling around before it started, we spread pamphlets on all the chairs denouncing Radice for her activities in the NEA. They were unveiling a videotape with Walter Cronkite about the arts in America— all watercolors and crafts. We needed a big campaign to save the Endowment, but dance companies weren't getting involved because censorship is not their issue, and museums weren't getting involved. We wanted to say, "Yes, this is your issue. This is all of our issue, whether it affects you directly at this moment is not the point. The point is that if government gets into deciding what gets seen and heard, that's a problem."*

PY: Part of our interest in creating NCFE was to have more than only the Metropolitan Museum lobbying in Washington.

David: *When we started NCFE, I pointed out that it was called the National Campaign for Freedom of Expression, "campaign" meaning something you put forward, achieve, finish, and then you go back to your business. Now we're in our eighth year. It's a long-term haul that's gotten worse, not better. You had the elimination of individual artist's fellowships and a reduction of the budget of the NEA, you have a chill factor in the cultural community about content, you have a rise of censorship at the local level where people want art removed because it offends their sensibility. The PR battle was won by those who created the sound-byte terms of pornographic-artists-subsidized-by-taxpayer-dollars, artists who rub chocolate on their bare breasts, the elitist arts crowd wanting us to fund their depraved art, political correctness driving all the decision at the NEA, multiculturalism as a negative thing. All of these PR messages have successfully been implanted in the general public psyche. Now we're in a defensive mode.*

David: *The concept of censorship is related primarily to the First Amendment, and that means government censorship. The Campaign was initially begun because of that kind of censorship. However, particularly with regard to public policy work, we can't ignore economic censorship, funding censorship. There are people who will say you can't call that censorship. That's their opinion. But very often what we're talking about is really economic censorship: if you don't fund the whole range of cultural work, whether it's based on community or ethnicity or whatever, that is a form of censorship. If you decide to cut the budgets for community organizations and increase the budgets for major institutions, that has an impact. In trying to influence NEA funding policies, our purpose was often to show how those policies might have an economic censorship impact, as opposed to only focusing on requirements that grants meet standards of "decency."*

Lowery: *I think that every artist and curator should be able to get a grant to work without having to worry about financials once or twice in their careers. I also think, however, that the NEA gave a false sense of entitlement to artists. A lot of people took the situation for granted and confused censorship issues with entitlement. I can't think of another period in history when money was so available to artists by peer review, unobstructed by responsibility to donors. Artists need to be conscious that having the freedom to do their work is a rare thing, a privilege that should be cherished but not expected as a natural given right. There is an air of ingratitude on the part of artists who receive grants. I tried to say to people, "You're not censored, you just might not get funding." Censorship in China means you cannot do your art. You're suppressed and put in jail. There's a big difference. Andres Serrano may not get grants, but he's not stopped from doing his art.*

David: *There was a naive view that we were all in it together as the arts community. When the opposition realized that the big boys weren't going to march to the front lines, that they were going to leave the battle to puny organizations like NCFE, Creative Time, AMI, and some others, they could see that it wasn't going to be such a difficult fight. Divide and conquer. Those big guns had corporate leaders on their boards who often supported the people we were doing battle with. But their impulse was to cut the losses and take a conservative course. They circled the wagons around what could be protected—i.e., support for major institutions— and let gay and lesbian artists and artists who were working with controversial subject matter be the sacrificial lambs. Or artists period. Get rid of the fellowship programs. The fact is, there are a great many different "beliefs"—as in racism and sexism and homophobia and classism—that all exist in the arts community just as they do in the larger society. We're not free of it.*

Philip: *I would rather have seen the NEA go gloriously down the tubes than have the capitulation that occurred. I remember the world before government funding, and openly admit that funding had a tremendous effect for good. But if it can no longer operate independently, I would rather that it was over than just do ballet. Who gives a shit?*

> **Marianne:** When Jane Alexander replaced Frohnmayer, AMI organized a meeting with her and the heads of a number of foundations. It was a, "Well, What Are You Going To Do Jane?" kind of meeting. She got up and spoke in a very flat, soft voice, and said, "My hands are tied. What are *you* going to do?" It was chilling because I was sitting around the table with a bunch of people who probably weren't going to do anything.

Philip: *Relatively few people will forgive certain administrators of certain artist spaces for siding with the NEA. A lot of people had gotten used to their power by that point. When there was a lot of money and good times in the '80s, they were generous and open. When it became clear that their jobs were in jeopardy because of limitations on funding, people got chicken-shit and their defense of artists became very superficial. I remember a meeting with the heads of most of the credible arts spaces in the country where I brought up the work of Annie Sprinkle. I said, "I want you to tell me why what she does is art." Not one of those people could say why it's art, and about half of them said it isn't. I said, "You guys are fucked. How can you even think about advocating for public funding when you can't get it together amongst yourselves to defend what at least some of you are presenting, much less discuss it, much less try to make other people understand it." That was a moment of real crisis for me. Karen Finley put it really well once. It was before the NEA crisis. She was performing at a NAAO meeting and she began as Karen instead of as a character, and she said, "It's just amazing to be here and have all you people who turned down my requests and rejected me sitting in the audience." And then, typical Karen, she switched and said, "You're the soul of the art world." To which one could have added, "Such as it is." If there was a soul in the art world. These were the people who were doing their best. And compared to the curators at the Modern, they were saints. But they were people with personal ambition who had become security-conscious and at that point sold out the artists. Many of them had been selling artists out for years without being called on it, but when things got tough it became very clear.*

> **MB:** You get pretty damn passionate when you know you're one of the last organizations out there willing to say, "It's important to give artists and their visions a chance."

Philip: *Issues of sexuality or gender or politics or gay and lesbian concerns all became red flags to people who had any turf to protect. And the foundation world is about turf protection and the maintenance of power within a certain framework more than it is about generosity or changing the world.*

Laurence: *The politicians continue to bash artists. I doubt we'll see an end to that soon. What worries me more is the lack of leadership from the large foundations.*

Philip: *The NEA probably got in trouble because it was taking the high road. And with the arrogance that's typical of the art world, not keeping people informed. Art is already outside the American value system. But that has been compounded by the art world's elitism and its unwillingness to address the fact that artists, for quite a long time, have made stuff that outdistances people's understandings, walling off people from art, and creating a specialty that wasn't part of cultural expression in the more general sense. That shifted in the late '80s, but by that time it was too late. It already created the sense that artists operate in an arena that doesn't matter and that giving money to artists is simply encouraging self-indulgence. You just don't know what you're going to get. It may not be much. It may not be comprehensible. And it may not be pretty.*

Mary: *Many Americans see art as decoration, as peripheral, or as elitist. Well, it is elitist in a way because not everybody's willing to engage it. It takes a certain amount of openness.*

Laura: *You either get it or you don't. If you deprive a human being of the opportunity to be involved with art, something higher, creativity, you're really depriving the human being of being. If you don't give the human organism mystery and visual beauty, if you don't give it even controversy and something to struggle with, the mind just shuts down, goes blank. I just can't imagine a world without art. . . but see over there, out in the street, there're a lot of people who don't have it.*

Lowery: *Elitism is something that any organization can slip into. The irony is that the issues artists are dealing with are so germane to that public.*

Cee: *Not all artists can be all things to all people, nor should they be. I think the public has the ability to choose. However, I don't think that an artist should be denied public support because he or she doesn't reach out to every member of the public. Just because I don't want my three cents going to that, it doesn't mean that it shouldn't be supported by the public sector of which my three cents is part. It's a question of democracy.*

David: *Our argument is that not everything should be funded, but through the system of peer panels and quality decisions, every viewpoint, every kind of culture has a right to have some support. The other argument that one hears more and more today is quite the reverse. It's saying, "If I don't like something, it shouldn't get any support."*

Kathy: *If it's public money, and part of it is my money, I also want to have some say about how it's spent. The public may feel that way, but I am part of the public. When the NEA decides that it's not going to give problematic grants, that's my tax money, too, and I want to see that risk-taking art. And why are you denying that to me? Because you might get in trouble with your right-wing constituency. But I'm part of your constituency, too. Gays and lesbians are part of your constituency, Latinos are part of your constituency. We want to see the art that reflects our existence. Yes, public money has to be accountable to the public, but I am the public.*

David: *I do think that artists have responsibilities, but I will trust the artist to let me know what those responsibilities are. I don't think a society or a funder should say it's your responsibility as an artist to do x, y, and z. Each artist I've talked to about this topic has a very good answer—a thought-out, intelligent, valid response—to the question of their responsibilities. But it's always different. In many circles these days, that's a very radical notion.*

Cee: *All art-making is political. Being an artist is a political statement even if you are a studio artist that works on your own in the quiet of the night. The fact is that in this country, in this age, being an artist says something particular to the general population, to Congress. Therefore, by default, making art makes you political. To any artist that says the NEA debacle is not my issue because I am an abstract painter, I'd say, "That's bullshit." Down the line, who's going to say you can't paint with blue? It gets just that ridiculous.*

Cultural Policy and

chapter **5**

Funding for the Arts

Calendar No. 8

105th CONGRESS

1st Session

S. 48

A BILL

To abolish the National Endowment for the Arts and the National Council
on the Arts.

January 21, 1997

Read twice and placed on the calendar

Calendar No. 8

105th CONGRESS
1st Session

S. 48

To abolish the National Endowment for the Arts and the National Council
on the Arts.

IN THE SENATE OF THE UNITED STATES

January 21, 1997

Mr. Helms introduced the following bill; which was read twice and
placed on the calendar

A BILL

CHRISTIE'S

MASTER OF ARTS
IN CONNOISSEURSHIP AND THE ART MARKET

Christie's is pleased to announce that the New York State
Board of Regents recently approved a one-year Master of
Arts in Connoisseurship and the Art Market. This program
is designed to provide rigorous academic training as prepa-
ration for professional positions in art and art-related fields
including galleries, museums and auction houses.

The first class of Master's candidates will enter the program
in Fall 1998. A supplement to our course brochure with
details of the newly approved program is available from:

CHRISTIE'S EDUCATION
502 PARK AVENUE, NEW YORK, NEW YORK 10022
TELEPHONE: 212 546 1092, FAX: 212 980 7845

CHRISTIE'S
INTERNATIONAL ART STUDIES

Congress acts bluntly.

But after three decades of furrowed brows and stiff upper
lips, the nonprofit arts seem destined to live a precarious
existence in this country.

— American Canvas report, NEA

"...capitalism is the atmosphere in which culture must now survive."[30]

To abolish the National Endowment for the Arts and the National Council
on the Arts.

Be it enacted by the Senate and House of Representatives of the
United States of America in Congress assembled,

SECTION 1. SHORT TITLE.

This Act may be cited as the ``National Endowment for the Arts
Termination Act of 1997''.

In April of 1996, Congress restructured the NEA as part of the 1996 appropriations process. The NEA budget was cut by 40% and almost all individual artists grants were eliminated. Congress also prohibited grants for seasonal or general operating support, requiring applicants to identify specific projects that will receive NEA funds.

"The problem for today's artists is not that rents are high. That has always been the case. What's different is that the '80s art boom glamorized the profession of art and conferred upon the moneyed life a new prestige. Expectations of worldly success rose in the '80s, and those expectations remain in place even though the market that created them no longer exists."[31]

"Arts philanthropy, ultimately, is affected by a number of factors, including competition with other parts of the nonprofit sector (of which public/society benefit and education have shown the most growth in recent years), and, more generally, the impact of the economy on charitable giving as a whole. Given the many social challenges facing American society, it's unlikely that the competition for funding will be any less keen any time soon."

— *American Canvas*, NEA, 1997

"Some American businesses have been very generous in their support of the arts. But this generosity depends on their public-relations needs. Increasingly, these needs are defined as social, rather than artistic. Hence the shift, in private philanthropy, to race- and gender-based programs, meant to make art what theatrical director Robert Brustein calls 'a conduit for social justice,' rather than art as art. As the newsletter Corporate Philanthropy Report recently noted, 'We no longer "support" the arts. We use the arts in innovative ways to support the social causes chosen by our company.'"[32]

Business Week's Work of Art

e special section within the pages of the Dec. 5 issue of Business Week brought in $1.5 million from a gallery of leading advertisers, with 10 percent going to the museum.

By ANDREW L. YARROW

usiness Week cast an admiring at the collections of the Metropolitan Museum of Art in putting together a 60-page glossy advertising plement in its Dec. 5 issue.

he pullout section, called "The ropolitan Museum of Art: Trustee for Humanity," features a Renoir roduction on the cover, a full-page several dozen photographs of r works, as well as 12,000 words lowing prose about the museum's ections, history, public programs, nces and goals.

usiness Week, which conceived produced the supplement, ight in nearly $1.5 million in advising revenue, and on Wednesday t donated 10 percent of that to the eum.

A 60-page ad supplement honors the Metropolitan.

In addition to its focus on art, the supplement features a 31-page gallery of advertising by 27 corporate masters like American Express, Merrill Lynch, I.B.M., Xerox and Chrysler, the biggest advertiser with four pages.

Fujitsu, NEC, Nynex and United Technologies each took out two full pages.

With a North American circulation of 892,000, Business Week charged

$58,255 for a full-page four-color ad and $38,325 for a black-and-white ad. Alvin Grossman, who has designed books for the Metropolitan, was hired by Business Week as art director for the supplement, and members of the museum staff helped prepare the material.

"We felt it was a winning team and a winning idea, and the support was immense," said John W. Patten, Business Week's publisher, who presented a check to the Metropolitan Wednesday night during a reception at the museum.

The president of the Metropolitan, William H. Luers, said: "This was an experiment for them and for us to see if it would help us get a broader audience in the business world. It is a commercial venture, not a work of art history, but we're very pleased with it. It also gets our story out to a lot of people who could support the museum."

SOTHEBY'S
FOUNDED

ART & AUCTION

10 BEST WAYS TO *LOSE* MONEY

WHAT THE BILLIONAIRES COLLEC

**IS WALL STREET
DRIVING THE ART**

**PLUS: 1997 ART WORLD
POWER**

Special:

The business of

"But anyone who thinks the market decline will instantly produce saner relations between art and

the public ought to think again. In the long run, in art as in nature, the fittest will survive."

"America is experiencing a boom in the development of large cultural facilities--new libraries, museums, and concert ha

Concurrently, significant capital improvement of existing cultural facilities is also occurring. In the face of all these mi

being spent on arts institutions, artists are being told that there is less or no money for them.'

"The persistent drumbeat of cynicism on the talk shows and in the new Congress reeks of disrespect for the arts and

artists. But what else is new? (...) As recently as last year, artists who have spoken out politically have been derided

as airheads, bubbleheads, and nitwits. And this is not just by someone like Rush Limbaugh, who has called peopl

my industry the 'spaced-out Hollywood left.' This is also the rhetoric of respectable publications.

Ironically, contempt for the artist as citizen is often expressed by those most eager to exploit the celebrity or t

entertainer. Both journalists and politicians feed off the celebrity status of the successful artists."[35]

DECEMBER 1997 •
$4.95 U.S./$6.95 CAN

Endtroduction

The expansion of the art market in the 1980s and the escalation of attacks on public subsidy for culture since 1989 should be understood not as two disparate processes that are merely chronologically coincidental, but as interconnected and overlapping forces. In the 1980s, representations of art and artists in entertainment and news media emphasized the monetary value of art and the art industry's embrace of promotional culture. Mainstream media reported and reproduced derogatory glamorizations which rendered art superficial in the public imagination. Such media representations contributed to the conditions against which congressional forces effectively initiated their agenda to "get the government out of culture," thereby leaving art to prove itself, or not, in the marketplace of ideas. In the late 1980s, critiques and campaigns against public cultural funding trafficked in the demonization of art as well as artists: portraying the art field at best as elitist and at worst as a moral threat to American society. The art market's crash in 1990 and its persistent sluggishness since has functioned effectively as a backdrop for the sustained denigration of contemporary art by politicians and religious fundamentalists.

The intermingling of these parallel tracks registers the paradoxical status of contemporary art and the individual artist by juxtaposing polarized notions of the artist as commodity and the artist as threat to America's moral value system. The materials presented here reference the perception of contemporary art in many people's minds, shifting from obscure novelty to newsworthy commodity, to liberal conspiracy, and once again to commodity—albeit humiliated. These ephemeral materials, fragmented and montaged, are things one comes across in everyday life: accessible "popular" versions of the roles art plays in society.

—Julie Ault, 1998

Notes

1. Robert Hughes, "Careerism and Hype Amidst the Image Haze," *Time*, June 17, 1985.
2. Donald R. Katz, "Art Goes to Wall Street: A Professional's Guide to Financial Matters," *Esquire*, July 1989.
3. Steven H. Madoff, "Riding the Rebounding Art Market," *Money*, September 1983.
4. Anon., "There's one born every minute," *Economist*, May 27, 1989.
5. Bradley Hitchens, "At What Price Art? The Answer is: High, Very High," *Business Week*, December 29, 1986.
6. Anon., "There's one born every minute," *The Economist*, May 27, 1989.
7. Julia Reed, "To be rich, famous, and an artist," *U.S. News & World Report*, March 9, 1987.
8. Ibid.
9. Kim Foltz, and Maggie Malone, "Golden Paintbrushes," *Newsweek*, October 15, 1984.
10. Joseph Epstein, "Culture and Capitalism," *Commentary*, November, 1993.
11. Sherman Lee.
12. Robert Hughes, "Why America Shouldn't Kill Cultural Funding," *Time*, August 7, 1995.
13. Robert Hughes, "The Great Massacre of 1990," *Time*, December 3, 1990.
14. Ibid.
15. James Servin, "SoHo Stares at Hard Times," *New York Times Magazine*, January 20, 1991.
16. Robert Hughes, "The Great Massacre of 1990," *Time*, December 3, 1990.
17. James Servin, "SoHo Stares at Hard Times," *New York Times Magazine*, January 20, 1991.
18. Ross Bleckner quoted in Deborah Solomon, "The Art World Bust," *New York Times Magazine*, February 28, 1993.
19. Joseph Epstein, "Culture and Capitalism," *Commentary*, November 1993.
20. Kay Larson, "The Rube Tube," *New York*, November 8, 1993.
21. Gardner, James, "Schlock on th Block," *National Review*, June 8, 1992.
22. George F. Will, "Giving Art a Bad Name," *Newsweek*, September 16, 1985.
23. Joseph Epstein, "Culture and Capitalism," *Commentary*, November, 1993.
24. James Servin, "SoHo Stares at Hard Times," *New York Times Magazine*, January 20, 1991.
25. Robert Hughes, "Why America Shouldn't Kill Cultural Funding," *Time*, August 7, 1995.
26. Kay Larson, "The Rube Tube," *New York*, November 8, 1993.
27. Chris Adams, and Robert N. Bellah, "Individualism and the arts," *Christian Century*, July 14–21, 1993.
28. Richard Bolton, ed., *Culture Wars* (New York: New Press, 1991).
29. Joseph Epstein, "Culture and Capitalism," *Commentary*, November, 1993.
30. Ibid.
31. Deborah Solomon, "The Art World Bust," *New York Times Magazine*, February 28, 1993.
32. Robert Hughes, "Why America Shouldn't Kill Cultural Funding," *Time*, August 7, 1995.
33. Robert Hughes, "The Great Massacre of 1990," *Time*, December 3, 1990.
34. Robert Bedoya in *The American Canvas*, NEA, 1997.
35. Barbra Streisand, "The Artist as Citizen," Harvard Speech, February 3, 1995.

Selection and layout of materials by Julie Ault.

OUR BLANKETS FOR YOUR BEAVER

OUR KETTLES FOR YOUR OTTER

OUR BEADS FOR YOUR MINK

OUR GUNS FOR YOUR FOX

OUR WHISKEY FOR YOUR SANITY

OUR GOD FOR YOUR SPIRIT

OUR PROMISES FOR YOUR COLONIZATION

OUR PROFIT FOR YOUR EXPLOITATION

The Children of John Adams:
A Historical View of the Fight Over Arts Funding

LEWIS HYDE

It was May of 1989, and Andres Serrano's photograph *Piss Christ* had been troubling the sleep of one of the senators from New York. Taking to the floor of the Senate on May 18, Alfonse D'Amato tore to pieces a reproduction of Serrano's image, declaiming to his colleagues,

> *If this is what contemporary art has sunk to, this level, this outrage, this indignity—some may want to sanction that, and that is fine. But not with the use of taxpayers' money. This is not a question of free speech. This is question of abuse of taxpayers' money. If we allow this group of so-called art experts to get away with this, to defame us and to use our money, well, then we do not deserve to be in office.*[1]

There are many possible responses to such hectoring—more subtle discussions of free speech, more nuanced views of what the work was about, and so on. But at the height of the debates over arts policy in the late 1980s, such rejoinders carried no political weight. The touchstones of D'Amato's opening salvo—a shocked indignity and a mockery of "so-called experts"—were immediately taken up by other legislators and by some journalists. A month later, for example, a columnist for the conservative *Washington Times* was proclaiming, "The artistic community has its own 11th commandment: *Thou shalt grant federal funds to art that's too intellectual for you to understand, you rube.*"[2] And soon after that, Senator Jesse Helms of North Carolina was defending an amendment he had authored which would have prohibited the National Endowment for the Arts from funding "indecent materials": "It simply provides for some common sense restrictions on what is and is not an appropriate use of Federal funding for the arts."[3] Senator Helms had earlier noted that "the National Endowment's procedures for selecting artists and works of art deserving of taxpayer support are badly, badly flawed."[4] And in July of 1989 he played the trump card in any discussion of American values: "No artist has a preemptive claim on the tax dollars of the American people; time for them, as President Reagan used to say, 'to go out and test the magic of the marketplace.'"[5]

Chapter opener:
David Wojnarowicz, *The Redesign of the Dollar Bill*, 1988–89, collage, ink, string, twelve black-and-white photos, spraypaint on masonite, 46 1/2 x 67 in. Photo courtesy of The Estate of David Wojnarowicz and PPOW, New York. Art Matters grant recipient, 1989, 1990, 1991.

Left:
REPOHistory, from the series "Lower Manhattan Sign Project," 1992: *John Jacob Astor and Native Americans,* street sign by Alan Michelson. Photo courtesy of REPOHistory. Art Matters grant recipient, 1992.

These attacks, though simplistic and bigoted from the art world's point of view, were surprisingly resonant with the general public, who suddenly became suspicious toward all federal funding for the arts. Why was that? What was it about the way critics of the NEA pitched their claim that caught the public's ear, while the art community's responses seemed so easy to ignore? Although the fusillades in question were often aimed at particular works of art and particular communities, what I'm curious to understand is not the targets so much as the surrounding language, the coating on the bullets. The underlying puzzle, then, is to decipher what it is about the mythology or history of America that makes this anti-art rhetoric so effective. What portion of our tradition or self-image makes it easier to criticize than to defend patronage drawn from the public purse? And—if a look toward history offers any answers—what hope is there for the kind of collective cultural support the NEA was meant to embody?

To resolve such questions, I spent a recent month letting two historians guide me into the territory that I hoped might offer some answers. I turned first to Richard Hofstadter's 1963 *Anti-intellectualism in American Life*, my assumption being that the forces that have regularly empowered themselves by scorning the life of the mind in this country might share some ground with those that have scorned the arts. After Hofstadter, I turned to one of his students, Neil Harris, whose 1966 volume *The Artist in American Society* has become a classic description of the tensions that accompanied the rise of American cultural institutions before the Civil War. I emerged from the company of these two writers with my own short list of themes whose roots are very old but whose fruits we still seem to be harvesting. We clearly have a surviving ethic of Protestant simplicity, for one thing; we have, as well, a strong suspicion of anything that doesn't seem practical and useful; and, finally, from our early emphasis on the value of voluntary association, we have inherited a particular sense of what it means to contribute taxes to any common enterprise.

To begin with the issue of simplicity, Harris argues that it was not Puritanism that engendered American hostility to the arts (the Puritans weren't suspicious of art, they were merely indifferent) but rather the "enlightened rationalism" of Founding Fathers such as John Adams and James Madison. These men associated art with luxury. (Having toured the great English estates and seen the great cathedrals, Adams, for one, thought of "art" as signifying the aristocratic and ecclesiastic opulence of Europe.) In addition, they believed that luxury would corrupt one's character by appealing to and gratifying the senses. In their psychology, character was founded

Muntadas, *The Board Room*, 1989, installation at Power Plant, Toronto. Photo courtesy of the artist. Art Matters grant recipient, 1985.

upon reason (steady and unchanging), and reason was threatened by the passions (volatile and shifting). More than that, theirs was a political psychology: the final link in this chain of logic held that if the character of the populace were thus corrupted, then republican government would fail, for in a republic the virtues of the government derive from the virtues of the people.

From "the dawn of history," Adams wrote, the fine arts "have been prostituted to the service of superstition and despotism."[6] In the same line, his wife, Abigail, once wrote to Jefferson saying that she thought Shays' Rebellion was the result of "luxury and extravagance, both in furniture and dress."[7] A contemporary, the moral philosopher Richard Price, summed up the issue nicely: "The character ... of popular governments depending on the character of the people, if the people deviate from simplicity of manners into luxury, the love of shew and extravagance, the government must become corrupt and tyrannical."[8] Thus does freedom itself demand that the healthy republic forgo the pleasures of fine art.

To this matter of the citizen's character, Adams himself added an analysis of the social structure he thought the fine arts would bring with them. It wasn't just the built opulence of Europe that put him off, it was the hierarchies of wealth that the stuff implied. If we had that sort of grandeur in America, who would pay for it, and how? As Adams put it in a 1817 letter to Jefferson,

How it is possible [that] Mankind should submit to be governed as
they have been is to me an inscrutable Mystery. How they could bear
to be taxed to build the Temple of Diana at Ephesus, the Pyramyds
of Egypt, Saint Peters in Rome, Notre Dame at Paris, St. Pauls in
London, with a million Etceteras..., I know not. [9]

Adams had visited Blenheim in England, a palace that had taken
twenty-two years to build. Did Americans wish to repeat the class
system required for that kind of project? If so, then the nation would
soon face deep divisions of labor and either a huge national debt or
the burden of taxes, all in service of soft leisure for some and hard
sweat for the rest. For John Adams, as Harris notes, works of art,
"like other luxuries..., were superfluous..., for they served no real
need; they could not grow, be planted, or reproduce their own
kind." [10] Instead of crops they produced dukes and duchesses, and
thus any touch of luxury seemed suspiciously like the beginning
of the end of the Great Republic. It overstates the case only a little
to say that Adams believed, as a like-minded Frenchman had put it,
that even "wallpaper could ruin Revolutionary courage." [11]

Adams's anxieties about the fine arts and their supposed corrup-
tions had religious as well as political dimensions. "Luxury, wherever
she goes, effaces from human nature the image of the Divinity," he
wrote to Abigail during his first diplomatic tour in France. [12] Years
later, he asked the painter John Trumbull,

please to remember that the Burin and the Pencil, the Chisel and
the Trowell, have in all ages and Countries of which we have any
Information, been enlisted on the side of Despotism and Superstition....
Architecture, Sculpture, Painting, and Poetry have conspir'd against
the Rights of Mankind: and the Protestant Religion is now unpopular
and Odious because it is not friendly to the Fine Arts. [13]

The nation that John Adams was helping to imagine into existence
was not a Catholic republic, or a pagan republic, or even a secular
republic. It was a Protestant republic. And the character of the people
and the state depended on Protestant simplicity in all things. To avoid
joining the lineage of despotic powers, Adams felt, the citizenry
would have to resist all "shew and extravagance," and the state, in
turn, would have to resist levying the kind of taxes needed to build
monuments to its own magnificence.

This profound wariness about art and its supposed luxuries has
often been repeated in American politics, though generally it appears
not so much as an aversion to art itself but as an attachment to
the useful, the practical, and the down-to-earth—values that are,
in turn, linked to an egalitarian ideal. Hofstadter's discussion of the
rhetoric of Jacksonian democracy makes a fine illustration of how
the utilitarian style got turned into an American political virtue.

Moyra Davey, *Purse Strings*, 1989, Ektacolor, 30 x 40 in. Photo courtesy of the artist. Art Matters grant recipient, 1989, 1992, 1993, 1994.

The presidential election campaign of 1828, which pitted Andrew Jackson against John Quincy Adams, provides his prime example.

In terms of how a government's relationship to art is imagined, the younger Adams was not quite his father's son. His excellent education and interest in science had not led him away from an enthusiasm for fine art. He was, Hofstadter says, "the last nineteenth-century occupant of the White House...who believed that fostering the arts might properly be a function of the federal government."[14] And it was exactly on such terms that he was attacked by the Jackson camp, which painted him as an aristocrat able to quote law but not to make it, able to write but not to fight. Jackson, on the other hand, appeared in the popular press as having "escaped the training and dialectics of the schools." He had "that practical common sense" which is "more valuable than all the acquired learning of a sage." Such a man could be "raised by the will of the people... to the central post in the civilization of republican freedom" precisely because his mind had not tarried on "the tardy avenues of syllogism."[15]

The Adams-Jackson campaign may have been the first national event in which "common sense," that is, a *lack* of interest in the arts and intellect, was connected to the freedoms of "the common man," but that correlation has been with us ever since. To take one last example, Hofstadter rehearses the late-nineteenth-century fights over civil-service reform. Yankee bluebloods, weary of having civic

257

Moyra Davey, *Copperhead No. 1*, 1990, Ektacolor, 24 x 18 in. Courtesy of the artist. Art Matters grant recipient, 1989, 1992, 1993, 1994.

offices filled by the spoils system, hoped to institute competency tests, whereupon they were attacked for demanding useless knowledge when only the useful was needed. On the floor of the House of Representatives, a congressman from Mississippi spun out the following fantasy:

> Suppose some wild mustang girl from New Mexico comes here for a position, and it may be that she does not know whether the Gulf stream runs north or south, or perhaps she thinks it stands on end. . . , yet although competent for the minor position she seeks, she is sent back home rejected.... [16]

A senator from Wisconsin worried that a businessman, his mind "long engrossed in practical pursuits," would be rejected for public service in favor of a "dunce who has been crammed up to a diploma at Yale." [17] Another member of Congress, a full stranger to those "tardy avenues of syllogism," was happy to conclude that civil-service reform would be "the opening wedge to an aristocracy in this country." [18]

Hofstadter revisits both this debate and the Adams-Jackson campaign to address anti-intellectualism in America, but the stories speak just as easily of anti-aestheticism. If we are to have art at all, it, too, should be practical and common, not a wedge for aristocracy. In the very early days of the republic, as Harris explains, we had neither fine arts nor fine artists. Before 1816, there wasn't even a shop where an artist could buy a paint brush. In that sparse environment, portrait painters "were also house painters, sign painters, blacksmiths and cameo cutters. They decorated furniture, designed family crests, engraved calling cards and incised tombstones." [19] Painters were given artisanlike instructions ("I wish the drapery to be white") and were paid in an artisanlike fashion ("Americans would ask only how long it took to paint a painting, and then divide up the price by the number of days." [20]) Moreover, as Harris notes, many painters "accepted the notion...that the artist's life was not basically different from any other craftsman's, nor deserving of special favor." [21] A lack of "favor" was the crux in an emerging republic: "In a society based upon equality of opportunity..., artists were forced to make stilted pleas for special privileges." [22]

My point here is that all of these anecdotes contain the same logic. They yoke together practical intelligence, the common citizen,

and republican government. By inference, the opposites are also joined: artistic talent, the citizen of special favor, and the inequalities of aristocracy become one and the same. The common citizen needs character and nothing more to participate in government (even at the highest levels), and even though character must be developed, it can be developed from materials that nature has given to all men and women. If, on the other hand, nature has given a man or woman some special endowment, that gift should not be put into play politically—not if we wish to be the Great Republic.

My final historical theme suggests yet another reason why, among all the industrialized nations, the United States has been the most resistant to institutions of public patronage. Following the work of the historian Sidney E. Mead, Hofstadter suggests that "a new and distinctive form of Christianity" emerged in early nineteenth-century America.[23] The essence of this new "denominationalism" was voluntary association:

> The layman...felt free to make a choice as to which among several denominations should have his allegiance. In the older church pattern, the layman was born into a church, was often forced by the state to stay in it, and received his religious experiences in the fashion determined by its liturgical forms. The American layman, however, was not simply born into a denomination nor did he inherit certain sacramental forms; the denomination was a voluntary society which he chose to join often after undergoing a transforming religious experience.[24]

Early in both the eighteenth and nineteenth centuries, the country had been swept by "great awakenings." In these religious revivals, established clergymen were regularly outshown by itinerant preachers whose authority came from neither tradition nor learning but from their enthusiasm, and from the conversions they produced, one by one, in the population. Moreover, Hofstadter connects such evangelical denominationalism to democratic ideals, for in both the actor is an individual, freed from inherited obligation. By way of illustration, he describes Gilbert Tennent, a minister active in Boston in the 1740s, and his warnings about the dangers of unawakened ministers.

> What [Tennent] was advocating could be called religious democracy. If, under existing church organization, a congregation had a cold and unconverted minister, and if it was forbidden to receive an awakened one except with the consent of the unconverted, how would the congregation ever win access to "a faithful Ministry"? Like a true Protestant, Tennent was...addressing himself to a major problem—how the faith could be propagated under conditions of religious monopoly.[25]

Later, in the nineteenth century, the revival movement happened to coincide with Andrew Jackson's presidency, and thus the Second

Great Awakening, Hofstadter concludes, "quickened the democratic spirit in America....by achieving a religious style congenial to the common man."[26]

But if it was this historical contingency that quickened our spirit, then democratic practice has inherited a particular style, one linked to the Bible and to an aggressive individualism that will regularly undercut any kind of collective action not in accord with its beliefs. Reading about this "evangelical democracy" thus set me to thinking of tax resistance, both the twentieth-century resistance to the income tax on principle and the periodic tax resistance that has addressed itself to specific items in the list of public expenditure.

Henry Thoreau comes to mind, not for his more famous resistance to the poll tax, but, rather, for an earlier incident in which he found that he was being taxed as a matter of course to support the Congregational church. It was the custom in Massachusetts to have town tax officials collect a church's assessments on its members, and when Thoreau first got such a bill he went to the tax office and demanded that his name be eliminated from the lists. He then filed a statement with the selectmen saying, "I, Henry Thoreau, do not wish to be regarded as a member of any incorporated society which I have not joined" (adding wryly that if the town would give him a list of all the societies he had not joined, he would be happy to sign off, one by one).[27] Here we have a man withdrawing from the church rather than signing up, but the spirit is still denominationalist, for there is no voluntary association without the possibility of voluntary dissociation. My point, however, is to note the three things that nicely converge in this instance. First, there is the American understanding that groups form from willing individuals (not, say, from tradition, location, family ties, occupation, or an obligation to the state); second, in America, one prototype for such groups is the denominational Protestant church; and third, the payment (or withholding) of a tax is presumed to be the outer sign of inner conviction.

Thoreau is usually taken to be a left tax resister, but tax resistance can come from either the left or the right, depending on what is being resisted. Thus, in this same lineage, we find William Jennings Bryan, during the Scopes trial, attacking the teaching of evolution in the public schools by asking,

> What right have the evolutionists—a relatively small percentage of the population—to teach at public expense a so-called scientific interpretation of the Bible when orthodox Christians are not permitted to teach an orthodox interpretation of the Bible...? They have no right to demand pay for teaching that which the parents and the taxpayers do not want taught.[28]

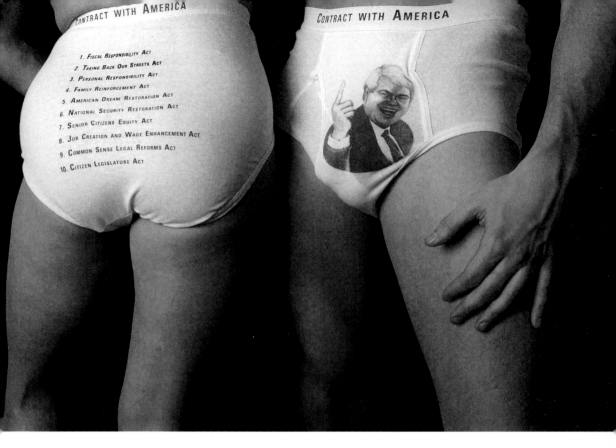

It is not a long leap from Bryan's question to the current debates over cultural policy, where the question has been, "Why should my Aunt Molly have to see her tax dollars spent on art she doesn't like?"[29] Nor, I'm arguing, is it that long a leap from the Great Awakenings to this contemporary question about art and taxes. Ours was a Protestant republic at its inception, and our history of evangelical Christianity suggests that even today when someone asks about the fate of "my tax dollars," we are hearing a religious question.

In closing this survey of themes from U.S. history, let me say that most of the ones I've touched on—our love of the practical, our suspicion of luxury, our ethic of voluntary association, and so on— share a common concern with egalitarianism. Though there is a tradition of political thought in which republican government would empower and benefit from differences in talent, in its popular form the republican ideal imagines democracy as a homogeneous space filled with citizens, each equally empowered. For that to be the case, it would be best if citizens themselves were made of some homogeneous material. Material that takes time, money, and talent to develop will not do, but an inborn, practical wit and a ready heart, everyone has these, and if they are the common currency of

Ligorano/Reese, *Contract with America Limited Edition Underwear*, 1995, silkscreened underwear. Photo courtesy of the artists. Art Matters grant recipients, 1986, 1992, 1994.

public life, then democracy can flourish. With such logic behind it, an aggressive egalitarianism has periodically set itself against the experts, professors, and creative artists, and against a learned or established clergy—against all the supposed patricians of culture, preferring (at least in rhetoric) the Patent Office over the painter's studio, homespun over silk, the revival tent over St. Paul's Cathedral, and that "mustang girl" over the man from Yale.

I say "in rhetoric" because when it comes to actual cases, the egalitarian appeal is typically more snare than promise, so narrowly focused as to be not egalitarian at all. Politicians often unroll the rhetoric of equality in the early fall, hoping to garner votes to support the inequalities they actually represent. Take that fantasy of the poor girl denied her job: what was at stake in the debate over civil-service reform was the system of political patronage; civil-service reform was a step toward equality of opportunity and away from the inequalities of the spoils system. The appeal to the "common" man and woman is there to preserve a set of privileges already in place. More broadly, let us not forget that during the heyday of Jacksonian democracy, one-fifth of the population was enslaved, women were not allowed to vote, and Andrew Jackson... well, Jackson's policy toward Native Americans was hardly a model of homogeneous democratic space.

To this excavation of older themes in American history I want to add a note about several more recent events that have lent their energy to the attack on public funding of the arts. After all, the issues I have enumerated may be part of our tradition, but traditions lie dormant most of the time, so we must wonder what current matters have managed to stir them, and to borrow on the passions they arouse.

One answer might be that in the 1980s something new was in fact happening in the content of the art being contested. The complaints were, after all, quite narrowly focused; only a select group of artists found themselves honored by Congressional scrutiny. Representative Pete Hoekstra, a Republican from Michigan, for example, went after an NEA-supported film titled *The Watermelon Woman*, attacking a single lesbian sexual scene that "shocked" him. Frank Rich describes the film in a *New York Times* column as "a charming...mock documentary by Cheryl Dunye..., [who] retrieves the lost history of the title character, a gifted black gay actress of the '30s whose career was relegated to 'mammy' roles in Hollywood and ghettoized 'race pictures.'" Rich then wonders why Mr. Hoekstra was upset by *this* movie and not something else:

If you're against Federal arts funding, that's one thing, but Mr. Hoekstra
is selective in his opposition. Were his real purpose to impartially investi-
gate errant NEA grants—as opposed to creating scapegoats—wouldn't
there be at least one mediocre, NEA-supported provincial orchestra on
his hit list? They exist.[30]

They exist, but no one cares. What we were asked to care about
made for a rather short list, and this one example can almost stand
for the whole, containing as it does most of the scapegoaters' favorite
items: feminism, homosexuality, and race. That is, the specific targets
are the rights, freedoms, and empowerment of women, homosexuals,
and minorities. And perhaps the debate broke out because there
actually were changes in the land having to do with the expanded
civil entitlements of these groups.

Probably so, but is this a sufficient explanation? It would be hard
to find a decade in our history in which we *didn't* have mud slung
in the name of the white race and patriarchal marriage. (Late-
nineteenth-century civil-service reformers, for example, were called
"the third sex"—"effeminate without being either masculine or
feminine; unable either to beget or bear; possessing neither fecundity
nor virility; ... doomed to sterility, isolation, and extinction."[31])

Daniel Martinez, *Untitled
(Whitney Biennial)*, 1993,
projection. Photo courtesy
of the artist. Art Matters
grant recipient, 1990.

Women, gays, blacks (even Catholics)—
these are the usual suspects of American
demagogery, which is to say that the com-
plaint about the NEA may not be about
the stated targets at all, but about issues
harder to see and understand, for which
the usual suspects have been rounded up
and forced to suffer their symbolic duty.

In areas unrelated to sexuality, gender,
and race this country has gone through
profound disruptions. A lot of new wealth
was created in the 1980s, but essentially all
of it went to the rich (before 1976, the
upper class—the top one percent of our
population—controlled one-fifth of the
wealth of this nation; by 1992 they con-
trolled two-fifths).[32] Over the last few
decades the growth rate of the United
States economy slowed to historically low
levels. Perhaps the 1973 Arab oil embargo
started the decline, or perhaps it was
changes in technology, or changes in the
global economy—but whatever the cause,

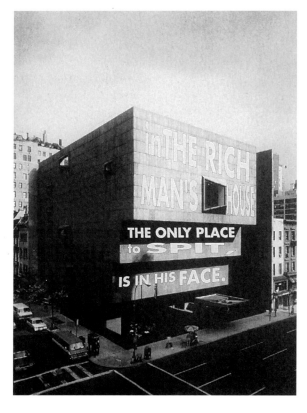

the effects are measurable. As a recent essay in the *New York Review of Books* explained, if the growth rate we knew from 1900 to 1980 had prevailed into the 1990s, every family in this nation would have $50,000 more than it now has. That's a nice amount of money. Having lost it to unknown forces could easily lead to some free-floating resentment.[33]

There are other striking shifts in our body politic (such as the unprecedented gap between rich and poor bequeathed to us by Reagan's tax policies), but the point is simply that none of this has much to do with race, sexual preference, or women in the workplace. Moreover, while these changes may be hard to explain, the anxiety they produce is real, and it is a classic political ploy to take the uneasiness and resentment aroused by complicated problems and focus them onto easy-to-see but unrelated targets. And, as it has traditionally been the task of artists and intellectuals to help a community cope with complex changes, we might say that the attacks on the endowments amount to an attack on change itself.

During these years there were, in addition to these domestic matters, some dramatic changes beyond our borders that may have influenced our debates over cultural policy. Specifically, the breakup of the Soviet Union coincided significantly, I think, with the debate about the NEA. It was the Cold War that had energized much of the public funding devoted to art and science between 1965 and 1989.[34] These were the years when it was important to our leaders to show off the liberal, capitalist state, and to contrast its vitality with the banality of the Eastern Bloc. Neutral nations, and dissidents in Eastern Europe, were meant to see the remarkable energy and innovation our freedoms produced. Thus would the USIA send Dizzy Gillespie to Europe in the 1950s. Allen Ginsberg may well have been a suspicious character to our own FBI, but having him crowned King of the May in Czechoslovakia in 1965 (and then deported by the Czechs) was fit demonstration that capitalist democracy was where the action was. Not that Ginsberg got any federal coin for that trip, but—like black jazz musicians—his style and actions were of a piece with the pattern of underlying propaganda: the West is hip, the East is square. The West supports artists, the East puts them in jail. (Imagining the rise of the endowments as part of American Cold War self-fashioning dovetails nicely with one of the odder facts about the origins of those institutions: it was under Richard Nixon that they came into their own. Kennedy was interested in them, Lyndon Johnson was not, but Nixon the Cold Warrior doubled and redoubled their budgets.[35])

By 1989 the Cold War was over, however. Before that, conservatives may well have disliked seeing federal dollars spent to export

African–American music or honor argumentative poets, but it was not an apt moment to act upon that dislike. Once the Berlin Wall came down, however, there was no one very important to show off to, and older domestic reservations about supporting culture surfaced.[36] The Berlin Wall, it would seem, wasn't confined to Berlin; it ran through the halls of Congress, keeping at bay old suspicions about spending public money to support the arts.

Which brings me to a final issue that shaped the NEA debate, and that is the tax revolt that began in California in 1978. Certain conservatives, most notably Howard Jarvis, the author of California's Proposition 13, had started out simply arguing against a range of government programs. A *wide* range: Jarvis himself wanted to end public financing of parks, libraries, garbage collection, schools, social security, and Medicare. The problem is that if you show up at the city council meeting and say, "Let's get rid of the library and the garbage trucks," you get no support. Having done that for a fruitless decade, Jarvis realized that if he went after taxes themselves he could just sit back. The trick was to separate the money from the programs it supported. Cutting taxes rather than programs meant that within a few years the city council would find itself low on funds, forced to decide by itself whether to close the library or cut back on garbage removal.

This strategy worked very well, first in California and then nationally. It also left the nation $3 trillion in debt when Reagan and Bush left office (versus $914 billion when they entered), and soon Congress found itself arguing not just about shutting libraries, but about cutting food stamps to the poor, closing down legal aid, cutting back on Medicaid and Medicare, and so forth. When the question "Why should my tax dollars go to art I don't like?" is raised in that context, it seems even harder to answer. In a climate of scarcity, created or not, people will always put food and medicine before opera and painting.[37]

No wonder, then, that the cause of public patronage found such thin support in the last decade. The immediate situation made it hard to argue for supposed luxuries, while shifting world politics cleared the way for older prejudices to surface. The conservative assault, moreover, found the rhetoric able to activate those more traditional biases. They began, first of all, by descrying "this group of so-called art experts," "*too intellectual for you to understand, you rube*," an elite who select artists by "procedures [that]...are badly, badly flawed." This is patent anti–intellectualism of ancient lineage in this land, and it is set up to invoke its opposite, the notion that decisions about art require only "common sense" that all citizens have and could exercise, were they not being shouldered aside by

the snobs. This supposed standoff between Everyman and the Art Expert was played out in terms of how art grants were awarded. Senator Helms regularly complained about the "panel review system,"[38] by which he meant *peer* panels set up so that artists might be judged by professionals in the field. Here, it should be noted that peer panels were originally designed not only because it is right that artists judge artists (as scientists judge scientists, and educators judge educators) but also because the panels provide a buffer between the art world and the politics of the Congress. This separation was a conservative concern when the endowments began in the 1960s, the fear then being that liberals in the Congress would force their agenda onto traditional scholars and artists. As Senator Edward Kennedy remembered it in a 1989 speech, the institution of peer panels "was a conscious effort ...to separate the review process from political interference....We have heard a great deal in recent months about several controversial grants....Without the peer system, there would have been persistent and chronic controversies of grant awards throughout the last 24 years."[39]

That is to say, peer review has egalitarian goals. For years, the NEA's individual artist's fellowships were awarded on merit, through blind competition, a system that gave a start to many unknown artists, artists who never would have been singled out in a more strictly political or commercial system. It should be a badge of honor that the endowment could find and reward a filmmaker like Cheryl Dunye, or, for that matter, a writer like Garrison Keillor, whose "Prairie Home Companion" had NEA support long before it could earn its own way. The wider point, however, is that the rhetoric of the NEA attacks depends heavily on an old American suspicion of artistic and intellectual elites who are portrayed as usurping rights and insulting the beliefs of common citizens.

This brings me to a second point about the way the attacks were framed: they connected Christianity, voluntary association, and tax-paying. Since Serrano's *Piss Christ* actually featured a Christian icon, it became the perfect tool to use in arousing evangelical Christians. But what made the attack especially effective was not the work alone but wedding it to "the use of taxpayers' money." This seals the trick because, with crablike logic, it makes the nation into a church and makes the payment of taxes the outer sign of an inner conviction that has led the citizen to join this particular flock. All of which makes unquestioned sense in communities where evangelical Protestantism and the United States are felt to be one thing, not two.

Finally, these attacks also call out the voters' affection for things that are clearly useful, practical, and productive. Posing the attack

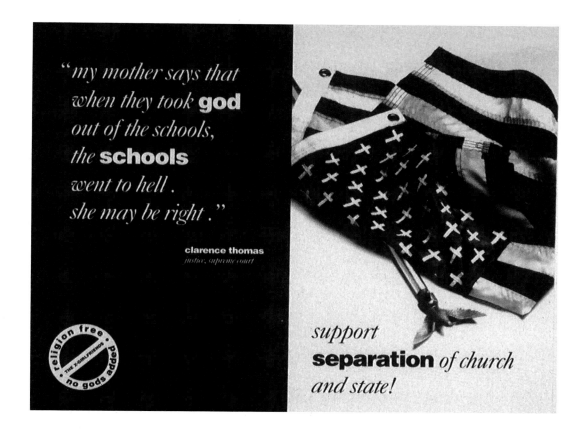

"my mother says that when they took **god** out of the schools, the **schools** went to hell . she may be right ."

clarence thomas
justice, supreme court

religion free / no gods allowed
THE X-GIRLFRIENDS

support **separation** *of church and state!*

in terms of taxes removes it from the abstract arena of cultural or aesthetic values (and the freedoms needed to foster them) and sets it down in the practical land of scarce dollars. Limits on the public purse always haunt policy debates, but they became even more urgent after "tax reform" had severed the means from the ends and then decimated the means. Who is going to support the arts, whose uses are vague, when we have been set to arguing about Medicare, whose uses are clear?

More subtly, the American love of utility gets roused by the gay-bashing in these attacks. Photographer and cultural critic Allan Sekula suggests how this hidden logic works:

According to conservatives, gays and lesbians are suspect because they don't reproduce 'normal' family life. They supposedly don't have children, and they often work in 'frivolous' fields on the fringe of the GNP. In other words, conservatives project their own fears of both unfettered desire and an impotent economy onto gay and lesbian people, who are easily scapegoated in a society obsessed with productivity. . . . [A] conservative intellectual, Gertrude Himmelfarb, recently suggested a connection between the (supposed) spendthrift shortsightedness of Keynesian economics and John Maynard Keynes' personal life as a homosexual.[40]

As I mentioned early on, Neil Harris pointed out that John Adams was cautious before the arts because "they served no real

The X-Girlfriends, *Separation of Church and State*, 1994, PSA, *Babble* magazine, 5 1/2 x 8 1/2 in. Photo courtesy of the artists. Art Matters grant recipient, 1994.

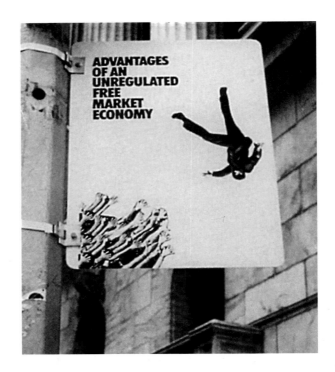

REPOHistory, from the series "Lower Manhattan Sign Project," 1992: *Stock Market Crash*, street sign by Jim Costanzo. Photo courtesy of REPOHistory. Art Matters grant recipient, 1992.

need; they could not grow, be planted, or reproduce their own kind."[41] By these conceits, productivity and utility are heterosexual virtues, and any argument in favor of art turns out to be an argument against heterosexual love and its social embodiment, the family. This is nuts, of course, but that doesn't mean it carries no political weight, especially in a land with a forebear like Adams, who believed that the republic would fall if the passions were ever enjoyed as ends in themselves.

One final thing needs to be said about the framing of these attacks, and that is that they present the marketplace as the true and final court of opinion and value. "I have fundamental questions about why the Federal Government is supporting artists the taxpayers have refused to support in the marketplace,"[42] insisted Jesse Helms, blind to the fact that asking most artists to survive in the marketplace is like asking most senators to live on their salary. For complicated reasons, artists have almost always needed patronage; in this nation, one of our ongoing tasks has been to find the form of patronage that will accord well with democracy. Simply to send American artists back to the marketplace is at best a misunderstanding of the nature of artistic value.

What are we to make of this history and this analysis? What especially might we do now, those of us who still seek ways in which this nation might, collectively, foster the arts? If there were to be such a thing as "democratic patronage," how would we build it, and what would it look like?

First of all, let us call by their right name the more strident of those who have attacked the Endowment and, by extension, the community of artists. They are demagogues. Demagogues are those who simplify complex issues, make emotional appeals to the people, and arouse animosities that divide us one from another. Rather than seeking to understand and lead us through the complicated changes this nation is undergoing, and rather than healing the divisions we suffer, demagogues call out fear and anxiety and transform them into resentment and intolerance (not to mention dollars and votes). In this nation, demagoguery takes particular forms. A demagogue in China would attack the bourgeoisie and the landowners; in Iran, the target might be Christians and the Bahai. Demagogues in the United States stir up intolerance toward blacks, immigrants, gays, and women who don't conform. More subtly, they activate resentment toward professionals, intellectuals, and artists, the supposed mandarins in a supposedly egalitarian republic.

Second, we need a fuller discussion of what it means to pay taxes toward democracy's common ends. We need to remember that it is adult, civilized, and honorable to contribute toward our collective enterprises.[43] It is an old truth that no civilization can grow and thrive without self-taxing. Put differently, groups tax themselves in order to empower themselves. That being the case, an attack on taxes is often an attack on collective action, especially those collective actions that cannot arise from market forces alone. In this country, taxes paid into the public purse promote the collective of the public, as opposed to the collective of the corporations, and as opposed to the noncollective of individualism. Arousing tax hostility allows the last two of these to trump the first, and all those things that the market cannot support nor individual action create are consequently weakened.

And what shall we say to those who do not want their tax dollars to go to programs they do not believe in? Arthur Danto, art critic for The *Nation*, suggests one answer:

> It is imperative to distinguish taxpayers from individuals who pay taxes, as we distinguish the uniform from the individual who wears it. As individuals, we have divergent aesthetic preferences.... But aesthetic preference does not enter into the concept of the taxpayer, which is a civic category. What does enter into it is freedom. It is very much in the interest of every taxpayer that freedom be supported, even—or especially—in its most extreme expressions.... The taxpayer does not support one form of art and withhold support from another as a taxpayer, except in the special case of public art. The taxpayer supports the freedom to make and show art, even when it is art of a kind this or that individual finds repugnant.[44]

There are cultural programs that have emerged from the NEA that I myself find silly and insulting, just as there are members of Congress that I find silly and insulting, but as a citizen I support both institutions, and would hesitate to destroy the whole simply to register my complaint about the part.

Third, if the goal is to develop democratic patronage, we will need to articulate a better rationale or ethic of that patronage, one that combines political egalitarianism, aesthetics, and an understanding of the economics of art. One of the striking things about John Adams was that, having seen the opulent arts of Europe, he could not imagine that democracy might have arts of its own, arts *not* "prostituted to the service of superstition and despotism." It would be some time before Walt Whitman, Frederick Law Olmsted, Isadora Duncan, Frank Lloyd Wright, and others would concern themselves with imagining such an art.

The NEA was originally heir to that kind of imagining, I think. While allowing that "no government can call a great artist or scholar into existence," its enabling legislation nonetheless spoke of the high hope that democratic governments might "help create and sustain not only a climate encouraging freedom of thought, imagination, and inquiry, but also the material conditions facilitating the release of this creative talent." We clearly need to do more to make such an ideal part of common understanding. As one portion of that effort, we need to work to preserve the NEA. Like seed corn preserved through a punishing winter, it has not disappeared, and the seasons will change. It would be very difficult to recreate the endowment from scratch; better to be patient, and, in the fullness of time, work to repair an existing institution.

The NEA's original enabling legislation contains one vision of what "democratic patronage" might look like in this country. I want to close with my own. To my mind, democratic patronage would, first of all, support the arts as widely as possible. It would preserve artistic treasures from the past and enable both institutions and individuals active in the present. It would be egalitarian, a patronage not only for the rich, or the well-connected, or those whose careers are well under way, or those living in the centers of power, or those who went to certain schools, or those who practice one aesthetic and not another. It would seek to empower a meritocracy of artistic talent.

Democratic patronage has some built-in tensions, and it would need to be structured so as to compensate for them. For one thing, the phrase itself may be a contradiction in terms: "patronage" usually implies hierarchies of wealth and power potentially at odds with democracy's egalitarian impulse. Some portion of democratic patron-

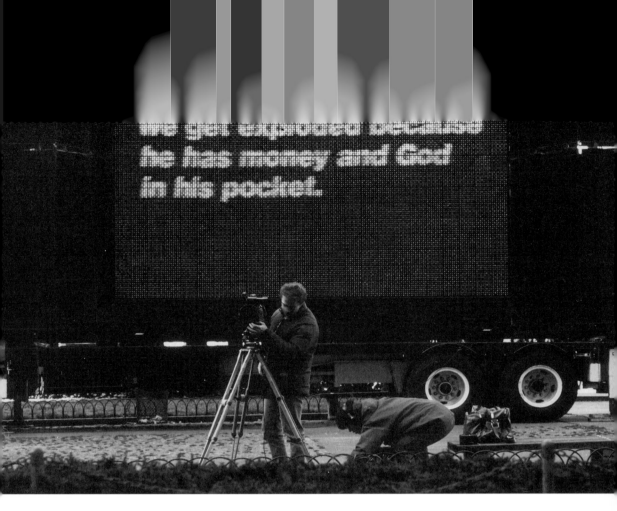

Jenny Holzer, *Sign on a Truck*, 1984, moving video installation. Photo courtesy of the artist. Art Matters grant recipient, 1987.

age would, therefore, have to come from public funds so that private wealth did not dominate the picture. There is no necessary conflict between democracy and private capital, but if all our patronage derived from the rich it would not be democratic, just as our elections and our schools would not be democratic if they served only the interests of the rich.

Second, there needs to be some way to deal with the fact that patronage is sometimes at odds with the artists it supports. One of art's classic functions has been to put the civic harmonies out of joint, and what city (or nation) is going to be happy having solicited, let alone fostered, such rudeness? All legislatures would like to plant hemlock groves near their halls in case the poets and philosophers get too restive. We need some way to encourage them to plant laurel instead, or if not that then to structure things so that there are buffers between the legislature and the creative community.

Taking these goals and the tensions into account, what then might democratic patronage look like? Let us say that it begins with some equivalent of universal suffrage. We all chip in. The arts will

be supported "by the people," a phrase I use because it quickly suggests yet another inborn tension: if patronage is "by the people," must the art it supports be "for the people"? It seems an impossibility, "the people" being so various, so diverse. How could there possibly be art that pleased all of us? There can't be. But that does not mean we have to abandon the hope of a democratic insitution here. On the contrary, democracy's supporting institutions often gather common means to enable diverse ends. We all pay for the apparatus of a general election, for example, but that does not mean that the results of the election must please everyone. More broadly, we all chip in to protect and nourish free speech, even though—in fact *because*—that speech will be displeasing to some. It takes our common energy to create the house of free speech, even though the voices that fill it may be greatly at odds.

An example from history may clarify my metaphor. In Benjamin Franklin's autobiography, we read that when the itinerant preacher George Whitefield came to Philadelphia in 1739, he found himself denied the use of the local pulpits, and so began to preach in the fields. Franklin tells what happened next:

> *It being found inconvenient to assemble in the open Air, subject to its inclemencies, the building of a house to meet in was no sooner propos'd and persons appointed to receive contributions, but sufficient sums were soon receiv'd to procure the ground and erect the building which was 100 feet long and 70 broad, about the size of Westminster Hall....*
>
> *Both house and ground were vested in trustees, expressly for the use of any preacher of any religious persuasion who might desire to say something to the people of Philadelphia, the design in building not being to accommodate any particular sect, but the inhabitants in general, so that even if the Mufti of Constantinople were to send a missionary to preach Mahometanism to us, he would find a pulpit at his service.* [45]

This Hall is a democratic space in the sense I am proposing: general, nonsectarian support creates an institution to enable particular, even sectarian, expression. To move from Franklin back to the present, my point is to insist that diversity of artistic practice is itself a form of free speech, and our patronage must reflect that fact if we wish to have a flourishing cultural democracy. It cannot only support art that pleases the established clergy of Philadelphia, as it were. If we wish to live in a land where we might one day hear the Mufti of Constantinople or someday see art that challenges our beliefs, then we must preserve the ethic that allows our common wealth to underwrite a variety of ends. To dismantle the house of public patronage by claiming that the issue is money and not free speech is a little like refusing to fund the judicial system saying that the issue is money and not justice. Freedoms cannot be separated from

the means that enable them. In short, democratic patronage has to differ from much traditional patronage, not just in the sources of its funds, but in the freedom it gives to artists to go their own way. In much traditional patronage, the patron controls the client (as when Nelson Rockefeller, finding that Diego Rivera had included a portrait of Lenin in a mural for Rockefeller Center, fired the man and destroyed the mural). Democratic patronage needs a lighter touch. As with pure scientific research or academic scholarship (two other enterprises worthy of this kind of support), we cannot know and control the ends of artistic production, nor would we want to in a society as diverse and changing as ours. Thus, public patronage needs to include loose links between the sources of wealth and the artists it encourages (include them by having peer panels make key funding decisions, for example, and by having those panels insulated from the legislature).

In thinking of democratic patronage, I have so far been imagining public institutions because, as I said above, if all our patronage must begin with those who have money to spare, it will probably not be democratic. Given a healthy public sector, however, democratic patronage would best be served by a mixed economy. If individuals, families, businesses, private colleges, and foundations were added to the mix, we would end up with patronage more varied, more able to take risk, and more flexibile in its responses to a changing scene. The heiress who bankrolled Art Matters did so exactly because public patronage had become skittish under right-wing attacks. It may well be that the liveliest democratic patronage comes from competition between public and private sources, each offering to do what the other won't, and each thereby keeping the other attentive.

This essay began with early American history, and I want to return to it in closing. Continuing to have broad-based public patronage of the arts in this country would, in many respects, amount to a break with tradition. It has probably been some time since we thought that "deviating in simplicity" would call tyranny down upon our heads, but it would be nice to know, as well, that our attachment to practicality and common sense could now be leavened with touches of beauty, or pointless play, or uncommon speculation. It would be nice to find ourselves supporting cultural life for its own sake, not merely to show it off to our enemies. It would be nice to find this nation, so rich in material things, confidently transforming a portion of the commonweal into a commons of culture.

We have old ways of thinking to overcome, but even their earliest spokesmen knew they would not, and should not, last. In a 1780 letter to his wife, John Adams wrote what is perhaps his most famous remark on art in America:

I must study politics and war that my sons may have liberty to study mathematics and philosophy. My sons ought to study mathematics and philosophy. . . , in order to give their children a right to study painting, poetry, music, architecture, statuary, tapestry, and porcelain.[46]

Adams clearly imagined a changing America, one in which republican simplicity would not always be the rule, and painting and poetry would come to have their place. The institutions of public patronage are still very young in this country—only three decades old, and embattled for a third of that time. But that does not mean that we cannot build them if we are patient. As Adams indicates, these changes require generations to unfold.

1. Richard Bolton, ed., *Culture Wars: Documents from the Recent Controversies in the Arts* (New York: New Press, 1992), p. 28.

2. Ibid., p. 45.

3. Ibid., p.74.

4. Ibid., p. 31.

5. Ibid., p. 76.

6. Neil Harris, *The Artist in American Society: The Formative Years 1790-1860* (New York: Braziller, 1966), p. 36.

7. Ibid., p. 31.

8. Ibid., p. 30.

9. *The Adams-Jefferson Letters*, edited by Lester J. Cappon (Chapel Hill: University of North Carolina Press, 1959), p. 510.

10. Harris, *The Artist in American Society*, p.34.

11. Ibid., p.50.

12. Wendell D. Garrett, "John Adams and the Limited Role of the Fine Arts," *Winterthur Portfolio* 1, no. 1 (1964): p. 247.

13. Ibid., p. 251.

14. Richard Hofstadter, *Anti-intellectualism in American Life* (New York: Vintage, 1963), p. 158.

15. Ibid., pp. 159-60.

16. Ibid., p. 183.

17. Ibid., p. 183

18. Ibid., p. 181.

19. Harris, *The Artist in American Society*, p. 56.

20. Ibid., p. 59.

21. Ibid., p. 57.

22. Ibid., p. 58.

23. Hofstadter, *Anti-intellectualism in American Life*, p. 81.

24. Ibid., p. 82.

25. Ibid., p. 67.

26. Ibid., p. 74.

27. Walter Harding, *The Days of Henry Thoreau* (New York: Knopf, 1965), pp.199-200. The Congregational Church was the established church of the Common-wealth of Massachusetts until 1834. The date of Thoreau's refusal is apparently 1838, so the town of Concord seems to have been slow to drop its establish-mentarian habits. See Henry Seidel Canby, *Thoreau* (Boston: Houghton Mifflin, 1939), p. 231.

28. Cited in Hofstadter, *Anti-intellectualism in American Life*, pp. 128-29.

29. This kind of tax resistance always centers on matters of belief and culture, and not so much on practical matters (or those supposedly practical). "I have never declined paying the highway tax," says Thoreau, "because I am as desirous of being a good neighbor as I am of being a bad subject...." During all the recent tax revolts and complaints about big government, one never heard of a town that refused federal disaster relief after an earthquake or hurricane. And taxes were easy to raise for the space program because it was one part Patent Office and two parts Cold War.

30. *New York Times*, March 13, 1997.

31. Hofstadter, *Anti-intellectualism in American Life*, p. 188.

32. Edward N. Wolff, "How the Pie is Sliced," *American Prospect* 22 (Summer 1995): 58-64.

33. *New York Review of Books*, November 19, 1992, p. 12.

34. A talk given by Neil Harris started my thinking in this line, and I am indebted to him.

35. Stephen Benedict, ed., *Public Money and the Muse: Essays on Government Funding for the Arts* (New York: W.W. Norton, 1991), p. 53.

36. A similar story was played out in basic science, which was well supported during the Cold War, but abandoned once the Soviet Union fell. In a recent interview, Leon Lederman, the particle physicist who won the 1988 Nobel Prize, said, "We always thought, naively, that here we are working in abstract, absolutely useless research and once the Cold War ended, we wouldn't have to fight for resources. Instead, we found, we *were* the Cold War. We'd been getting all this money for quark research because our leaders decided that science, even useless science, was a component of the Cold War. As soon as it was over, they didn't need science." See *New York Times,* July 14, 1998.

37. Alan Brinkley, "Reagan's Revenge—As Invented by Howard Jarvis," *New York Times Magazine*, June 19, 1994, pp. 36-37.

38. Bolton, *Culture Wars*, p. 75.

39. Ibid., p. 79.

40. Ibid., pp. 119-20.

41. Harris, *The Artist in American Society,* p. 34.

42. Bolton, *Culture Wars*, p. 91.

43. The financial collapse of Orange County, California, was another late fruit of Proposition 13, by the way. Finding itself short on funds, and hoping to continue collecting the trash, the county officials decided to go gambling in the derivatives markets. That is the opposite of an adult and honorable action; it is what happens to people who will not tax themselves.

44. Cited in Bolton, *Culture Wars*, p. 97.

45. Benjamin Franklin, *Benjamin Franklin's Autobiography*, edited by J.A. Leo LeMay and P.M. Zall (New York: W.W. Norton & Co., 1986), pp. 87-88.

46. Garrett, "John Adams," p. 255.

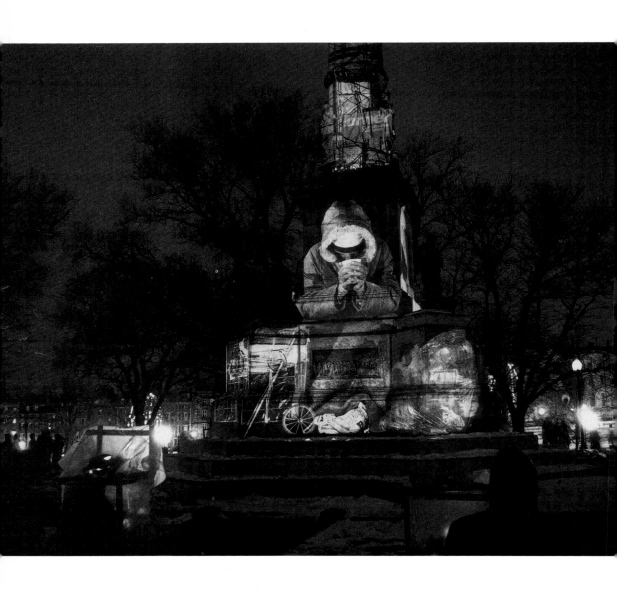

Theses on Defunding (1982)

MARTHA ROSLER

1. The presence of monetary support for art cannot be viewed as neutral.
2. The source of monetary support cannot be viewed as neutral.
3. The presence and the source of funding have a systematic influence that is both economic and ideological.
3a. For the sake of the argument, the aesthetic is a subset of the ideological.
4. Government support, foundation support, and corporate support differ in their effects on the art system. The government, by ideological necessity, has had to adopt standards that seem disinterested and depoliticized—that is, that appear firmly aesthetic—and has supported work that satisfies criteria of newness and experiment. Nevertheless those who do not share the associate assumptions about the meaning and direction of life—assumptions, say, of egalitarianism, cultural and personal pluralism, social progressivism or liberalism, and scientism—perceive the ideological character of art and reject the claim of sheer aesthetic worth.
4a. State granting agencies are idiosyncratic. They are likely to change quickly as they take up more of the burden of funding under the rubric of "the new federalism." State agencies are probably more prone than federal ones to bow to conservative tastes and right-wing pressure.
5. Foundations and, even more so, corporations are not expected to be even-handed or even impartial in the way that government must seem to be so. Rather, they are expected to stand on the bedrock of self-interest.
5a. Foundations vary in their policies, but many must now choose between supporting services to the poor that have been cut and supporting art. Several giant foundations have already announced policy shifts toward services to the poor, at the expense of a variety of other activities.
5b. Corporations are expected to maintain a monolithic public image that is anthropological to the extent that personality traits can be attributed to it. Thus, by lending an air of philanthropy

Krzysztof Wodiczko, *Homeless Projection 2*, 1988, projection on a Civil War memorial, Boston. Photo courtesy of the artist. Art Matters grant recipient, 1988.

This text was originally published in *Afterimage* (Summer 1982), pp. 6–7.

> Unlike many corporate donors who finance performances of established works such as "Swan Lake" and "Carmen," Philip Morris seeks out the experimental and avant-garde. In addition to Hopper and German Expressionism, there has been a Jasper Johns retrospective, shown at the Whitney and subsequently in Cologne, Paris, London and Tokyo. And there has been a photography show at the Museum of Modern Art. The company has also underwritten Michelangelo at the Morgan Library, North American Indian art at the Whitney and a traveling show of American folk art . . .
>
> Philip Morris executives express a fundamental interest in helping to develop the arts and shape public taste.
>
> —Sandra Salmans, "Philip Morris and the Arts," *New York Times* (Business Section),November 11, 1981.

and generosity, corporate benevolence can be used to defuse charges of wholesale theft, as in the case of Mobil or Exxon. One required trait is good taste, which is assured only in aesthetic territory that is already known and ideologically encompassed, territory necessarily barren of present, cutting-edge art, ideologically engaged art, or anything other than the safe. Most corporate money for art goes to the old, the safe, the arch, stuff that is above all redolent of status and spiritual transcendence, work that is more likely to be embalmed than alive.

5c. Many large and influential corporate funders are quite willing to congratulate themselves (before business audiences) for the public relations value of their contributions to culture.

6. In high times, when the economy has been strong, and large numbers of people have felt relatively secure about the future, the interest in personal well-being has risen beyond a survival level to an interest in personal happiness and cultural pursuits. Art is then accepted as important to society as a whole and therefore to its individual members.

6a. The latter part of the '70s saw corporations competing with each other to attract executives and other employees not only with economic lures but also with quality-of-life incentives, most of which involved the reclaiming of urban areas and especially the refurbishing of urban culture: that is, centrally, cultural outlets and activities.

7. In high times, art has been treated as the symbol and the vehicle of the spiritual treasure trove that is civilization and history. It is paradoxically both "priceless," meaning irrespective of mere monetary valuation, and "priceless," meaning terribly expensive. People think that art is a good thing even if they don't like, know, or care about what goes by that name—and nonbelievers are not given much of a hearing.

8. As the economy has skidded and recessions have come more and more frequently, economic considerations have taken prece-

dence over most other aspects of collective and personal life.

8a. In the second meaning of "priceless," that is, expensive, art is a speculative good, a store of monetary value. This side of art, art as investment, becomes more prominent in speculative times, when the social values that underlie a confident economy are in question and the future is uncertain. But art, as being above price, transcendent, bears social values. In speculative times, the opponents of *current*, unlegitimated art begin to gain a following because of that art's social uselessness in reinforcing traditional values. For those outside the closed-in system of consumption and investment, art has appeared as a monetary drain as well as ideologically—morally and politically, as well as aesthetically—suspect.

> "We believe that supporting the arts is one of the best investments NCR can make," says William S. Anderson, chairman and chief executive officer of the Dayton-based NCR Corporation and chairman of the Dayton Performing Arts Fund. "There is a high level of competition throughout the industry to hire the caliber of people we need. Dayton is not in the Sun Belt. It is neither on the East Coast nor on the West Coast. In fact, whether we like it or not, many people consider this part of the country just a step or two removed from the boondocks. When we recruit new employees, they want to know what they are getting into. This inevitably leads them to ask what the Dayton area has to offer in the arts and cultural activities."
>
> A concentrated effort has been made to upgrade the cultural climate in the Dayton area in the past half-dozen years. The availability of new resources and some good artistic choices have made the job credible.
> —Paul Lane, Jr., "Who Covers the Cost of Culture in Middle America?" *New York Times* (Arts and Leisure section), March 28, 1982.

8b. The current [Reagan] administration's radical restructuring of American institutions includes an aggressive repoliticization of many aspects of culture. The shifting of constituencies to include a sector of the radical right-wing and fundamentalist elements in working-class and middle-class strata has given powerful encouragement and an official platform to the nonbelievers in the reigning paradigms of art and in the nonpolitical nature of art. In placing right-wing ideologues in policy positions, the National Endowment for the Arts has not been spared. Thus, even within the administration, the nature of art is under attack, though a muted one.

9. Corporations follow the lead of federal programs. During the 1970s, as government contributions to art increased, the contributions made by business increased dramatically. The withdrawal of government money is a signal to corporations to cut back their contributions as well, or to restrict them more closely to the most public-relations-laden kind of art.[1]

9a. The government follows the lead of corporations. Much of the government's giving, except to individuals, is done through matching grants: each government dollar must be matched by one from a private giver. The government will pay only as much as the private sector will match, no matter how far short of the original award that might fall.

9b. Many corporations will also give only on a match basis: without government funding, they will no give money. Such corporations

as Exxon, ITT, and Aetna Life have declared themselves reluctant to replace the government in funding cultural activities.

10. Policy shifts with ideology. As ruling cities restore the legitimacy of big business as well as its economic preeminence, corporate givers gain more credibility as policy sources and are able to influence the policy of grant-giving agencies. These agencies are now likely to be headed and staffed by pro-business people. Further, corporations gain more influence as givers as they take on an increasingly significant role in the funding of culture. By unofficially signaling their wish to give to certain individuals and projects, corporations reportedly have already managed to influence the government to match their contributions.

11. The government's policies aggressively favoring corporations and the rich affect funding. The 1982 tax act is projected to cause a drop in private giving to nonprofit institutions conservatively estimated to be above $18 billion in the next four years. According to the Urban Institute, an independent research and education organization in Washington, D.C., such groups would lose at least $45 billion in combined funds from the government and private donors. Educational institutions, hospitals, and cultural activities were considered likely to be the most adversely affected.[2]

11a. The pattern of giving will likely be shifted by the new tax law from the rich (who are inclined to support educational and cultural institutions) to those earning under $25,000 (who are more likely to give to religious organizations).[3]

12. Many small, community-based, and community-oriented cultural organizations must have a steady income to stay in existence. A gap of even a couple of months would force many to fold. Yet, the next few years are considered a transition period in which adequate money must be successfully solicited from the private sector to replace withdrawn federal money. Therefore, many small organizations, especially those serving ethnic communities, will close.[4]

12a. Fewer ethnic- and community-oriented artists (including dancers, theater people, musicians, and so on) will be encouraged to continue their work. Consequently, we can expect their numbers to decline proportionally more than more mainstream-oriented artists. Cultural pluralism will fade as a reality as well as an ideal.

12b. Ideologically, cultural pluralism has already been tacitly discarded. We should be clear that ethnic arts have been targeted for defunding as being "divisive" and perhaps un-American, as well as (predictably) aesthetically inferior. (The Visual Arts section of the NEA was advertised a few years ago with a mass mailing of

a poster in which "Visual Arts" was written on a wall as a graffito in Mexican-American barrio-style *placa* writing. We shall see nothing of the sort for at least the next few years.)

12c. The "populist" orientation of the Carter NEA has been discarded by the pseudopopulist Reagan administration, which is in this as in other policies intent on reestablishing the material signs and benefits of great wealth—in this case, an elite, restricted cultural practice.

13. Artists are as sensitive as anyone to changes in wind direction and as likely to adjust to them. The production of artists depends on conditions "in the field" of art as a sector of the economy as well as a sector of the ideological. There are more chances to enter and pursue a life of art making when there is more money devoted to art. There are more places in school and more jobs in education, more general attention to a broader range of art activities. As the climate favoring government support of art and art education darkens, and the amount of money available for things perceived as nonessential to personal and societal survival declines, fewer people are attracted to a life of art making. Fewer parents are likely to encourage nascent artists.

13a. Severe cuts in student aid will affect art and the humanities far more than business and engineering, and nonwhite and working-class students far more adversely than middle-class whites. Minority recruitment has also been de-emphasized under the new administration, as have affirmative-action hiring policies. Thus, the conspicuous lack of nonwhite staff and staff of working-class backgrounds in museums and most other cultural services will probably become even more egregious.

14. Artists have been quick to bend the replacement of the humane and generous social ideal of liberal administrations with an ideal of aggressive and cynical me-firstism. (The several reasons for this go beyond my scope here.) Although the image of the artist as predator or bohemian has gone in and out of favor, a questionnaire by a West Coast artist suggested that by the late '70s a surprising number of artists, some quite well known, were calling themselves politically conservative and expressed the wish to make a lot of money. Artist-landlords are now common. (Of course, the impulse to make money rather than reject a life of financial comfort can be traced to the monetary success of art making starting around 1960.)

15. Artists still vacillate between doing just what they want and developing a salable product. That is, their integration into the commercial system is not complete. The institutionalization of art and the replacement of the paradigm of self-oriented

expression with that of art as a communicative act helped bring to art a uniformity of approach and a levelheaded interest in "success"—as well as the expectation of its accessibility.

15a. The current generation of artists sees art as a system and knows how to operate by its rules.

15b. Thus, it is not a surprise that after the announcement of drastic funding cuts, especially in the National Endowment for the Arts, there was a disproportionate drop in the number of applications for fellowships. Next year will presumably bring a disproportionate rise, when word of the excessive timidity gets out. Equilibrium will eventually be reached, assuming that the Endowment survives, but meanwhile artists will adapt to the requirements of other kinds of monetary support (which is still likely to be a job outside art).

15c. The blurring of the line between commercial and fine-art production is most advanced in photography, which therefore may be the visual art most easily swayed by corporate backing— and most likely to attract it.

16. The "lower" end of the art system will continue to strangle, and the "upper" will swell and stretch as more of the money available from all sources will be concentrated in it. SoHo will become more elite and exclusive. Artists who are serious about pursuing money will continue to seek it, and the rewards will, perhaps, be greater than they have been in the past. Superstars will be heavily promoted and highly rewarded, while the absolute number of people calling themselves artists will shrink drastically.

16a. The restratification or perhaps bifurcation of the art system will continue, mirroring the labor-market segmentation in the economy as a whole.

16b. As artists' incomes shrink, except for the relative few, and as urban real estate in most cities continues to escalate in value, artists, who have functioned as pioneers in reclaiming decayed urban areas, will find themselves displaced, and the existence of artists' communities, so essential to the creation of art, will be seriously threatened. This is already happening in New York.

16c. The policies of the present administration—such as the rewriting of the law to greatly increase the "safety" of tax shelters, especially in real estate—as well as the moderation of inflation and, perhaps, other factions as well, have made the tangibles and collectibles market, a product of the rampant inflation of the '70s, soften and fade, while the top of the art market is doing better than ever.[5] Sotheby Parke-Bernet, the largest auction house in the world, which rode to the top of the collectibles wave, refused to

announce its losses for 1981.[6] At least one dealer felt it necessary to advertise his continuing solvency and reliability.[7]

17. The nature of the alternative system will change. The smaller spaces will close, perhaps; the politically dissident centers will come and go, relying as they must on member artists' funds; the most bloated ones, such as P.S. 1 in New York and the Los Angeles Institute of Contemporary Art, which basically were products of the Endowment system, will become more and more indistinguishable from the junior museums they in fact are.

17a. New "alternative" spaces, perhaps most easily those for photography, will be financially supported by corporations and private dealers.

17b. Private dealers and, perhaps, corporate galleries will continue to tighten their grip on the exhibition system.

17c. The Museum Purchase Grant category has been eradicated. Private funds must now be sought for acquisition. Typically, foundations and fund-raising communities are inclined toward "historical" rather than current purchases, and toward physically large work—paintings or sculpture, say—rather than photography. Once again, the dealer's or collector's loan or gift of art will regain its former influence in determining what is shown in museums.

18. The number of institutional art jobs, from grade-school through college teaching, to administrative, curatorial, and other art-bureaucratic jobs, will drop steeply, so that artists will once again have to become petit-bourgeois entrepreneurs, attempting to make money through selling their work. They may seek financial support directly from corporations, perhaps photographic ones, so that their work will risk becoming, in effect, advertisements, like Marie Cosindas's work for Polaroid.

18a. Grant-getting agencies and agents, like the swollen few no-longer-alternative spaces, will see great expansion. Art promoters employed by art organizations are now being turned out by business schools, in programs that have existed for only the past few years. According to Valerie Putney's article "More than Talent" in *Pace*, Piedmont Airlines' magazine,[8] the first such program was at Yale's drama school in 1965. At the State University of New York at Binghamton, the program aims to produce students able to "influence future policy regarding the appropriate role of the arts in a diverse technological free-enterprise society." These unashamed bottom-liners spout the language of fiscal accountability, while like-minded artists may also need to learn it to gain grants from cost-conscious corporations (and other sources,

including the government). Or they may simply buy the services of agents themselves. (An old example of someone with grant moxie is Christo, whose career has depended on it.)

19. The parts of the system adjust to one another: artists learn the language of the accountants, and their thinking becomes more like accountants' (or salespersons') thinking. Art institutions and art-makers adapt their offerings to the tastes of grant-givers (that is, to the current ideological demands of the system). The new head of the Humanities Endowment has already disclaimed certain projects of the preceding head,[9] and the current head of the Arts Endowment has held up certain project grants. Will these kinds of grants now be curtailed?

20. Throughout the past decade, art organizations of all sorts had already begun adapting their offerings to the ideal of entertainment for a broad audience (partly a funding ploy). The reduction in funding has also spurred more and more of them to advertise for money and attendance in print media, on the radio, and on television. "Arts management seminars" teach ways to "target" audiences and get good returns for advertising dollars, as well as "how to identify and solicit the most receptive customers— through marketing surveys, direct mail, or whatever means has [*sic*] proven best."[10]

20a. In using the techniques of advertising, art organizations adapt their thinking and their offerings to the form of advertising. Increasingly, these appeals have been to pretentiousness, cultural ignorance, and money worship.

21. Because the pauperization of artists and others is connected to the reactionary policies of the current administration, while the absolute number of artists shrinks, proportionately more artists are likely to become social dissidents.

21a. The model of activism for artists and other cultural workers was slowly rebuilt during the Vietnam era, and that process will not have to be repeated today. Our society as a whole is much more given to public display and political activism of every variety than it has been for most of the period after World War II.

22. The conservative or reactionary artistic tastes of the corporate donors and private buyers will be prepotent, perhaps decisive, in their influence. But the *content* of their tastes cannot be assumed in advance: the ideologically reactionary work is not necessarily the most formally conservative, and we may find work that appears "advanced" formally backed by some political reactionaries. We may return to a kind of formalist modernism; artists, dealers, and their coteries will speak again of "quality" and mean

"formal values," while other artists will expect only to make their living outside the high-art system and refuse its values.

22a. If modernism is not restored, its formalist "investigations" may yet continue as part of a fragmented art scene, in which the present imagery expressing antirationalism, alienation, and uncertainty provides the theme.

22b. The next generation of artists, if there is one, will be part of a "postinstitutionalized" art system with a solidly restored hierarchy of glamour, wealth, and status. But the probably metaphysical high style it draws in its train may well be shot through with the cynicism of a delegitimating vision—one that questions the authority of art and its forms as well as that of social institutions.

22c. The inevitable corollary will be that this smug display of wealth and ostentation, particularly if combined with flashy nihilism, will be a spur to the resurgence of a well-developed, socially engaged, and egalitarian art, such as has recurred in the industrialized world for over a century. Networks of artists who are interested in making such art have proliferated in the past few years.

1. *SVA* [School of Visual Arts] *Alumni Chronicle* (Winter 1982).

2. *New York Times*, August 28, 1981.

3. Ibid.

4. See Harold C. Schonberg, "Cuts in Federal Arts Budgets to Hit Small Groups Hardest," *New York Times*, February 19, 1982.

5. See, for example, Rita Reid, "Auction: Art Records Set in May," *New York Times*, June 7, 1981; "Auctions: A Low Volume But a High Yield," *New York Times*, November 8, 1981; "The Collectibles Market in Decline," *New York Times*, January 3, 1982; under the heading "Investing" (Business Section), see H.J. Maidenberg, "Slack Days in the Tangibles Market," *New York Times*, March 21, 1982; and, under the heading "Personal Finance," see Deborah Rankin, "There's More Shelter Now in Real Estates," *New York Times*, August 23, 1981.

6. R.W. Apple, Jr., "Sotheby's Tries to Overcome Business Problems," *New York Times*, March 18, 1982, and "Sotheby Troubles Shake Art World," *New York Times*, March 21, 1982.

7. Howard Beilin, Inc., *New York Times*, March 28, 1982. Sotheby's also ran a series of color ads in British magazines.

8. Valerie Putney, "More Than Talent," *Pace* (March/April 1982).

9. See Ivan Molotsky, "Humanities Chief Calls PBS Film Propaganda," *New York Times*, April 9, 1982.

10. Putney, "More Than Talent," p. 30.

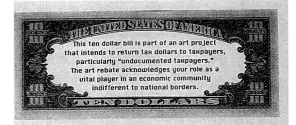

This ten dollar bill is part of an art project that intends to return tax dollars to taxpayers, particularly "undocumented taxpayers." The art rebate acknowledges your role as a vital player in an economic community indifferent to national borders.

- The economic growth of California and the Southwestern U. S. could never have happened without the labor of undocumented workers.

- Historically, the U.S. government, business and society have been willing to look the other way as long as they are enjoying the profits afforded by undocumented labor.

- Today, in a wrecked economy, the so-called "illegal alien" is once again blamed for the social problems of the region and portrayed as a drain on the economy. In fact, there is no credible statistical evidence that undocumented workers take more in social services than they give in combined local, state and federal taxes.

Not only are the crucial economic contributions of the undocumented overlooked or denied, these workers pay federal income tax, social security, state income tax, DMV fees, sales tax and more.

- Undocumented workers are undocumented taxpayers.

- You pay taxes when you eat a taco at 'berto's, shop for socks at K-Mart, buy toilet paper, hand soap or razor blades at Lucky or fill up your tank at Thrifty Gas.

- Regardless of your immigration status, if you shop you pay taxes. Period.

"Art Rebate" is a project by Elizabeth Sisco, Louis Hock and David Avalos. It is part of the "La Frontera/The Border" exhibition co-sponsored by the Centro Cultural de la Raza and the Museum of Contemporary Art, San Diego, and made possible, in part, through the generous support of the National Endowment for the Arts, a federal agency, The Rockefeller Foundation, the City of San Diego Commission for Arts and Culture, and the California Arts Council.

Undocumented Workers Taxpayers

The Privatization of Culture (1997)

GEORGE YUDICE

The conservative attacks on the NEA since the
summer of 1989, when Jesse Helms proposed a
ban on public funding for "obscene and indecent
art," are undoubtedly engraved in your mind to
this day.[1] He was reacting, you will remember,
to exhibitions of sexually explicit and presumably
blasphemous photographs by, respectively, Robert
Mapplethorpe and Andres Serrano, which were
financed in part with NEA funds. After these two
incidents, vigilant conservatives in Congress
protested the funding of the so-called NEA Four

Left and above:
Elizabeth Sisco, Louis Hock,
David Avalos, *Arte Reembolso/
Art Rebate*, 1993, art intervention,
San Diego, California/Mexico
border. Photos courtesy of
Louis Hock. Art Matters grant
recipients, 1987

in 1990—John Fleck, Holly Hughes, Tim Miller, and Karen Finley.
Objections to the first three revolved around their dissemination
of a gay "attitude toward life"; and conservatives took offense at the
latter's "unspeakable acts."[2] Helms and other moral monitors, like
Hilton Kramer, justified their attacks by arguing that in passing itself
off as art, the political agenda of "social deviants" had illegitimately
shielded itself in the armor of aesthetic autonomy.

Eight years later, in the summer of 1997, many of these allegations
were rehearsed anew when the House of Representatives voted to
abolish the NEA.[3] The NEA was saved, however, when the House-
Senate conference committee deferred the NEA's death sentence
for another year, not without further reducing the budget and
compromising the agency's autonomy by putting Congressional
members in its decision-making committees.[4] The $98 million
allocated by Congress is $1.5 million less than the 1997 allocation,
and just over half (56 percent) of the $176 million allocated in 1992,
the onset of the downward slide.

I shall not belabor this story, for it is not the substance of my
argument. It is merely the starting point of a narrative of govern-
ment withdrawal from support of the arts. But, as I hope to argue,
this is, in several senses, a restructuring of governmentality, giving
rise to a new way to channel conduct and enable action, efforts
that require new legitimation narratives for the arts and culture.

This is the text of a lecture given at the University of Kansas, Lawrence, Nov. 6, 1997.
An expanded version of this essay appears in *Social Text* (Summer 1999).

I will argue that the defunding of the NEA is part of a larger restructuring of the relation between government, capital, and society.

While the conservative attacks have without a doubt wreaked damage on the NEA, the restructuring that concerns me is part of a bipartisan consensus. The attacks facilitate the withdrawal of federal funding from the arts, in an analogous fashion to what has happened in social services and health insurance, thus requiring these sectors to legitimize themselves in new ways. The slashing of the NEA budget is in itself insignificant. It amounts to no more than sixty-six cents per person (for a budget of $176 million) or thirty-six cents per person (for a budget of $98 million), as compared with a median of forty dollars per person in Western European countries. In truth, it is misleading to put so much emphasis on these paltry amounts, since overall support, including private contributions to the arts, has been about $10 billion per year in the 1990s, matching the forty dollars per person in Europe. It is, rather, the change in the communicative or symbolic function that is important. The budget cuts and the likely elimination of the NEA are meant to head off the possibility of an official cultural policy which focuses on democratization. Indeed, the President's Committee on the Arts and Humanities, which has called for a national reflection on American creativity, stated that "a healthy cultural life is vital to a democratic society."[5] Unlike European or Latin American countries, the U.S. does not have a cultural policy, a point made in a government position paper at UNESCO's 1969 Monaco Round on Cultural Policies.[6]

Statements taken from the legislation that established or amended the NEA and NEH are the closest thing to a policy. Public Law 89-209, which established the NEA and NEH in 1965, for example, states: ". . . while no government can call a great artist or scholar into existence, it is necessary and appropriate for the Federal Government to help create and sustain not only a climate encouraging freedom of thought, imagination, and inquiry, but also the material conditions facilitating the release of this creative talent."[7]

This statement is significantly reversed by Congressional action on the NEA since 1989, not only with regard to the foundation's budget, but also with respect to the premise of artistic autonomy, the "freedom of thought, imagination, and inquiry," sounded thirty-two years ago. The struggle to reauthorize the NEA this year resulted in a Pyrrhic victory, surrendering to Congress a say on how funds are distributed and direct representation on the committee that decides which organizations will receive awards. Indeed, the NEA had already distanced itself from "controversial avant-garde projects" as part of its legitimation strategy under "difficult circumstances."[8]

The difference that partly explains the championing of artistic freedom in 1965 and its abandonment in the 1990s is the Cold War. The dissemination of a belief in artistic and scholarly freedom, and the apparent reversal of the witch hunts of the 1950s, were two moves in a complex strategy to distinguish the U.S. from the Soviet Union. I argue elsewhere that cultural subvention was also a means to mitigate opposition to the Vietnam War by artists, intellectuals and scholars. Like the antipoverty programs of the 1960s, the NEA and NEH were conceived, among other reasons, to "strengthen the connections between the Administration and the intellectual community," as recommended by Arthur Schlesinger, Jr., at the time.[9]

Government also sought to use subsidies for cultural activism as a way of channeling the expression of opposition. Johnson's Great Society was a complex mechanism for crisis management: to deal with the deterioration of social control unleashed by migration to the cities and unemployment among blacks and other racial minorities; to shape and direct blacks as an electoral constituency in urban centers, especially in the North, as Republicans made inroads among whites in the South. The federal strategy in the cities involved the creation of various service programs for the inner cities: youth development under the Juvenile Delinquency and Youth Offenses Control Act; community center attention to mental illness under the community Mental Health Centers Act; community action programs under Title II of the Economic Opportunity Act (the anti-poverty program); urban renewal programs under Title I of the Demonstration Cities and Metropolitan Development Act and the Neighborhood Service Program. These programs elevated "poverty" to public prominence, governmentalizing its management as Democrats sought quite deliberately to empower blacks. Bypassing local governments, they made it possible for black activists "to staff and control many of these agencies, much as Italians or Irish or Jews controlled municipal departments." The new intermediaries between the national government, the communities and the private social agencies, many of whom were selected from the cadre of civil rights activists and other "young minority-group spokesmen," were drawn into an "intricate mesh of interactive effects." As directors of local agencies, the constraints and guidelines of government funding ultimately brought into the fold even those activists who initially used federal money for their own purposes.[10]

Let me try to bring these points into focus. Big government was necessary, on the one hand, to wage the Cold War, developing the requisite technology and surveillance not only to fight off communism as an ideology, but also and more importantly to consolidate the hegemony of American capitalism. Big government

was also necessary, on the other hand, to quell social disorder. I should make reference, at least parenthetically, to the university, where different parts of this strategy converged. R.C. Lewontin has argued that, unlike Japan or Europe, only war or a major economic crisis can legitimize the state's intervention in the U.S. It alone carries the force that can overcome "American antistate ideology."[11] The Cold War thus "became the instrumentality of a vital national economic policy," channeling policy and institutional practice.[12]

This is evidenced in the growth of the university and its increasing receipt of federal and state subsidy. Basic research, which is not profitable in the short term expected by corporations, was located in the universities. "The problem for innovation then was to produce a large body of scientifically trained experts with an orientation toward research as a career, and to provide those research workers with libraries, laboratories, technical assistants, equipment, expendable supplies, and channels for communication of preliminary results."[13] The competitiveness of the market could not have sustained a similar general location for research. As in the arts and humanities endowments, a peer-review system for selecting grant sites was instituted, virtually putting in the hands of researchers the control over government subsidies.[14]

Of course, the National Science Foundation's budget was ten times greater than that of the endowments. Nevertheless, both the endowments and the NSF promoted "freedom," a necessary ideologeme in the war against communism. Until the endowments ran into political problems in the late 1980s, their awards were largely protected by the concept of artistic freedom. Analogously, the basic research promoted by the NSF was "free" from the profit-oriented ethos of corporations. Over the long term, however, it was expected to contribute to the economy. The cost was thus socialized under the control of entrepreneurial professors who had a relative autonomy from ideological control. Since socialization runs against the American grain, the mobilization of freedom and resources necessary to wage the Cold War became the means to overcome this "ideological antipathy" to state intervention. Indeed, to this day, so many government policies have been cast in the rhetoric of war: the "war on cancer," the "war on disease," the "war on poverty," the "war on crime," the "war on drugs."[15]

In the context of the Cold War, academics achieved "institutional governance."[16] They thus oversaw the expansion of the university to accommodate the baby boom, which supplied the labor needs of the Cold War economy. Science researchers set the model of the entrepreneurial professor, who "no longer worked for universities, but in universities."[17] Something like this model was adopted in

the social sciences and the humanities, as star professors became "free agents" in the 1980s. Part of the reason for the extension of the work conditions enjoyed by science researchers to humanities and social science professors (small teaching loads, funds for research, etc.), has to do with the eschewal of a "discrepancy" between the two sectors of the academy. The terms of employment established in the sciences were extended to the other faculties through governance. "Increases in the collective power of faculty governance that have resulted from the financial power of individual recipients of research money have . . . gone disproportionately to humanists and social scientists because of the social organization of scientific work."[18] The corporatization of the university as the Cold War wound down necessarily included overriding faculty governance.

As the Cold War receded in the 1980s, this arrangement disintegrated. Government slashed defense-related research in the universities, leading to restructuring, a new partnership with the corporate sector. What we are seeing at the end of the '90s is a corporatization of the university, from trustees to administration to curriculum decisions. Part of this corporatization is the restructuring of graduate education, especially in the humanities. Let me give at least one example. The cheap labor provided by part-time instructors and TAs will most likely be formalized by establishing non-tenure-bearing positions for the teaching of composition and rhetoric and foreign languages. In some cases, these instructors will be housed in special centers administratively separate from English and foreign language departments. This new arrangement will facilitate downsizing graduate programs, a desideratum for state higher education economists who see no justification for the subsidy, via TAs, for the production of Ph.D.s who are not needed to teach these courses. This "solution" will maintain a cheap labor supply as non-tenurable since instructors with M.A.s will earn less and teach more. Higher education institutions will continue to differentiate into a small number of elite institutions that draw corporate money for research, middle-level colleges and universities financed by states to produce middle management, and community colleges and special training centers that produce the workforce, financed in part by President Clinton's K-14 program as well as by special contract with corporations.[19]

I have touched on the Cold War in order to point more clearly to the change in academic and cultural legitimation narratives in the 1990s. Significantly, the arts and humanities play a role in the legitimation of the post-Cold War society. Both in the university and in the cultural sector, the so-called culture wars have served the function of delegitimizing the place of culture in society. On the one hand, conservatives and many liberals have sought to cut arts

budgets over the apparent demotion of high culture. Or they have attempted to reinstate the classics, fearful that Shakespeare will no longer be taught. In the process, they have raised the ire of populist and cultural studies critiques of gatekeeping practices. The debates have often lapsed into reciprocal condemnations of "special interest," thus emptying out the "intrinsic" value once thought to be the province of art. On the other hand, universities and arts organizations have increasingly resorted to a pragmatic defense of the humanities and culture. They have resorted to characterizing the arts as tools that enhance employability in the academic setting, junior partners to those in the science faculties who produce profitable intellectual property. In the cultural sector, the arts become part of a social service rationale or of economic development plans for communities, thus justifying subvention by corporations and foundations. In fact, what the new legitimation discourse encourages are partnerships between government, business, and the third or nonprofit sector.

This shift from government to a partnership is a way of resituating the management of the social squarely within civil society. As Foucault has argued, "Civil society is the concrete ensemble within which these abstract points, economic men, need to be positioned in order to be made adequately manageable."[20] Neoliberalism, then, reintroduces the expectation that "institutions of assistance" will be situated within civil society rather than in government. A recent NEA report on the state of the arts, titled *American Canvas*, characterizes this new pragmatism as the "need to 'translate' the value of the arts into more general civic, social, and educational terms" so that they can be more convincing to the public and elected officials.[21] This pragmatic legitimation is made even more forcefully toward the end of the report, which I will take as my main case study in what follows. It says:

> No longer restricted solely to the sanctioned arenas of culture, the arts would be literally suffused throughout the civic structure, finding a home in a variety of community service and economic development activities— from youth programs and crime prevention to job training and race relations far afield from the traditional aesthetic functions of the arts. This extended role for culture can also be seen in the many new partners that arts organizations have taken on in recent years, with school districts, parks and recreation departments, convention and visitor bureaus, chambers of commerce, and a host of social welfare agencies all serving to highlight the utilitarian aspects of the arts in contemporary society.[22]

I have established an analogy between the academic and culture sectors; there are, of course, significant differences. The growth of the university is one of the ways in which the state has indirectly subsidized the economy. This is not the case with arts and culture,

although, as I will explain, even this function—fueling the economy—is now being touted as a significant legitimation of the subsidy of the arts. The end of the Cold War brought a public demand for a reduction in state expenditure, especially, by conservative forces. Opposition to continued high levels of state support for education and other social services, including the arts, is the ideological strategy to produce a different contract with America. That the Democrats have largely capitulated is a demonstration of the force of this strategy, which potentially creates a problem for state support of the economy. The trick is how to reduce expenditures and at the same time maintain the level of state intervention for the stability of capitalism. The easy route has been to attack the powerless: cut entitlements and redistributive programs that benefit marginalized groups. This move to reduce state expenditures, which might seem like the death knell of the nonprofit arts, is actually their condition of continued possibility. The arts and cultural sector is now claiming that it can solve America's problems: enhance education, salve racial strife, help reverse urban blight through cultural tourism, create jobs, and even reduce crime. This reorientation of the arts is being brought about by arts administrators. Much as in classic cases of governmentality, in which there is a "total subordination of technicians to administrators," artists are being channeled to manage the social.[23]

I am not arguing that this is all smoke and mirrors, an opportunistic rush into the vacuum left by the retreating state. The state has not disappeared, only reoriented its modus operandi. It is the state, in fact, that has encouraged the partnerships between government, the corporate sector, the nonprofits, and civil society. You will remember that that was the purpose of President Bush's Thousand Points of Light. Perhaps privatization is not the accurate term for this process. Privatization proper assumes that the state no longer directly manages what was a state enterprise, say, a utility. The notion of partnership, however, blurs the boundaries between the private and the public, a composite arrangement already foreshadowed in the nonprofit corporation, which is simultaneously private and public. This argument, by the way, is substantially different from the notion that culture is being commercialized. This latter notion holds that products of creativity are essentially commodities, and that their appeal is rooted in the fetishistic character of the commodity, enhanced exponentially by the electronic media. What I am talking about, however, does not operate so much at the level of desire, which the commodity fetishism debate presumes to oscillate between autonomy and cathexis to capital. The emphasis in post–Cold War culture is on the character of the public good, which is no longer to

be defined either by the state or civil society. It is now negotiated or partnered in the triangle of government, the corporate sector and civil society. It makes no sense to speak of public and private, for they have been pried open to each other in this triangulation.

Let me give a little history about the formation of the arts and culture sector. In a very insightful essay, John Kreidler attributes the creation of the nonprofit arts sector to the Ford Foundation's initiatives.[24] The arts grant, he notes, "was invented by W. McNeil Lowry, vice president for Arts (1957–76) of the Ford Foundation in the 1950s, as a vehicle for the long-term advancement of individual nonprofit arts organizations, as well as a means for the strategic development of the entire nonprofit arts sector." The arts grant was seen as leveraged investment rather than charity. Until Ford's initiative, almost all cultural philanthropy had been vested in individuals. Ford invested more than $400 million in arts during Lowry's tenure to fiscally revitalize nonprofit organizations (NPOs), decentralize NPOs beyond New York city, create arts service organizations (e.g., the Theatre Communications Group), enhance conservatories and visual arts schools. Ford saw itself as catalyst rather than perpetual funder. To this end, Ford invented the concept of the matching grant, a tactic to recruit new donors and to establish a pattern of long-term support spread across many sources. This is what Kreidler means by leverage.

Before this "Ford era," only the Carnegie, Rockefeller, and Mellon Foundations had entered arts philanthropy. With Ford, the idea of the matching grant spread throughout various funding sectors, including Big Government. Johnson's War on Poverty, for example, required matching funds from state and local governments. Ford was also instrumental in the creation of NEA in 1965, under Johnson's presidency. NEA initiatives like "Treasury Funds, state block grants, and Challenge and Advancement programs, owe much to the Ford strategy of leverage, decentralization and institutional expansion." Prior to 1965, only four states had arts-funding agencies. With the stimulus of NEA block grants, all states created arts agencies by 1980. And eventually almost four thousand local arts councils were created (one-fourth of which were tied to local government and another three quarters as NPOs). Two other philanthropic branches grew from Ford initiatives: foundation and corporate support. Foundations acquired specialized staff to formulate funding strategies and analyze grant applications. By the end of the Ford era, aggregate arts funding from foundations would surpass $1 billion per year, over three times the aggregate budgets of state and national government art agencies. Corporate arts funding started later and was spearheaded by Exxon, Dayton Huston, Philip Morris, and

AT&T; it has been more concerned with marketing strategies than strategic development of the arts.

But corporate funding was the fastest growing sector of arts funding in the 1990s. The effect of the Ford model was to channel high-art organizations into a nonprofit model, rather than the proprietary model characteristic of the pre-Ford era. Ford's strategy has been quite successful. In the pre-Ford era there were only twenty to thirty arts organizations in the San Francisco Bay area. By the 1980s, there were over a thousand NPOs.

As in the case of the university, briefly examined above, the burgeoning infrastructure of the arts was due to government money and foundation money, but also to the emergence in the 1960s of a huge generation of artists, technicians, and administrators, driven not by funding or economic gain, but, rather, by their interest in producing art. They founded many arts organizations, not so much because of the market but because they had the training and the desire. This happened at a time of significant shifts in societal values, a peak in economic prosperity, the arrival of the massive baby-boom generation on American college campuses, the momentary ascendancy of liberal arts education, and a marked increase in leisure time. This new generation was large, mostly white and affluent, and contributed to the creation of NPOs and arts audiences. It provided the labor supply for the massive expansion of the entire nonprofit sector of health, environmental, educational and social service organizations that received foundation and expanded government funding. The expansion of "free expression" and the complementary change in attitudes toward public service were in tension and in tandem with the Cold War investment in an American premium on freedom versus communist repression. Economic prosperity and the expansion of liberal arts education also created a large public of arts consumers. It is important to emphasize that culture consumers were highly educated, a narrow band of society. In contrast, most of the public obtained its art and entertainment from commercial sources.

As I argued earlier, the changes in the 1980s find both the university and arts sectors overgrown with respect to the economy. In the culture sector, the lion's share of profits were in the entertainment industry, where the masses of consumers obtained their cultural fare. Further impacting the economy of the sprawling nonprofit culture sector was a stagnation in the institutional money supply. Until the later '90s, it was thought in the federal and state government sectors, as well as in foundations, that "seed funding" would bring about leverage; the NEA constantly refers to an eleven-to-one multiplier effect for each NEA dollar. Impact studies were commissioned to prove this. But this model rests on an untenable projection of

unlimited growth of resources. Kreidler likens it to a chain letter. The point is that we have entered a new historical period in which the crisis facing the arts sector—and the university system, I would add—cannot be temporarily weathered by more of the same measures. At first it seemed like cuts in funding since the 1980s were "a temporary aberration of the economy." Now it is evident that there has been an epochal shift. But the economy is only one factor. Just as important is the change in the public. Here is where the changes in higher education have repercussions in the arts and culture sector: the shift toward business and science, with a concomitant veering away from social values and public service; the downgrading of the humanities; the tendency toward valorization of sectors others than the white middle class.

As Kreidler explains, "a significant portion of the veteran generation that founded the Ford era organizations is departing, and it is not being adequately replaced by a new generation of discounted labor." The new generation of arts organization labor supply is smaller, in part because fewer students major in liberal arts, and also because, within the current economy, the newer generation looks out for better job security and is less willing to "discount" its labor. The crisis of NPOs is also due in part to this slippage in public demand for the certain traditional nonprofit services. Hence, the systematic linkage of the arts and culture sector with the nonprofit social services sector. Legitimation of art and culture veered from the humanistic belief that they provide uplift, a safe haven for freedom or inner vision, and took on the utilitarian characteristics advocated in *American Canvas*. The privatization or partnership of education and art with corporate culture is quite consistent with Rep. Newt Gingrich's emphasis on employment skills (see his "Contract with America"). In what follows, I will review some of the premises and examples of the utilitarian partnership.

Skilling is a major aspect of the arts touted by *American Canvas*. In one section, a report by the Arts and Education Commission is quoted which states that the arts should be "part of [students'] preparation for productive work [insofar as they] help . . . build the specific workplace skills needed to ensure their own employability and their ability to make a solid economic contribution to their communities and the nation. The arts teach and enhance such skills as the ability to manage resources, interpersonal skills of cooperation and teamwork, the ability to acquire and use information and to master different types of symbol systems, and the skills required to use a variety of technologies."[25]

The report goes so far as to suggest that the arts can be as tough as the times require, inculcating in students a cognitive "muscularity,"

that is, "wir[ing] children's brains for successful learning."[26] The arts, moreover, will teach self-esteem[27] and tolerance for differences.[28] Aware that he may have gone too far in this utilitarian direction, the author of the report apologetically points out that this approach may be "understandable in these difficult, distrustful times" and cautions that it can "ultimately subvert the very meaning of art."[29] Curiously, this 200-page report has virtually nothing to say about art practice itself or its meaningfulness. It is taken for granted, if at all. Although the author sounds such cautions as the one just mentioned, he nevertheless concentrates his efforts on the leverage that the arts can gain from partnerships with business and social service agencies. He is not alone. The report is a synthesis of six town-hall discussions with people from all sectors of society interested in salvaging the support system for the arts.

One arts activist, Syd Blackmarr, president of the Georgia Assembly of Community Arts Agencies, advocates folding the arts into civic activity. He is reported as saying, "It is time for those who know the power of the arts . . . to become members of the school board, the city and county commission, the planning and zoning commission, the housing authority, the merchants association, the library board." "The point," adds the report's author, "is not simply to underscore the relevance of the arts to those various civic concerns, but to tap the public funds that flow through these channels, some of which might be used for the arts." Blackmarr is quoted again as saying that "we must insist that when roads, sewers, prisons, libraries and schools are planned and funded. . . that the arts are also planned and funded. We must find the line items, the budget categories, the dollar signs in all of these local sources."[30]

It is quite evident that the turn to schools and communities is made with an eye to the bottom line. The report moves glibly from renewing the idea of the artist-as-citizen[31] who works with communities, to using those communities as a springboard for drawing resources from urban revitalization and tourism.[32] This is not, of course, a one-sided gain, for urban-renewal projects are enhanced by cultural tourism. The report gives the example of Lowell, Massachusetts, which became a kind of theme park of itself, and the Philadelphia Museum of Art, which brought hundreds of millions of dollars to Philadelphia with the blockbuster Cézanne show in 1996. A participant in another town meeting of the *American Canvas* said that the "arts are a tremendous asset" in giving some communities an edge in the competition of the marketing of destinations for tourists.[33]

The boundaries between economic, civic, and artistic activities are blurred in these examples, to the point that several participants

spoke of the fusion of the everyday and art without the slightest awareness that they were echoing the most radical dreams of the historical avant-gardes. As I stressed before, this is not exactly the same as the commodification of art—as in the case of museum tie-ins: mugs, T-shirts, ties, posters, paperweights, etc. Although not mentioned in the *American Canvas* report, the fusion of art with urban and community development is more in line with the international movement known as "culture and development"—that is, the concern with development that does not put communities at risk (culturally or ecologically) while contributing to the economy. The central concept in the culture-and-development movement—promoted by UNESCO and the World Bank, along with the Rockefeller and Ford Foundations—is the promotion of civil society, understood as the self-organization of communities. Yet it is evident that this self-organization can no longer be understood as an autonomous process. Now it is in partnership with the global nongovernmental organization and nonprofit sector, as well as with capital.

The blurring of the private and the public has also been accompanied by the approximation of the right and left on the political spectrum. Many of the civil society activists in the U.S. and around the world who were much more critical of capital are now spearheading these partnerships. As progressives move away from class struggle and anti-imperialism, and as capital—at least those sectors of it that have branched into cultural marketing and point-of-purchase politics—espouse environmentalism, antiracism, and antisexism, community activists can feel that they are working on behalf of social justice. This is certainly the tenor of *American Canvas*, which oscillates between radical statements and more conservative accommodations. In fact, in at least one case, an organization organized an exhibition that included gay and racial civil rights artworks and then invited a cross-section of the community, including conservatives, to discuss how it might be contextualized so as to be acceptable to all. Here the notion of partnership extends from public and private (or economic and civic) arrangements to the embrace of political adversaries. The director of this community organization in Winston-Salem waxed enthusiastic that "suddenly, these people were all partners, rather than adversaries."[34]

We might be skeptical about the viability of this new post-Cold War legitimation strategy. But *American Canvas* is staking the entire future of the NEA and the support system for the arts on it. It attacks the entertainment industry for prostituting America's values and advocates transmitting a cultural heritage that will preserve what the culture industry leaves aside. In the process, however, it abandons the notion of artistic value. When art critic Arthur Danto

wrote about the report in the *Nation,* he pointed out that there is a difference between table settings and quilts, on the one hand, and artwork that has won the recognition of other artists and critics. Of course, his complaint might originate in the absence of critics in the *American Canvas.* After all, the report reflects the concerns of arts organizations. One last thought: the 1980s were declared the decade of the curator—he or she was considered to be the real protagonist of the arts. I wonder whether the arts-organization activist is not attempting to take on the protagonist role. The exclusion of critics and academics here might be a hint. The new governmentalization requires subordinating the arts to administrators.

1. Maureen Dowd, "Jesse Helms Takes No-Lose Position on Art," *New York Times,* July 28, 1989, pp. A1, B6. The word "indecent" was subsequently omitted in the "compromise" wording to the obscenity ban.
2. Hilton Kramer, "Is Art Above the Laws of Decency?" *New York Times,* July 2, 1989, p. H1.
3. Jerry Gray, "House Approves Measure to Kill Arts Endowment," *New York Times,* July 16, 1997, p. A15.
4. Judith Miller, "Alexander Plans to Resign As Leader of Arts Agency," *New York Times,* Oct. 7. 1997, p. A12.
5. President's Committee on the Arts and the Humanities, Creative America: A Report to the President (Washington, D.C.: February 1997), p. 1.
6. Michael Kammen, "Culture and the State in America," *Journal of American History* 83, no.3, (1996): 795.
7. President's Committee on the Arts and the Humanities, p. 23.
8. Miller, "Alexander Plans to Resign," p. A12.
9. Quoted in Milton C. Cummings, Jr., "Government and the Arts: An Overview," in *Public Money and the Muse: Essays on Government Funding and the Arts.* ed. Stephen Benedict (New York: Norton, 1991), pg. 49.
10. Frances Fox Piven and Richard Cloward, *Regulating the Poor: The Functions of Public Welfare* (updated edition; New York: Vintage/Random House, 1993), pp.261, 274.
11. R.C. Lewontin, "The Cold War and the Transformation of the Academy," in Noam Chomsky et al., *The Cold War and the University: Toward an Intellectual History of the Postwar Years* (New York: New Press, 1997), p. 23.
12. Ibid., p. 7.
13. Ibid., p. 8.
14. Ibid., p. 9.

15. Ibid., p. 23.
16. Ibid., p. 28.
17. Ibid., p. 29.
18. Ibid., p. 30.
19. This vision of the new system of higher education was voiced by Allan Lee Sessoms, President of Queens College-CUNY, at a forum on The Privitization of Higher Education, CUNY Graduate Center, New York, October 31, 1997.
20. Michel Foucault, lecture, College de France, Apr. 4, 1979; cited in Colin Gordon, "Governmental Rationality: An Introduction," in *The Foucault Effect: Studies in Govermentality,* edited by Graham Buschell et al. (Chicago: University of Chicago Press, 1991), p. 23.
21. Gary O. Larson, "American Canvas" (Washington, D.C.: National Endowment for the Arts, 1997), pg. 81.
22. Ibid., pp.127-28.
23. Robert Castel, "From Dangerousness to Risk," in Burchell, *The Foucault Effect,* p. 287.
24. John Kreidler, "A Leverage Lost: The Nonprofit Arts in the Post-Ford Era," online: http://www.inmotion-magazine.com/browse/publish/lost.html., Nov. 23, 1996.
25 Larson, *American Canvas,* p. 100.
26. Ibid., p. 102.
27. Ibid., p. 103.
28. Ibid., p. 109.
29. Ibid., p. 111.
30. Ibid., p. 83.
31. Ibid., p. 84.
32. Ibid., p. 86.
33. Ibid., p. 87.
34. Ibid., p. 70.

Chapter 5:
"I don't see a lot of altruism."

Marianne: *All private foundations involved with art realized that what was happening with the NEA was going to impact their constituencies.*

>Marianne: Before Laura left, she provided an initial $2 million for an endowment for AMI. But as the NEA started to go by the wayside, we weren't able to give away nearly as much money as we wanted to. It took about a year before we started getting more and more applications.

>Philip: If we had stopped funding for four or five years our endowment would have grown, but artists did not want us to do that. We needed to try something drastic to continue to fund people in a time of greatly diminished resources available to artists.

>Linda: Giving out twenty teeny grants a year was beneficial to twenty people, but we had an opportunity to do more: to create a model that would have a broader effect.

Linda: *The old models of fundraising were not working. It looked like the NEA was going to be dismantled. Artists were under attack. There was no longer a consensus on supporting artists with public funds. Foundations were getting busy with other agendas and almost none were supporting artists directly. There didn't seem to be any models of support that were not either tied to the whims of foundations or politics.*

>Laurence: So we set about trying to figure out how we were going to raise more money to give away to artists. We looked at lots of different options.

>Marianne: The Arts Forward Fund was our formal response to the NEA crisis.

>Cee: Running AFF, like giving office space to Creative Time, Visual AIDS, and NCFE, was a way in which AMI practiced what it preached, finding ways a foundation can actually do something that benefits the community without its necessarily requiring a lot of money.

>Marianne: AFF aimed to bring together funders to form a pool of money that would be given away by peers in the field to replace, ideally, the funds that the NEA had cut. It never got close to that. We then went from trying to raise big money from foundations and individuals to trying to raise little money through direct mail. And that finally led to the idea of trying to generate big money of our own with a mail-order catalogue of artist-produced products.

>Mary: Our vision was of lots of people supporting the arts through purchases and small donations.

Linda: We had as much intellectual interest in a new model as practical interest in generating new income. The catalogue was a way of creating a model that was impervious to the political environment and, at the same time, educated people about artists and how art is part of one's life.

Marianne: We tried vigorously to strike a balance between art and commerce. The intention was not to support artists who create merchandise, so much as to make money that we could then give to artists who weren't in the marketplace. The catalogue was conceived of as a money-making effort, but the educational component did have much more impact than I expected with people from all over the country. Not just, "I can't get my hands on anything like this out in Texas," but also, "I never knew that artists made things like this."

Linda: *At at a time when artists were being demonized and the process of making art devalued, when artists were represented as wild people nobody knew and nobody cared about, it was about saying, "Whether you know it or not, an artist's sensibility is in your home."*

David: We went through an enormous amount of thought, discussion, debate, and research before we decided to do the catalogue. We were spending almost the entire endowment of the foundation. We mailed out about 1.5 million catalogues and had $1.2 million in sales the first year. We won awards for catalogue design and direct marketing. It was a viable business. But like many small start-up businesses, we were undercapitalized. And we couldn't get the capital we needed. Foundations considered it too risky and wouldn't get involved. Banks strung us along. We missed a season, and it was over. There was so much lip service being paid in that era to isn't-it-horrible-that-Congress-has-eliminated-support-for-individual-artists, and here was an organization with a great history coming forward with a viable option and people just wouldn't touch it. It was one of the most painful things I've ever gone through.

Adam: The foundation community had been talking up entrepreneurialism. Yet when we went to those foundations with an entrepreneurial effort that had a successful, one-year track record, we got zero back. Nothing. We couldn't even get a loan. We couldn't even get a Program-Related Investment. Foundations don't know what they're talking about when it comes to being entrepreneurial. You can't say, be entrepreneurial, and then give a $25,000 grant. You have to be ready to underwrite a business for three to five years at a level that's going to be adequate.

Philip: *The idea that the art world should follow the entrepreneurial model to solve it's problems is a product of the Reagan era.*

Lowery: *There continue to be challenges to the tax deductibility of merchandising by nonprofits. It's a dicey situation, particularly when you get to the Metropolitan, which has such a prominent merchandising program. But the relationship between nonprofit and for-profit has always been extremely fluid in this country. The reality for any nonprofit organization at this point is, if you don't have a patron with deep, deep pockets, you're going to have to figure out how to run your organization more like a business and to generate funds to support its activities.*

Linda: *While the point of the Reagan-Bush era was to decentralize services from government to nonprofits, they were in fact making it harder to get nonprofit status.*

Adam: *The arts are not going to be self-sustaining. A museum bookstore can't pay the way. How is a stressed-out theater company supposed to manage a restaurant?*

Linda: *Nonprofits are undercapitalized in terms of human resources. Community-based organizations and organizations of color are undercapitalized generally, and even the businesses in their communities are undercapitalized. If you live in a red-lined neighborhood in Brooklyn where there are no banks and the small businesses are under siege, what kind of business model does a nonprofit dream up?*

David: *I rather doubt that art that has a value to our culture and society and our lives is going to survive from entrepreneurial effort. What's happening in this country is that the right-wing voices have been so loud for the last decade that we're starting to sound like them. We are doing what they've told us to do, whether we realize it or not. We are thinking that the bottom line should be profit-making. If you want to make art, you should be entrepreneurial. The bottom line is the marketplace. If something is worth its salt, it will support itself. Art and culture don't always function that way in our society. It's unlikely that important intellectual and aesthetic investigation and social subject matter are going to be commercially successful. All you have to do is look at Hollywood films to see what survives in the marketplace. That's not what AMI was about and that's not what I'm interested in as a cultural activist.*

Cee: *David and I were looking at a book about WPA art, and the resemblance between what happened to the WPA and to the NEA is remarkable. The WPA was abolished by the government when artists became involved with political content. This is not the first time this has happened, and it probably won't be the last time. If there is going to be any support for the arts other than earned income, it's probably going to have to come from private or corporate philanthropy.*

> **Adam:** AMI also, like a lot of other organizations in the '80s, turned to the philanthropic community for support—including the corporate philanthropic community.
>
> **Cee:** The corporate funding AMI got was nominal: $3,000 from Chase. I don't even remember how much we got from Philip Morris.
>
> **David:** Was there an ethical question? Any time Philip Morris is on the table as a funder, it doesn't go without mention; but money is money and all money has its taint, whether it's from the Rockefellers or anywhere else. It's just gone through more or less laundering.

Gai: *I would rather see somebody in an entrepreneurial position making money for their own organization than taking it from Philip Morris.*

Bruce: *Artwork that cannot be used to promote or advertise the products and activities of corporations does not get corporate funding. The whole world has taken a turn toward the market to the point where there is very little so-called independent work being made, particularly in film and video. I believe that there are cycles. At some time public funding will come back and there'll be another flowering of interest in experimentation and support for work that somehow alters the existing reality, the existing language.*

Lowery: *With the NEA, the government made it okay to fund the arts in a way that brought others onboard, certainly corporations. But government funding is always going to be slightly politicized.*

Mary: *Public funding is subject to political whims. Government agencies are forced to think about being responsible to the public. What does the public want? The public doesn't know what it wants. It's unimaginable to have a government that doesn't support the arts, but the truth is, the U.S. government was never really that involved. Of course, there have always been military bands, which now get more from the government than the entire NEA.*

Marianne: *Even if public funding were still intact, it seems to me that there are sectors of society and branches of culture that are never going to appeal to a broad-enough public to be seen as deserving public support. The advantage of private foundations is that they can direct money to specialized or marginalized constituencies.*

Mary: *Private foundations have the freedom to establish, within legal boundaries, what they want to do with their money. That allows for a freedom of choice that's important in this country.*

Laura: *I really hope that the private sector can play a role that the public sector can't. Isn't that what this is about?*

Adam: *Even though private philanthropy is a multi-billion dollar industry, it pales in comparison to public support. To think that private philanthropy can fill the vacuum of public support, be it for education, health, or the arts, is absolutely catastrophic in its implications. There's just not enough money.*

Laura: *There's a lot of money running around this country. Sometimes I wish people would just get off it and fund the arts. But right now there is also a huge social challenge that looks more compelling than the making of art. People are going to put their funds into social programs until they understand that there is no such thing as an isolated social challenge. Slowly, people will begin to understand the relationship between a homeless person and forms of expression.*

Lowery: *I just got a study which argues for increasing state support of the arts by showing that the arts are a high-return, low-risk investment. For example, the Met, just by itself, attracts more spectators per year than all the sports events in the tri-state area combined. I don't know if that includes Little League. We do an analysis of how many people come, and project how many hotel rooms are booked, restaurant meals eaten, and how much shopping done, and we prove that the arts pump billions of dollars into the local economy. And we still can't get a fair share of support. The government subsidizes the auto industry and the tobacco industry. Here is an industry that would probably require a minimal amount of money, but people still can't get it. If there were no art in New York, I'm not sure why anybody in their right mind would come.*

Kathy: *Support for the arts has got to come from somewhere. I would prefer to have it come from government. But when governmental funding for the arts is crashing down around our ears, it's hard to define what an adequate response from the foundation community would be.*

Mary: *Public funding is subject to political whims. But private funding is subject to the whims of private people. We've also seen that happen over and over again.*

Philip: *Foundation funding sucks, corporate funding sucks, public funding sucks: they all suck.*

Marianne: *There are kinds of expertise that aren't widely shared by people in the government or by foundation trustees. That's a problem, because then other kinds of economies and values come into play. But many private foundations, to their credit, do invite people from the field to participate. Given that, I would say that private foundations aren't any more or less corrupt than public funding has been.*

Bruce: *The best thing about private foundations is their freedom from government restrictions and their potential to be activist. But most foundations are reactionary. They're founded by conservative people looking for a tax write-off, or out of vanity, to boost their social position. They're in it for their own power and glory. It's a whole world view. Investment. Promotion. They have a standing in the community. They belong to the Rotary Club. They don't want to ruffle feathers. They're not going to stick their neck out for Bob Flanagan or Karen Finley.*

> **Marianne:** We did try to find another major donor for AMI but there wasn't enough kick-back. AMI wouldn't provide cachet for an individual. It was too democratic. When we talked about bringing money people on it was abundantly clear that the most important thing was not to change the structure of the organization.

> **Laurence:** All of us had come out of institutions where money-boards often consumed more energy than they were worth.

Laura: *I came out of a philanthropic past. My family has a printing business in Chicago. It's very big, but very Midwestern. I came from that culture. You give back. My father was very forward-thinking and very, very generous. He told a story about his grandmother sitting him down and telling him, "This has all been given to you by God and God expects you—you have a duty—to provide for others."*

David: *The "thousand points of light" we've been hearing about for the past decade is really about advocating for a return to the pre-1960 model. It's the re-privatization of American society. The result would be support for the things that rich people like. Which is not to say that some people with money wouldn't want to support diversity, but by and large not.*

Bruce: *Foundations are the product of the trickle-down theory of the turn of the century. It's just like Reaganomics. What a nightmare. What kind of theory is that? If the rich get richer they give more to the poor? It's never going to happen. There's still a belief that rich people are going to support the arts, but these days it's even hard for symphonies and ballets to get support.*

Laura: *Private funding comes from people who have gotten to a place where they feel a sense of mission and responsibility to support what they believe in. I don't think the idea that philanthropy should take a bigger place in partnership with the public sector is a bad impulse. A lot of people are naturally discovering service. It's really just one of the highest impulses there is.*

Cee: We also went to big artists and got almost zero response. We found out that many artists who've made it are just not very generous. Mapplethorpe wasn't. The same with Warhol. They wouldn't have started foundations while they were alive.

Laurence: The only exceptions were Roy and Dorothy Lichtenstein and Jenny Holzer. The others had an almost capitalist attitude: "I had to pay my dues, I struggled and did it and I'm not going to help anybody." That's a sensibility this country suffers from.

Lowery: *The brilliance of the tax code was in creating an artful alliance between public good and private wealth. A lot of foundations have been put together by people who really cared. Other people are just dodging taxes. That's what makes this country great.*

Laurence: We also considered the traditional put-together-a-national-committee-with-Bianca-Jagger-and-have-a-party-at-Barney's, etc. None of us wanted to pay the price that it took to do that.

Laura: *I personally don't think that the public sector is going to get downsized that much. At the same time, the nonprofit sector is going to expand because there's more and more money. The number of foundations is growing like crazy because people don't want to give their money to the government. They're finding that foundations are a great way to keep their money out of that system.*

Laurence: *You have to be extraordinarily wealthy for a foundation to make sense in terms of taxes.*

Mary: *I'm not a Marxist and I don't think all should be equal to all people. We should have basic healthcare, etc., but there should be incentives and money is the biggest incentive. It's important to create opportunities for people who make money to do something good with it.*

Philip: *It's not clear that many arts foundation are anything more than tax shelters for collections.*

Linda: *Should foundations exist? I'm a socialist. I don't think anyone should have that kind of money.*

Adam: *Foundations started early in this century in the United States. They became an area for some terrible tax abuse. In 1967 an investigation was initiated by Congress which led to the tax codes for foundations being rewritten in 1969. Basically, when you establish a foundation, in exchange for paying a nominal tax on your investments, you have to annually give away a minimum of 5 percent of your accumulated assets. Minimum. That includes all program-related costs, not just grants. The rest can be added to the corpus. Five percent is not much, especially considering how the stock market has performed since 1969, and I would venture that 95 percent of foundations operate at that 5 percent level. In return, you can manage the money as a public trust. It's literally no longer your money, but public money that you can invest for charitable work. You're simply overseeing it. People forget that.*

David: *I've heard arguments in recent years that foundations should be held more accountable to the public.*

Adam: *But if the majority of Americans support getting rid of the NEA, do we really want private foundations to be more accountable to the public? Do we want to open up that can of worms? Or, are we better off slowly trying to move forward the agenda of those exceptions, those Joyce Mertz-Gilmore Foundations and Warhol Foundations. . . .*

Kathy: When AMI started to raise money from other foundations, we knew it would be problematic, but that was why we went. We were hoping that foundations would open not only their doors, but also their heads; and would realize that in a time of crisis it might be necessary for them to take risks. Different foundations reacted differently, certainly some of them weren't very favorable.

Laurence: We tried to raise money from other foundations that are concerned about individual artists, but didn't have the mechanisms to fund them. We discovered that not very many foundations are concerned about individual artists. They may care about the arts, but that's vastly different than caring about artists.

David: How can I justify to my board giving money to AMI to fund Bob Flanagan? I'm sure those discussions happened somewhere at some point.

Laurence: *Most large foundations have drawn the parameters around themselves so tightly that it's very hard for them to fund outside the plan, whatever the plan is.*

Adam: *Many foundations do play a catalytic and questioning role, but I would like to see the foundation community be a little more reflective of the society it serves. Are foundations really responding to the needs of the community or the just internal needs of their organization? My feeling is that the majority of foundations serve the needs of their organizations first and the needs of their so-called constituencies second. I don't see a lot of altruism.*

Philip: *The best people in the foundation world are afraid of their power and the worst are just interested in protecting it. They're not about to give up the perks that come with the job, so anything that threatens their position is out of the question.*

Adam: *As long as foundation boards are only made up of a certain social order, foundations will remain as they are. If you want change, it should be mandated that foundations that support the arts must have a certain number of artists on the board. Foundations involved with education must have educators. But there's no chance of that kind of change. None. The mood of the country right now is less government intrusion.*

Philip: *It's about power.*

Adam: *Yeah, and once this gets published, I'll be. . . . I have a four-year old. Keep that in mind.*

Shirin Neshat, *I am its secret*, 1993, black and white
photograph and ink, 46 x 60 inches. Photo courtesy
of the artist. Art Matters grant recipient, 1994.

chronology

1980

Former actor and California governor Ronald Reagan is elected the fortieth president of the United States; George W. Bush, once head of the CIA, is elected vice-president.

Civil war erupts in the Central American country of El Salvador.

The National Endowment for the Arts (NEA) is budgeted at $158.79 million for fiscal year (FY) 1981.

Pablo Picasso's self-portrait, *Yo Picasso* (1901), sells at auction for $5.83 million.

John Lennon is assassinated in New York City.

1981

On January 20, President Reagan is inaugurated, and Iranian dissidents release fifty-two American hostages held for 444 days.

Within weeks, there are assassination attempts on lives of President Reagan (March 30) and Pope John Paul II (May 13).

President Reagan appoints the Presidential Task Force on the Arts and Humanities to review the activities of the National Endowment for the Arts (NEA) and National Endowment for the Humanities (NEH). Reagan recommends a 50 percent budget cut for each; ultimately, the U.S. Congress settles on 10 percent reductions.

The Centers for Disease Control in Atlanta reports the presence of a deadly form of pneumonia found in five homosexual men in Los Angeles. At first called the "gay flu," the disease is later named the Acquired Immunodeficiency Syndrome (AIDS); 148 cases are reported in New York City.

Gay Men's Health Crisis (GMHC) formed in New York.

Richard Serra's site-specific sculpture *Tilted Arc* is installed at Federal Plaza in New York City. Two months later, 1,300 people who work in adjacent buildings sign petitions calling for its removal.

1982

The Equal Rights Amendent expires, three states short of ratification.

Wisconsin becomes the first state to institute anti-gay-discrimination legislation.

Amid much controversy, the Vietnam War Memorial is dedicated in Washington, D.C.

The Spectacolor Board in Times Square begins showing artists' spots in a program initiated by the Public Art Fund.

1983

The United States invades the Caribbean island of Grenada to forcibly depose its leftist government.

First personal computer system inaugurated by IBM.

NEA chairperson Frank Hodsoll vetoes a panel-approved grant to the Heresies collective and PAD/D that would have supported public forums featuring Hans Haacke, Martha Rosler, Suzanne Lacy, and Lucy Lippard.

1984

Gas leak at a Union Carbide plant in Bhopal, India, kills 3,300.

Rev. Jesse Jackson runs for presidency, becoming the first major African-American candidate, and inspiring large black voter turnout.

Gregory Lee Johnson is arrested for burning a U.S. flag in front of the Republican National Convention in protest of the Reagan administration's Central American policies. His conviction is later overturned on Constitutional grounds.

President Reagan and Vice-President Bush are reelected, defeating Walter Mondale and Geraldine Ferraro, the first female vice-presidential candidate.

1985

Mikhail Gorbachev assumes power in the U.S.S.R., and advocates *glasnost* and *perestroika*.

The Reagan administration creates the Attorney General's Commission on Pornography (the Meese Commission) to investigate the connection between pornography and antisocial behavior.

The Guerrilla Girls begin their campaign against racism, sexism, and homophobia within the art world. Their 1984 census of NY galleries shows that fewer than 10 percent of the artists exhibited were women.

The General Services Administration (GSA), which commissioned Serra's *Tilted Arc*, announces that it will move the sculpture.

Rep. Steve Bartlett (R.-Tex.) proposes an amendment to a FY 1986 appropriations bill that would prohibit NEA grants to any artist whose work is "patently offensive to the average person." After debate, the amendment is defeated in committee.

Rock Hudson dies of AIDS, bringing worldwide attention to the epidemic.

1986

Space shuttle Challenger explodes moments after liftoff, killing its seven-member crew, including New Hampshire schoolteacher Christa McAuliffe, the first private citizen to be sent into space.

An accident at Chernobyl, Soviet nuclear power plant, releases a raioactive cloud over much of Europe.

Iran-Contra scandal, involving sale to missles to Iran to fund U.S.-backed, right-wing Contras in Nicaragua, is exposed.

At Howard Beach, a neighborhood of Queens , N.Y., a gang of white youths attack three African-American men, killing one.

A national survey records over 350,000 homeless nationwide, 58,000 in New York City alone.

U.S. Supreme Court rules in *Bowers* v. *Hardwick* that consensual homosexual acts, even in private, are not protected by the Constitution.

NEA chair Frank Hodsoll vetoes grant to Jenny Holzer for display of her *Sign on a Truck* near several government sites in Washington, D.C.

1987

The U.S. Supreme Court rules that it is constitutional for Congress and the Justice Department to label foreign films that could influence public opinion on U.S. foreign policy as "political propaganda."

A federal judge rules that the GSA may remove Serra's *Tilted Arc*. A special NEA panel requests that the work not be removed.

On October 19, the Dow Jones Industrial Average drops a record 508 points, the largest single decline since 1914. Losses of $500 billion are reported.

Van Gogh's *Irises* sells for $53.9 million at auction. This is the highest price ever paid for a painting.

ACT UP (AIDS Coalition to Unleash Power) is formed in New York. The group initiates an AIDS activist poster project with the slogan "Silence=Death."

1988

Vice-President George W. Bush is elected president; his running mate, Sen. Dan Quayle, becomes vice-president.

When a Pan American jumbo jet explodes over Lockerbie, Scotland, some 270 pasengers are killed. A terrorist bomb is suspected.

Virginia artist Alice Sims is investigated for child pornography after a drugstore processing her film notices nude photographs of children. Police search her house and take custody of her children for a night.

1989

In one of the worst environmental disasters in history, the tanker *Exxon Valdez* runs aground, spilling eleven million gallons of oil into Prince William Sound and devastating 1,100 miles of Alaska coastline.

Gavin Lee, from *Jade Cicada*, from the series *Concerning George*, 1994, digital image. Photo courtesy of the artist. Art Matters recipient, 1993.

Chinese students, urging democratic reforms in communist China, stage a peaceful protest in Beijing's Tiananmen Square. Government troops, sent to curtail the demonstrations, kill untold hundreds of students.

Calling the novel *The Satanic Verses* blasphemous to Islam, Ayatollah Khomeini places a *fatwah*, or death sentence, on author Salman Rushdie.

After twenty-eight years as a symbol of Cold War division, the Berlin Wall dividing East and West Germany comes down.

U.S. troops invade Panama.

AIDS is cited as the leading cause of death for men and women ages 25 to 34; 23,066 cases reported in New York City alone.

Hundreds march on the Art Institute of Chicago to protest the display of art student Scott Tyler's work *What is the Proper Way to Display a U.S. Flag?*, which involves a comment book and a flag placed on the floor where viewers must stand to record their comments.

The U.S. Supreme Court rules that desecration of the flag is protected by the First Amendment.

Rev. Donald Wildmon of the American Family Association calls attention to Andres Serrano's photograph *Piss Christ*, which depicts a plastic crucifix submerged in urine. Appealing to the Congress and the media, Wildmon berates the photo as blasphemous and condemns the government for funding the work. (In fact, Serrano received federal funds indirectly; his $15,000 fellowship from the Southeastern Center for Contemporary Art [SECCA] was partly supported by the NEA.)

On May 18, Sen. Alfonse D'Amato (R.-N.Y.) tears up a copy of the catalogue reproducing Serrano's *Piss Christ* on the Senate floor. Sen. Jesse Helms (R.-N.C.) says, "Serrano is not an artist, he is a jerk."

In early June, more than 100 members of Congress send a letter to the NEA criticizing its support for the retrospective *Robert Mapplethorpe: the Perfect Moment* organized by the Institute of Contemporary Art in Philadelphia. The Corcoran Gallery of Art in Washington, D.C., abruptly cancels its scheduled display of the exhibition. Artists, critics, and Corcoran staff members loudly protest the cancellation.

On July 25, Congress cuts the NEA budget by $45,000, the total amount of the grants given SECCA and the Philadelphia ICA, and used to fund the Serrano and Mapplethorpe exhibits.

In a nearly empty chamber on the evening of July 26, Sen. Helms successfully introduces an amendment to an Interior Department appropriations bill prohibiting NEA grants to fund "indecent" or "offensive" art.

Kim Dingle, *Priss* (installation view), 1994, porcelain, china paint, painted steel wool, dimensions variable.
Art Matters grant recipient, 1994.

In September, the full House defeats the Helms Amendment and later a compromise bill is passed calling for a twelve-member commission to study the NEA's standards for funding works of art, and prohibiting support to any work that is legally obscene.

Newly appointed NEA chairperson John Frohnmayer revokes a $10,000 NEA grant awarded to Artists Space in Manhattan for *Witnesses: Against Our Vanishing*, an exhibition about AIDS, because a catalogue essay by artist David Wojnarowicz denounces several prominent public figures. After protests from the arts community, Frohnmayer restores the grant.

After a nine-year debate, Serra's *Tilted Arc* is removed from Federal Plaza in New York.

Picasso's self-portrait, *Yo Picasso* (1901), again sells at auction—this time for $47.9 million.

1990

South Africa frees political prisoner Nelson Mandela; South African President F.W. de Klerk begins dismantling apartheid system.

Former Solidarity union leader Lech Walesa becomes president of Poland.

When *Robert Mapplethorpe: The Perfect Moment* opens at the Contemporary Art Center in Cincinnati, the museum's director is indicted for misdimeanor obscenity charges by a grand jury.

The American Family Association attacks the David Wojnarowicz retrospective *Tongues of Flame*.

The home and studio of San Francisco photographer Jock Sturges are raided by FBI agents in search of child pornography. Sturges notes that his photographs of nude children were all made with the permission of the children's parents and were in no way pornographic.

The Recording Industry Association of America announces voluntary "Parental Advisory/Explicit Lyrics" label for potentially controversial recordings.

Members of of the rap group 2 Live Crew are arrested on obscenity charges following a Florida performance; obscenity charges are filed against the band members and a record-store owner.

David Wojnarowicz files federal suit against the American Family Association, seeking $1 million in damages for copyright violation, defamation of character, and violation of a New York law prohibiting unauthorized alteration and dissemination of an artist's work. Wojnarowicz later wins the case and a symbolic one-dollar award.

With support from Art Matters, the National Campaign for Freedom of Expression (NCFE) is formed by artists and activists in Washington.

On June 29, NEA chair Frohnmayer vetoes grants to performance artists Karen Finley, John Fleck, Holly Hughes, and Tim Miller.

The newly formed NCFE, along with the ACLU and the Center for Constitutional Rights sue the NEA on behalf of Finley, Fleck, Hughes, and Miller, charging the agency violated their constitutional rights by denying them grants for political reasons.

On Oct. 5, Contemporary Art Center deirector Dennis Barrie is acquitted of obscenity charges in showing the Mapplethorpe exhibition.

U.S. Congress reauthorizes the NEA for three years in a compromise that eliminates explicit restrictions on the type of art that may be funded. The bill does, however, require that grantees consider "general standards of decency and respect for the diverse beliefs and values of the American public."

1991

U.S. declares victory in Persian Gulf War (Operation Desert Storm).

Televised Senate hearings to confirm the nomination of Clarence Thomas as Supreme Court justice turn into a national forum on sexual harassment when former employee Anita Hill charges that Thomas made unsolicited advances to her.

Amateur video showing African-American motorist Rodney King being beaten by numerous white Los Angeles policemen stirs national outcry.

The NEA's so-called loyalty oath, a pledge by grant-seekers not to make obscene works, is declared unconstitutional by federal judge.

The NEA 4 case, known as *Finley* v. *NEA*, is amended to include a challenge to the constitutionality of the "decency and respect" clause.

In an abortion case, *Rust* v. *Sullivan*, the U.S. Supreme Court rules that the government can define the limits of a program it supports.

Frohnmayer rejects $10,000 grant to Texas artist Mel Chin for environmental project approved by peer panel and National Council.

Federal judge rules that postmodern artist Jeff Koons violated copyright when he based a 1986 sculpture of puppies on a greeting-card photograph; this ruling is later upheld by the U.S. Supreme Court.

1992

Acquittal of L.A. police officers in beating of Rodney King sparks massive, three-day riot in Los Angeles.

On Feb. 21, just as Republican presidential challenger Patrick Buchanan is about to make the NEA an issue, President Bush abruptly fires Frohnmayer; Anne-Imelda Radice becomes acting NEA chief.

In May, Radice promptly vetoes exhibition grants to MIT's List Visual Art Center and Virginia Commonwealth University's Anderson Gallery, dismisses the solo performance panel, and redirects the $210,000 from the Theater Arts panel to education. Stephen Sondheim and Wallace Stegner turn down National Medals of Arts in protest.

After Bush's defeat in 1992 presidential election, lame-duck NEA chair Radice personally vetoes grants to three gay and lesbian media fests.

Women's Action Coalition (WAC) formed.

1993

U.S. Congress ratifies the North American Free Trade Agreement (NAFTA)

Israel signs peace accord with the Palestinian Liberation Organization (PLO).

President Clinton nominates actress Jane Alexander as head of the NEA, and academic Sheldon Hackney as chair of the NEH.

The 1993 Whitney Biennial, organized by Elisabeth Sussman, features art "shaped by social, cultural, and political concerns."

1994

Nelson Mandela is elected president of South Africa.

In midterm elections, Republicans, under the promise of a "Contract with America," win control of the U.S. House and Senate; conservative congressional leader Rep. Newt Gingrich (R.-Ga.) becomes Speaker of the House.

The NEA's National Council on the Arts rejects recommended photography fellowships to Merry Alpern, Barbara DeGenevieve, and Andres Serrano.

The NEA prohibits grantees from subgranting to other organizations and artists.

1995

After a year-long trial, former football star O.J. Simpson is found not guilty of the stabbing death of his wife and her friend.

In Washington, D.C., Nation of Islam leader Louis Farrakhan leads the so-called Million Man March for African-American men.

On April 19, a truck bomb destroys a federal office building in Oklahoma City, Oklahoma, killing 168.

The NEA's National Council rejects funding to Urban Bush Women and Schubert Performing Arts Center. Later, the Council also rejects exhibition grants to the Institute of Contemporary Art and the Renaissance Society.

In August, U.S. Congress restructures the NEA, slashing its budget by 40 percent and eliminating almost all grants to individual artists. General operating grants are prohibited; instead, applicant organizations are required to identify specific projects that will receive public funds. All NEA funds are to stop by 1997.

1996

President Clinton and Vice-President Gore are reelected.

On Nov. 5, the U.S. Court of Appeals upholds the ruling in *Finley* v. *NEA* invalidating the "decency and respect" clause, adding that the clause illegally restricts artistic content and viewpoint.

1997

Lady Diana, former Princess of Wales, is killed in a car crash in Paris; millions mourn worldwide.

Ceasefire resumes as Northern Ireland peace process move forward.

NEA chair Jane Alexander, under pressure from Congress, rejects a proposed grant to Canyon Cinema.

Taking on the grantmaking role itself, the Mecklenburg (N.C.) County Commission cuts $2.5 million in funding for the local arts and science council, as part of its resolution to support only projects that promote "the traditional American value system."

On July 16, the House of Representatives votes to abolish the NEA by eliminating its funding for FY1998. Ultimately, the Senate overturns this vote, restoring funding to the NEA but also adding six members of Congress to the NEA's National Council as nonvoting members.

President Clinton names William Ferris as head of the NEH and William Ivey as head of the NEA.

1998

Under prodemocracy pressure, dictatorial President Suharto of Indonesia resigns after thirty-two years in power.

Despite surprising losses in midterm elections, Republicans barely hold edge in House and Senate; House Speaker Gingrich resigns in disgrace.

U.S. House of Representatives impeaches President Clinton for obstruction of justice and perjury over his affair with Monica Lewinsky.

In one of the most brutal examples of gay-bashing, twenty-two-year-old Matthew Shepard is beaten, tied to a fence and left to die in Wyoming.

St. Louis Cardinal Mark McGwire sets major-league baseball record with seventy home runs in a season.

The Supreme Court reverses earlier decision in *Finley* v. *NEA*, and asserts that the NEA may consider "general standards of decency" in awarding arts grants.

1999

President Clinton is acquitted by the U.S. Senate.

NEA head William Ivey rejects a grant to Cinco Puntos Press when it is revealed that one of their children's books, *The Story of Colors*, was authored by a leader of the Zapatista guerrillas in Mexico.

— compiled by Karen Kurczynski

Contributors

JULIE AULT is an artist who organizes exhibitions and projects collaboratively and independently. Ault cofounded the artists' collaborative Group Material in 1979. Her independent projects include the exhibition *Power Up: Reassembled Speech, Interlocking, Sister Corita and Donald Moffett* at the Wadsworth Athenaeum, Hartford, 1997.

DOUGLAS CRIMP is a critic whose writing focuses on contemporary art, AIDS, and postmodern museology. His published works include *On the Museum's Ruins* (MIT Press, 1993) and an essay in *Mary Kelly* (Phaidon, 197). He is currently Professor of Art History and Visual and Cultural Studies at the University of Rochester.

DAVID DEITCHER is a writer and the editor of *The Question of Equality: Lesbian and Gay Politics in America Since Stonewall* (Scribner, 1995).

RICHARD ELOVICH has been performing his own work since 1980. He was an organizer of ACT UP/ New York's needle exchange AIDS prevention effort. He is currently public policy associate at Gay Men's Health Crisis.

ANDREA FRASER is an artist whose work encompasses performance, installation, writing, and audio and video works. Her most recent project is "Reporting from São Paulo, I'm from the United States," five broadcasts produced by TV Cultura Brazil and the 24th Bienal de São Paolo in 1998.

COCO FUSCO is a writer and interdisciplinary artist who has lectured, performed, exhibited, and curated throughout the North America, Europe, South Africa, and Latin America. Her collection of essays on art, media, and cultural politics is called *English Is Broken Here: Notes on Cultural Fusion in the Americas* (New Press, 1995).

LEWIS HYDE is the Luce Professor of Art and Politics at Kenyon College. A MacArthur Fellow, he is the author of *The Gift: Imagination and the Erotic Life of Property* (Vintage, 1983) and *Trickster Makes This World: Mischief, Myth and Art* (Farrar Straus & Giroux, 1998).

HOLLY HUGHES is a New York-based, Obie-prize-winning performance artist and playwright. Her latest book, *Clit Notes: A Sapphic Sampler* (Grove/ Atlantic, 1996), includes a selection of writings derived from her performances.

LUCY R. LIPPARD is a writer and activist. She is the author of more than twenty books, including, most recently, *The Lure of the Local: Senses of Place in a Multicentered Society* (New Press, 1996) and *On the Beaten Track: Tourism, Art and Place* (New Press, 1999).

KOBENA MERCER is a cultural critic whose work addresses the politics of representation in the visual arts of the African diaspora. He is the author of *Welcome to the Jungle: New Positions in Black Cultural Studies* (Routledge, 1994).

MARTHA ROSLER is a contemporary artist and writer. She has published three books, including *If You Lived Here: The City in Art, Theory, and Social Activism* (Bay Press, 1991).

KATHLEEN M. SULLIVAN teaches at Stanford University and writes on constitutional and criminal law. She is the coauthor, with Gerald Gunther, of *Constitutional Law* (13th ed., Foundation Press, 1997).

CAROLE S. VANCE, an anthropologist at Columbia University, is the editor of *Pleasure and Danger: Exploring Female Sexuality* (Pandora, 1993).

MICHELE WALLACE teaches in the English Department at City College and at the Graduate Center at the City University of New York. She is the author of *Black Macho and the Myth of the Superwoman* (Dial, 1979) and *Invisibility Blues: From Pop to Theory* (Verso, 1990).

BRIAN WALLIS is a cultural critic and writer whose books include *Art After Modernism: Rethinking Representation* (Godine, 1984), *Democracy: A Project by Group Material* (Bay Press, 1990), and, with Maurice Berger and Simon Watson, *Constructing Masculinity* (Routledge, 1996).

MARIANNE WEEMS is an artist and board president of Art Matters. Her own work has been performed internationally, and she is director of The Builders Association, a multimedia performance company.

PHILIP YENAWINE is an arts educator, author, and cofounder of Art Matters. He was Director of Education at the Museum of Modern Art from 1983 to 1993, and is now the codirector of Visual Understanding in Education.

GEORGE YUDICE is Director of Graduate Studies in the American Studies Program at New York University. His writing focuses on transnational politics and culture, social movements, and Latin American intellectual culture. His publications include *We Are Not the World: Identity and Representation in an Age of Global Restructuring* (Duke University Press, forthcoming).